THE MEL COMPANION

Maya Scripting for 3D Artists

THE MEL COMPANION

Maya Scripting for 3D Artists

DAVID STRIPINIS

CHARLES RIVER MEDIA, INC.

Hingham, Massachusetts

Publisher: Jenifer Niles
Production: Publishers' Design and Production Services, Inc.
Cover Design: The Printed Image
Cover Image: David Stripinis

CHARLES RIVER MEDIA, INC.
10 Downer Avenue
Hingham, Massachusetts 02043
781-740-0400
781-740-8816 (FAX)
info@charlesriver.com
www.charlesriver.com

This book is printed on acid-free paper.

David Stripinis. *The MEL Companion: Maya Scripting for 3D Artists*.
ISBN: 1-58450-275-4

Library of Congress Cataloging-in-Publication Data

Stripinis, David.
 The MEL companion : Maya scripting for 3D artists / David Stripinis.
 p. cm.
 ISBN 1-58450-275-4 (Paperback with CD-ROM : alk. paper)
 1. Computer animation. 2. Maya (Computer file) 3. Three-dimensional
display systems. I. Title.
 TR897.7.S78 2003
 006.6'96—dc21
 2003002079

Printed in the United States of America
03 7 6 5 4 3 2 First Edition

CONTENTS

ACKNOWLEDGMENTS

The book you are holding in your hands is the product of a lot of hard work over the past year of my life, and I couldn't have done it without the aid and support of a few people, whom I'd like to now thank.

First and foremost, Jenifer Niles and the entire staff at Charles River Media. You put up with a lot, and really made this book happen.

Paula Suitor, Danielle Lamonthe, Ken Knobel, and everyone at Alias|Wavefront.

Bryan Ewert and Julian Mann for being there when I was learning MEL.

The crew at Factor 5 who supported my learning MEL in the first place, especially Dean Giberson, Jamie Uhrmacher, and Thomas Engel.

My mentor and friend Hal Hickel.

Andre Bustanoby, Jarrod, DJ, Matt, and Tom at House of Moves for getting me into this whole thing.

Lisa and Deb, my muses.

And, of course, my family—Thanks!

AN INTRODUCTION TO THE MAYA EMBEDDED LANGUAGE

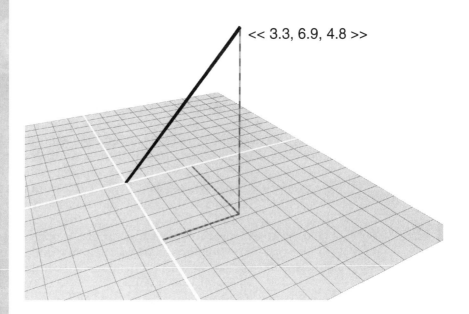

The Maya Embedded Language, or MEL, is an important part of what makes Maya so powerful. Yet, many artists working within Maya—out of ignorance, fear of the unknown, or a mistrust of programming—do not exploit it.

MEL is not just another aspect of Maya, it is the very foundation of the Maya application itself. While many of the core pieces of the software are "hard coded," you will be surprised, if not stunned, to discover the amount of functionality Maya provides with scripting. While this provides a lot of cross-platform stability (one of the reasons why Maya can appear on so many platforms), it also allows for an incredible amount of control for the MEL-savvy user. Whether customizing the workspace, modifying the tools that already exist, or creating new tools, an artist versed in MEL is ready to fully exploit the true power of Maya.

By now, you're probably wondering, if MEL is so great, why doesn't everyone know it? Good question, and no easy answer. Earlier we proposed that it was possibly out of ignorance. Well, if you purchased this book and read this far, that excuse is no longer valid.

The other two possibilities—a mistrust of programming and fear of the unknown—go hand in hand. Artists really only mistrust programming because it represents a whole other world. A world filled with words like *variable*, *conditional statements*, and *vector cross-product* do nothing for your average artist. You might as well be speaking another language—oh wait, you are.

Therein lies one of the keys to learning MEL. They are called "programming languages" for a reason. They have their own vocabulary and rules of grammar. It is simply a matter of learning those rules.

Many scripters, when asked by an eager young artist, "How can I learn MEL?" respond with, "Look at the scripts that are out there and see how they were done." That is ridiculous. You wouldn't hand somebody who wanted to learn French a copy of *Les Miserables* in the original French and expect him or her to just catch on, would you? Of course not. The documentation provided with Maya does little more than provide syntax definition and rules for those already versed in programming. Again, not much use to an artist.

That's where this book comes in. The first section, cleverly entitled "Part I," covers the syntax, vocabulary, and the structure of MEL—it's grammar, if you will. It also covers some basic math concepts such as types of numbers and simple math equations. Finally, we cover concepts of building and constructing any program, which is applicable because scripts are, in fact, computer programs. The second section, with the also clever but somewhat predictable title of "Part II," covers the construction of some scripts that detail some of the ways you can use MEL.

This book makes some assumptions about you, the reader. First, we assume that you have a fundamental knowledge of working in 3D and the Maya program. We don't explain what XYZ co-ordinates are, what

the Hypergraph is, or other basic operating knowledge. In addition, although you might not have an extensive knowledge and understanding of mathematics, you should have some willingness to learn the basics of working with numbers. This is essentially a programming book, and all programming is built on manipulating numbers. Other than that, everything else is explained in language that is hopefully as clear as it is entertaining.

In Chapter 2, "A Primer on Mathematics," we explain what the different types of numbers are, how they're used, and some of the basic concepts needed for working with 3D math. It is not a comprehensive text on 3D math (that subject could fill an entire book, and, in fact, there are many quality books on 3D math out there); however, we give you enough to get by.

That is the essential philosophy of this book. The author is not a programmer by training, he is an artist. This book was written with the artist in mind. A basic tenet of art is that if it *looks* right, it *is* right. This book's philosophy is the same. While fast tools are good, and efficient tools are good, usually it's better if they work. Many useful MEL tools can be done with the programming version of duct tape. Cheating, digital smoke and mirrors, and programming duct tape are a basic part of putting together tools fast. And, of course, you can do things "the right way." By the end of this book, you'll have hopefully learned both. MEL is about problem solving. It, and you, really shouldn't care how you achieve the result, as long as that result is what you want. We refer to this as "guerilla scripting." It's a philosophy and approach that many programmers are aghast at publicly, but actually adhere to it in practice. And it's a concept familiar to artists everywhere.

So, dive in. It's best not to skip any sections, because although we have tried to explain things as simply as possible, any type of programming can be confusing. Occasionally, because two concepts are interdependent, one topic won't make sense until you read the entire section. We avoided this wherever possible, and where we couldn't, we made sure to notify you so you know it's coming.

THE MAYA EMBEDDED LANGUAGE

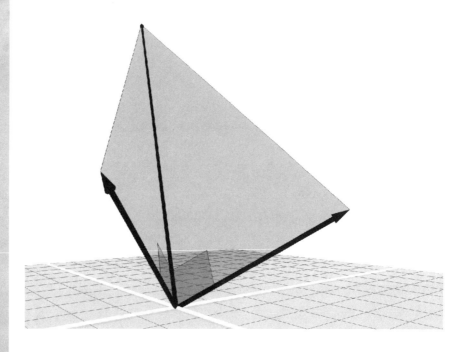

A PRIMER ON MATHEMATICS

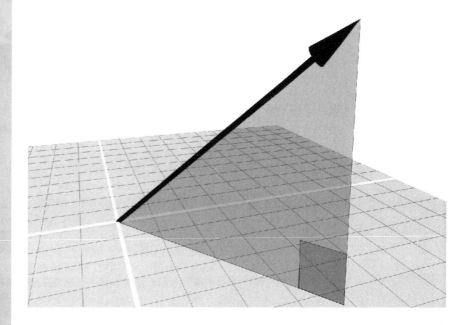

There is perhaps no single aspect of scripting that scares artists like that of math. Many artists spent most of their time in math classes drawing little doodles in their notebooks rather than paying attention, thinking "I'm an artist, I don't need math!" Fast-forward a few years and suddenly, with our day-to-day interaction with computers to create our art, we do, in fact, need math.

People working within a 3D application like Maya have a fundamental understanding of mathematics, although they might not realize it. Unbeknownst to them, artists working in Maya perform vector calculations, derive solutions using methods used in analytical geometry, and do complex algebra calculations nearly every day. While Maya actually performs the calculations required, the artist knows both what he wants as a result, and what to use as inputs to get that result. When we as artists decide to go to the next level, and start to work with MEL, it is often necessary to gain a more robust understanding of the fundamental concepts of the mathematics used in computer graphics. We are actually in a better position than most while learning this because Maya is built to make many of the operations needed as easy as possible.

This chapter introduces us to the mathematic concepts that a scripter most often needs to know to write useful and effective scripts. This is not to say that every script we write will involve complex algorithms, or that this chapter answers every possible problem a scripter might need to solve. Rather, it is meant to impart a basic understanding to both complete the projects in this book, and help solve the problems encountered when undertaking the challenge of writing original scripts.

NUMBERS

The most basic element of math is the number. While this is probably not news to most people, it is important, especially in the world of programming, to realize that all numbers are not created equal. Mathematicians have many types of numbers: *natural numbers*, *real numbers*, *complex numbers*, *prime numbers*, and so forth. For our purposes, we really need only an understanding of *integer*, *rational*, and *irrational* numbers. While there are those of you who might someday need to gain an understanding of the intricacies of complex numbers, there are books out there twice the size of this tome dedicated to that subject alone. The majority of scripters will never need that level of knowledge, and therefore it is not included in this book.

Integers

The integer is perhaps the simplest of all numerical concepts in math, representing non-fractional numbers that are both positive and negative.

For example, if we were to list every integer between –5 and 5, we would get –5, –4, –3, –2, –1, 0, 1, 2, 3, 4, and 5.

Rational Numbers

Rational numbers are numbers that can be represented as a fraction, and therefore are called *fractional* numbers. For example, ¼ is a rational number. So is 0.25, and they are in fact the same number. An interesting realization is that every integer is also a rational number; for example, ⁸⁄₂ = 4. The concept that one value can be two types of numbers is especially important to programming. Within a computer system, all rational numbers are stored as decimal numbers. That is, instead of storing a number as ¾, it is stored as 0.75. If we were to multiply that by 10, we would get 7.5, or if we were to divide it by 10, we would get 0.075. The decimal point essentially "floats" among the numbers, giving us the programming term *floating-point* number. The other concept relating to rational, or floating-point numbers that a programmer has to realize is that of the limited precision of some of these numbers within the computer. Some fractions, like the ratio of a television screen ⁴⁄₃, when solved produce an endless series of 3s as seen in Example 2.1.

EXAMPLE 2.1 A repeating remainder of a rational number.

$$\frac{4}{3} = 1.3333333333333333...$$

Other rational numbers, while they might not produce an infinite repeating series of numbers, might produce a number so small that Maya cannot accurately represent it. While this floating-point *precision* does not generally cause a problem with the first representation of the number, when we use that number, possibly combined with other numbers that are also slightly less-than-accurate, we can receive a result that, while not technically incorrect, is not what we would have received if we had been more precise. In programming, we term this a *floating-point error*. These errors can add up over time and produce very noticeable discrepancies in the final result. Think of a photocopy. If we take a visual medium with high resolution, such as a black-and-white photo, and make a photocopy of it, the copy does not have nearly the quality of the original, but is still recognizable as the original photo. However, if we make a copy of the copy, and then a copy of the new copy, each resembles the original photograph less and less. If we repeat this process enough, we are eventually left with a completely unrecognizable mess. MEL uses 15 points of precision, which unless you are working at incredibly small scales or work with extraordinarily high tolerances, are more than enough for most uses of MEL.

Irrational Numbers

The other type of number a MEL scripter often comes into contact with is the irrational number. Irrational numbers are those numbers which, to the best of human knowledge, never terminate, but are not a repeating remainder as in the case of ⁴⁄₃. Perhaps the best known irrational number to artists is π, which has been calculated out to millions of decimal places, with no noticeable pattern or end in sight. Pretty neat, if we consider that for a moment. While π is the best known, there are others, such as $\sqrt{2}$. Because irrational numbers are also stored inside MEL as floating-point numbers, they also suffer from the same precision errors as the endlessly repeating rational numbers.

MATHEMATICAL FUNCTIONS AND THE COMPUTER

Most people are familiar with the basic mathematical operations, such as addition, subtraction, multiplication and division, and their *operators* +, −, ×, and ÷. However, within the world of the computer we use slightly different notation. While +, −, and = are the same, we use * for multiplication and / for division. Therefore, while in written equations we will see the traditional math operators used, code examples will use the programmatic operators.

 For really intensely technical reasons that are really intensely boring, division is significantly harder for a computer processor than multiplication. If you were to divide 1000 different numbers by 4, it would take noticeably longer than it would to multiply those same numbers by 0.25. Wherever possible, use multiplication instead of division.

Other functions, such as finding square roots, raising numbers to a power, have notation specific to the computer language you are programming in. MEL is no exception, and contains a variety of specific commands for most common complex math functions. Throughout this book, as with the mathematical operators, we will show both the mathematical notation and the MEL code for any mathematical equation. Unless otherwise stated, notation for any mathematical operation is the same in MEL as it is in standard mathematical notation.

MATHEMATICAL DISCIPLINES

When working in MEL, there are three mathematical disciplines we often use. Algebra, trigonometry, and vector mathematics form the basis for the majority of all calculations carried out within MEL. Although there

advanced mathematics such as analytical geometry
calculations might be necessary, these are few and
verage scripter.

ith multiple layers of complexity, and while most of
equations we deal with in the realm of computer
metry and its associated laws, algebra provides a
alculations carried out within geometric equations.
understanding of algebra, we will be able to ap-
with confidence.

concepts of algebra is the order of operations. Within
fined by the *associative*, *commutative*, and *distributive*
t to have an extended discussion of algebraic theory
iscussion to how it affects MEL. In MEL, operators
ce over others. For example, multiplication and divi-
efore addition and subtraction. If there are multiple
he precedence in one equation, we do the operations
Example 2.2.

rator precedence in action.

$$4 + 25 \times 3 = 79$$

$$75 \div 3 \times 4 = 100$$

of course, when we might want to carry out an ad-
re using the results in a multiplication operation. To
cept known as *nesting* or *grouping*. We use parenthe-
nctions we want to calculate first. We can even en-
eration inside of another, hence the term *nesting*. If
host as a hierarchy, you calculate all the operations
the same point in the calculation, again from left to
.3.

uping different functions together.

$$(4 + 2) \times (15 - 5) = 60$$

$$6 \times 10 = 60$$

$$((4 + 2) \times 15) - 5 = 85$$

$$(6 \times 15) - 5 = 85$$

$$90 - 5 = 85$$

It is also important to note that within mathematical notation, it is possible to imply multiplication, as seen in Example 2.4.

EXAMPLE 2.4 Implied multiplication.

$$4 \times (10 - 5) = 20$$
$$4(10 - 5) = 20$$

This shorthand is not possible within MEL, but we will use it when appropriate in written formulae.

Algebra is most often used to solve for an unknown quantity. The idea of having a number as unknown is the basis for most algebraic equations. What we try to accomplish to solve an algebra problem is to get all the known information on one side of the =. We use letters to represent these unknown quantities, such as x, a, or i. There are some guidelines as to which letters are supposed to represent what, but it is really up to you. Most often, an unknown quantity is given the letter x. Whenever you do any math equation, you are essentially solving for an unknown, as seen in Example 2.5.

EXAMPLE 2.5 Solving for the unknown quantity, represented by x.

$$x = (5 + 6) \div (14 - 9)$$
$$x = 11 \div 5$$
$$2.2 = 11 \div 5$$
$$x = 2.2$$

Once we start solving for more complex unknown quantities, we need to begin flexing some of our algebraic muscles. This process is shown in Example 2.6.

EXAMPLE 2.6 Solving for x by using the inverse operations.

$$2x = 40$$
$$\frac{2x}{2} = \frac{40}{2}$$
$$x = 20$$

What is handy about these notations is they are used across disciplines, and even into other disciplines that require mathematical equations, such as physics. A tenet of Newtonian physics is that *force = mass × acceleration*, or $f = ma$. Once two of these factors have been determined, we can solve for the missing value.

As we have seen, algebra finds its way into multiple math disciplines, and having at least a basic understanding of the algebraic processes will come in handy as we explore trigonometry, vectors, and analytical geometry.

Trigonometry

Trigonometry is the study of the mathematical relationships that exist within triangles. As triangles are the basic foundation of all geometry that exists in 3D computer graphics, an understanding of trigonometry is a good thing for a scripter to have.

The basic foundation of trigonometry is that there exists within all triangles a relationship between the length of their sides and the angles of the triangle. The relation of each of the three sides and the three angles of a triangle is an exact and nearly magical science.

A triangle containing a 90°, or *right*, angle is referred to as a *Right Triangle*. The side opposite the right angle is called the *hypotenuse*. The other sides of the triangle do not have specific names, but names given based on the angle we are either trying to find, or that we know if we are trying to determine the length of a side. In Figure 2.1, we use the symbol ß to represent the angle used in the equations to follow.

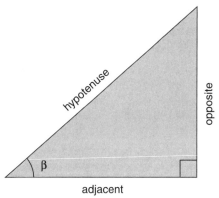

FIGURE 2.1 A triangle for use in the following equations.

The three basic trigonometric functions are *sine, cosine,* and *tangent*. The trigonometric ratios given by these three functions are shown in Example 2.7. Note that we have used the common mathematical abbreviations for each of these functions. Coincidently, these common abbreviations are also the MEL commands for these same functions.

EXAMPLE 2.7 The three basic trigonometric functions.

$$\sin(\beta) = \frac{\text{opposite}}{\text{hypotenuse}}$$

$$\cos(\beta) = \frac{\text{adjacent}}{\text{hypotenuse}}$$

$$\tan(\beta) = \frac{\text{opposite}}{\text{adjacent}}$$

Sine, cosine, and tangent values are known. Therefore, as long as we know the length of one side and any other piece of information on a right triangle, be it the length of another side or any angle in that triangle, we can use algebra as seen in Example 2.8 to solve for the unknown quantities for the triangle shown in Figure 2.2.

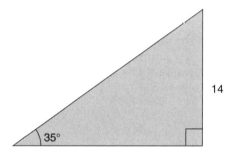

14

35°

FIGURE 2.2 A triangle in need of solving.

EXAMPLE 2.8 Finding the length of the unknown side.

$$\sin(35°) = \frac{14}{hypotenuse}$$

$$0.5735764364 = \frac{14}{x}$$

$$x \times 0.5735764364 = \left(\frac{14}{x}\right)x$$

$$x \times 0.5735764364 = 14$$

$$\frac{x \times 0.5735764364}{0.5735764364} = \frac{14}{0.5735764364}$$

$$24.4082551386954 = x$$

$$\cos(35°) = \frac{adjacent}{24.4082551386954}$$

$$0.8191520443 = \frac{y}{24.4082551386954}$$

$$24.4082551386954 \times 0.8191520443 = \left(\frac{y}{24.4082551386954}\right) 24.4082551386954$$

$$24.4082551386954 \times 0.8191520443 = y$$

$$19.9940720943896 = y$$

When the triangle is not a right triangle, we employ the sometimes more useful *sine rule*. The sine rule states:

$$\frac{a}{\sin A} = \frac{b}{\sin B} = \frac{c}{\sin C}$$

Where side a is opposite angle A, side b is opposite angle B, and side c is opposite angle C. We can use the sine rule to find the dimensions of nearly any arbitrary triangle.

Luckily, because Maya essentially acts as a operating system specialized for doing 3D graphics when you're working in MEL, finding many of these values is a simple process, as are the functions to calculate those you can't simply query from your scene.

Vector Mathematics

The term *vector* refers not to a method of mathematics, but rather to a type of number. Of course, the math related to vectors has its own set of specific rules and some specific operations, which we'll cover.

The numbers we have used so far are actually rather simple compared to vectors. A vector contains multiple pieces of information, and not just because it contains three numbers. For example, a single vector can contain the direction an object is traveling and its current speed.

 In the wider world of math and physics, not all vectors have three components. Within computer graphics, however, this is both the most common type, as well as the type MEL uses.

A vector is a very special type of number in 3D space, and possibly the most confusing to artists. As 3D artists, we actually deal with vectors all the time and never realize it. In creating a hierarchy of objects, assuming the transforms of those objects haven't been reset, the translate values of each object represent a vector between that object and its parent, even if that parent is the world. In Figure 2.3, we see a visualization of a vector from the origin.

As we learned, vectors contain multiple pieces of information, the obvious being a point in Cartesian space. However, that vector also has a

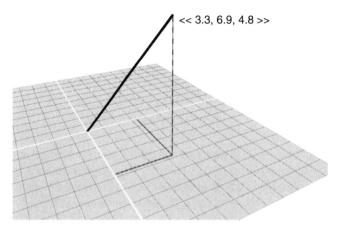
<< 3.3, 6.9, 4.8 >>

FIGURE 2.3 A vector visualized in 3D space.

length. We call this value the *magnitude* of the vector. A vector's magnitude can be used to represent not just distance, but speed, the intensity of a physical force such as a gravity field, or any item that contains both direction and intensity. It is no coincidence that the attribute on dynamic fields in Maya that controls the intensity is called "magnitude."

Mathematical vector notation can be done in *column* or *row* formatting. Each number in the vector is referred to as a *component*. For purposes of clarity, we refer to these components as *x, y, z*. We use bold letters to signify a vector within standard mathematical notation—please refer to Example 2.9.

EXAMPLE 2.9 Vector notation.

$$\mathbf{v} = \begin{bmatrix} \mathbf{x} \\ \mathbf{y} \\ \mathbf{z} \end{bmatrix}$$

$$\mathbf{v} = \begin{bmatrix} \mathbf{5} \\ \mathbf{1} \\ 2 \end{bmatrix}$$

If we want to represent the magnitude of a vector, we enclose the vector representation in vertical braces, as in

$$|\mathbf{v}|$$

To determine the magnitude of a vector by hand, we use the formula

$$\sqrt{x^2 + y^2 + z^2}$$

To visualize a simple vector, we assume that the vector's *tail*, or beginning, is at the world origin. The *head* is placed at the coordinates of the vector, depicted as an arrowhead in Figure 2.4.

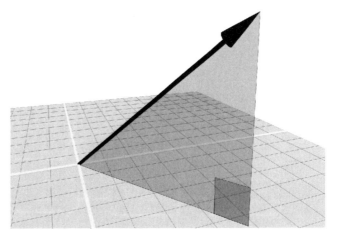

FIGURE 2.4 The standard depiction of the vector.

Vectors, like any type of number, can be used in mathematical equations. Adding and subtracting vectors from each other is a rather simple matter of adding or subtracting each of the components together, as seen in Examples 2.10 and 2.11. These two equations are visualized in Figures 2.5 and 2.6.

EXAMPLE 2.10 Addition of two vectors.

$$\mathbf{a} = \begin{bmatrix} 5 \\ 4 \\ 8 \end{bmatrix}$$

$$\mathbf{b} = \begin{bmatrix} 6 \\ 2 \\ 1 \end{bmatrix}$$

(continued)

EXAMPLE 2.10 *(Continues)*

$$\mathbf{v} = \left(\mathbf{a} + \mathbf{b}\right)$$

$$\mathbf{v} = \begin{bmatrix} \left(5 + 6\right) \\ \left(4 + 2\right) \\ \left(8 + 1\right) \end{bmatrix}$$

$$\mathbf{v} = \begin{bmatrix} 11 \\ 6 \\ 9 \end{bmatrix}$$

EXAMPLE 2.11 Subtraction of two vectors.

$$\mathbf{a} = \begin{bmatrix} 5 \\ 4 \\ 8 \end{bmatrix}$$

$$\mathbf{b} = \begin{bmatrix} 6 \\ 2 \\ 1 \end{bmatrix}$$

$$\mathbf{v} = \left(\mathbf{a} - \mathbf{b}\right)$$

$$\mathbf{v} = \begin{bmatrix} \left(5 - 6\right) \\ \left(4 - 2\right) \\ \left(8 - 1\right) \end{bmatrix}$$

$$\mathbf{v} = \begin{bmatrix} -1 \\ 2 \\ 7 \end{bmatrix}$$

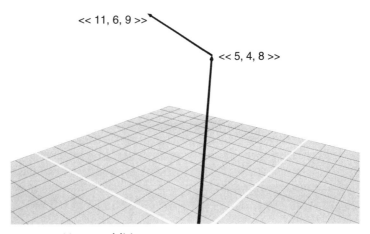

<< 11, 6, 9 >>

<< 5, 4, 8 >>

FIGURE 2.5 Vector addition.

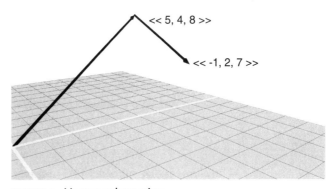

<< 5, 4, 8 >>

<< -1, 2, 7 >>

FIGURE 2.6 Vector subtraction.

We can see how the simple addition of multiple vectors can be used to determine the effects of multiple forces on a particle, or where a vehicle traveling 90 m.p.h. will be during a 20° left turn after 3 seconds.

If we need to determine the magnitude of a vector that does not begin at the origin, we first build a new vector by subtracting the tail from the head, and treat it as a vector starting at the origin. We refer to the value of the new components as the *delta*, signified by the Greek letter Δ. In Example 2.12, we see how we find the magnitude of a vector that does not begin at the origin.

EXAMPLE 2.12 Finding the magnitude of the delta vector. This magnitude is the distance between the two points defined by the vectors a and b.

$$\mathbf{a} = \begin{bmatrix} 14 \\ 6 \\ -4 \end{bmatrix}$$

$$\mathbf{b} = \begin{bmatrix} 6 \\ -2 \\ 3 \end{bmatrix}$$

$$\Delta = \begin{bmatrix} \mathbf{b_x} - \mathbf{a_x} \\ \mathbf{b_y} - \mathbf{a_y} \\ \mathbf{b_z} - \mathbf{a_z} \end{bmatrix}$$

$$\Delta = \begin{bmatrix} -8 \\ -8 \\ 7 \end{bmatrix}$$

$$\left| \Delta \right| = \sqrt{\Delta_x^2 + \Delta_y^2 + \Delta_z^2}$$

$$\left| \Delta \right| = 13.304$$

While you work within MEL, many of these functions are greatly simplified. However, it is important to know the origins of these calculations if, for example, we have a bug in our code and we need to track down where that erroneous number is coming into our calculations.

To add, subtract, or multiply a simple number, called a *scalar* number, to a vector, is straightforward: simply multiply the scalar by each of the components of the vector, as seen in Examples 2.13, 2.14, and 2.15.

EXAMPLE 2.13 Adding a scalar and a vector.

$$a + \begin{bmatrix} \mathbf{b_x} \\ \mathbf{b_y} \\ \mathbf{b_z} \end{bmatrix} = \begin{bmatrix} \left(a + \mathbf{b_x} \right) \\ \left(a + \mathbf{b_y} \right) \\ \left(a + \mathbf{b_z} \right) \end{bmatrix}$$

EXAMPLE 2.14 Subtracting a scalar and a vector.

$$\begin{bmatrix} \mathbf{b_x} \\ \mathbf{b_y} \\ \mathbf{b_z} \end{bmatrix} - a = \begin{bmatrix} (\mathbf{b_x} - a) \\ (\mathbf{b_y} - a) \\ (\mathbf{b_z} - a) \end{bmatrix}$$

EXAMPLE 2.15 Multiplying a scalar and a vector.

$$a \begin{bmatrix} \mathbf{b_x} \\ \mathbf{b_y} \\ \mathbf{b_z} \end{bmatrix} = \begin{bmatrix} (a\mathbf{b_x}) \\ (a\mathbf{b_y}) \\ (a\mathbf{b_z}) \end{bmatrix}$$

Now that we know what is involved in multiplying a vector by a scalar, we can introduce the concept of a *unit vector*. A unit vector is simply a vector with a magnitude of 1. The process of converting a vector to unit form is called *normalization*. To normalize a vector, we apply the formula shown in Example 2.16.

EXAMPLE 2.16 The formula for normalizing a vector.

$$\mathbf{v} = \begin{bmatrix} \mathbf{x} \\ \mathbf{y} \\ \mathbf{z} \end{bmatrix}$$

$$\frac{1}{|\mathbf{v}|} \mathbf{v}$$

By dividing 1 by the magnitude of our vector, we find the number we must multiply each of that vector's components by to normalize the vector. Because unit vectors, having a magnitude of 1, evaluate quicker when involved in many calculations, they are often used to speed up and simplify vector calculations. For example, let us say that we have an object at co-ordinates 5, 14, − 3 in Cartesian space. Those co-ordinates create a vector from the origin to that object. Let us further assume that we want that object to be 10 units away from the origin—in this example a completely arbitrary choice, but it is a real-world calculation done quite

often in 3D programming. In Example 2.17, we find its magnitude quite easily.

EXAMPLE 2.17 Finding the magnitude of our vector.

$$\mathbf{v} = \begin{bmatrix} 5 \\ 14 \\ -3 \end{bmatrix}$$

$$|\mathbf{v}| = \sqrt{5^2 + 14^2 + -3^2}$$

$$|\mathbf{v}| = 15.1657508881$$

Now that we know the magnitude, we can normalize the vector, as in Example 2.18.

EXAMPLE 2.18 Normalizing the vector from Example 2.17.

$$\frac{1}{|\mathbf{v}|}\mathbf{v} = \mathbf{v_u}$$

$$\frac{1}{15.1657508881} \times \begin{bmatrix} 5 \\ 14 \\ -3 \end{bmatrix} = \begin{bmatrix} 0.3296902367 \\ 0.9231326628 \\ -0.197814142 \end{bmatrix}$$

With our newfound unitized vector, we simply multiply that by our proposed distance, 10, we find the point along the same vector that is 10 units long. This calculation, along with its proof, is seen in Example 2.19.

EXAMPLE 2.19 Changing our vector from 2.14 to be 10 units long.

$$\begin{bmatrix} 0.3296902367 \\ 0.9231326628 \\ -0.197814142 \end{bmatrix} \times 10 = \begin{bmatrix} 3.296902367 \\ 9.231326628 \\ -1.97814142 \end{bmatrix}$$

$$\sqrt{3.296902367^2 + 9.231326628^2 + -1.97814142^2} = x$$

$$\sqrt{100} = x$$

$$10 = x$$

Now that we have considered multiplying a vector by a scalar, there hopefully is some curiosity as to what happens when two vectors are multiplied together. Multiplying two vectors is both more difficult and more useful than adding and subtracting vectors. In fact, the multiplication of vectors is the foundation of rendering, polygonal shading, and 3D physics calculations. There are two ways to multiply two vectors together; one involves multiplying the magnitudes of the vectors together, leading to a scalar result, and the other is actually multiplying the vectors together. Although both are used in computer graphics, we will only discuss the calculations of the first type in depth.

To find the *scalar product* of two vectors, we first, of course, need the vectors themselves. In Figure 2.7, we have visualized two vectors. For convenience, we have drawn them with a common tail, although this quality is not a requirement of our calculations.

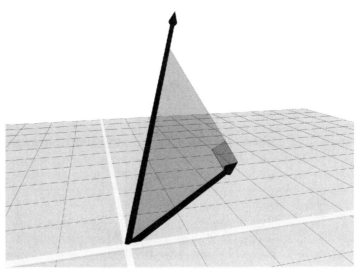

FIGURE 2.7 The dot product is visualized.

While we could simply multiply the magnitudes together, this value is arbitrary and does not take into account the orientation of one vector to another. To bring this angle into the equation, we will now compute a projection of our first vector onto our second vector, to form a right triangle. If we think back to what we learned in the section "Trigonometry," we realize our first vector, **h**, acts as the hypotenuse, and its projection on our second vector, **v**, is the adjacent side to the angle between them. That means that the length of that projection is $|\mathbf{h}| \cos \beta$. Now we can define our scalar product to the formula seen in Example 2.20.

EXAMPLE 2.20 The formula for finding the scalar product.

$$\mathbf{v} \cdot \mathbf{h} = |\mathbf{v}| \cdot |\mathbf{h}| \cos \beta$$

In the formula, we use the symbol \cdot to signify the multiplication of the two vectors, to differentiate our calculation from our *vector product* calculation. We call this the *dot product* of the two vectors. We could engage in a complicated mathematical proof of the why, but it is not the purpose of this book to fully examine the intricacies of vector calculations. Therefore, we'll cheat and just show the way the dot product works in Example 2.21.

EXAMPLE 2.21 The dot product.

$$v \cdot h = |v| \cdot |h| \cos \beta = \left(v_x h_x\right) + \left(v_y h_y\right) + \left(v_z h_z\right)$$

Now that we have a formula for finding the same number in multiple ways, we can use simple algebra to find an unknown quantity. Here is one of those occasions where using unit vectors come in handy. In Example 2.22, we use the dot product to solve for the unknown angle between two vectors.

EXAMPLE 2.22 Finding the angle between two vectors.

$$\mathbf{v} = \begin{bmatrix} 1 \\ 3 \\ -2 \end{bmatrix}$$

$$\mathbf{h} = \begin{bmatrix} 4 \\ 1 \\ 1 \end{bmatrix}$$

$$\mathbf{v}_u = \begin{bmatrix} 0.267261242 \\ 0.801783726 \\ -0.534522484 \end{bmatrix}$$

$$\mathbf{h}_u = \begin{bmatrix} 0.942809042 \\ 0.23570226 \\ 0.23570226 \end{bmatrix}$$

$$\cos \beta = \left(\mathbf{v}_{ux}\mathbf{h}_{ux}\right) + \left(\mathbf{v}_{uy}\mathbf{h}_{uy}\right) + \left(\mathbf{v}_{uz}\mathbf{h}_{uz}\right)$$

$$\cos \beta = 0.314970394$$

Now that we know that the cosine of our unknown angle is 0.314970394, it is a simple matter to find our angle as 71.6409734729205°. Obviously, finding the angles between two points is extremely useful. The same formula can be used to find a point 25° and 15 units away from a given point, or to determine if an object is within a camera's field of view, or calculate the illumination of a Lambert shaded surface. Make note that using this method will always find the shorter of the two angles, the one less than 180°. Moreover, these calculations are made in the relative plane of the two vectors, not the rotation values for an object.

As we said, the vector product is used quite often in computer graphics. Because the vector product, called the *cross product* because in mathematical formula it is signified with the standard multiplication symbol ×, is quite complicated to calculate longhand, we won't go into the specifics to avoid possible confusion. Those interested in the subject are encouraged to read specific material on the matter. MEL provides the capability to calculate the cross product, as well as the dot product, so we need only understand what it is. The cross product is a vector that is 90° to both the contributing vectors as seen in Figure 2.8.

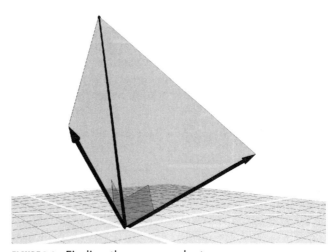

FIGURE 2.8 Finding the cross product.

Using the cross product of two vectors is how we determine such information as the normal of polygon, draw an offset of a line, and determine the area of a surface.

The other type of complex number used within MEL is the *matrix*. Math involving matrices is about as complicated as you can get. Matrices are a fundamental aspect of moving points around in space. In fact, there is a very special, very specific type of matrix computation in Maya called the *transformation matrix*. Almost every calculation that requires

knowledge of the transformation matrix in normal 3D math is handled by MEL commands.

Addition and subtraction of matrices is simple but restrictive. Within the operation, each matrix has to have the same dimensions. The addition or subtraction is carried out as a simple scalar operation between the corresponding elements of each matrix. Example 2.23 shows matrix subtraction.

EXAMPLE 2.23 Matrix subtraction.

$$
\begin{array}{|c|c|c|c|} \hline A0 & A1 & A2 & A3 \\ \hline B0 & B1 & B2 & B3 \\ \hline C0 & C1 & C2 & C3 \\ \hline \end{array}
-
\begin{array}{|c|c|c|c|} \hline a0 & a1 & a2 & a3 \\ \hline b0 & b1 & b2 & b3 \\ \hline c0 & c1 & c2 & c3 \\ \hline \end{array}
=
\begin{array}{|c|c|c|c|} \hline (A0-a0) & (A1-a1) & (A2-a2) & (A3-a3) \\ \hline (B0-b0) & (B1-b1) & (B2-b2) & (B3-b3) \\ \hline (C0-c0) & (C1-c1) & (C2-c2) & (C3-c3) \\ \hline \end{array}
$$

The complications with matrix math come when we begin to multiply two matrices together. The first rule to keep in mind is the sizing of each array. The number of columns in your first array must be equal to the number of rows in your second array. The resultant matrix has the same number of rows as the first matrix, and the same number of columns as the second matrix.

The actual calculation of the values in the resultant matrix is somewhat more complicated. The resultant matrix values are computed by multiplying and adding values together, as seen in Example 2.24.

EXAMPLE 2.24 Matrix multiplication.

$$
\begin{array}{|c|c|} \hline A & B \\ \hline C & D \\ \hline \end{array}
\times
\begin{array}{|c|c|} \hline a & b \\ \hline c & d \\ \hline \end{array}
=
\begin{array}{|c|c|} \hline Aa+Bc & Ab+Bd \\ \hline Ca+Dc & Cb+Dd \\ \hline \end{array}
$$

Matrix calculations are an extremely complex form of mathematics, and are rarely calculated within MEL scripts. The main use of matrix multiplication is in calculating transformation information, which is largely handled internally by Maya. Again, those interested in exploring the complex world of matrix math are encouraged to explore it independently. Additionally, due to some major limitations in how MEL handles matrices, they are quite infrequently used in MEL scripts.

ANGLES AND UNITS OF MEASUREMENT

Feet and meters, Celsius and Fahrenheit, radians and degrees. If there is a way to measure something, rest assured that the human race has come

up with at least 10 ways of doing it. At least we are no longer measuring distances as "a day's travel on a stout pony." However, we humans have devised two ways of defining angular measurement, both of which exist within Maya: radians and degrees.

While Maya can work with either angular measurement, most MEL commands assume you are working in radians. Because the information you retrieve from a Maya scene could be in either format, it is important to know whether to convert one to another. In Chapter 9, "Lighting and Rendering," we'll learn more about retrieving and modifying a user's personal preferences to discover which measurement type an artist is operating in when a script is executed. Both radians and degrees have their advantages and disadvantages when working within a program like Maya.

Artists don't like working with radians. There, it's been said. Radians do not seem to have any rationale to an artist. When an artist turns an object a ¼ turn, he wants to look at the rotation channels and see 90°— not 1.5707963267949 radians! Sure, once an artist realizes that $180° = \pi$, he might start to understand the system. However, degrees are just so much more than what artists are used to.

Programmers, on the other hand, love radians. They're clean, concise, and usually only mathematicians understand them. That, to a programmer, is the perfect type of number.

While almost every person is used to working with degrees as a unit of measurement, it is quite an awkward system. Most of the world exists in a world based on the decimal system, rather than a seemingly meaningless measurement system where 1 = 360, or more plainly, one rotation is equal to 360°. While those of us living in countries that use feet and inches are used to seemingly arbitrary measurements, it is best, whenever possible, to work in both radians and metric measurements. It is much easier and cleaner to convert whatever unit of measurement the end user is working in to a standard in software as a single step, than it is to create multiple evaluations of formulae based on user settings

An important thing when doing this is to be a considerate programmer and return any information to the user in the format in which he is working. Sometimes it is even necessary to evaluate commands in different ways, such as the creation of certain types of cameras and lights, which can have attributes containing angular information. Not doing so can result in errors. More on bulletproofing your scripts in these situations in Chapter 5, "The Script File."

CONCLUSION

Although brief, we now have enough of an understanding of mathematics to proceed to learning about MEL itself. While this chapter did not

examine every aspect of mathematics necessary to program every tool we might ever need, it did provide both a foundation to understand the coming projects and an impetus to go out and discover more complex areas, such as Bezier curves, interpolation calculations, or analytical geometry.

3

MEL BASICS

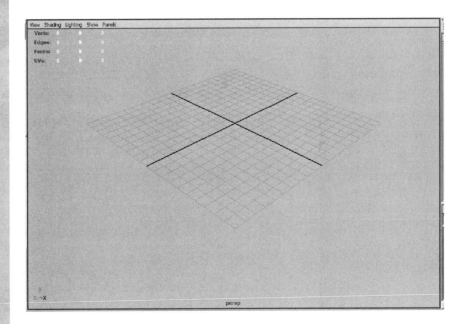

M EL is not just a small part of Maya—MEL *is* Maya. Nearly every feature of Maya is accessible via the language, and the large majority of the interface is created with MEL scripts. So, how exactly do we access MEL within Maya?

THE INTERFACE: WORKING WITH MEL IN THE MAYA UI

Within the Maya interface, there are three ways to enter and execute MEL commands. The first and perhaps most obvious is the *Command Line*.

The Command Line

The Command Line, seen in Figure 3.1, allows us to quickly and easily enter MEL commands one line at a time.

FIGURE 3.1 The Command Line.

The Command Line, and its sibling UI element the *Command Feedback* area, let us quickly execute MEL commands, and review any information

that might be returned. Many Maya users would no doubt be surprised at the number of functions that can be more easily accomplished with one quick command than by using the interface. For example, if we wanted to turn on rotational snapping we would use the command `manipRotate-Context`, as seen in Example 3.1.

EXAMPLE 3.1 A basic MEL command.

```
manipRotateContext -s on;
```

While entering that one command at the Command Line over and over might not seem efficient, the fact that we can attach that MEL command to a hotkey, or put it into a marking menu suddenly makes it much more appealing. Or, if the Command Line has the cursor's focus, we can use the Up and Down arrows to navigate through the history of commands we have executed.

In the Maya Preferences, under Interface, we can set the Command Line to hold the cursor focus after we enter a command. By default, Maya returns the cursor focus to the main workspace. Of course, this being a book about MEL, we should know that we can also set it by entering the command `optionVar -iv commandLine-HoldFocus true;`

The Command Shell

The *Command Shell*, seen in Figure 3.2, which is opened under the menu Window>General Editors>Command Shell, is essentially the Command Line and Command Feedback area all in one.

FIGURE 3.2 The Command Shell.

Similar to a Unix Terminal or DOS prompt, we issue a command and receive the feedback in the same window. In most ways, the Command Line or the *Script Editor* (to be discussed next) are superior ways of entering MEL commands. The Command Shell is significantly less useful than the Script Editor, takes up a lot of precious screen real estate compared to the Command Line, and offers no advantage over either. It is, however, a user interface control command (`cmdShell`), and can therefore be included in our own UI layouts, if we so desire. See Chapter 10, "Creating

Tools in Maya," for details on creating our own windows and user interface elements.

The Script Editor

The Script Editor is a separate window, opened by using the menu under the Window>General Editors>Script Editor, or by using the button to the far right of the Command Feedback area. The Script Editor, seen in Figure 3.3, is split into two areas, History and Input.

FIGURE 3.3 The Script Editor.

As an artist works in Maya, most of what is done within the interface is echoed within the History area. This is an excellent way to learn what different commands do, as well as learn the various flags different commands have. In fact, many people start their scripting by simply copying and pasting commands from the History area. This process, sometimes called *harvesting*, is done all the time by even the most experienced scripters. Only the commands that Maya considers significant are echoed within the History area, however. These are almost never all the commands issued, nor are they necessarily all the commands we might want to learn about. Three options can be set within the Script Editor to aid in the education of a scripter; the option panel is seen in Figure 3.4.

FIGURE 3.4 Script Editor options.

Edit > Echo All Commands turns Maya into an echoing machine. By turning this option on, nearly everything done within Maya is echoed. Sometimes the feedback can be a little too much, and a user can suffer

from command info overload. By working occasionally with the option off as well as on, a scripter can learn how Maya works on a "behind the scenes" level. This is how we often learn about panel construction within the user interface, as well as commands that are executed as MEL scripts, rather than MEL commands. The difference is subtle but important, and will be discussed later in this chapter.

The other two options, Show Stack Trace and Show Line Numbers, both aid in the debugging of scripts and procedures. Stack tracing follows the flow of commands from one script file to another. When we use inter-dependent scripts, stack tracing is a good idea. Show Line Numbers allows us to quickly and easily find errors in a command. The error will be reported as two numbers separated by a period, seen in Example 3.2.

EXAMPLE 3.2 An error as issued by Maya.

```
// Error: Line 1.6: Syntax error //
```

The number preceding the period is the line number, or the number of lines down from the beginning of the executed code. The second number is the number of characters over from the left to the right. It basically nails down the point where Maya becomes confused. Always keep in mind that an error on one line might actually be caused by an error made on another, be it not terminating a command line or a simple misspelling.

The input area of the Script Editor lets us enter multiple commands, or even full scripts. One thing about working within the Script Editor is the different behaviors of the two Enter keys on the computer keyboard. The main Enter key behaves as would be expected in any text editor, and goes to the next line. To actually execute MEL code, there are three options. We can select Script>Execute from the Script Editor menu, use the CTRL+Enter shortcut, or use the Enter key on the numeric keypad to execute commands. If any text is highlighted in the input area, only the highlighted portion is executed. This is an excellent way to debug specific passages of code. In addition, when code is executed while a passage is highlighted, the input area of the Script Editor does not automatically clear itself, as it does when code is simply run. This is a great aid when working out the specifics for a command, saving a user from having to type it in again and again.

Now, a point of exquisite irony. For all the options that Maya offers for entering MEL commands, the majority of scripters don't use any of them to actually create scripts. Sure, the Command Line is used to quickly access a single command, and we will use the Script Editor to create quick little shelf buttons. However, for the good stuff—the down-and-dirty stuff that probably makes a user want to go out and buy this book—we'll want to use a dedicated text editor. Many have features dedicated to programming, and can be highly customized to work with the

MEL language. Available programs vary from platform to platform, although some popular ones such as *vi* are available on multiple operating systems. All the scripts for this book were created in Visual SlickEdit, a text editor designed for programming in languages such as C++ and Java that is easily adapted to work with MEL.

THE MEL COMMAND

Now that we know where to enter MEL commands in the Maya interface, it might be beneficial to know exactly what a MEL command is.

The most fundamental element of any use of MEL is the *command*. Although Maya does a wonderful job of abstracting end users from manually entering commands, almost every button pressed in Maya in actuality executes a MEL command.

What essentially happens when a user presses that button is that the interface figures out which options have been set for that command, and executes the command with those options. The best way to see this in action is to open Maya's Script Editor. As an example, open the Create>Polygonal Primitives>Sphere Options box and set the options to those seen in Figure 3.5.

FIGURE 3.5 The Polygon Sphere Options box.

Click Apply so that the Options box stays open. If we open the Script Editor, in the History section we will see text similar to that in Example 3.3.

EXAMPLE 3.3 The command feedback results of creating a sphere.

```
polySphere -r 10 -sx 15 -sy 30 -ax 0 1 0 -tx 1 -ch 1;
// Result: pSphere2 polySphere1 //
```

You can begin to see the relationship between the interface and the actual commands issued. The actual command is called `polySphere`. The options for the command, called *flags*, are easily distinguished by the "-" that prefaces them. Flags are important aspects of any command. A flag allows us to set values for various aspects of a command. Note that when any command is passed to Maya without a flag specifying a particular value, Maya will use the default value, or the value set by user preferences, as in the case of construction history.

Every command available in MEL, and any flags associated with it, is included in the online documentation of Maya. Also available is the `help` command, which can quickly call up a listing of commands and their flags. For example, if in the input area of the Script Editor we enter the code seen in Example 3.4, we get a listing of each of the possible flags available for the `polySphere` command.

EXAMPLE 3.4 Getting help on the polySphere command.

```
help polySphere;
```

An interesting and important aspect of command flags is that, much like attribute names, Maya allows a single flag to have two names, both a short and a long name. While the appeal of using the short names for flags is understandable, using the long versions makes code easier to read for the original author and anyone else who might need to work with it in the future.

We should notice that Maya echoes the command flags using the short flags. Therefore, if we look at our `polySphere` command and use the information gleaned from the `help` command, we can break our `poly-Sphere` command down to decipher the origin of each flag. If we take the code from Example 3.3, and use the information gathered from the `help` command used in Example 3.4, we can translate the command into something more readable, which we see in Example 3.5.

EXAMPLE 3.5 Converting short arguments to long arguments.

```
polySphere -r 10 -sx 15 -sy 30 -ax 0 1 0 -tx 1 -ch 1;

polySphere
    -radius 10
    -subdivisionsX 15
    -subdivisionsY 30
```

```
      -axis 0 1 0
      -texture on
      -constructionHistory on
      ;
```

As we can see, the command becomes infinitely more readable. Not only have we replaced the short name of each flag with its long version, we have replaced the values for the `texture` and `constructionHistory` flags with the word on instead of the value 1. Both flags are a *Boolean* value, meaning either on or off. We discuss Boolean values in Chapter 4, "An Introduction to Programming Concepts."

Each value from the Polygon Sphere Options box is represented within the issued command. Also in the command is the construction history flag. Construction history is, by default, turned on in Maya. What happens is when any command that can possibly create construction history is issued, whether through the user interface or via MEL if no flag is set, Maya looks to see whether the user currently has construction history toggled on or off. Maya combines all these *variables* (remember this word—we will hear it a lot in this book) and issues the command. It is important to check the documentation for any command used in a MEL script, because we never know when an obscure flag with a default value will produce an unpredictable result.

Command Modality

One important concept to understand when dealing with commands is that they are *modal*. Modal means that when the command is issued, it is set into one of three modes: *create, edit,* or *query*. Not every command allows for every mode, nor is every flag available in every mode.

Sounds confusing? It can be, but in practice, it really becomes second nature. We never explicitly tell a command to be in create mode; by default, a command will be in create mode. This is not to say that the command is necessarily creating anything. A more applicable name would be the "do" mode. Essentially, unless we explicitly use the –edit or –query flags on a command, it is in create mode.

The edit mode is used to set flags on a node after it has been created. The –edit flag should be set immediately, before any other flag. After setting the command to edit mode, we can set as many flags as we want, providing that they operate in the edit mode for that command. The query mode is used to request information pertaining to a particular flag. As with the –edit flag, the query flag should be issued first, before any flags. The query mode returns only the information for the last flag in the command. The –edit and the –query flags are mutually exclusive, and only one can be used at a time. Interestingly, because of Maya's node-based structure, many of the options set by flags are actual attributes on

nodes, and can be accessed and set using the commands `getAttr` and `setAttr`. Even within MEL, Maya's open architecture allows multiple solutions to one problem. In Example 3.6, we edit the sphere created in the previous examples.

EXAMPLE 3.6 Using a command in `edit` mode.

```
polySphere -edit -radius 3 - subdivisionsX 30;
```

Our sphere is now smaller, and has 30 subdivisions around the axis. We can confirm this by using the `polySphere` command in the `query` mode, seen in Example 3.7.

EXAMPLE 3.7 Using a command in `query` mode.

```
polySphere -query -radius;
// Result: 3 //
```

The value returned can be seen in the Command Feedback, in the Script Editor's History area, or directly in the Command Shell. Notice that we only get a result if we have the sphere selected. If we had deselected the sphere, and then executed our command, we would have received an error similar to the one seen in Example 3.8.

EXAMPLE 3.8 A MEL error from not having the object selected.

```
// Error: No object was specified to edit //
```

Maya is actually very inconsistent when it comes to executing commands with multiple items selected. Some commands will find the first available object on which to operate. Others will operate on the entire selection list. Some will return an error when multiple objects are selected, and others will not even function if something is selected. Luckily, the engineers at Alias|Wavefront realized this, and provided a third standard argument for any command that allows us to specifically name an object on which we want to execute a command.

In a new scene, at the Command Line type the command seen in Example 3.9.

EXAMPLE 3.9 Creating a sphere with default parameters.

```
polySphere —constructionHistory on —name myBall ;
```

Since we did not explicitly set flags for the radius, subdivisionsX, or subdivisionsY, Maya uses the default values. Now, de-select the sphere.

By adding the name of our object, our "target" if you will, to the end of our command, we can use the edit or query flags on our sphere, even if we do not have our object selected, as seen in Example 3.10.

EXAMPLE 3.10 Using a node name to query information.

```
polySphere —query —radius myBall ;
// Result: 1 //
```

Command Arguments

Occasionally, a command will need specific information to function. If a command requires information, called an *argument*, to be passed to it, the command will fail if these arguments are missing. A perfect example is the move command. What use is the command if we can't tell it how much to move? As a general rule, any command arguments will come after any flags have been set, but before the command target, which, along with flags, can technically also be termed an argument.

At the end of every command we have entered is a semicolon. The semicolon is to MEL what a period is to a sentence. It encapsulates one thought or command together and delineates it from another, even if one command is spread across multiple lines, or multiple commands are on the same line. This is most important when executing multiple commands at once, such as when we create a shelf button, in an expression, or most obviously, as in a script. The ability to split a single command across multiple lines doesn't do anything for Maya, but can do wonders for the readability of a command string.

Now, we have our standard format for MEL commands, seen in Example 3.11.

EXAMPLE 3.11 The MEL command construct.

```
command
    [command mode]
    [-flag flagValue]
    [required arguments]
    [ target ] ;
```

Believe it or not, we now have the capability to write tiny little tools. By highlighting any MEL commands and middle-mouse-button (MMB) dragging the text to a shelf, we can create a shelf button. One of the easiest things we can do is create commands with preferences preset, or that carry out a series of commands over and over. At this point, we have to hard code each line, but we will soon learn to create more dynamic and

flexible tools. In our final example, seen in Example 3.12, we use a series
of MEL commands to create a polygonal book object.

EXAMPLE 3.12 A series of MEL commands, essentially a simple
script.

```
polyCube
    -width 2.2
    -height 0.4
    -depth 3.2
    -axis 0 1 0
    -texture 1
    -constructionHistory off
    -name book ;
select
    -replace book.f[0] book.f[2] book.f[4] ;
polyExtrudeFacet
    -constructionHistory off
    -keepFacesTogether on
    -localScale 1 0.782538 1 ;
polyExtrudeFacet
    -constructionHistory off
    -keepFacesTogether on
    book.f[0] book.f[2] book.f[4];
move
    -relative
    0 0 -0.0434924
    book.f[0] ;
move
    -relative
    -0.0434924 0 0
    book.f[4] ;
move
    -relative
    0 0 0.0434924
    book.f[2];
select
    -replace
    book.f[16] book.f[19] ;
move
    -relative
    0.0434924 0 0;
polySoftEdge
    -angle 0
    -constructionHistory 0
    book.e[0:43] ;
select -clear  ;
```

Conclusion

After reading through this chapter, and exploring some commands within Maya, we gained an understanding of MEL commands and arguments, and learned where and how to enter them within Maya. Next, we will learn the programming structures that allow us to create more flexible commands, and eventually full scripts.

4

AN INTRODUCTION TO PROGRAMMING CONCEPTS

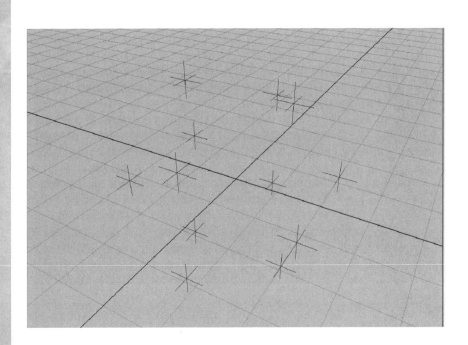

M EL is a programming language, and follows many of the rules and structures of any programming language. Unfortunately, most artists have no idea what even the most basic elements of a computer program are. This chapter hopes to introduce these programming concepts and is rather intensive technically. However, it is the foundation of all scripting, so it is important that we gain a complete understanding of these concepts before moving on to subsequent chapters.

VARIABLES

A *variable* is essentially defined by its name. A variable is a placeholder for data within a MEL script. Confused? Don't be. It's easiest to explain it as you would any language.

Let's tell a little story about a guy named Bob. He goes into a room. He then picks up a wonderful book on MEL scripting.

If someone were asked who picked up the book, there is little doubt that he would have no problem knowing it was Bob, even though we only referred to him using a nondescript pronoun. See, we just did it again, and still we had no problem knowing we were speaking of Bob. What we did is define who the "he" was before we ever referred to Bob as "he."

Within MEL, it's very much the same. We create a placeholder, and then put data in it. We can then access and manipulate that data, including changing that value. This is what gives scripts their flexibility and power. In MEL, a variable is defined by any word that begins with $. It's that simple. Almost. When we first tell MEL we want a variable, or *declare* it, we have to tell it what type of variable we want. Of course, first we need to understand what types of variables are available within MEL.

The Variable Types

In MEL, there are five types of declarable variables:

- Integer numbers
- Floating-point numbers
- Vector numbers
- Strings
- Matrices

Integers

Within MEL, integers are referred to simply as *int*. Integers are especially useful while dealing with Boolean or *enum* attributes, since even though within the Maya interface we see words such as *on* or *off*, when queried Maya returns an integer. For Booleans, this means 0 for "off," "no," or

"false," and 1 for "on," "yes," or "true." For enumerated attributes, Maya will return an integer of what's known as the *index value*, which is simply the item's position in the list, beginning with 0. Index values are covered in more depth later in this chapter. The declaration of an integer variable, $i, is seen in Example 4.1.

EXAMPLE 4.1 Declaration of an integer variable.

```
int $i = 4;
```

Floating Points

Floating-point numbers are the type of number we will most often encounter in Maya. All transform values are floating-point values, as well as things like skin weight values, and even colors. Within MEL, a floating-point number is called a *float*. Even values that are often perceived as integer numbers, such as the current frame, are treated as floating points because we never know when a user might set that value to something fractional.

There are two issues we should be aware of when dealing with floating-point numbers. First, is their memory requirements, or "footprint." A floating point takes up significantly more RAM than an integer does. Now, when we're dealing with a single number, this difference is insignificant. To any system that runs Maya, the difference is trivial. However, multiply that difference a thousand-fold or more, and we start talking about a serious memory disparity. The other issue with floating points is their precision. Internally, Maya treats floating points with a great deal of precision. However, when we ask Maya to print a float value either to the interface or to a file, Maya truncates it to 6 points of decimal precision. A workaround for this limitation is covered later in this chapter under data type conversion, as well as in Chapter 13. Example 4.2 declares the irrational number π as a float variable.

EXAMPLE 4.2 Declaring π as a float variable.

```
float $pi = 3.1415926536 ;
```

Vectors

Vectors in MEL are both entered and returned as three floats separated by commas, surrounded by angled brackets, as seen in Example 4.3.

EXAMPLE 4.3 The declaration of a vector variable.

```
vector $up = << 0, 1, 0 > ;
```

Often within Maya, values we would like or even assume would be returned as a vector—like position values, colors, or ironically an IK handle's pole vector—are instead returned as a series of floats. A majority of the time it is worthwhile to convert those numbers to vector variables. Because vectors allow us to store three values in one variable, it makes tracking information that has three float components easier, as well as allowing us to use vector-based math functions like *dot* and *cross*. Vectors also allow a wily scripter to exploit the system, as it were, as the ability to store multiple values in one variable is quite useful.

Strings

A string variable contains text information. That text can be anything from an object's name to the name of a UI element to a command we dynamically build within a MEL script.

Of course, it's never just that simple. There are two issues we should always be cognizant of when working with strings.

The first is an issue of case sensitivity. As with variable names, the word "cat" is not the same as the word "Cat" or "CAT." It is a simple enough concept, and can be easily overcome with either the toUpper or toLower commands, which converts strings to either all uppercase letters or all lowercase letters, respectively.

Strings can also contain text-formatting information, such as a carriage return or a tab indent. These are done with *escape characters*. Within MEL, the character "\" is used to "escape" a character. When Maya parses a string, if it encounters a "\" it looks at the next character either as a special function, such as a "\n" that signifies a carriage return, or a tab-over, as in "\t". The other function of an escape character is to explicitly be that character. Since when we declare a string we place it within quotes, if we want to place quote marks or for that matter the \ character in a string, we simply preface it with \. In Example 4.4, we use the escape character \n to place a carriage return at the end of our string.

EXAMPLE 4.4 A string variable with the escape character \n, representing a new line, as well as using the escape to include the quotation marks in the string.

```
string $sentence = "Please set the
                    visibility to \"on\".\n" ;
```

The escape characters most often used in scripts are:

- \n: new line
- \r: carriage return
- \t: tab character

Arrays

Before we cover the fifth type of variable, the matrix, we should become familiar with the concept of an *array*. An array allows us to store multiple values in a single variable, as a list. Integers, floating points, vectors, and strings can all be declared as an array, so in actual practice there are essentially nine types of variables.

To declare a variable as an array, we place block brackets at the end of a variable name. When we declare an array, we can either explicitly declare the size of the array, or allow it to be built dynamically. There is no right or better way to do it, as there are reasons why we would want to do each. In Example 4.5, we declare two arrays, one that can be dynamically sized, and the other of a predetermined size.

EXAMPLE 4.5 Declaration of array variables.

```
int $numObj[] ;
float $position[3] ;
```

Arrays are incredibly useful, and we will often find ourselves using arrays rather than singular variables. After declaration, when we need to access an individual item in the array, or an *element*, we use its *index* value. One aspect of arrays that can confuse people new to programming is that of the 0 index. That is to say, the first item in any array is index 0. The second is index 1, and so on. In Table 4.1, we see a visualization of a string array that has five items in it.

TABLE 4.1 Visualization of an Array Variable

$object[0]	polySurface1
$object[1]	polySurface3
$object[2]	polySurface9
$object[3]	polySurface14
$object[4]	polySurface2

Matrices

We declare a matrix variable by explicitly stating its size in a fashion similar to an array, by using square brackets to state the size of the matrix. If we think of a matrix as an array of arrays, the first number states the number of arrays in the matrix, and the second number declares the number of elements in each of those arrays. Assignment of values is either done during declaration, or by assigning each element a value individually, seen in Example 4.6.

EXAMPLE 4.6 Assignment of matrix values.

```
matrix $firstMatrix[3][2] = << 3.8,19.73; 4.14,19.75;
  25.6,94.01 >;

matrix $secondMatrix[5][5];
```

The second matrix variable from Example 4.6, $secondMatrix, has 25 elements, each assigned a value of 0. After declaration, we can assign values as we would with any variable, seen in Example 4.7.

EXAMPLE 4.7 Assigning a value to a single element of a matrix.

```
$secondMatrix[2][4] = 3.4521224;
```

Matrices have a major limitation within MEL, and it puts severe restrictions on their usefulness within a MEL script. That limitation is that the dimensions of a matrix have to be set explicitly during declaration of the variable, and cannot be sized dynamically. Under some circumstances, such as storing transformation information for a single object, it's not an issue because we know exactly how many numbers will be needed. However, in many situations, having to explicitly set the dimensions of a matrix limits the flexibility of a script.

Local and Global Variables

Variables can be declared as either *local* or as *global*. A local variable is temporary, and is cleared out of memory as soon as the script using it is done using it. A global variable is held within memory until the current Maya session is ended. Wherever possible we should use local variables instead of global to save on memory usage. It is important to remember that any variables we declare within the Maya interface, unless contained within a *group*, are global. Please refer to the section, "Command Groups," later in this chapter for specifics on groups.

The global of local nature of a variable is important because once a variable of a given name is declared as one type, it cannot be re-declared as another. This includes going between simple variables and variable arrays. Therefore, if we are working within the Maya interface, such as in the Script Editor, and declare an integer variable called $temp, and then try to declare a floating-point array variable called $temp, Maya returns an error as seen in Example 4.8.

EXAMPLE 4.8 The error from attempting to re-declare a variable as a different type.

```
int $temp;
```

```
float $temp[];
//Error: float $temp[]; //
//Error: Line 1.13 Invalid redeclaration of variable
    "$temp" as a different type //
```

There is no way to "undeclare" or clear a variable from memory, so it's best to keep track of the variables used, and to reuse them whenever possible. A good practice is to develop a standard list of variables, such as *$tempInt, $tempFloatArray[],* and *$selectionList[],* and use them within any code executed within the Maya interface. This avoids issues with memory, and standards can help by making code more readable.

Variable Conversion

Variables can be converted from one type to another by using the variable as the value to be assigned to a variable of the type we want to wind up with. In Example 4.9, we convert the data stored in the float variable to a string.

EXAMPLE 4.9 Converting a float to a string.

```
float $tempFloat = 5.874 ;
string $tempString = $tempFloat ;
```

Conversion from one type to another is not always exact, for obvious reasons. Some number types simply contain more data than others, as floats have more data than integers, while others are formatted differently, such as vectors and matrices. However, conversion can be extremely useful for comparison of data, writing data to files, or the simplest of vector calculations. Table 4.2 (see page 48), details how each variable behaves when converted to another type.

In our discussion of floating-point variables, we mentioned the precision errors when writing floating points out to files, rounding the float to six points of decimal precision. Alias|Wavefront currently suggests converting the number to a string, but that actually can make the situation worse. Doing so gives us nine digits of precision, which is actually more precise when dealing with numbers between 1000 and –1000, but anything larger in absolute value and we start to lose decimal precision. Referring to Table 4.2, we can see that converting a float to an int strips off the fractional information. If we then subtract the resulting integer from the original float, we get only the fractional information. Convert this to a string with nine digits of precision, and combine it with the integer to get a fairly precise string. While not ideal, without the use of more advanced scripting it is the best that can be done.

Another useful conversion trick is to convert a vector to a float. The resulting number is the vector's magnitude, assuming that the vector

TABLE 4.2 Data Conversion

	INT	FLOAT	VECTOR	STRING	MATRIX
int	-	perfect	<< int, int, int >	perfect	No conversion
float	int, rounded down	–	<< float, float, float >	nine digits of precision	No conversion
vector	Magnitude, rounded down	Magnitude	–	"vector.x vector.y vector.z"	If matrix is [1][3], perfect; else, no conversion
string	If begins with number, same as float; else, 0	If begins with number, perfect; else, 0	If begins with vector or floating-point numbers, perfect; remaining elements 0	–	No conversion
matrix	For [1][3] matrix or smaller, same as vector	For [1][3] matrix or smaller, same as vector	For [1][3] matrix or smaller, same as vector	No conversion	–

begins at the origin. This is a simple way to find an object's distance from the origin or, by simply finding the resultant vector of subtracting two vectors, the distance of two objects from each other. Of course, we can use a vector equation to find the vector length, but as with many things in Maya, the problem has multiple solutions.

STATEMENTS

A *statement* is how we set or compare data within MEL. The simplest of all statements, the *assignment* statement, we have already seen used during the declaration of variables. There are three types of statements:

- Assignment
- Arithmetic
- Conditional

The Assignment Statement

An assignment statement's most important element is the singular equal sign =. After evaluation of an assignment statement, the variable on the left side of the equal sign is set to the value on the right side. Assignment is not limited to being used during declaration. In fact, we are able to set the value of a variable at anytime after declaration and can do so repeatedly. Whenever possible, reuse variables to save on memory usage, seen in Example 4.10.

EXAMPLE 4.10 Re-declaring a variable value.

```
float $tempFloat = 3.48;
$tempFloat = 3.21212;
```

Note that when we reassign a new value to the variable $tempFloat, we do not re-declare its type as a float.

The humble assignment statement is the basis for all data gathering within MEL. In Chapter 3, "MEL Basics," we learned that most commands contain an aspect called a *return value*. By putting a MEL command on the right side of the = in an assignment statement, we can capture that return value and assign it to a variable. In order to capture the return value, we enclose the command within single left-hand quotes (`). In Example 4.11, we capture the value of the translate X value of an object called ball, and store that value in a float variable called $translateX.

EXAMPLE 4.11 Capturing the value returned by the getAttr statement.

```
float $translateX = `getAttr ball.translateX` ;
```

When we use an assignment statement to capture the return value of a command, it is important to assign it to a variable that can actually hold that data. For many beginning scripters, the most frustrating aspect of this comes with array variables when they want to catch only one item. A perfect example is building a selection list when we have only one object selected, seen in Example 4.12.

EXAMPLE 4.12 Attempting to assign captured data to the wrong type of variable.

```
string $object = `ls -selected` ;
//ERROR : Cannot cast data of type string[] to string.
```

The command ls always returns a string array, even if that array is empty or has just one object in it. Data return types for each command can be found within the documentation for that command.

The Arithmetic Statement

An *arithmetic* statement is simply a statement containing a mathematical equation. We don't necessarily need to capture the result of any mathematical statement to a variable; we can often put a mathematical statement in any command or statement directly. This can save both a line of programming, as well putting one less variable in memory. In Example 4.13, we demonstrate using both methods.

EXAMPLE 4.13 The arithmetic statement in action.

```
float $value = `getAttr ball.translateX`;
setAttr ball.translateX ( $value + 5 ) ;

setAttr ball.translateX (`getAttr ball.translateX` + 5 );
```

Within MEL, only certain mathematical functions are allowed with certain number types.

Refer to Table 4.3 to see how each operator functions on each data type.

TABLE 4.3 The Operators and Variables

OPERATOR	OPERATION	VALID DATA TYPES
+	Addition	I F V S M
-	Subtraction	I F V M
*	Multiplication	I F V M
/	Division	I F V
%	Division Remainder	I F V
^	Cross Product	V

Legend:

F = Floating Point
I = Integer
M = Matrix
S = String
V = Vector

One concept that often seems strange is using strings within a mathematical function. The only operator that works is addition, which takes multiple items and compiles them into one string, seen in Example 4.14.

EXAMPLE 4.14 String addition.

```
string $myString = ( "red " +"ball" );
//Result: red ball
```

Adding strings together can be most useful when adding a variable into a command. In Example 4.15, we use the first item in the string array $selectionList and create a new string that has .translateX appended to the selected object; in this example, "myBall".

EXAMPLE 4.15 Accessing an array element.

```
string $selectionList[] = `ls -selection` ;
string $channel = ($selectionList[0] + ".translateX" );
// Result: myBall.translateX
```

Math Shortcuts

Arithmetical statements are used so often within all computer programs, including scripts, that the creators of these languages have developed a shorthand notation for writing two common operations carried out on variables.

We often find ourselves taking a variable, and adding or subtracting a number to it, as in Example 4.16.

EXAMPLE 4.16 A common action done on variables.

```
float $num = `getAttr myBall.translateX`;
$num = ( $num + 5 ) ;
```

MEL, like many other languages, provides a typing shortcut for carrying out this operation. It works with all operators for integers, floats, and vectors. This shorthand speeds up typing, not the actual execution of the script. In Example 4.17, we take the value of myBall's translate X channel, assign it to the variable $num, and then reassign $num that value multiplied by 3.

EXAMPLE 4.17 An arithmetic shortcut.

```
float $num = `getAttr myBall.translateX`;
$num *= 3 ;
```

While all the operators work on int, float, and vector variables, only the += shortcut will work with string variables.

The other operation we find ourselves doing quite often is increasing or decreasing a variable, often an integer, by 1. To do this, we use a double operator, as seen in Example 4.18. Used mainly for iterating through an array, the important syntax is whether the operator comes before or after the variable. When it comes after the variable, MEL looks at the value of the variable and uses it in the current statement before increasing it by 1. When the operator comes before the variable, MEL calculates the new value before using it in the current statement. Both of these usages are demonstrated in Example 4.18.

EXAMPLE 4.18 Increasing and decreasing a variable by 1.

```
int $x = 0 ;
int $i = $x++;
print $i ;
0
print $x ;
1
```

```
int $y = 10 ;
int $n = --$x ;
print $n ;
9
print $y ;
9
```

The Conditional Statement

A *conditional* statement executes a command based on whether a given value satisfies a test condition. The condition is always reduced to a simple Boolean question; it's either true or false.

The if Statement

The basic conditional action is the *if* statement. The syntax of an if statement is seen in Example 4.19, with the test condition enclosed in parentheses.

EXAMPLE 4.19 The if statement syntax.

```
if ( condition )
    statement;
```

Within the parentheses, you can place a simple argument, such as a variable, or a command you want to capture the return value from. It is remarkably similar to vernacular language, such as "If it's raining outside, open your umbrella." In Example 4.20, we test to see if an object called ball exists within the scene, and if so, we delete it. We don't just execute the command delete, because if an object called ball does not exist, the command would issue an error.

EXAMPLE 4.20 The if statement in action.

```
if ( `objExists ball`)
    delete ball ;
```

If statements are wonderful for controlling the flow of actions within a script, and checking for errors, seen in Example 4.21. In Example 4.21, we check the size of an array holding our selection list, and issue an error, using the command error if the user has selected no objects, or if they have selected more than one object.

EXAMPLE 4.21 Using an if statement as an error check.

```
if ( `size $selListing`)
    error "Please select just one object." ;
```

The `if` statement has two possible sub-statements that greatly increase the power of the `if` statement. The first is the argument *else*. By using the `else` statement, we can institute a course of action if your test condition of the `if` statement fails. The syntax of the `if-else` is seen in Example 4.22.

EXAMPLE 4.22 The >SC>if-else statement syntax.

```
if ( condition )
     statement;
else
     statement;
```

If-else statements are excellent for building flexible scripts. While `if` statements execute a command only when the condition is true, `if-else` statements provide a sort of backup plan. Even if a test condition fails, the script still execute a command.

The second possible addendum to the `if` statement is the *else if* argument. `Else if` allows us to layer `if` statements together. The syntax of the `if-else if` is seen in Example 4.23.

EXAMPLE 4.23 The `if-else` if statement syntax.

```
if ( condition )
     statement;
else if ( condition )
     statement;
```

We can layer as many `else if` as we want, which can be useful for producing modal scripts. We could, for example, execute different actions based on what type of geometry is selected.

We can also use the `else` statement with the `else-if` statement, which allows you full control no matter what your return value might be. In Example 4.24, the syntax of this statement, the `if-else if-else` statement, is shown.

EXAMPLE 4.24 The syntax for the most complex `if` statement variation, the `if-else if-else` statement.

```
if ( condition )
     statement;
else if ( condition )
     statement;
else
     statement;
```

The switch Statement

The other conditional action is the *switch* statement. Using switch we can construct complicated rules based on the value of a return statement. Given the value of a conditional argument, the switch statement executes one of several possible commands. The syntax for the switch command, seen in Example 4.25, is rather daunting for people new to scripting. The command switch also introduces us to the flow control word *break*. When MEL encounters the command break, it exits the current argument or command and continues on to the next part of the script.

EXAMPLE 4.25 The switch statement syntax.

```
switch ( condition )
    {
        case possibility:
            statement;
            break;
        case possibility:
            statement;
            break;
        case possibility:
            statement;
            break;
        case possibility:
            statement;
            break;
        default:
            statement;
            break;
    }
```

While the break statement is not necessary, without it each statement will execute until it encounters a break or the switch statement ends. We also used the default argument, which acts in a manner similar to the else argument of an if-else statement. If none of the values provided by the case statements is satisfied, the default statement is evaluated.

Conditional Operators

Much like mathematical statements, conditional statements have operators. These operators can be split into two basic groups, *logical* and *comparison*. Both use two arguments and return either a 1 if true or a 0 if false.

There are three logical operators, as shown in Table 4.4.

TABLE 4.4 The Logical Operators

OPERATOR	MEANING
\|\|	Returns true if either of the two arguments is true.
&&	Returns true if both arguments are true.
!	Returns true if the argument is false.

If we now use these operators in a conditional statement, we can compare two pieces of data. The syntax usage of all three logical operators are seen in Example 4.26, which uses simple `if` statements for demonstration purposes, although the operators work in all variations of the `if` statement and the `switch` statement.

EXAMPLE 4.26 Using conditional operators in conditional statements.

```
if ( argument || argument )
    statement;

if ( argument && argument )
    statement;

if ( ! argument )
    statement;
```

The other operator type used in a conditional statement is the comparison, or *relational* operator. The relational operators are used, to no one's surprise, to compare two pieces of data in relation to each other. The available operators are shown in Table 4.5.

All relational operators can be used with integers, floating points, and vectors. The *is equal to* operator (==) and the *does not equal* operator (!=)

TABLE 4.5 The Relational Operators

OPERATOR	MEANING
>	Returns true if the value on the left side of the operator is greater than the value on the right side.
<	Returns true if the value on the left side is less than the value on the right side.
==	Returns true if the values are exactly equal.
!=	Returns true if the values are not exactly equal.
>=	Returns true if the value on the left side is greater than or equal to the value on the right side.
<=	Returns true if the value on the left side is less than or equal to the value on the right side.

also work with string variables. It is important to remember that when we compare strings, the comparison is case sensitive. When a comparison is made between vectors using the *is equal to* or *does not equal* operators, a comparison is made between the corresponding elements of each vector. When using the other relational operators, a comparison is made using the magnitude of each vector.

While statements using logical and relational operators return an integer value of either 1 or 0, and can be used to assign a value to a variable, they are most often directly used in conditional statements, as in Example 4.27.

EXAMPLE 4.27 Using an inline captured value in a conditional statement.

```
if ( `getAttr myBall.translateX` > 0 )
    setAttr myBall.translateX 0;
```

Operators can be grouped together following algebraic rules to control the evaluation of conditional statements. In Example 4.28, we execute the command setAttr if, and only if, both the translate X value of the object ball is greater than 0 and the current time is less than frame 100.

EXAMPLE 4.28 Using multiple conditional statements.

```
if ( (`getAttr ball.translateX` > 0)
    &&
    ( `currentTime –query` <= 100) )
        setAttr ball.translateY 0;
```

LOOPS

The ability to repeat commands over and over, while not the most exciting aspect of programming, is one of the most common uses of scripting. There are two basic loops, although each has a subset that alters its behavior slightly.

The while Loop

The *while* loop sends MEL into a loop until a specific test condition is met. Like conditional statements, the condition is Boolean, and continues to execute as long as the test condition returns true. The syntax for the while statement is similar to the if statement, as we can see in Example 4.29.

EXAMPLE 4.29 The syntax for the `while` statement.

```
while ( condition )
    statement;
```

When MEL encounters a `while` statement, it evaluates the condition, and if true, executes the statement. It then re-evaluates the conditional statement, and if it still returns true, repeats the process. This can be dangerous. If the test condition is never satisfied, the loop will never end. The code in Example 4.30 will, for example, never self-terminate, continually printing out ever-increasing numbers. If this code is executed, the current session of Maya has to be terminated. (Please refer to your OS documentation to determine how best to terminate a process.)

EXAMPLE 4.30 An endless `while` loop.

```
int $i = 1;
while ( $i > 0 )
    print ( ($i++) + "\n" );
```

The `do-while` Loop

The *do-while* loop is similar to the `while` loop, but differs in one important way. The statement is evaluated before the test condition is evaluated. After the first execution, the behavior of the `do-while` loop is identical to the `while` loop. However, that first execution is an important difference, because the `while` loop has no guarantees that the statement will be evaluated even once. The syntax for the `do-while` loop is laid out in a manner similar to the `while` loop, but with the statement before the condition, seen in Example 4.31.

EXAMPLE 4.31 The `do-while` syntax.

```
do
    statement;
while ( condition );
```

An important difference is the semicolon after the closing parentheses encompassing the test condition. Neglecting this semicolon will result in an error.

Both the `while` loop and the `do-while` loop are useful when you cannot predict how many times you will have to execute a command. For example, if you wanted to move an object called ball by 5 units along X until it is beyond the 100-unit mark, you could use Example 4.32. You don't need to know what the starting position of ball is; MEL will just move the object in 5-unit increments until the translate X value is larger than 100.

EXAMPLE 4.32 The while loop in use.

```
while ( `getAttr ball.translateX` < 100 )
    move -r 5 0 0;
```

The for **Loop**

The other basic type of loop is the *for* loop. The for loop is almost a version of the while loop, and we could actually build the same functionality of a for loop with the while statement, and vice versa. The for statement's conditional argument contains three aspects: the *initialization*, the test condition, and the *condition change*. Each of these elements is separated by a semicolon, seen in Example 4.33.

EXAMPLE 4.33 The basic for loop syntax.

```
for ( initialization; condition; update condition )
    statement;
```

The initialization step is optional, but is often useful. It is used to set the value that will be evaluated by the test condition the first time. Note that it is possible to implicitly declare a variable in the initialization step. Next comes the actual test condition, which is the same as you would use in any conditional statement. Finally comes the update action, which is simply a statement that is executed after the commands in the for loop. Many programmers use for loops to iterate through arrays. In Example 4.34, we iterate through the array $selList, which holds the selection list captured in the first line of code. We also use the variable $i to stand in for the index value referenced in the array in the print statement;

EXAMPLE 4.34 Using a for loop to parse an array.

```
string $selList[] = `ls -selection`;

for ( $i = 0; $i < `size $selList`; $i++)
    print ( $selList[$i] + "\n" );
```

As you can see, because we can use the integer $i within the actual loop itself, it gives us easy access to the value of the current index of an array. Also notice that the test condition continues the for loop as long as $i is a value less than the value returned by the size command. Because Maya uses a 0-based index system, the last index number will be 1 less than the total number of items in an array. It is a somewhat confusing concept, but one that is important to understand.

Any of the three elements of the for loop—the initialization, the test condition, and the condition change—can be left out. Of course, elimi-

nating the test condition will cause the loop to never end, causing Maya to hang. Even if you don't want to use any particular element of the `for` statement, the parentheses must contain three semicolons. These semicolons signify to Maya which element is which, seen in Example 4.35.

EXAMPLE 4.35 Omitting unnecessary elements of the `for` statement.

```
for ( ; $i != 15;  )
    print $++i;
```

In Example 4.36, we see that we can also initialize and update multiple items in the `for` statement; simply separate the items with commas.

EXAMPLE 4.36 Multiple initializations.

```
for ( $i = 0, $e = 15; $e >= $i; $e-- )
    print "This is fun!\n";
```

The `for-in` Loop

As we discovered, programmers across many languages use the `for` loop to iterate through arrays. While this structure works fine, MEL actually provides a separate loop that requires less typing and is more readable than the standard `for` loop. This loop, called the *for-in* loop, works only with arrays. Its structure is seen in Example 4.37.

EXAMPLE 4.37 The `for in` loop syntax.

```
for ( $variable in $array )
    statement;
```

Using the `for-in` loop provides no speed benefit during execution, but it does make the loop both shorter to write and easier to read. For these reasons, the `for-in` loop is used the majority of the time to loop through an array. In Example 4.38, we duplicate the functionality of Example 4.34, but in a more elegant fashion.

EXAMPLE 4.38 Using a `for-in` loop to parse an array.

```
string $selectionList[] = `ls —selection`;

    for ( $eachObj in $selectionList )
        print ( $eachObj + "\n" );
```

As with regular `for` loops, you can implicitly declare a new variable in the `for-in` statement. In both types of `for` loops, if we implicitly declare the variable in this manner, it is visible only within that loop.

While `for-in` loops are generally more effective for iterating through arrays, if we need to know the index value of a current array element, such as if we are referring to the corresponding elements of multiple arrays, we can of course use the regular `for` loop, as we do in Example 4.39.

EXAMPLE 4.39 An example of when the `for` loop is superior to the `for-in` loop.

```
for ( $i = 0; $i < `size $listOfJoints`; $i++ )
    print ( $listOfJoints[$i]
            + " : "
            + $skinnedObject[$i]
            + "\n" );
```

COMMAND GROUPS

The final concept vital to a basic understanding of MEL is that of *command grouping*. The most basic use of command grouping is to have MEL execute a number of statements and commands where normally MEL would only allow one statement. To group commands together, use curly braces ({}). In Example 4.40, we want to execute multiple commands during the execution of a `for-in` loop, so we enclose all those commands in curly braces.

EXAMPLE 4.40 Grouping commands together.

```
for ( $each in $selectionList )
    {
        $x = `getAttr ( $each + ".translateX" )`;
        rename $each ( $each + $x );
    }
```

Notice that each statement within the curly braces is terminated with a semicolon, but there was no semicolon following the curly braces themselves.

We can also place grouped commands within other groups, which we see in Example 4.41. In this example, we iterate through an array with a `for-in` loop, and then use an `if` statement as a conditional statement. The commands within the curly braces are only executed if the type of object stored in the current index of the array `$selectionList` is a transform node.

EXAMPLE 4.41 Nesting command groups.

```
for ( $each in $selectionList )
    {
        if ( `nodeType $each` == "transform" )
            {
                select -replace $each masterGroup;
                parent;
            }
        print ( $each + "\n" );
    }
```

This process, called *nesting*, is the fundamental element of the MEL script, the procedure.

PROCEDURES

The MEL procedure is similar to variables in many respects. Both must be declared before being used. Both must have a unique name. In addition, both variables and procedures can be declared as either local or global.

The basic procedure declaration is relatively simple, but it can have multiple levels of complexity. The simplest form of procedure declaration is almost identical to the declaration of a variable, seen in Example 4.42.

EXAMPLE 4.42 The basic procedure syntax.

```
proc procedure_name ()
    {
        statements;
    }
```

The statements contained within the confines of the curly braces of the procedure are executed whenever the procedure is executed. However, if we create a procedure in such a manner, Maya does not seem to recognize it. The reason for this is quite simple, and actually a useful and well thought-out feature of MEL. In order for a command to be readily available to Maya, it must be declared as a *global procedure*. In Example 4.43, we see that a global procedure is declared in much the same way as a global variable is.

EXAMPLE 4.43 The syntax for a global procedure.

```
global proc procedure_name ()
    {
        statements;
    }
```

Now, whenever our procedure name is executed, whether at the command line or from within another script, Maya knows what group of commands we want to evaluate.

What we are essentially doing is creating our own MEL commands. And like any command, we can both pass information using arguments, and receive information back from the execution of a procedure. This allows us to create scripts in a modular fashion by writing smaller procedures, which eliminate redundant typing and allow for easy reuse of code.

To pass values to a procedure we put variable declaration statements within the parentheses that follow the procedure name, seen in Example 4.44.

EXAMPLE 4.44 Declaration of variables in the procedure declaration.

```
global proc procedure_name ( variable declaration )
        {
            statements;
        }
```

We can pass as many variables as we want, but whenever the procedure is executed, it must be passed all the values for those variables. The values must also be passed in the correct order. In Example 4.45, we create a procedure to quickly hide or unhide objects by name.

EXAMPLE 4.45 Passing multiple variables.

```
global proc setObjectVis ( string $obj, int $vis )
        {
            setAttr ( $obj + ".visibility" ) $vis;
        }
```

Here we have declared the procedure, and stated that every time we execute it, we will pass it two values. First will be the name of an object, passed as a string. Second will be an integer that will control the visibility of the passed object. We issue the command in Example 4.46.

EXAMPLE 4.46 Issuing the command from Example 4.45.

```
setObjectVis persp 1;
```

If we do not pass setObjectVis both an object name and an integer, we receive an error similar to that seen in Example 4.47.

EXAMPLE 4.47 The error from making an improper script call.

```
// Error: Wrong number of arguments on call
    to setObjectVis
```

The other major feature of the standard MEL command that we might want to add to our procedures is the ability to return information. We add this capability to a procedure declaration by simply adding the type of information we want to pass back right before the name of the procedure. The return type can be any of the various variable types. The syntax model for this is seen in Example 4.48.

EXAMPLE 4.48 The syntax for adding a return statement.

```
global proc return_type procedure_name ()
    {
        statements;
    }
```

When you want to return an array, place square brackets right after the type of return value. In the two procedures in Example 4.49, the first procedure returns a single integer, while the second returns a string array.

EXAMPLE 4.49 Making the returned value an array.

```
global proc int isLightRed ()
    {
        statements;
    }

global proc string[] listAllSkinnedObjects ()
    {
        statements;
    }
```

FLOW CONTROL

Within any loop grouping, you can use *flow control* statements. The two flow control terms not yet fully covered (technically, all loops and conditional statements are flow control statements) are *break* and *continue*. The command break was covered briefly within our discussion of the switch statement, but it can be used within any loop. When the break command is evaluated, it immediately exits out of the current group of commands. It can be useful for avoiding possible math errors, like dividing by 0, which is demonstrated in Example 4.50.

EXAMPLE 4.50 Using flow control statements within a script.

```
for ( $eachObj in $selectionList )
    {
    $objTX = `getAttr ( $eachObj + ".translateX" )`;

    if ( $objTX == 0 )
        break;

    setAttr ( $eachObj + ".translateX" ) ( 5 / $objTX );
    }
```

The other flow control statement used within loops is `continue`. When the `continue` statement is evaluated, MEL skips the rest of the statements in the group, and proceeds to the next iteration of the loop.

It is sometimes hard to figure out when it is best to use `continue` rather than use other flow control statements, like the `if` statement. There is no hard-and-fast rule; rather, it is a skill that develops with time and experience.

Variable Visibility

The very last issue to be aware of when dealing with groups is that of *variable visibility*. A variable is only visible to the group in which it is declared, and groups that are nested within that group. This is quite useful when trying to manage memory and keep track of variable names. If we declare a local variable inside a group, and attempt to call on it from outside that group, Maya will issue an error. Once a particular group has finished evaluating, whether it is a loop, conditional statement, or procedure, all local variables declared within that group are cleared from memory. It is best to declare a variable at the lowest level possible to carefully preserve memory.

One obvious exception is global variables. While global variables carry their information across procedures, it is necessary to re-declare their existence before using them in any way. Be careful not to combine declaration and assignment statements with global variables, because you will overwrite any information stored within those variables.

CONCLUSION

We covered a lot of ground in this chapter. From variables to statements to command grouping, you are now familiar with the basic elements of programming in MEL. If you are unsure of any of the sections, do not fret too much. Many of these concepts only reveal their true elegance and power when seen in action in an actual MEL script, which we will be getting to very soon.

5

THE SCRIPT FILE

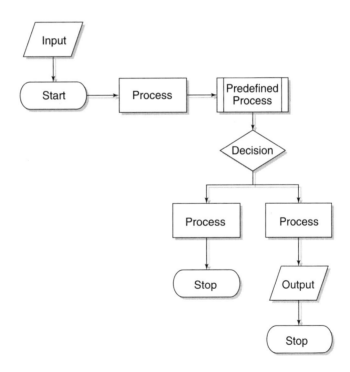

Now that we have a fundamental understanding of MEL procedures, commands, and how we structure them, we can consider actual scripts. A MEL script is simply a series of commands and procedures stored in a text file that ends with the extension .mel.

To the artist working on a single workstation, simply dragging MEL code to the shelf to create buttons might be enough, but what happens when those tools need to be transferred to a new computer? Using this method, there is no manageable way to distribute custom tools to a studio full of artists, let alone over the Internet, if that is the goal. By using MEL scripts, we create easily distributable files that allow the hard work of a scripter to be shared with others. More than just that, however, putting procedures into individual MEL scripts allows the creation of modular tools, and stops the repeated recreation of common procedures.

In the last chapter, we discussed the concept of a global procedure, and how those procedures act as custom commands within Maya. The question still unanswered is, how does Maya know that those commands exist? Maya actually has no clue that a procedure exists until one of two things happens—either we execute the script or we execute the Maya command sourceon the script.

A short explanation is in order as to how Maya treats MEL scripts. Whenever a command is sent to Maya, whether it is at the command line, through another script, or from a menu in the Maya interface, Maya searches all the commands currently in memory to see if the command is known; if not, Maya searches for a MEL script file with the same name. For example, if we were to execute the command myProcedure at the command line, Maya looks for a command called myProcedure in memory. If it does not find it, Maya first searches the script directories for the user, then the script paths internal to Maya for a file called myProcedure.mel. Once finding that file, Maya searches for a global procedure within that script file called myProcedure, as seen in Example 5.1.

EXAMPLE 5.1 The declaration of a global procedure called myProcedure, stored in a file called myProcedure.mel.

```
// Begin myProcedure.mel

global proc myProcedure ()
{
    print "I am myProcedure.mel" ;
}
```

If Maya cannot find a file called myProcedure.mel, or if myProcedure.mel does not contain a global procedure called myProcedure, Maya will return an error.

The order of directories that Maya searches to look for a script is not arbitrary. By searching the user directories before Maya's internal direc-

tories, Maya allows us to customize the tools it provides as MEL scripts without altering the original.

Once a procedure has been loaded into memory, Maya uses that procedure until a new procedure of the same name is sourced into memory. Sourcing is the method by which we update a procedure within Maya's memory, and is most often used during the construction of a script. Writing scripts is an iterative process, with the script essentially being built in layers. Even if we make changes to the physical .mel file, those changes are not reflected within the executable command unless the script is first sourced. While the extra step to source a file is a hassle, it aids in the quick execution of scripts, allowing them to reside in memory.

SCRIPT PATHS AND THE MAYA.ENV FILE

To add more directories to the paths Maya searches when looking for a script file, We need to modify the *maya.env* file. Open the *maya.env* file in any text editor and add the text seen in Example 5.2:

EXAMPLE 5.2 Setting script paths in the maya.env file.

```
MAYA_SCRIPT_PATH = path ; path ;
```

with "path" representing the full path to the directory to be added to the script search. These changes will not take effect until a new Maya session is launched.

SCRIPTING STYLE AND PRACTICES

Finally, we have all the information we need to construct our scripts. However, we still have a little more to learn about the process of constructing the scripts themselves. While there are no real rules to constructing scripts other than those relating to syntax, and many scripters are happy simply if their script successfully runs, there are some guidelines to keep in mind that will make our scripts more flexible, easier to read, and possibly even execute faster.

ACTIONS VS. TOOLS

Almost any MEL script, or any plug-in or program for that matter, can be put into one of two categories—an action or a tool. An actionable script has a single effect. Although it can have options associated with it, an action script, once executed, simply does its job and has no further effect on an object or scene. Examples of actionable items that currently exist

within Maya are the Rebuild Curve, Triangulate, or Prefix Hierarchy functions. These tools always have the same functionality, require a unique input, or have a set of options, which are stored within Maya. Yet all of these functions can be considered actions under our definition. The other type of script is best termed a *tool*. Tools require continuing input from the user after being executed. Although we could consider such things as the transformation manipulators tools, in the context of scripting, tools generally take the form of items like the Extrude Face, or Create Polygon tool. Some behaviors can work just as well as an action or a tool; in fact, Maya provides a preference setting to determine whether many of Maya's functions behave like a tool or an action.

 This setting can be recalled with the optionVar -query *command. If we are so inclined to provide the dual functionality of a tool and an actual script, we can use this command to determine the behavior of our script.*

While a script can be either an action or a tool, for purposes of simplicity throughout this text we will refer to any script within Maya as a tool, even if it could be termed an actionable item. A good percentage of scripts can be built as an action, a tool, or both. The choice is dictated by design guidelines, production philosophies, and the amount of time that can be dedicated to creating the script.

THE SCRIPTING PROCESS

It is important to realize that the pre-production process is as vital to a well-constructed script as it is to a well-built art asset. An animator would never sit down to work on a complex shot without storyboards, thumbnails, or both. A modeler would never begin a sculpture of an important character or item without a model sheet or a portfolio full of production sketches. Scripting is the same. While we often do the scripting equivalent of sketching, playing things by ear, this process just doesn't work with more complex tools. The analogies made were chosen for a reason. In art, there are occasions when we do not have an extensive pre-production. Perhaps the director needs a quick reaction shot of a character, or wants to digitally insert an object into the background. With MEL, it's much the same. Perhaps all that is needed is a shelf button to do a simple three- or four-step process, like triangulating 400 objects, putting them in a specific layer, and then saving the file. This use of MEL, while still very useful and can technically be called scripting, is not what we mean when we refer to a script.

So what does the word *script* apply to? When we speak of a script, we are referring to a tool that is either a multifunction, multipurpose item, or a tool that serves a very specific purpose, but requires the structures a

script provides. The complexity of the proposed action plays no relevance in whether to make it an actual script, and some of the more useful scripts can actually be surprisingly short. What makes a script a script is the action existing as a self-contained file containing a global procedure of the same name.

The process of creating a script is similar to creating any computer program. Every script, every program, begins with a problem. This can either be an actual problem, such as the need for a custom file exporter, or a new approach to doing an everyday task. Many users turn to scripting not to create wholly new functionality, but to realize tools that other software implements that Maya does not include in its base package. Whether it is something as simple as a way to automatically hide cameras or as complex as a subdivision surface modeling system, the process for creating any script is the same.

The process for creating a script can be broken down into four basic steps:

1. Definition and vision.
2. Research and development.
3. Design and implementation.
4. Bug-fixing and refinement.

Definition and Vision

We start the scripting process by defining what we want to accomplish with the tool. This definition process most often begins by setting goals for our script and asking ourselves, or the members of the production for which we are creating the tool, what the tool needs to do. There are some basic questions that should be asked at the outset of this design process.

Form Follows Function

The American architect Henri Sullivan was famous for promoting the concept that a building's form is defined by its function, Although this idea was popularized by more famous designers later in the twentieth century, such as Frank Lloyd Wright and Mies Van Der Roe, it was Sullivan who originated the concept of stripping away unnecessary elements and making a building's design fit its purpose rather than designing a building simply to be, regardless of its use. This basic tenet also applies to programming. When designing a script, simplicity is key. By stripping away the extra elements, we can concentrate on keeping the core functionality both efficient and flexible.

To begin a script, we first begin by setting an overall design goal. What is the main function of our tool? Most tools can be put into one of the following categories, with some examples for each:

- Data I/O
- Motion capture data import
- Proprietary game data export
- Scene meta-data for production tracking
- Geometry creation/modification
- Custom primitives
- Third-party renderer specific data type (e.g., RenderMan sub-divisional surfaces)
- Modeling tools not offered in the base package
- Animation tools
- Muscle simulators
- Rigging/setup controls
- Crowd AI behavior
- Lighting /rendering tools
- Automatic creation of common complex Shader setups
- Pre- and post-render effects
- Making calls to third-party renderers
- Dynamics
- Custom particle behavior
- Cloth simulation
- User interface customization
- Custom character controls
- Removal of invalid Maya commands (e.g., removing the creation of NURBs surfaces at a game development studio)
- UIs for a tool

While occasionally a random tool will fall outside these basic types, it is rare. The purpose for classification is to guide the scripter in planning his work. Once the script type is determined, we have a basic structure of questions that need to be asked.

At this point, all that exists of our script is our problem. We now decide how to solve this problem. This is a simple matter of brainstorming. At this point, it is important to remember there is no such thing as a bad idea. Some ideas are better than others, but every idea should at least be explored. Invest in a good whiteboard, some dry erase markers, and a good source of caffeine. Try not to go into this process with any preconceived notions. Occasionally, the goal seems to define the solution, such as an importer for a specific file type, but often this step requires some creative thinking. Good questions to ask are:

- If it were possible, how would this process be done by a person?
- Are there any existing tools that are similar that can serve as a template?
- Is this functionality already provided in Maya, but is hidden?

Before we explore the validity of any of these possible solutions, three questions should be answered that will help us determine which is the best solution to pursue.

- Who needs this tool?
- When is the tool needed?
- What is the importance of the tool?

The answers to these three questions will guide us in many of our upcoming decisions. The answers actually overlap in determining where our resources need to be spent during the creation of our tool. There are no hard-and-fast rules, no magic formula, because it is such a nebulous process. For example, while most artists like working with clever user interfaces, if a tool is being created to accomplish a single effect, it is most likely not worth the effort to create a UI. However, if that one effect is likely to go through 500 iterations, and is the big money shot of the show, the time spent adding a UI might no longer be considered a waste. Another common situation is where a tool is needed immediately, but will be used throughout the entire 18-month production cycle. Therefore, a first iteration of a tool might not have all the usability bells and whistles, but later versions might add such things as a UI, saved preferences, and so forth.

Research and Development

With the basic elements of our script design in place, we can move into what is often the most challenging aspect of scripting for non-programmers—research and development. This is the point in the process that most often acts as a stumbling block for artists trying to get into scripting.

Often, this step involves opening up those scary math or physics books. Since we gained a basic understanding of math in Chapter 2, "A Primer on Mathematics," and since all physics we deal with in computer graphics is an implementation of mathematics, we can now tackle this step with confidence.

If the proposed tool does require mathematics or physics, we need to make sure we have all the equations needed to accomplish the goal on hand. Many of the operations we covered in Chapter 2 exist as commands in MEL; for example, calculating dot products and cross products. However, by having an understanding of how they work, we can perhaps use them in a way not intended. We might even stumble onto some new mathematical proof not yet discovered. While that might sound ridiculous, we should remember that Albert Einstein was a clerk in the patent office before going on to discover that whole Theory of Relativity thing.

Another great source for effective math and physics routines to solve our computer graphics problems are the proceedings from the AMC SIGGRAPH and the Game Developers Conferences. More and more, the papers at these conferences serve as simple abstracts to protect the intellectual property of the studios or software developers who originated the research, but many universities still publish extensive treatises on advanced concepts. Even the papers that do not publish the complete

algorithms used can generate and inspire new ideas, and help us come to a viable solution.

Making Decisions Based on Acquired Research

Once all the research has been accumulated, we can realistically evaluate our possible solutions generated during the definition stage. At this point, we evaluate each possibility based on the balance of two qualities:

- How easy is this solution to implement?
- How effective and efficient is this solution computationally?

The importance of the answers to these two questions is modulated by the requirements of the project. If the tool is needed immediately, picking a solution that can be implemented quickly, even if it takes the programmatic equivalent of the scenic route, can be beneficial. On the other hand, if this is a tool that will be used by 25 artists, each using it 100 times a day, creating a solution that manipulates our data in two minutes as opposed to six minutes adds up to significant time savings. In fact, that previous example would save an astounding 166 man-hours a day. Considering the salaries paid to artists, that is a significant monetary cost. Faster tools also allow us to do more iterations, if for example, our tool is a dynamic solver, as in the case of a cloth simulator. More iterations mean we less frequently have to settle for something "good enough," and get something that's "just right."

At this point of our script building process, we have nearly finished the research and development process. We have all the mathematical formulas at our fingertips, have decided which of the possible processes we will pursue, and have at least a rudimentary idea of the form the final script will take.

Design and Implementation

The design and implementation step is where the script comes into existence. Before we sit down at our computer to create the actual script file, we have to complete the final design of our script. Many programmers, both the traditional code writers and MEL scripters alike, neglect to do any planning when creating tools. This is hubris and folly. A good plan of attack is essential to creating efficient tools, and key to that planning is the *flowchart*.

The Flowchart

A flowchart is a diagram that defines each action that takes place within a script. More than a simple listing of parts, the flowchart helps to visualize how each action relates to each other action. The creation of the flow-

chart can be a very educational experience both in regard to what MEL commands will be needed, and how data will be passed around the script. How elaborate a flowchart needs to be is determined more by the programmer than the program itself.

Some programmers prefer to just list out different areas of the script, while others create elaborate poster-size diagrams complete with colored lines, small passages of code written out, and so forth. In fact, there are entire programs that exist just to create flowcharts. One such program, OmniGraffle, was used in the creation of all the charts in this book. Note that OmniGraffle is a Macintosh-only program.

Throughout this book, we will take something of a middle-ground approach, providing a complete picture of the structure of a script, but without an overly extensive "pre-writing" of the script. A flowchart example is seen in Flowchart 5.1.

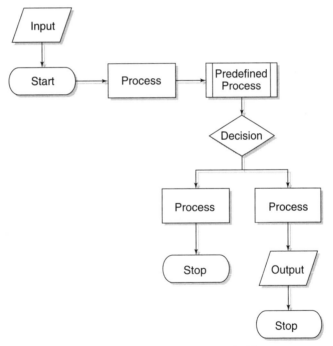

FLOWCHART 5.1 What a typical flowchart looks like.

Multiple Procedures

Often, when writing scripts, the same action is used multiple times, but not in a way that can use one of the many types of looping commands available within MEL. While a scripter can choose to simply write the action again, or more likely cut and paste the lines of code, a more elegant way is to have that action as a separate procedure.

Before we go any further, we will add a new term to our vocabulary, one that doesn't exist within the standard MEL manual, but does exist within C and C++ programming, and that is the *function*. In this book, we will occasionally use the label of "function," and its use, which is termed a *function call*, to refer to a non-global procedure. The term *function* is used in a slightly different way in other languages, but it is simpler to use a familiar term than to invent some new word. It is also for issues of clarity, or we would be using the term *procedure* so often that confusion could reign.

Now that we have our terminology issues cleared up, we should discuss why and how we split up a script into separate procedures and functions. The *why* is threefold.

The first is for memory usage reasons. It is important to realize that when a script file is sourced, through either the first execution of a script or by explicitly sourcing it, Maya stores all the global procedures it encounters within that file, not just the one with the same name as the script. While almost every workstation running Maya is equipped with ample amounts of RAM, almost every artist always seems to use up every available kilobyte of RAM, and then some, leading to the inevitable paging and hence a slowdown in operation. In some cases, lack of RAM can even cause Maya or the entire OS to crash. Obviously, everything the scripter can do to minimize the memory usage of a script is important. Structuring large scripts so that a large majority of their functionality is not held in global procedures can put a little less strain on the resources of a workstation.

The second reason to cut one procedure into separate pieces is that it makes writing scripts much more manageable. By taking different parts of the script and splitting them up according to their function, we make the process of writing, and more importantly debugging, scripts much easier. If, for example, when the script is executed, it crashes when sorting our selection into different object types, we know exactly which procedure or function to check for errors. While stack tracing with line numbers helps to find errors, by splitting different actions into separate functions, the errors reported by stack trace are easier to find. Later in this chapter, we discuss the activities of debugging and bulletproofing scripts.

The last of the big reasons to split some actions off is for efficiency in the production of the script itself. If within a script we find ourselves doing the same, or so similar it can be adapted to be the same, action specific to the script multiple times within a script, it is best to place that as a function within that script file itself. However, what often happens is that some functions have such a universal utility that it can be worthwhile to split these procedures off to their own global functions, which allows them to be called from multiple unrelated scripts. Looking through the functions in the MEL command list, some of the more useful ones dealing

with manipulating variable data such as `stringArrayContecate` are actually scripts rather than true commands. Creating these same types of tools are a perfectly valid way to split up scripts, but an important part of splitting scripts up this way meant for distribution is to co-ordinate the distribution of the utility scripts as well. For this reason, if scripts are meant for dissemination to the public, it is important to be sure that the names of procedures and script names are not too generalized.

There are different ways we can approach splitting a script up and adding those pieces as separate functions. The first is to split off sections of code that constitute a complete action and place these functions in the same script file, being sure to place them before the global procedure and before any other functions that need to make call to that function.

The second choice is to convert these into their own individual global procedures. For very specific actions, this is not a good choice, as it simply adds to the memory footprint of a script's components and adds complication to maintaining a tool. However, if we were to create a utility script, such as to return only the base name of an object regardless of its path, then that could be worthy of its own tool.

The final choice is to create a utility script with functions within it, to carry out specific operations. This is a great technique for easy programming; rather than having to remember the names of a multitude of various scripts and maintain a vast library of scripts, it is a simple matter of compiling scripts structured around common themes. For example, imagine that two utilities are needed; the first, the aforementioned tool to get the base name of an object, the other to get the full path name of an object. While it is possible to create separate utilities for each, it would also be possible to create a utility simply called `returnName` that we could pass arguments, such as `returnName -base` or `returnName —path`. Creating and using scripts that serve a utilitarian purpose make the job of scripting easier, faster, and less likely to have bugs.

SCRIPT FORMATTING

To Maya, it truly does not matter whether the script looks pretty. The MEL interpreter really doesn't care whether there are carriage returns and tab-overs in the file. In fact, the script could be one long line, with the only spaces those dictated by syntax rules and semicolons separating the various commands. For the human mind, however, this is a most difficult way to work.

Putting some care into the formatting of our script helps the author during the creation and debugging phases, and aids in any further modification by others. There are some basic elements added to a well structured script that greatly increase its readability to all those who might need to look at the source code.

Whitespace

The most basic thing one can do to aid in the readability of a script is use *whitespace*. To use an art metaphor, whitespace is the negative space around the text of a script. That is to say that while looking at an image, much can be discerned simply by looking at the area around a drawing. With text it's much the same. By separating different groups of commands together by adding in extra carriage returns, the script becomes much more legible, and makes it easier to find specific sections. In Examples 5.3 and 5.4, we have written the same code (which simply takes the translation attributes and rearranges their values) twice, once with a simple extra carriage return, which adds much to the code fragment's readability and visual cohesiveness.

EXAMPLE 5.3 Lack of whitespace makes code difficult to read.

```
$x = `getAttr object.tx`;
$y = `getAttr object.ty`;
$z = `getAttr object.tz`;
setAttr object.tz $x;
setAttr object.ty $z;
setAttr object.tx $y;
```

EXAMPLE 5.4 Simple carriage returns add visual clarity to code.

```
$x = `getAttr object.tx`;
$y = `getAttr object.ty`;
$z = `getAttr object.tz`;

setAttr object.tz $x;
setAttr object.ty $z;
setAttr object.tx $y;
```

Another useful tool for structuring whitespace is indentation. Most often done with tabs, many text editors allow the number of spaces contained in a tab to be user configurable. In this book, we use four, but each user can set the tab size to his or her liking. Indentation is used to control the visual flow of a script, easily identifying nested command groups and loops. In Examples 5.5 and 5.6, we again take the same code and use whitespacing to add legibility and visual organization to our code.

EXAMPLE 5.5 Code without tabs blends together.

```
if ($printVal)
for ($each in $list) {
print $each;
print "\n"; }
```

EXAMPLE 5.6 Tabs separate out different command groups.

```
if ( $printVal )

    for ( $each in $list )
        {
            print $each;
            print "\n";
        }
```

By simply adding a few spaces, indentations, and extra carriage re-
turns, our code goes from being something that looks like a meaningless
listing of code to a program with structure and thought. While it might
seem like a minor thing to put such craftsmanship in the structure of text
that will more than likely be seen by no one other than the author and
the MEL interpreter, using whitespace well adds an ease-of-use factor
to the process of writing and debugging scripts.

Comments

Comments are both one of the most useful and most underused aspects of
scripting. The irony of this underuse is that whenever the concept of
commenting scripts is spoken of in the communities that scripters fre-
quent, there is nearly universal agreement that commenting is a good
thing. The basic definition of a comment is a segment of text that is ig-
nored by the interpreter. Comments are created by prefacing any text
with two forward slashes, //. Once a line has been commented, all text
to the right of those slashes will be ignored; both styles are seen in Exam-
ple 5.7.

EXAMPLE 5.7 Adding single line comments.

```
// The following gets the translate x value of $obj
float $x = `getAttr ( $obj + ".tx" )`;

float $x=`getAttr ($obj+".tx")`;//gets the $obj tx value
```

MEL also supports multi-line comments that allow a scripter to add
large amounts of commented text to a script. Multi-line comments are
extraordinarily useful for adding headers to scripts, which we will cover
in just a moment. To comment out blocks of text, enclose the text with
two markers. The opening marker is a forward slash followed by an as-
terisk, /*; to close a comment, use the reverse, an asterisk followed by a
slash, */. Example 5.8 provides a demonstration of the multi-line com-
ment in use.

EXAMPLE 5.8 Multiline comments are often used at the beginning of files or to explain complicated sections of code.

```
/*
The following switch-case looks at input from the global
procedure passPolyInfo.  Because of this make sure
passPolyInfo.mel is included with any distribution of this
file.
*/
```

Note that while single-line comments are valid within expressions (see Chapter 10, "Creating Tools in Maya"), multi-line comments are not. Either keep expression comments brief or begin each comment line with a //.

Comments of both types are useful for debugging, by essentially removing a line or entire blocks of text from a script without actually deleting that text. Comments are also essential for scripts that are created in a group environment, to explain what each procedure and action's intended purpose is. Finally, because MEL is based on the English language, if a script is to be used in an environment where another language is prevalent, putting explanations in that language, even re-writing pseudo-code in that language, can be useful. Because MEL commands are mostly composed of words or word fragments in the English language, it is easier for an English speaker to decipher what is going on at each point in the script.

Those scripters working in a text editor that supports color coding are well advised to add comments as a drastically different color, which makes code with comments highly readable at a moment's glance.

Header Information

At the very top of a script file should be the *header* information. While each production environment will most likely have requirements and guidelines as to what information needs to be included, and in what order that information should be presented, there is some information that every file should contain. Enclosing this information as a multi-line comment prevents it from being executed and highly visible.

Any header should, at minimum contain the following: author's name, date of last modification and by whom, the version of Maya the script for which it was written, and how the script is used. Other common information is a script version number, a version history, as well as extensive instructions, and the author's e-mail address or Web homepage. A common header is seen in Example 5.9.

EXAMPLE 5.9 A sample header.

```
/*
myScript.mel
```

```
   author: John Doe ( jdoe@themelcompanion.com )
  version: v1.01a
 last mod: 05-16-2002 18:34 ( Doe )

    usage: myScript name number
 function: myScript prints name to the script
           editor number times.

 ver. history: v0.9  - printed "John Doe" 20 times
               v1.0  - added support for name entry
               v1.1  - added support for number entry
               v1.1a - fixed bug that would accidentally
                       kill a user's pet goldfish
*/
```

Obviously, that last bug fix is most likely not going to creep into any scripts, but it proves as a good case example. By keeping a log of what changes have been made to a script, a user can intelligently make decisions as to whether he needs or wants to get the latest version of a script. In addition, please note the use of whitespace and formatting of the header. More than any other part of a script, the header needs to be easily readable by any user, even those not versed in MEL.

Any header of a script meant for public distribution should contain a legal disclaimer in the form of an *End User License Agreement (EULA)*. The EULA is meant to protect a script's author if, by using the script, an artist deletes all of his models, formats the hard drive, and e-mails his credit card number to every hacker site known to humankind. Actually, not that last part—that's pretty much illegal. The scripts on the CD-ROM accompanying this book all contain EULAs, which can be used as the basis for the EULA of any script.

DEBUGGING, ERROR CHECKING, AND NAMING CONVENTIONS

Nothing is more frustrating than putting an hour, to say nothing of a day or two, into the writing of a script, run it the first time only to see line upon line of errors fill the Script Editor's history area. The bad news is that these errors, called *bugs* in coding vernacular, are inevitable. Bugs are bound to happen to even the best scripters. The good news is that every bug is fixable, and with the aid of the Stack Trace and Line Numbering is a relatively painless practice. Notice we said *relatively* painless. *Debugging*, the practice of finding and eliminating these bugs, can sometimes be a frustrating process, but in time every scripter learns the mistakes he commonly makes and can spot them quite quickly.

 The programming term "bug" comes from the very early days of computer programming, which of course was only 60 years ago. In those ancient times, transistor vacuum tubes were used to complete circuits, which would then provide a calculation of a mathematical problem. Every so often, an insect would find its way into the room sized-computers and complete a circuit, giving an incorrect answer and frying itself in the process. Hence, today when we have an error in our calculations or code, we have encountered a "bug."

The process of writing a script generally produces two types of errors, functional errors and syntax errors. Functional errors are often not reported by Stack Trace. They are not errors in the sense that they don't work; rather, they simply do not produce the result intended by the script's author. Although occasionally a functional error will be reported, such as attempting to carry out a command on an invalid selection type, it is often quite a challenge to track them down. Syntax errors are much more common than functional errors, most often the result of a simple typo, such as misspelling a command word or forgetting to end a line with a semicolon. Note that occasionally a syntax error will produce a functional error, such as getting the *x* and *y* components of a vector mixed up. These are often the hardest to track down, especially in larger scripts, simply because of the overwhelming amount of text. This is yet another reason to separate as many actions as possible into separate procedures, allowing the debug process to be modular.

A powerful technique used to prevent script failures is *error checking*. Oddly, error checking is actually used to create errors, but through the MEL command error. If a script requires a specific action to be taken by the user, such as having a single polygonal object selected, or requires the Maya environment to be set in a specific manner, such as having the angular units in radians, a scripter can check for these qualities with some if statements. In Example 5.10 we see a typical error check, in this case to see if the user has selected any objects, by seeing if the variable $selList, having been previously declared and assigned the selection list, has any items in it.

EXAMPLE 5.10 Using a conditional statement to error check.

```
if ( `size $selList` < 1)
    error "Please select at least one object."
```

The MEL command error is used to create a specific error feedback. It both immediately terminates the further execution of a script, and gives the users feedback as to what they have done wrong.

Error checking does not always require an error statement. There are situations in which a script wants to confirm an action. This is often done in situations where undoing a script is not possible, like batch processing (and

therefore saving) files, or when proceeding will take an inordinately long period of time. Using the `confirmDialog` command, and then querying the user's response in an `if` statement, allows for this capability. Dialogs are covered in depth in Chapter 11, "Customizing the Maya Interface."

Using `error` checks is one of the hallmarks of an experienced scripter. They both prevent a script's user from possibly harming the data and provide a way for the needs of a script to be easily communicated to a user. Through the careful implementation of `error` checks, a scripter can guarantee that when the time comes to execute the real body of a script, it is operating on both the exact data it should, and in the environment for which it was designed, allowing the script to function exactly as planned.

The final practice commonly used by skilled programmers is that of a standardized and cohesive naming structure for all components of a script. This includes variables, procedures, and the names of the script files themselves. Script and procedure names should be both distinctive and descriptive. If the tool being created will be composed of multiple scripts or procedures, especially if they are global procedures, add either a prefix or suffix to the name to prevent the wrong procedure from being called, as well as to identify the separate scripts as part of a larger whole. The latter reason leads us to more often than not use a prefix, to allow for easy sorting and grouping within a file browser or system call. For example, a tool to create an ocean environment might have a main script called `buildStormySea.mel`, but with separate scripts for building the user interface and for providing help and instructions, called `bss_ui.mel` and `bss_help.mel`, respectively. Many scripters also prefix their scripts with either their own initials or those of their production facility. This is done to allow tools similar in functionality and naming to existing tools to exist side by side. An example might be a script called `dps_pointConstraint.mel`, which could produce an effect similar to Maya's point constraint, without overwriting the standard functionality of the Maya command `pointConstraint`.

Variables must also be named carefully, most particularly in the case of global variables. Since global variables are visible outside of a script, they can easily conflict with other global variables declared in other scripts. With global variables, it is also important to remember that all variables declared at the Command Line, Script Editor, or Command Shell not contained in a command group are global.

Variable names should be descriptive, but it is often desirable to keep them short to allow for quicker programming. For example, it can become quite a hassle to type in a variable named `$polygonSelectionList` over and over in a script rather than something just as descriptive but shorter, such as `$polySelList` or even `$polySel`. Having long variable names is also a common cause for errors within a script. A scripter is more likely to misspell a long variable than a short variable.

This is yet another situation where an external, dedicated text editor designed for programming can aid in the creation of MEL scripts. These external editors often have auto-completion features that allow for highly descriptive long variable names while speeding the programming process and avoiding spelling errors.

CONCLUSION

We now have at our disposal all the knowledge we need to actually move into programming. We explored the process by which we design the structure of tools, as well as determine what outside knowledge we might need to accomplish our intended goal, which is remarkably similar to the process artists go through in the creation of any asset. We also covered a variety of practices that aid in the readability and flexibility of code. There are in actuality very few concrete rules that must be followed to construct a functioning script, merely guidelines that make scripting easier for an actual human to read and write. By following the guidelines and suggestions we covered here, we can create stylistically consistent, structurally sound scripts built in such a way as can be easily expanded upon.

▌▌

Working With MEL

6 GEOMETRY

Perhaps the most common use of MEL for beginning scripters is to create and manipulate geometry. Whether it is to integrate a mathematical formula, take advantage of the computer's ability to manipulate large data sets, or to expand upon Maya's tool base, MEL can be used to do all this and more.

Geometry, and specifically polygonal geometry, is also perhaps the easiest type of data to manipulate for beginning scripters and programmers, so we shall begin there. To those who want to work with higher order geometries such as NURBs, rest assured that this chapter provides a solid foundation for those data types. However, our goal is an education in MEL, not in the intricacies of Bezier splines and Catmull-Clark surfaces.

In this chapter, we present three projects dealing with common modeling challenges that serve as an introduction to the actual scripting process.

PROJECT

6.1: CREATING A NEW PRIMITIVE

Project Overview

By default, Maya includes relatively few primitive objects. Those it does include, with the exception of the sphere, are actually quite easily built by hand. One of the more useful primitive types Maya does not include is the *Regular Polyhedron*. A regular polyhedron, also called a *Platonic Solid*, is defined as a solid object where each face has an equal number of vertices, and all the angles of the face are equal. In addition, two spheres are defined as a Platonic Solid. The first, called the *circumscribed sphere*, is defined by the vertices, and the second, the *inscribed sphere*, is defined by the center of each face.

With all those rules, it should come as no surprise that there are five, and only five, of these objects: the tetrahedron, the cube, the octahedron, the dodecahedron, and the icosahedron. Of these, obviously artists are most familiar with the cube. However, to anyone who has played games involving dice of more or less than six sides is most familiar with the other types as well.

For our first project, we will create a script to construct an icosahedron. Icosahedrons are incredibly useful for modeling objects for video games and for use in soft body simulations involving springs, due to their inherent structural integrity. The icosahedron is also the foundation for the *geodesic sphere*.

This project will present the simplest way of constructing the icosahedron, without the complications of having to pass the script data or work too extensively with sub-object components. In the final project of this chapter, we will revisit the icosahedron, using what we learn in Project 6.2 to enhance the usefulness of our script.

The one disadvantage to constructing primitives with MEL rather than the API is the lack of construction history. There are ways to add some similar, albeit limited functionality to primitives created in MEL, through expressions and dynamic attributes, but for this project, simplicity is key.

Definition and Design

Our tool is rather simple; our only goal is to create a polygonal icosahedron. The shape itself is not complicated, simply made up of 20 triangular faces. Logically, the simplest way to create the icosahedron is to create each of the 20 faces and merge them together to create a single object. The important question is how to determine the co-ordinates of our icosahedron's vertices.

With this simple definition, we are able to create our flowchart, seen in Flowchart 6.1.

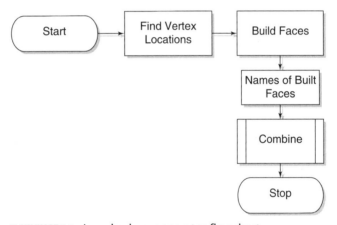

FLOWCHART 6.1 Icosahedron generator flowchart.

This is our first project, so the obvious simplicity is to our advantage. Looking at our diagram, we can see the need for the ability to do, at minimum, three functions with MEL.

We need to:

- Determine the vertex co-ordinates
- Create raw polygonal faces at those co-ordinates
- Merge that geometry together

Now that we have our script essentially designed and some potential problems defined, we can move on to finding solutions to those problems, which we do through research.

Research and Development

Our most pressing problem in the creation of our icosahedron is finding an equation to determine the vertex co-ordinates. Our first stop is the Internet. We can easily find definitions of the relationship between the radius of an icosahedron and the length of an edge. We could use trigonometry to build our icosahedron, since we now know the ratio of each side to each other. While this is a workable solution, a more elegant solution exists, found in the FAQ for comp.graphics.algorithms, an Internet newsgroup.

Looking at Figure 6.1, we see that the 12 vertices of an icosahedron are defined by three intersecting rectangles.

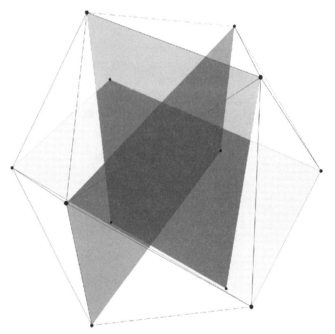

FIGURE 6.1 The intersecting rectangles defining the icosahedron.

These rectangles are defined by the *Golden Ratio*. This ratio is considered to be the ideal ration of width to height of any rectangle. How it interacts with our icosahedron stems from the fact that the Golden Ratio is a number relating to the interaction of a triangle and a circle. This means that we can use the Golden Ratio to define our vertex locations. The equation for the Golden Ratio is shown in Equation 6.1.

$$\left(\sqrt{5} - 1\right) / 2$$

From this, we can derive our 12 vertex locations, where *x* is the Golden Ratio:

- (+/− 1, 0, +/− *x*)
- (0, +/− *x*, +/− 1)
- (+/− *x*, +/− 1, 0)

Implementation

Now, we will start building our script to test our vertex locations. Open a new script file, and save it within your scripts directory as `buildPolyIcosohedron.mel`.

We begin by declaring our procedure, named the same as our file. Be sure to add the curly brackets to create an empty procedure, as seen in Example 6.1. Then, save your file.

EXAMPLE 6.1 Declaration of our procedure.

```
global proc buildPolyIcosohedron ()
{

}
```

Open Maya, and create a new shelf called MEL_Companion. Using the Script Editor, create a shelf button to source and execute our script. We do this so we can update our script file and have these updates reflected when we execute the script. The code needed to do this is seen in Example 6.2.

EXAMPLE 6.2 Creating a shelf button to both source and execute a script eases script development.

```
source buildPolyIcosohedron ;
buildPolyIcosohedron ;
```

We build this into a button simply to save us the effort of retyping the commands over and over, and freeing up the Script Editor should we want to test a section of code. If we now execute the sourcing code, nothing should happen. That's actually a good thing. Our procedure is empty, so it's not doing anything, but if Maya was unable to find the script file, and therefore the procedure, it will report an error. If this is the case, either move the script file to a location within your script path, or modify the path to the script file location.

Now that we have a fully functioning script file we can begin adding actual functionality. First up for our testing, we will want to define a variable to our Golden Ratio, as well as our vertex co-ordinates, which we will declare as vectors. We use the MEL command sqrt in the equation for the Golden Mean, but since we only execute the equation once, we do not waste excessive cycles using a divide rather than multiplying by 0.5, and we keep the equation in a familiar form, as seen in Example 6.3.

EXAMPLE 6.3 Creating variables to hold the vertex positions.

```
global proc buildPolyIcosohedron ()
{
// declaration and assignment of golden ratio
float $goldenMean = ((sqrt(5)-1)/2) ;

// declaration and assignment of vertices
vector $vert_01 = << 1, 0, $goldenMean >;
vector $vert_02 = << -1, 0, $goldenMean >;
vector $vert_03 = << 1, 0, ((-1.0) * $goldenMean) >;
vector $vert_04 = << -1, 0, ((-1.0) * $goldenMean) >;
vector $vert_05 = << 0, $goldenMean, 1 >;
vector $vert_06 = << 0, $goldenMean, -1 >;
vector $vert_07 = << 0, ((-1.0) * $goldenMean), 1  >;
vector $vert_08 = << 0, ((-1.0) * $goldenMean), -1  >;
vector $vert_09 = << $goldenMean, 1, 0  >;
vector $vert_10 = << $goldenMean, -1, 0  >;
vector $vert_11 = << ((-1.0) * $goldenMean) , 1, 0 >;
vector $vert_12 = << ((-1.0) * $goldenMean) , -1, 0 >;
}
```

ON THE CD

The text for this script is found on the companion CD-ROM as /project_01/ v01/buildPolyIcosohedron.mel.

In order to check the placement of our vertices, we will now place a locator at each of our 12 co-ordinates. To discover the MEL command used to create a locator, we look in the Script Editor's history after executing the Create > Locator command from the menu and see `spaceLocator –p 0 0 0; `. Looking up the documentation for the `spaceLocator` command, we see that the `-p` is the short flag for `-position`, which will allow us to place each locator at our co-ordinates. If we now add the code in Example 6.4 to our script, after the variable assignment, we will add 12 locators to our scene at each of the co-ordinates defined by our variables.

EXAMPLE 6.4 Creation of the locators.

```
// creation of locators at each of the twelve locations
spaceLocator
    -position ($vert_01.x) ($vert_01.y) ($vert_01.z)
    -name "Vertex_01"
    ;
spaceLocator
    -position ($vert_02.x) ($vert_02.y) ($vert_02.z)
    -name "Vertex_02"
    ;
spaceLocator
    -position ($vert_03.x) ($vert_03.y) ($vert_03.z)
```

```
        -name "Vertex_03"
        ;
    spaceLocator
        -position ($vert_04.x) ($vert_04.y) ($vert_04.z)
        -name "Vertex_04"
        ;
    spaceLocator
        -position ($vert_05.x) ($vert_05.y) ($vert_05.z)
        -name "Vertex_05"
        ;
    spaceLocator
        -position ($vert_06.x) ($vert_06.y) ($vert_06.z)
        -name "Vertex_06"
        ;
    spaceLocator
        -position ($vert_07.x) ($vert_07.y) ($vert_07.z)
        -name "Vertex_07"
        ;
    spaceLocator
        -position ($vert_08.x) ($vert_08.y) ($vert_08.z)
        -name "Vertex_08"
        ;
    spaceLocator
        -position ($vert_09.x) ($vert_09.y) ($vert_09.z)
        -name "Vertex_09"
        ;
    spaceLocator
        -position ($vert_10.x) ($vert_10.y) ($vert_10.z)
        -name "Vertex_10"
        ;
    spaceLocator
        -position ($vert_11.x) ($vert_11.y) ($vert_11.z)
        -name "Vertex_11"
        ;
    spaceLocator
        -position ($vert_12.x) ($vert_12.y) ($vert_12.z)
        -name "Vertex_12"
        ;
```

We enclose each of the vector components within parentheses as a rule of syntax.

ON THE CD

The text for this script is found on the companion CD-ROM as /project_01/ v02/buildPolyIcosohedron.mel.

If we now source and execute `buildPolyIcosohedron` in Maya, our viewport should look similar to Figure 6.2.

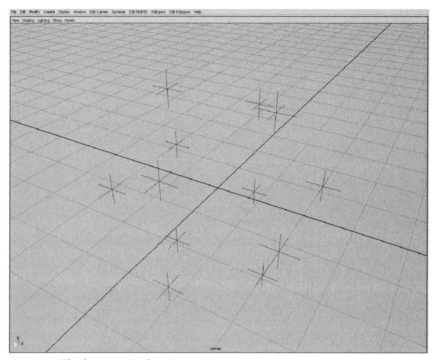

FIGURE 6.2 The locators in the viewport.

For purposes of clarity, we will now remap our vertex locator numbers, as seen in Figure 6.3.

ON THE CD *The text for this script is found on the companion CD-ROM as /project_01/ v03/buildPolyIcosohedron.mel.*

Now that our vertices are in the correct location, we need to build our individual faces. To create individual polygons in the Maya interface, we use the Polygon > Create Polygon tool.

An important aspect of creating polygonal faces is *vertex order*. In Maya, the normal of a face is defined on creation by the direction the vertices are created. As seen in Figure 6.4, if viewed along the normal, the vertices of a polygon proceed in a counterclockwise order.

If we start a new file, source and execute our script, we now have 12 locators corresponding to the 12 vertices of our icosahedron. We can now build each face using the Create Polygon tool, and turning on Point Snap to guarantee that each vertex will be placed on our newly created locators.

Following the rules for creating polygons, create 20 triangular faces in the following order:

Face 01: Vertex 01, Vertex 03, Vertex 02
Face 02: Vertex 01, Vertex 04, Vertex 03

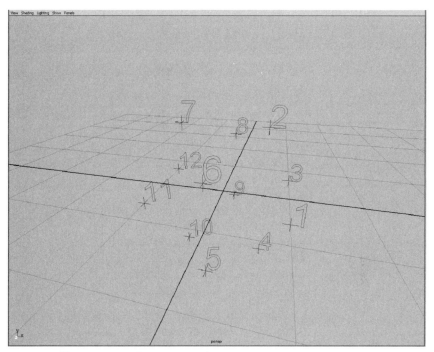

FIGURE 6.3 The remapped vertex numbers.

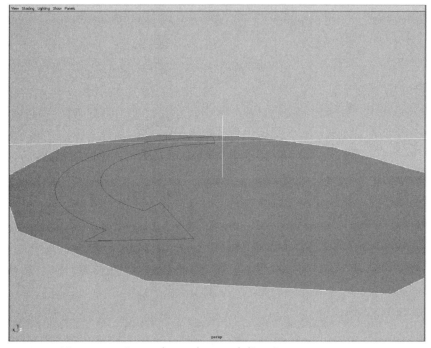

FIGURE 6.4 Vertex creation order and normal direction.

Face 03: Vertex 01, Vertex 05, Vertex 04
Face 04: Vertex 01, Vertex 06, Vertex 05
Face 05: Vertex 01, Vertex 02, Vertex 06
Face 06: Vertex 02, Vertex 03, Vertex 08
Face 07: Vertex 03, Vertex 09, Vertex 08
Face 08: Vertex 03, Vertex 04, Vertex 09
Face 09: Vertex 04, Vertex 10, Vertex 09
Face 10: Vertex 04, Vertex 05, Vertex 10
Face 11: Vertex 05, Vertex 11, Vertex 10
Face 12: Vertex 05, Vertex 06, Vertex 11
Face 13: Vertex 06, Vertex 07, Vertex 11
Face 14: Vertex 06, Vertex 02, Vertex 07
Face 15: Vertex 02, Vertex 08, Vertex 07
Face 16: Vertex 12, Vertex 07, Vertex 08
Face 17: Vertex 12, Vertex 08, Vertex 09
Face 18: Vertex 12, Vertex 09, Vertex 10
Face 19: Vertex 12, Vertex 10, Vertex 11
Face 20: Vertex 12, Vertex 11, Vertex 07

This should give us something resembling Figure 6.5, 20 separate objects that together form the shape of an icosahedron.

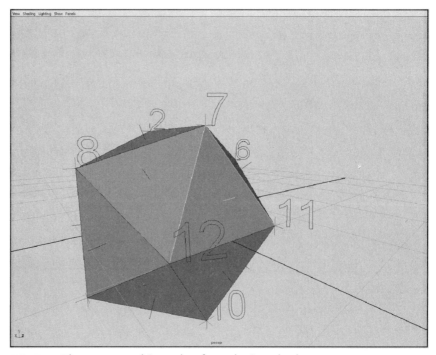

FIGURE 6.5 The separate objects that form the icosahedron.

So far, so good. We now have to put the creation of those polygons into the script. If we look in the History area of the Script Editor, we can see a series of `polyCreateFacet` commands. The command `polyCreateFacet` is the MEL command that creates polygonal faces. Each should look similar to Example 6.5.

EXAMPLE 6.5 The results of creating a polygonal face.

```
polyCreateFacet -ch on -tx 1 -s 1 -p 1 0 0.618034
    -p 1 0 -0.618034 -p 0.618034 1 0 ;
// Result: polySurface1 polyCreateFace1 //
```

One of the slightly illogical things Maya does when it gives feedback in the History area of the Script Editor is that it uses the short flags for each command, rather than the more informative long flag names. To decipher the flags, we can either refer to the online HTML documentation of MEL commands, or simply type `help polyCreateFacet` in the Script Editor. Doing so allows us to translate our command into that seen in Example 6.6. We have also cleaned up the command to add white space and readability.

EXAMPLE 6.6 Putting the command into an easily readable format.

```
polyCreateFacet
    -constructionHistory on
    -texture 1
    -subdivision 1
    -point 1 0 0.618034
    -point 1 0 -0.618034
    -point 0.618034 1 0
    ;
```

We can now replace the creation of the vertex locators in our script with 20 `polyCreateFacet` commands. In each, we will want to replace the numbers after each of the –point flags with the vector variables, in the same order we built the facets by hand. In Example 6.7, we see how the variables are used to build the first face.

ON THE CD

The text for this script is found on the companion CD-ROM as /project_01/ v04/buildPolyIcosohedron.mel.

EXAMPLE 6.7 Using the variables in the creation of our polygons.

```
polyCreateFacet
    -constructionHistory off
    -texture 1
    -subdivision 1
    -point ($vert_01.x) ($vert_01.y) ($vert_01.z)
```

```
        -point ($vert_03.x) ($vert_03.y) ($vert_03.z)
        -point ($vert_02.x) ($vert_02.y) ($vert_02.z)
    ;
```

We have chosen to turn off the construction history during the creation of our polygon faces because we have no need for the history, and having that history simply clutters the scene with unneeded nodes. As we will learn later, having these extra nodes does more than just add bloat to a file; they can actually slow down scripts when we have to navigate through the node connections of objects.

After adding the commands to create the 20 separate faces of our icosahedron, we can start a new file, source and execute our script, giving us essentially what we had before, but now created by the script.

Obviously, we don't want our icosahedron to be made of 20 separate pieces. We can select all the faces and from the Modeling menu select Polygon -> Combine to make one object of the individual polygons. If Construction History is on, we can look in the Hypergraph and see that the nodes that now make up the icosahedron still exist. Once we delete the construction history on the newly created icosahedron object, the nodes disappear. We can now look in the Script Editor history to find the commands for what we have just done.

The command to combine polygons is `polyUnite`. We can just copy the code for our `polyUnite` command, but alter the flag so that we do not create construction history, as seen in Example 6.8.

EXAMPLE 6.8 Combining the individual faces into one object.

```
polyUnite
    -constructionHistory off
    polySurface1
    polySurface2
    polySurface3
    polySurface4
    polySurface5
    polySurface6
    polySurface7
    polySurface8
    polySurface9
    polySurface10
    polySurface11
    polySurface12
    polySurface13
    polySurface14
    polySurface15
    polySurface16
    polySurface17
    polySurface18
    polySurface19
```

```
polySurface20
;
```

Now if we source and execute our script, unless it's a new scene, we get an error similar to that seen in Example 6.9.

EXAMPLE 6.9 An example of the error that likely occurred.

```
// Error: file: C:/Documents and Settings/Administrator
/My Documents/maya/scripts/TMC/chapter_06/
buildIcosohedron.mel line 284: No object matches
name: polySurface1 //
```

This is due to the command using the explicit names polySurface1, poly-Surface2, and so forth. As we can see from looking at the Hypergraph, the new faces start with the name polySurface22. When we combined our faces into the icosahedron, it became polySurface21. Because of the way Maya handles naming new objects, there is no guarantee that, even if we explicitly assign a name to the polygon faces upon creation, we can know the names of the actual polygon objects the script creates. What we need to do is catch the name of an object as it is created and assign that captured name to a variable. We do this by enclosing the `polyCreateFacet` command in single forward quotes, and assigning it to a string variable, as seen in Example 6.10.

EXAMPLE 6.10 Capturing the name of the created object.

```
string $surf_01[] = `polyCreateFacet
    -constructionHistory off
    -texture 1
    -subdivision 1
    -point ($vert_01.x) ($vert_01.y) ($vert_01.z)
    -point ($vert_03.x) ($vert_03.y) ($vert_03.z)
    -point ($vert_02.x) ($vert_02.y) ($vert_02.z)
    `

    ;
```

We use a string array variable because the `polyCreateFacet` command is designed to return not only the name of the object's transform node, but the nodes it creates when the command is used with Construction History turned on.

This idea, that Maya returns a single piece of information as an array, is the cause of many errors within scripts. While it is little more than an irritation when this occurs within a script, since it is a simple matter to add the [] to a variable to make it an array, it is a problem for global variables, since you cannot re-declare a variable of the same name as a different type. If you are unclear as to what type of data a command returns information as, simply

attempt to assign the return data to a known type of variable, and if the return type differs, the resulting error will reveal what the return data type is.

Add this variable assignment, using $surf_01[], $surf_02[], and so on, to each of the polyCreateFacet commands. Now, we can use those variables in place of the explicit object names in the polyUnite command, as seen in Example 6.11.

EXAMPLE 6.11 Using the captured names in the polyUnite command.

```
polyUnite
    -constructionHistory off
    $surf_01
    $surf_02
    $surf_03
    $surf_04
    $surf_05
    $surf_06
    $surf_07
    $surf_08
    $surf_09
    $surf_10
    $surf_11
    $surf_12
    $surf_13
    $surf_14
    $surf_15
    $surf_16
    $surf_17
    $surf_18
    $surf_19
    $surf_20
    ;
```

At this point we can now execute our script as many times as we want without errors and get a new icosahedron each time. We do have one last aspect of creating the icosahedron unresolved. An icosahedron has 12 vertices. Although it appears that our icosahedron has only 12, it actually has 60, which can be confirmed through the command polyEvaluate −vertex, a command that returns the number of vertices in a selected object. Although the polyUnite command combines the multiple objects into a single object, it does not unite any of the components. In the Maya interface we can use the Edit Polygons -> Merge Vertices command to merge all the overlapping vertices. The option settings for the Merge Vertices command are seen in Figure 6.6. We have to find a balance for the tolerance settings so that the overlapping vertices are merged, but not the neighbor vertices.

FIGURE 6.6 Merge Vertex Options box.

Successfully merging the vertices of a polygonal object is dependent upon the normals of an object. Because we put the effort into ensuring that all the normals of the polygons were created with the `polyCreateFacet` command, we should have no problems. The effort spent to create objects the "right" way often saves extra work and possible bugs later.

We can now harvest the resulting command from the Script Editor. Again, as we see in Example 6.12, an object is explicitly named in the command, `poly-MergeVertex`. Actually, the object is not named, but rather its vertex components. For now, since we are essentially dealing with all the vertices as a single entity, we will keep our component handling simple. We will cover object components in depth in Project 6.3.

EXAMPLE 6.12 The command to merge polygonal vertices.

```
polyMergeVertex -d 0.05 -ch 0 polySurface21.vtx[0:59];
```

As in the case of the `polyUnite` command, we need to know the name of the newly created icosahedron to pass to the `polyMergeVertex` command. Create a variable to catch the result of the `polyUnite` command, as seen in Example 6.13. Notice again that the variable is an array, although we are capturing only a single element.

EXAMPLE 6.13 Capturing the name of the polyUnite created object to a string variable.

```
string $united_poly[] = `polyUnite
                    -constructionHistory off
                    $surf_01
                    $surf_02
                    $surf_03
                    $surf_04
                    $surf_05
                    $surf_06
                    $surf_07
                    $surf_08
                    $surf_09
                    $surf_10
                    $surf_11
```

```
$surf_12
$surf_13
$surf_14
$surf_15
$surf_16
$surf_17
$surf_18
$surf_19
$surf_20
'

;
```

Since the name now held in the variable `$united_poly` is the name of the transform node, and we need to give the `polyMergeVertex` command a list of components, we need to use the captured name to create a new string. Although we could either create a new variable or modify the data held in `$united_poly`, there is no need—we can create the new string directly in the Merge Vertices command, seen in Example 6.14.

EXAMPLE 6.14 Implementing the Merge Vertices command.

```
polyMergeVertex
    -distance 0.05
    -constructionHistory off
    ($united_poly[0] + ".vtx[0:59]")
    ;
```

The text for this script is found on the companion CD-ROM as /project_01/ v05/buildPolyIcosohedron.mel.

An important aspect of using string arrays within a mathematical function is to use only a single element within the function. Attempting to use an entire array results in an error. It is rare to explicitly use a single element of an array in a script; most often, the command is enclosed in a loop to iterate through each of the items contained in the array. Here, since we know the array has only one element, adding the loop only introduces unnecessary complication, possibly leading to an error.

If we now source and execute the script, we have a solid icosahedron, with all the vertices merged. At this point, we could call the script finished, but we can now add one small touch, which will enhance the polish of the tool.

Whenever an object is created in Maya, by default it has a name appropriate to its type and shape; for example, pCube1, nurbsSphere2, and so forth. There is no reason why this functionality cannot be added to our script. Also, you will notice at this point, because our script ends with the `polyMergeVertex` command, the icosahedron's vertices are selected, not the transform node. When creating an object, a script should follow the Maya default structure and

make the newly created object the current selection. We will select the object first, using the −replace flag to guarantee that it is the only selection. We then use the rename command to name the object *plcosahedron1*. If there is already an object called plcosahedron1, Maya will automatically name the new object plcosahedron2, or if an object is named plcosahedron2, it will name it plcosa-hedron3, and so on. In Example 6.15, we see the code needed to add these final details to our script.

EXAMPLE 6.15 Adding finesse to the script.

```
select -replace $united_poly[0];
rename $united_poly[0] "pIcosohedron1";
```

With this, our script is complete. We have accomplished all of the goals set out in the initial definition of our script, and have produced a stable, working tool. There are more features we could add to the tool, but at our current level of knowledge, it is best to keep this tool simple for the time being to avoid confusion.

ON THE CD

The text for this script is found on the companion CD-ROM as /project_01/finished/ buildPolyIcosohedron.mel.

Project Conclusion and Review

As we have seen, by mimicking the workflow of working in the Maya interface and combining that with the mathematical precision of a computer, we can easily produce complex geometric shapes not easily created by hand. By harvesting the text returned by Maya in the Script Editor, we can quickly and easily build our scripts, and by simply replacing explicit names with variables, we can add stability and flexibility to any command. As we move on to more complex tools, these lessons will aid us in our journey.

Project Script Review

```
global proc buildIcosohedron ()
{
float $goldenMean = ((sqrt(5)-1)/2) ;

vector $vert_01 = << 1, 0, $goldenMean >;
vector $vert_02 = << $goldenMean, 1, 0 >;
vector $vert_03 = << 1, 0, ((-1.0)*$goldenMean) >;
vector $vert_04 = << $goldenMean, -1, 0 >;
vector $vert_05 = << 0, ((-1.0)*$goldenMean), 1 >;
vector $vert_06 = << 0, $goldenMean, 1 >;
vector $vert_07 = << ((-1.0)*$goldenMean), 1, 0 >;
vector $vert_08 = << 0, $goldenMean, -1 >;
```

```
vector $vert_09 = << 0, ((-1.0)*$goldenMean), -1 >;
vector $vert_10 = << ((-1.0)*$goldenMean), -1, 0 >;
vector $vert_11 = << -1, 0, $goldenMean >;
vector $vert_12 = << -1, 0, ((-1.0)*$goldenMean)>;

string $surf_01[] = `polyCreateFacet
    -constructionHistory off
    -texture 1
    -subdivision 1
    -point ($vert_01.x) ($vert_01.y) ($vert_01.z)
    -point ($vert_03.x) ($vert_03.y) ($vert_03.z)
    -point ($vert_02.x) ($vert_02.y) ($vert_02.z)
    `

    ;

string $surf_02[] = `polyCreateFacet
    -constructionHistory off
    -texture 1
     subdivision 1
    -point ($vert_01.x) ($vert_01.y) ($vert_01.z)
    -point ($vert_04.x) ($vert_04.y) ($vert_04.z)
    -point ($vert_03.x) ($vert_03.y) ($vert_03.z)
    `

    ;

string $surf_03[] = `polyCreateFacet
    -constructionHistory off
    -texture 1
    -subdivision 1
    -point ($vert_01.x) ($vert_01.y) ($vert_01.z)
    -point ($vert_05.x) ($vert_05.y) ($vert_05.z)
    -point ($vert_04.x) ($vert_04.y) ($vert_04.z)
    `

    ;

string $surf_04[] = `polyCreateFacet
    -constructionHistory off
    -texture 1
    -subdivision 1
    -point ($vert_01.x) ($vert_01.y) ($vert_01.z)
    -point ($vert_06.x) ($vert_06.y) ($vert_06.z)
    -point ($vert_05.x) ($vert_05.y) ($vert_05.z)
    `

    ;

string $surf_05[] = `polyCreateFacet
    -constructionHistory off
    -texture 1
    -subdivision 1
```

```
    -point ($vert_01.x) ($vert_01.y) ($vert_01.z)
    -point ($vert_02.x) ($vert_02.y) ($vert_02.z)
    -point ($vert_06.x) ($vert_06.y) ($vert_06.z)
    `

    ;

string $surf_06[] = `polyCreateFacet
    -constructionHistory off
    -texture 1
    -subdivision 1
    -point ($vert_02.x) ($vert_02.y) ($vert_02.z)
    -point ($vert_03.x) ($vert_03.y) ($vert_03.z)
    -point ($vert_08.x) ($vert_08.y) ($vert_08.z)
    `

    ;

string $surf_07[] = `polyCreateFacet
    -constructionHistory off
    -texture 1
    -subdivision 1
    -point ($vert_03.x) ($vert_03.y) ($vert_03.z)
    -point ($vert_09.x) ($vert_09.y) ($vert_09.z)
    -point ($vert_08.x) ($vert_08.y) ($vert_08.z)
    `

    ;

string $surf_08[] = `polyCreateFacet
    -constructionHistory off
    -texture 1
    -subdivision 1
    -point ($vert_03.x) ($vert_03.y) ($vert_03.z)
    -point ($vert_04.x) ($vert_04.y) ($vert_04.z)
    -point ($vert_09.x) ($vert_09.y) ($vert_09.z)
    `

    ;

string $surf_09[] = `polyCreateFacet
    -constructionHistory off
    -texture 1
    -subdivision 1
    -point ($vert_04.x) ($vert_04.y) ($vert_04.z)
    -point ($vert_10.x) ($vert_10.y) ($vert_10.z)
    -point ($vert_09.x) ($vert_09.y) ($vert_09.z)
    `

    ;

string $surf_10[] = `polyCreateFacet
    -constructionHistory off
    -texture 1
```

```
        -subdivision 1
        -point ($vert_04.x) ($vert_04.y) ($vert_04.z)
        -point ($vert_05.x) ($vert_05.y) ($vert_05.z)
        -point ($vert_10.x) ($vert_10.y) ($vert_10.z)
        `

    ;

string $surf_11[] = `polyCreateFacet
    -constructionHistory off
    -texture 1
    -subdivision 1
    -point ($vert_05.x) ($vert_05.y) ($vert_05.z)
    -point ($vert_11.x) ($vert_11.y) ($vert_11.z)
    -point ($vert_10.x) ($vert_10.y) ($vert_10.z)
    `

    ;

string $surf_12[] = `polyCreateFacet
    -constructionHistory off
    -texture 1
    -subdivision 1
    -point ($vert_05.x) ($vert_05.y) ($vert_05.z)
    -point ($vert_06.x) ($vert_06.y) ($vert_06.z)
    -point ($vert_11.x) ($vert_11.y) ($vert_11.z)
    `

    ;

string $surf_13[] = `polyCreateFacet
    -constructionHistory off
    -texture 1
    -subdivision 1
    -point ($vert_06.x) ($vert_06.y) ($vert_06.z)
    -point ($vert_07.x) ($vert_07.y) ($vert_07.z)
    -point ($vert_11.x) ($vert_11.y) ($vert_11.z)
    `

    ;

string $surf_14[] = `polyCreateFacet
    -constructionHistory off
    -texture 1
    -subdivision 1
    -point ($vert_06.x) ($vert_06.y) ($vert_06.z)
    -point ($vert_02.x) ($vert_02.y) ($vert_02.z)
    -point ($vert_07.x) ($vert_07.y) ($vert_07.z)
    `

    ;

string $surf_15[] = `polyCreateFacet
    -constructionHistory off
```

```
      -texture 1
      -subdivision 1
      -point ($vert_02.x) ($vert_02.y) ($vert_02.z)
      -point ($vert_08.x) ($vert_08.y) ($vert_08.z)
      -point ($vert_07.x) ($vert_07.y) ($vert_07.z)
      `

    ;

string $surf_16[] = `polyCreateFacet
      -constructionHistory off
      -texture 1
      -subdivision 1
      -point ($vert_12.x) ($vert_12.y) ($vert_12.z)
      -point ($vert_07.x) ($vert_07.y) ($vert_07.z)
      -point ($vert_08.x) ($vert_08.y) ($vert_08.z)
      `

    ;

string $surf_17[] = `polyCreateFacet
      -constructionHistory off
      -texture 1
      -subdivision 1
      -point ($vert_12.x) ($vert_12.y) ($vert_12.z)
      -point ($vert_08.x) ($vert_08.y) ($vert_08.z)
      -point ($vert_09.x) ($vert_09.y) ($vert_09.z)
      `

    ;

string $surf_18[] = `polyCreateFacet
      -constructionHistory off
      -texture 1
      -subdivision 1
      -point ($vert_12.x) ($vert_12.y) ($vert_12.z)
      -point ($vert_09.x) ($vert_09.y) ($vert_09.z)
      -point ($vert_10.x) ($vert_10.y) ($vert_10.z)
      `

    ;

string $surf_19[] = `polyCreateFacet
      -constructionHistory off
      -texture 1
      -subdivision 1
      -point ($vert_12.x) ($vert_12.y) ($vert_12.z)
      -point ($vert_10.x) ($vert_10.y) ($vert_10.z)
      -point ($vert_11.x) ($vert_11.y) ($vert_11.z)
      `

    ;

string $surf_20[] = `polyCreateFacet
```

```
        -constructionHistory off
        -texture 1
        -subdivision 1
        -point ($vert_12.x) ($vert_12.y) ($vert_12.z)
        -point ($vert_11.x) ($vert_11.y) ($vert_11.z)
        -point ($vert_07.x) ($vert_07.y) ($vert_07.z)
        `

        ;

    string $united_poly[] = `polyUnite
        -constructionHistory off
        $surf_01
        $surf_02
        $surf_03
        $surf_04
        $surf_05
        $surf_06
        $surf_07
        $surf_08
        $surf_09
        $surf_10
        $surf_11
        $surf_12
        $surf_13
        $surf_14
        $surf_15
        $surf_16
        $surf_17
        $surf_18
        $surf_19
        $surf_20
        `

        ;

    polyMergeVertex
        -distance 0.05
        -constructionHistory off
        ($united_poly[0] + ".vtx[0:59]")
        ;

    select -replace $united_poly[0];

    rename $united_poly[0] "icosohedron1";
    }
```

6.2: THE GRASS GENERATOR

Project Overview

Our next project comes from an actual real-world challenge. A request was made for a tool that would create a field full of grass. Doing any type of nature simulation within the realm of computer graphics is difficult. Nature has both a complexity and detail that can challenge the capabilities of both artist and hardware when an attempt is made to bring it into the digital realm. While there are solutions both within Maya and from third parties, they were eliminated for a variety of reasons, based on the required qualities needed for the grass.

Definition and Design

The grass generated had three required qualities:

- Raytraceable
- Maya native
- Detailed enough to hold up to film resolution renders

The project, a short film, was being done on a shoestring budget, and those shoes were actually slippers—so, in actuality there was no budget. Because of this, the project had to be created in Maya alone without the aid of third-party solutions, like outside renderers. The design of the project also required that the grass had to appear in raytraced reflections, refractions, and shadows. This eliminated possible Maya native solutions like Paint Effects and Maya Fur, which are applied as post effects. This, combined with the plan to render the final project to film, precipitated using actual geometry as the grass. We are lucky in that all our action takes place within a field; therefore, we do not need to do any type of surface detection.

At this point, we can draw a simple flowchart, which will outline the structure of our script, represented in Flowchart 6.2.

With this structure in place, we now have enough to begin work on the research needed for our script.

Research and Development

Grass is actually something easy to research. Sure, we could go to the library and check out some botany books. Or, we could just head outside. The amazing thing about nature and the human eye is how much detail there is, and how much of that detail we see. Even from a long distance, we can make out variations of color and shading. Like hair, grass is a mass of objects that are essentially the same color, that due to their specular nature, along with their

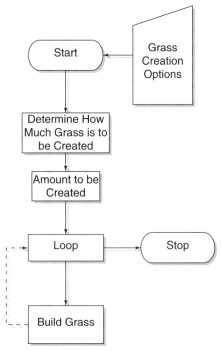

FLOWCHART 6.2 Grass generator flowchart.

shadows and shading, give away their nature as tiny individual objects. The look of a blade of grass is determined by geography and whether it is wild or cultivated. The grass found growing in a front yard is distinctly different from that growing in the middle of a field in a national park. Cultivated grass is usually healthier, with a deeper green from years of fertilizer and regular watering. Looking more closely at an individual blade, it is likely truncated from a lawn mower blade. Wild grass, like that which we want to create, tapers to a point. Moreover, because areas of cultivated grass are seeded, the grass is much more dense. Wild grass has more dirt space than cultivated grass. Grass, unless cropped to an extremely short length, is also not straight. Its blades bend and flop about. A long blade of grass cannot bear its own weight, so it bends, often more toward the tip than the base.

At this point, we should define what the needed qualities of our actual grass geometry are:

- Uniqueness
 - Shape
 - Placement
- Detail
 - User definable detail

- Control of the "look"
 - Length
 - Curl
 - Amount
 - Assignment of a shader

Now is also a good time to put some thought into how we are going to create the blades of grass. While we could take an approach similar to the creation of our icosahedron, building each blade polygon by polygon, that is not the best way to accomplish this task.

Instead of creating the blades with the `createPolyFacet` command, we will use the polygonal cone primitive. Open Maya and create a polygonal cone, with Construction History active. Either in the Channel Box or in the Attribute Editor, modify the Cone Creation attributes so that it has only three sides. If we then adjust the Height and Radius attributes, as well as scale the cone in X to a value of 0.25, we can achieve a very blade-like shape. Size is not really important here, the ratio of Height to Radius is. We can create a couple of different types of grass this way, from the short and stout crab grass to the long and graceful swamp grass, along with a variety of looks in between seen in Figure 6.7. It is handy to move the cone up half the Height attribute, to place it on the ground plane.

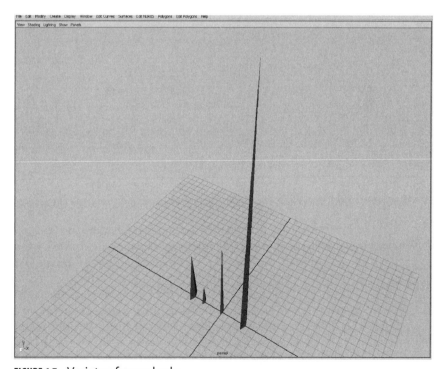

FIGURE 6.7 Variety of grass looks.

While settings might vary depending on what scale a user is working in, Figure 6.8 shows us some settings that produce a generic piece of grass.

FIGURE 6.8 The creation settings for the blade of grass.

Of course, the pieces of grass created so far appear to give us good cause to call them blades. People walking in a field of this grass would have their feet ripped to bloody shreds. While this might be a useful look in a music video for the latest nihilistic speed metal band, it is not the look we're after. As we previously discussed, a long blade of grass bends under its own weight.

Although it is somewhat hidden, Maya does have procedural deformers. Found under Animation>Deformers>Create Non-Linear>Bend, we can add a bend deformer to our cone. However, unless detail is added along the length of our grass blade, our blade will become deformed in a way that is visually unpleasant. If we now create a cone with 10 subdivisions along its length, we

have enough detail to represent our bend, which we'll add and set its Curvature to 1. This produces the geometry seen in Figure 6.9.

FIGURE 6.9 The bend result.

The bend deformer by default bends around the medial axis of the object to which it is added. We, however, want the base of the blade of grass to stay at ground level, so we alter the High Bound and Low Bound values to be 2 and 0, respectively. Now, only one half of our blade of grass is bent, so we have to move our bend deformer so that its center, the origin of the bend, is at the base of the cone. We can do this by setting the translate Y value of the deformer to 0. We can now try various settings on both the Curvature and Envelope settings to produce an amazing variety of grass, some examples of which can be seen in Figure 6.10. We use negative values for the Curvature value so the flat side of the blade faces toward the ground.

While it likely wouldn't hold up to serving as the main set pieces in an animated feature starring ants or bugs, this geometry serves our purposes quite well. If we add the shader found on the companion CD-ROM in Projects/Chapter06/Grass/grass.ma, which uses a ramp to soften the tip, we take advantage of the UV coordinates provided by using the cone primitive to create our grass.

The final step to perfect the look of our grass is to harden the edges of our geometry. However, the results can be somewhat unpredictable if done at this point, after the cone has been scaled and bent. Instead, we should do this process after the creation of the cone, but before it is scaled or bent.

FIGURE 6.10 Using negative bend to put the flat side down.

We now have the process worked out to produce a decent piece of grass:

1. Create a three-sided polygonal cone with suitable detail.
2. Position it on the ground plane.
3. Harden the edges.
4. Scale by .25 in X.
5. Add a bend deformation.
6. Move that deformation to the base of the cone.

Now that we have a process worked out for creating a specific piece of grass, we need to develop a way to randomize the attributes used to create the grass. This challenge is actually a fairly simple one within the realm of the computer. Computers, unlike people, are completely objective when it comes to randomness. If a person is asked to place a handful of marbles within a square painted on the floor, short of tossing them down to scatter, chances are the

human brain will start to impede. For example, the person will think, "This marble is bigger, so it needs more empty space around it. These three marbles are a similar red and would look nice all clustered together." But a computer is completely impartial. MEL provides the ability to generate random numbers through the `rand` command. For example, simply typing `rand 10` at the command line produces a random number between 0 and 10. No matter how often we execute it, we never get the same number twice. We will be able to use this command to apply randomness to the cone's height, radius, and the settings on the bend modifier, and use it to randomly place our grass.

Now that we have worked out both the process for building a blade of grass and how to apply randomness, we can write out our flowchart, seen in Flowchart 6.3.

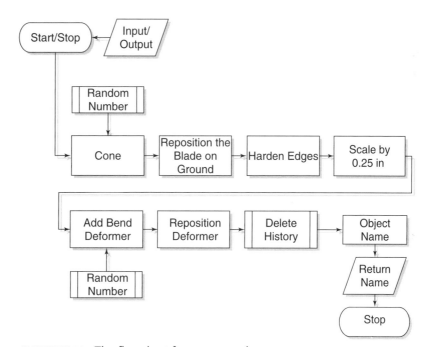

FLOWCHART 6.3 The flowchart for our procedure.

Although we might need to do some experimentation to figure the best way to distribute our blades of grass, we can now move on to creating our script.

Implementation

Open a new script file, and save it within your scripts directory as `generateGrass.mel`.

In this new file, declare the global procedure `generateGrass`, as seen in Example 6.16, and save your file.

EXAMPLE 6.16 Declaration of our procedure.

```
global proc generateGrass ()
{
}
```

We now can add a button to our MEL_Companion shelf to source and execute the script. We should run this to make sure the script is found within our script paths.

Looking at our flowchart, the first step in creating our grass is to create a base cone object. By either referring to the online documentation or by harvesting the command from the Script Editor, we learn that the MEL command to create a polygonal cone is `polyCone`. In our script file, we can add the `polyCone` command, using any of the settings from our earlier experimentation in the Maya workspace. Our first iteration of the script will create a standard blade of grass; we will add functionality to make variations on the commands in a later iteration. It is often beneficial, even with a fleshed-out plan, to build scripts in such a manner. See Example 6.17.

EXAMPLE 6.17 Adding the cone creation to the procedure.

```
global proc generateGrass ( )
{
// Creation of Poly Cone
polyCone
    -radius 0.04
    -height 1
    -subdivisionsX 3
    -subdivisionsY 10
    -subdivisionsZ 0
    -axis 0 1 0
    -texture 1
    -constructionHistory off
    ;
}
```

Saving, sourcing, and executing the script will now create a small cone. We have once again turned Construction History off for the creation of our cone. Our next step is to position the cone on the ground plane, by moving it up half the height. Of course, to do this we need to capture the name of the created polygonal cone, which we capture in a string array, since the `polyCone` command returns the name in this format, to accommodate returning the name of the `polyCone` node if the cone is created with construction history. We then use the captured name in a `setAttr` statement, all seen in Example 6.18.

EXAMPLE 6.18 Catching the names of the created cones and moving them to the ground plane.

```
global proc generateGrass ( )
{
// Creation of Poly Cone
string $blades[] = `polyCone
                        -radius 0,04
                        -height 1
                        -subdivisionsX 3
                        -subdivisionsY 10
                        -subdivisionsZ 0
                        -axis 0 1 0
                        -texture 1
                        -constructionHistory off
                        `

                        ;

// Bring the bottom of the cone to ground level
setAttr ( $blades[0] + ".translateY" ) .5;

}
```

Next, we want to harden the edges of our cone. Unfortunately, this is more complex to execute in MEL than it is in the Maya interface. If a user has the option set to automatically convert a selection, under Polygons>Tool Options> Convert Selection, and a user has an object selected when he executes the Edit Polygons>Normals>Soften/Harden, Maya automatically selects all the edges of the object, and then executes the command. Within our script, we must do something similar. We can issue the command without having the edges selected, though Maya will then leave us with those edges as the current selection, so we must switch back to object select mode after executing the `polySoftEdge` command. After the `setAttr` command we add the two commands, and we re-select the polygon cone to ensure it is the active selection. See Example 6.19.

EXAMPLE 6.19 Harden the edges of the cone.

```
// harden the edges of cone
polySoftEdge
    -angle 30
    -constructionHistory off
    ( $blades[0] + ".e[0:59]" )
    ;

changeSelectMode -object;
select -r $blades;
```

Again, save, source and execute the script. After adding the `polySoftEdge` command, we can now add the rest of the commands to scale our cone, adding and positioning our bend deformer. Because the deformers cannot be created without construction history, we delete the construction history on our cone before ending the script. After adding these commands, the script should resemble that in Example 6.20.

EXAMPLE 6.20 Adding the deformer.

```
global proc generateGrass ( )
{
// Creation of Poly Cone
string $blades[] = `polyCone
                    -radius 0,04
                    -height 1
                    -subdivisionsX 3
                    -subdivisionsY 10
                    -subdivisionsZ 0
                    -axis 0 1 0
                    -texture 1
                    -constructionHistory off

                    `
                    ;

// Bring the bottom of the cone to ground level
setAttr ( $blades[0] + ".translateY" ) 0.5 ;

// harden the edges of cone
polySoftEdge
    -angle 30
    -constructionHistory off
    ( $blades[0] + ".e[0:59]" )
    ;

// go back to object mode
// and ensure the cone is selected
changeSelectMode -object ;
select -replace $blades ;

// make the blade thin;
setAttr ( $blades[0] + ".scaleX" ) 0.25 ;

// add the bend deformer, capture the name to move it
string $bend[] = `nonLinear
                    -type bend
                    -lowBound 0
                    -highBound 2
                    -curvature (-0.5)
                    `
```

```
                                ;
       setAttr ( $bend[1] + ".ty" ) 0 ;
       setAttr ( $bend[0] + ".envelope" ) 0.8 ;

       // select the cone object and delete the history
       select -replace $blades ;
       delete -constructionHistory blades ;

       }
```

Now, when the script is executed, we create our blade of grass.

To add some variety to our grass, we will replace various attributes with variables. Replace the values for the cones radius and height with variables called $grassRadius and $grassHeight. Also replace the curvature value with a variable called $grassCurl. All three variables are stored as floating-point numbers, which must be declared at the beginning of the script. At this time, assign our previous values to the variables at declaration. See Example 6.21.

EXAMPLE 6.21 Using variables in place of explicit values.

```
       global proc generateGrass ( )
       {
       // Declaration of variables
       float $grassRadius = 0.04 ;
       float $grassHeight = 1.0 ;
       float $grassCurl = -0.5 ;
       float $envelopeVal = 0.8 ;

       // Creation of Poly Cone
       string $blades[] = `polyCone
                             -radius $grassRadius
                             -height $grassHeight
                             -subdivisionsX 3
                             -subdivisionsY 10
                             -subdivisionsZ 0
                             -axis 0 1 0
                             -texture 1
                             -constructionHistory off

                               `
                                ;

       // Bring the bottom of the cone to ground level
       setAttr ( $blades[0] + ".translateY" ) 0.5 ;

       // harden the edges of cone
       polySoftEdge
```

```
            -angle 30
            -constructionHistory off
            ( $blades[0] + ".e[0:59]" )
            ;

    // go back to object mode
    // and ensure the cone is selected
    changeSelectMode —object ;
    select —replace $blades ;

    // make the blade thin;
    setAttr ( $blades[0] + ".scaleX" ) 0.25 ;

    // add the bend deformer, capture the name to move it
    string $bend[] = `nonLinear
                        -type bend
                        -lowBound 0
                        -highBound 2
                        -curvature $grassCurl

                        `
                        ;

    setAttr ( $bend[1] + ".ty" ) 0 ;
    setAttr ( $bend[0] + ".envelope" ) $envelopeVal ;

    // select the cone object and delete the history
    select —replace $blades ;
    delete —constructionHistory blades ;

    }
```

We will now just refer to the process of saving, sourcing, and executing a script simply as executing the script. This does not mean you can neglect the sourcing of a script.

ON THE CD

The text for this script is found on the companion CD-ROM as /project_02/v01/ generateGrass.mel.

Executing this new version of the script should produce the same result, but should not cause an error. We can now alter the variable assignments to implement the random command. See Example 6.22.

EXAMPLE 6.22 Adding the rand command to give our variables a new value with each execution.

```
// Declaration of variables
float $grassRadius = `rand 0.02 0.06`;
float $grassHeight = `rand 0.7 1.2`;
float $grassCurl = `rand (-0.25) (-1.25)`;
float $envelopeVal = `rand 0.6 1.0`;
```

Now, with every execution our script, our blade of grass is slightly different. Notice, however, that each blade of grass is slightly below or above the ground plane This is because when we move the cone up, we are still moving it by 0.5. Since our height is no longer necessarily 1.0, we need to adjust this value to be half of the randomly determined height. See Example 6.23.

EXAMPLE 6.23 Bringing our random height into the "flooring" code.

```
setAttr
    ( $blades[0] + ".translateY" )
    ( $grassHeight * 0.5 ) ;
```

In Figure 6.11, we see 10 different executions after this revision, each moved in X to allow for easy comparison.

FIGURE 6.11 Ten random blades of grass.

Although each blade of grass now created with the script is unique, they are all generally the same "type," a short, generic piece of grass. In order for a user to control the look of the grass, we need to add a way to pass data to the script.

We now have to make a choice, in what type of control we want to give the artist working with `generateGrass.mel`. We could allow the user to individually set the values used in the `rand` command, but with three `rand` commands, that would mean passing six numbers every time we execute the command. It would also essentially nullify all the hard work we put in to figuring out various looks for the grass. Instead, we will pass the command a "style" of grass. To do this, we first modify the procedure declaration. See Example 6.24.

EXAMPLE 6.24 Adding a passed value to the procedure.

```
global proc generateGrass ( string $style )
```

If we now `source` the file, we receive a warning from Maya. See Example 6.25.

EXAMPLE 6.25 An example of the warning issued by Maya.

```
// Warning: New procedure definition for
"generateGrass" has a different argument list
and/or return type. //
```

This is, of course, true. If we source the script once more , there is no warning. Anytime we alter the declaration of a procedure, we should source the file twice, to be assured that Maya recognizes the changes. In addition, if we simply execute generateGrass, Maya returns an error. See Example 6.26.

EXAMPLE 6.26 A command must always be passed the correct number of arguments.

```
// Error: Wrong number of arguments on call to
generateGrass
```

We now have to pass `generateGrass` a string whenever we call the command. This string could be anything at this point, since the script does not yet use the passed string in any way. We will now add this functionality using a `switch` statement. See Example 6.27.

EXAMPLE 6.27 Implementing our `$style` variable with a switch command.

```
global proc generateGrass ( string $style )
{
```

```
// Declaration of variables
float $grassRadius = `rand 0.02 0.06`;
float $grassHeight ;
float $grassCurl ;
float $envelopeVal ;

// Change height and bend values to accommodate
// user input.
switch ( $style )
    {
    case "normal":
        {
            $grassHeight = `rand 0.7 1.2`;
            $grassCurl = `rand (-0.25) (-1.25)`;
            $envelopeVal = `rand 0.6 1.0`;
        }
        break;
    }

// Creation of Poly Cone

    . . .
```

We kept the randomization of the radius outside the switch statement because grass is pretty much uniform in its radius, with shorter grass being stockier, and longer grass being very thin, relative to their length.

By using the switch statement, we can quite easily add any number of presets, including putting in specific species of grass, like calling generate-Grass kentuckyBluegrass. For now, we will add only four options. See Example 6.28.

EXAMPLE 6.28 Adding more style options.

```
global proc generateGrass ( string $style )
{
// Declaration of variables
float $grassRadius = `rand 0.02 0.06`;
float $grassHeight ;
float $grassCurl ;
float $envelopeVal ;

// Change height and bend values to accommodate
// user input.
switch ( $style )
    {
    case "short":
        {
            $grassHeight = `rand 0.4 0.8`;
            $grassCurl = `rand 0 (-.1)`;
```

```
                    $envelopeVal = `rand 0.9 1.0`;
            }
        break;
    case "normal":
        {
            $grassHeight = `rand 0.7 1.2`;
            $grassCurl = `rand (-0.25) (-1.0)`;
            $envelopeVal = `rand 0.6 1.0`;
        }
        break;
    case "long":
        {
            $grassHeight = `rand 1 1.6`;
            $grassCurl = `rand (-0.35) (-1.25)`;
            $envelopeVal = `rand 0.5 1.0`;
        }
        break;
    case "very_long":
        {
            $grassHeight = `rand 2 3.5`;
            $grassCurl = `rand (-1) (-1.5)`;
            $envelopeVal = `rand 0.5 0.85`;
        }
        break;
    }

    // Creation of Poly Cone

    . . .
```

It would also be wise to add a `default` setting to the `switch` statement. If a user passes the command an unknown value, it will still work, using what we define as the default settings. After the `very_long` case, we add what is seen in Example 6.29.

EXAMPLE 6.29 Adding a default value.

```
    default:
            {
            warning ( "Type "
                    + $style
                    + " is unknown. Using
                        default settings." ) ;
            $grassHeight = `rand 0.7 1.2`;
            $grassCurl = `rand (-0.25) (-1)`;
            $envelopeVal = `rand 0.6 1.0`;
            }
            break;
```

The text for this script is found on the companion CD-ROM as /project_02/v02/generateGrass.mel.

We've added a `warning` command to the `default` statement to inform the user that the argument used was not valid. If we wanted to instead completely stop the user from using unknown values, we would put an `error` command in the default `case` statement.

We can now create variety of different grasses by executing `generateGrass` and passing it either `short`, `normal`, `long`, or `very_long`. We use the underscore in `very_long` so that it counts as a single string when passed at the command line.

We now have our final script for generating a single blade of grass. See Example 6.30.

EXAMPLE 6.30 The final script to build a single blade of grass.

```
global proc generateGrass ( string $style )
{
// Declaration of variables
float $grassRadius = `rand 0.02 0.06`;
float $grassHeight ;
float $grassCurl ;
float $envelopeVal ;

// Change height and bend values to accommodate
// user input.
switch ( $style )
    {
    case "short":
        {
            $grassHeight = `rand 0.4 0.8`;
            $grassCurl = `rand 0 (-.1)`;
            $envelopeVal = `rand 0.9 1.0`;
        }
        break;
    case "normal":
        {
            $grassHeight = `rand 0.7 1.2`;
            $grassCurl = `rand (-0.25) (-1.0)`;
            $envelopeVal = `rand 0.6 1.0`;
        }
        break;
    case "long":
        {
            $grassHeight = `rand 1 1.6`;
            $grassCurl = `rand (-0.35) (-1.25)`;
            $envelopeVal = `rand 0.5 1.0`;
        }
```

```
            break;
        case "very_long":
            {
                $grassHeight = `rand 2 3.5`;
                $grassCurl = `rand (-1) (-1.5)`;
                $envelopeVal = `rand 0.5 0.85`;
            }
            break;
        default:
                {
                warning ( "Type "
                            + $style
                            + " is unknown. Using
                            default settings.";
                $grassHeight = `rand 0.7 1.2`;
                $grassCurl = `rand (-0.25) (-1)`;
                $envelopeVal = `rand 0.6 1.0`;
                }
                break;

    }

// Creation of Poly Cone
string $blades[] = `polyCone
                        -radius $grassRadius
                        -height $grassHeight
                        -subdivisionsX 3
                        -subdivisionsY 10
                        -subdivisionsZ 0
                        -axis 0 1 0
                        -texture 1
                        -constructionHistory off
                        `
                    ;

// Bring the bottom of the cone to ground level
setAttr ( $blades[0] + ".translateY" ) ( $grassHeight * 0.5 ) ;

// harden the edges of cone
polySoftEdge
    -angle 30
    -constructionHistory off
    ( $blades[0] + ".e[0:59]" )
    ;

// go back to object mode
// and ensure the cone is selected
changeSelectMode -object ;
select -replace $blades ;
```

```
// make the blade thin;
setAttr ( $blades[0] + ".scaleX" ) 0.25 ;

// add the bend deformer, capture the name to move it
string $bend[] = `nonLinear
                    -type bend
                    -lowBound 0
                    -highBound 2
                    -curvature $grassCurl
                    `

                    ;

setAttr ( $bend[1] + ".ty" ) 0 ;
setAttr ( $bend[0] + ".envelope" ) $envelopeVal ;

// select the cone object and delete the history
select -replace $blades ;
delete -constructionHistory blades ;

}
```

ON THE CD

The text for this script is found on the companion CD-ROM as /project_02/v03/gen-erateGrass.mel.

The next step to creating our grass is to add functionality to generate large volumes of grass automatically. While we could add this to the generateGrass procedure, this situation is perfect for splitting into multiple procedures.

Modify the current generateGrass procedure to be a non-global procedure called generateBlade. See Example 6.31.

EXAMPLE 6.31 Turning our global procedure into a local procedure.

```
proc generateBlade ( string $style )
```

After the last curly brace of our procedure, add a new global procedure called generateGrass. See Example 6.32.

EXAMPLE 6.32 Adding a global procedure that calls the local procedure.

```
global proc generateGrass ( string $style )
{
generateBlade $style ;
}
```

By adding the `generateBlade` command to our script, the functionality remains the same. To create multiple copies of our grass, we enclose the command in a `for` loop. See Example 6.33.

EXAMPLE 6.33 Adding a simple loop to create 10 blades of grass.

```
global proc generateGrass ( string $style )
{
// for loop to create multiple blades of grass
for ( $i = 0; $i < 10; $i++ )
    generateBlade $style ;
}
```

Executing the script will create 10 blades of grass. Obviously, this is a number we will want to put under user control, by adding in an int variable to be passed to `generateGrass`. We separate the declaration of the variables with commas, but we do not separate the arguments passed to `generateGrass` with anything other than spaces. See Example 6.34.

EXAMPLE 6.34 Passing a value from the command line to the loop.

```
global proc generateGrass ( string $style, int $density )
{
// for loop to create multiple blades of grass
for ( $i = 0; $i < $density; $i++ )
    generateBlade $style ;
}
```

The amount of grass that can be created and the time it takes to do so is highly dependent on the hardware running Maya. Use lower amounts of grass for testing purposes.

ON THE CD

The text for this script is found on the companion CD-ROM as /project_02/v04/ generateGrass.mel.

We now have the capability of creating any number of blades of grass. At this point, however, each blade is at the origin. We will want to move the blades to a new, random location.

To this point, whenever we wanted to address anything about a node we created in a script, we captured the name of the node on creation by enclosing the command in single forward quotes. However, our `generateBlade` command does not `return` any data upon execution. We need to rectify that before proceeding.

The first step to add `return` data to a procedure is to decide what type this data should be. A procedure can `return` any type of data that can be stored as

a variable. Therefore, in our grass procedure, we want to `return` the name of the newly created blade of grass, a string. We alter the declaration of the `generateBlade` procedure to return a string. See Example 6.35.

EXAMPLE 6.35 Adding a return value to the procedure.

```
proc string generateBlade ( string $style )
```

We also need to add the command to actually `return` the data. At the very end of the script, just before the closing curly brace, add the command to `return` the variable holding the name of the geometry's transform node. See Example 6.36.

EXAMPLE 6.36 The return statement must be included in any procedure with a return value in its declaration.

```
   . . .

return $blades[0];
}
```

Now, when we call the procedure `generateBlade` from within `generateGrass`, we can capture it in a string variable. We use the iteration variable of the `for` loop, the int `$i` to assign the returned string to ever-increasing index values of the array. At the end of the script, we select the created geometry, partially because we should always select newly created geometry, but also to check to make sure we are capturing the data returned by `generateBlade`. See Example 6.37.

EXAMPLE 6.37 Capturing our own return value to an array variable.

```
global proc generateGrass
    ( string $style, int $density )
{
// Declare Variables
string $createdGrass[];

// for loop to create multiple blades of grass
for ( $i = 0; $i < $density; $i++ )
    $createdGrass[$i] = `generateBlade $style` ;

// Select the created geometry
select —replace $createdGrass;

}
```

The text for this script is found on the companion CD-ROM as /project_02/v05/ generateGrass.mel.

Executing the command now should result in the requested number of grass blades to be created, and left selected when the script is finished running.

Now, we can again use the `rand` command to produce random translate attributes for our grass. Before doing so, however, we need to modify the `gen-erateBlade` command to freeze the transform values of the generated grass. The MEL command to do this, as well as to reset the pivot point to the origin, is `makeIdentity`. In the `generateBlade` procedure, after the scale and translate attributes are set, use `makeIdentity` twice; the first freezes the transforms, and the second resets the pivot to the origin. See Example 6.38.

EXAMPLE 6.38 Cleaning the transformations of our created geometry.

```
// Reset transformations and pivot point
makeIdentity
    -apply true
    -translate true
    -rotate true
    -scale true
    $blades[0]
    ;
makeIdentity
    -apply false
    -translate true
    -rotate true
    -scale true
    $blades[0]
    ;
```

Once this is done, we are free to use the `rand` command to generate a new position for each new blade of grass. We turn our `for` statement into a command group, and place the `setAttr` commands within. See Example 6.39.

EXAMPLE 6.39 Randomly positioning the grass.

```
global proc generateGrass
    ( string $style, int $density )
{
// Declare Variables
string $createdGrass[];

// for loop to create multiple blades of grass
for ( $i = 0; $i < $density; $i++ )
    {
    $createdGrass[$i] = `generateBlade $style` ;
```

```
    // Generate Random Values for translation
    float $randomX = `rand -5 5`;
    float $randomZ = `rand -5 5`;

    // Assign the random values to the translate values
    setAttr
        ( $createdGrass[$i] + ".translateX" ) $randomX;
    setAttr
        ( $createdGrass[$i] + ".translateZ" ) $randomZ;
    }

// Select the created geometry
select -replace $createdGrass;

}
```

ON THE CD

The text for this script is found on the companion CD-ROM as /project_02/v06/ generateGrass.mel.

Executing the command at this point, to generate 500 blades of grass produces a result similar to Figure 6.12.

FIGURE 6.12 Five hundred blades of grass.

Although we could nest the `rand` commands directly within the `setAttr` command, assigning them to a variable keeps the clutter of our `setAttr` command down. We have hard coded the dimensions to generate the grass within the script. We will next turn this over to user control.

Although it adds a large amount of complexity to the command, we must add four new float variables to the procedure declaration, and use those variables in the `rand` commands generating the translate X and translate Z values. See Example 6.40.

EXAMPLE 6.40 Adding the variables to allow the user to pass values for the positioning of the grass.

```
global proc generateGrass ( string $style,
                                    int $density,
                                    float $minX,
                                    float $maxX,
                                    float $minZ,
                                    float $maxZ )
   {

   . . .

      // Generate Random Values for translation
      float $randomX = `rand $minX $maxX`;
      float $randomZ = `rand $minZ $maxZ`;

   . . .
```

We can now generate any number of grass blades, in any dimensions. The problem that now becomes apparent is we have given perhaps too much control to the user. If we create 1000 pieces of short grass between –1 and 1 in X and Z, we get a result similar to Figure 6.13.

However, if we now create 1000 pieces of short grass between –10 and 10 in X and Z, our result is similar to Figure 6.14, where the grass is much sparser.

ON THE CD

The text for this script is found on the companion CD-ROM as /project_02/v07/generateGrass.mel.

What we now need to do is generate a number that will produce the same density of grass if we create a 1x1 square patch, or a 20x30 patch.

Our first step is to determine the area we are trying to cover with grass. The area of a rectangle is defined by its width x height, as seen in Figure 6.15.

To determine the area we are trying to fill with grass within our script, we subtract the minimum values from the maximum values, and then multiply those results together. See Example 6.41.

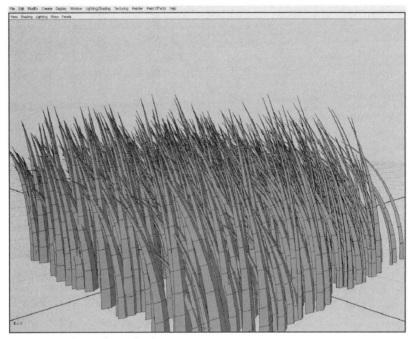

FIGURE 6.13 Densely packed grass.

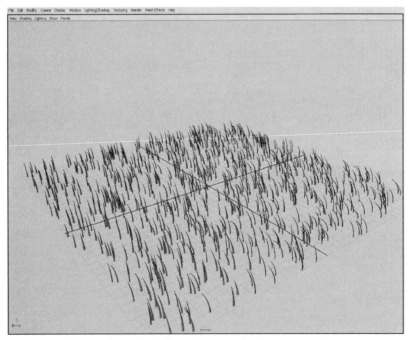

FIGURE 6.14 Generating 1000 pieces in a much sparser area.

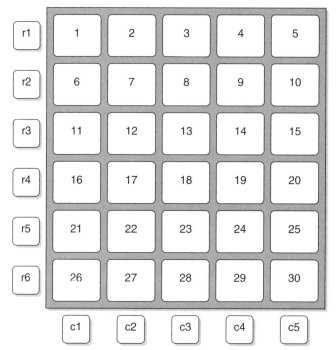

FIGURE 6.15 Determining area.

EXAMPLE 6.41 Determining the area to be filled with grass.

```
float $area = ( ($maxX - $minx) * ($maxZ - $minZ) ) ;
```

We can then multiply that number by our $density variable to relate the user input to the number of blades of grass. See Example 6.42.

EXAMPLE 6.42 Calculating the amount to create.

```
int $amountToCreate = ( $area * density ) ;
```

We can then optimize this to one variable assignment, eliminating the $area variable. See Example 6.43.

EXAMPLE 6.43 Combining the two equations into one.

```
int $amountToCreate = ((( $maxX-$minx )
                    * ( $maxZ-$minZ ))
                    * density ) ;
```

At this stage, the script creates enough grass to put within each 1x1 square unit space the number passed to the script in the $density variable. This does not mean that each square unit will have an equal amount of grass. Because the results of the rand command truly is random, while the placement is generally even dispersed, there might be small patches that are a little more dense or a little more sparse. This is a very organic quality, and one for which we should be thankful. Creating organic material in the computer is never easy, and these irregularities help dispel that "computer" look. In Figure 6.16, we see the results of executing the latest version of our script with the following settings (see Example 6.44):

Density: 100
Minimum X; –10
Maximum X: 10
Minimum Z: –10
Maximum Z: 10
Style: Normal

EXAMPLE 6.44 The command to create the grass.

```
generateGrass normal 100 −10 10 −10 10;
```

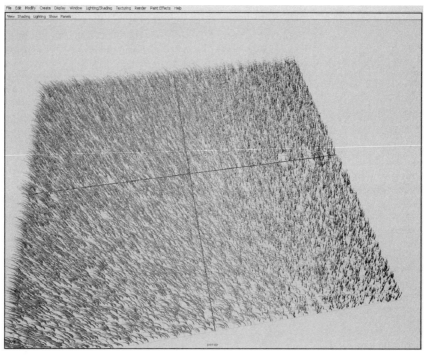

FIGURE 6.16 40,000 pieces of grass.

We have now produced 40,000 pieces of grass.

ON THE CD *The text for this script is found on the companion CD-ROM as /project_02/v08/ generateGrass.mel.*

While this version of the script produces some decent results, and could be considered a pre-Alpha version, we notice a series of problems, some associated with design, and some with implementation. Our design called for user definable detail; although this can be defined through grass types, it can also be added as a user variable. Another issue when looking at our grass is that all the blades are bending the same direction. Unless our scene is taking place in a wind tunnel, it is doubtful that this would occur. Moreover, because we are creating an enormous number of nodes, scenes created with our tool are very unwieldy. Finally, while we have given the user a great amount of control over the density of the created grass, there is still too much ambiguity left to the user.

In the implementation of software, certain terms are often used to refer to various stages of development. The more complex and complicated the tool, the more important these terms become.

Pre-Alpha: *Functional software which, while it might not support every feature to be found in the finished product, will have the ability to have this functionality added without destroying previous work.*

Alpha: *All features in and supported, but some functionality will need refinement.*

Beta: *All aspects of the software complete, including any UI, but bugs might be present and should be dealt with before release. Often distributed to select users for testing.*

Release Candidate: *Usually only used in situations where a tool will be distributed to a team or to the public. All known major bugs eliminated, but possible issues might come up when put into full production use.*

Release: *The finished software.*

The first problem we will address is that of all the grass facing the same direction. This is easily addressed by adding a new rand statement to our script, and assigning that value to the Y rotation of each blade. We add this to the script in the same section as the random translation values. See Example 6.45.

EXAMPLE 6.45 Randomly rotating the grass.

```
// Generate Random Values for translation
float $randomX = `rand -5 5`;
float $randomZ = `rand -5 5`;
float $randomRotation = `rand 0 360`;

// Assign the random values to the translate values
```

```
setAttr
    ( $createdGrass[$i] + ".translateX" ) $randomX;
setAttr
    ( $createdGrass[$i] + ".translateZ" ) $randomZ;
setAttr
    ( $createdGrass[$i] + ".rotateY" )
    $randomRotation;
```

Although we could put in a check to generate and assign a rotation value based on whether the user is working in radians or degrees, it is largely irrelevant, because the generated number is random.

ON THE CD

The text for this script is found on the companion CD-ROM as /project_02/v09/generateGrass.mel.

Now, the generated grass appears to be much more realistic and organic, as can be seen in Figure 6.17.

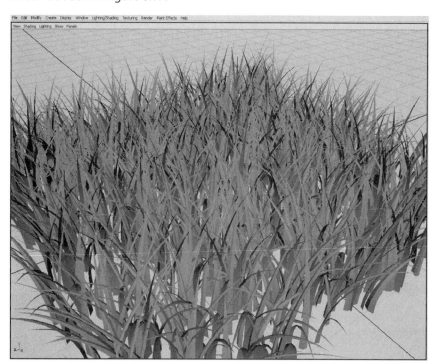

FIGURE 6.17 Organic-looking grass.

While it would be a simple matter to add the capability for an end user to control the rotation amount, there is no reason to do so. Unless the grass is being created for a very specific groomed location, such as a sports field, the grass rotation should be completely random. In the rare instances that

the grass does need to face in a specific direction, those changes can easily be put directly into the script. This is one of the major advantages of a script over a compiled plug-in; the quick changes that can be made, both during creation of a tool, as well as by an end user familiar with MEL.

The next issue we will tackle is that of the distribution of the grass. While the density argument is functional now, we can tweak its behavior so that the user does not have to guess what a good number of objects to create is. We will do this by converting the `$density` variable into a percentage value.

Before we make any changes to our code, we should do some experimentation within Maya using our existing code. Create a small patch of grass with a variety of density settings. Our goal is to find the number that achieves the maximum density that will reasonably be requested by a user. The important thing is to not go overboard with our density values. In Figure 6.18, we see a patch of grass created with the settings:

Density: 100
Minimum X; –1
Maximum X: 1
Minimum Z: –1
Maximum Z: 1
Style: Normal

See Example 6.46.

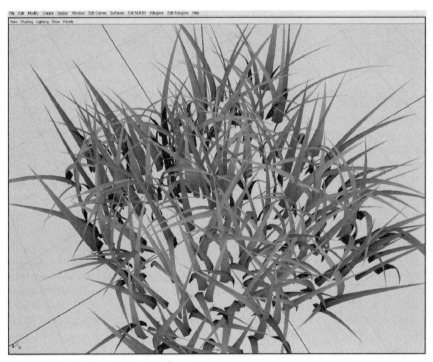

FIGURE 6.18 A density setting of 100.

EXAMPLE 6.46 The command used to create the grass seen in Figure 6.18.

```
generateGrass normal 100 −1 1 −1 1;
```

The amount of grass is much too light, so let's try a significantly larger number a blades, seen in Figure 6.19, which was created with the following settings :

Density: 1500
Minimum X; −1
Maximum X: 1
Minimum Z: −1
Maximum Z: 1
Style: Normal

See Example 6.47.

EXAMPLE 6.47 The command that gives the results in Figure 6.19.

```
generateGrass normal 1500 −1 1 −1 1;
```

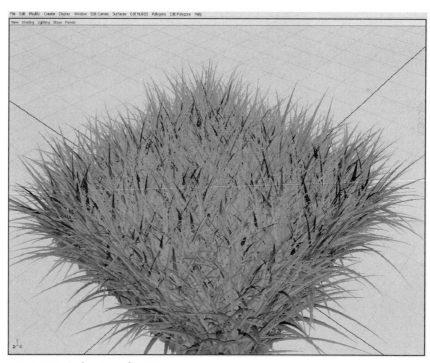

FIGURE 6.19 A density of 1500.

This is obviously much too dense to look real. There is a simple but laborious task ahead of us: we must go through multiple iterations of the tool, each time attempting to narrow in on a number for the density argument that works well. After some experimentation, we discover that a density value of 325 seems to work well, as seen in Figure 6.20. While a somewhat arbitrary choice, occasionally in the design of tools, choices have to be made by the software engineer.

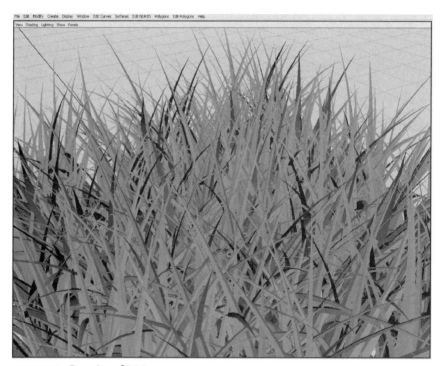

FIGURE 6.20 Density of 325.

To bring this number, our new maximum density value, into the equation determining the number of blades of grass to create in the `for` loop, we will now use the density value as a percentage value, instead of an explicit number. We will divide our passed density argument by 100, and multiply 325 by the result. See Example 6.48.

EXAMPLE 6.48 Implementing our new density equation.

```
int $amountToCreate = ((($maxX-$minx)
                    * ( $maxZ-$minZ ))
                    * (( $density/100 )
                    * 325));
```

Now, if we pass the script a density value of 100, it creates 325 blades of grass in each 1x1 square. If we pass a density value of 50, no blades will be produced, which is curious.

Whenever MEL computes a floating-point number, if all the contributing factors are integers, the result, while stored as a floating point, is an integer value. For example, when we divide 50 by 100, we get .5, but since both 100 and 50 are integers, this result is converted to 0. To rectify this, we assure that at least one number involved in the equation is a floating point. See Example 6.49.

EXAMPLE 6.49 Whenever we want to calculate a floating point and use an explicit value in the equation, we must use it as a floating point rather than an integer.

```
int $amountToCreate = ((( $maxX - $minx )
                      * ( $maxZ - $minZ ))
                      * (( $density/100.0 )
                      * 325 ));
```

 The text for this script is found on the companion CD-ROM as /project_02/v10/generateGrass.mel.

Now, we can create grass of any size and be assured that the density of the grass created is irrelevant to the dimensions called. We can confirm this by making two separate calls to generate grass. The first we will create a 2x2 patch, with the density set to 50%. See Example 6.50.

EXAMPLE 6.50 Issuing our command with 50% density.

```
generateGrass normal 50 −1 1 −1 1;
```

Giving us the result in Figure 6.21, which has 650 pieces of grass, or 162.5 per 1x1 square.

Then, in a new file, we make a call to create a 6x6 patch of grass, again with the density set to 50%. See Example 6.51.

EXAMPLE 6.51 Making a larger patch of grass also at 50%.

```
generateGrass normal 50 −3 3 −3 3;
```

Giving us the results in Figure 6.22, which produces 5850 pieces of grass, again creating 162.5 blades per 1x1 square.

The best aspect of using this method is it still does not take away the ability to have more than 325 pieces of grass per square unit. A user can overcrank the density value, creating 150%, 200%, or even 1000% density if he chooses.

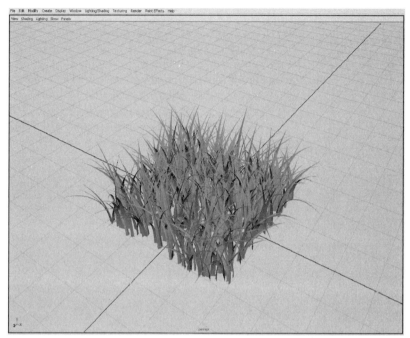

FIGURE 6.21 A 1x1 patch of grass with our new density setting at 50%.

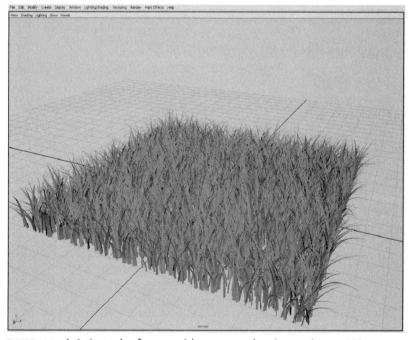

FIGURE 6.22 A 6x6 patch of grass with our new density setting at 50%.

The only limitation is the capabilities of the hardware on which an artist is working.

The next issue to be addressed is that of controlling the level of detail for the blades of grass. Leaving out the detail call was not so much an oversight as it was a specific choice to serve as an example of how a script can easily evolve during implementation. We had put the detail feature in the design, but we could just as easily added a feature that became evident during the programming of the tool.

There are multiple ways to deal with the detail problem:

- Explicit declaration of detail.
- Level of Detail Groups, similar to how game developers create levels of detail.
- Leaving the `polyCone` node intact and adjusting the Y subdivisions on-the-fly.

While each of the three methods has its advantages, for now we will keep things simple and just use the first method, and explicitly declare the detail of our created grass. The other two solutions are viable, but require a more advanced level of programming than we currently possess.

We could simply ask the user to pass a number to the tool to use as a subdivision in the `polyCone`, but we raise all the same issues we had with the density argument. Leaving that much control to the artist is both confusing and unnecessary. Instead, we will pass a value of "low," "medium," or "high."

The first step is to add the argument to pass the user's level of detail choice to the tool. We will have to add the argument to both the `generateGrass` global procedure and the `generateBlade` local procedure. We will place the argument call between the style and density arguments of the `generateGrass` procedure. See Example 6.52.

EXAMPLE 6.52 Adding the detail argument.

```
global proc generateGrass ( string $style,
                            string $detail,
                            int $density,
                            float $minX,
                            float $maxX,
                            float $minZ,
                            float $maxZ )
```

The second step is the call to `generateBlade` function. See Example 6.53.

EXAMPLE 6.53 Adding the same argument to the grass blade creation procedure.

```
proc generateBlade ( string $style, string $detail )
```

The only change we have to make to the generateGrass procedure is to pass the detail call to the generateBlade function. See Example 6.54.

EXAMPLE 6.54 Adding the argument call to our command in the loop.

. . .

```
$createdGrass[$i] = `generateBlade $style $detail` ;
```

. . .

The changes that we need to the generateBlade function are much more extensive. We need to replace the subdivisionsY flag value with a variable, making sure to declare it at the beginning of the file. We then nest a switch statement inside each of our presets for grass style, so that we can set appropriate detail for each. Obviously, even the high-detailed short grass does not need to be as detailed as the medium-detailed long grass. Again, use of the switch statement allows a user to add possible arguments, such as an ultra-high detail level, with little trouble. See Example 6.55.

EXAMPLE 6.55 Implementation of our detail argument in the creation step.

```
proc generateBlade ( string $style, string $detail )
{
// Declaration of variables
float $grassRadius = `rand 0.02 0.06`;
float $grassHeight ;
float $grassCurl ;
float $envelopeVal ;
float $grassDetail ;

// Change height and bend values to accommodate
// user input.
switch ( $style )
    {
    case "short":
        {
            $grassHeight = `rand 0.4 0.8`;
            $grassCurl = `rand 0 (-.1)`;
            $envelopeVal = `rand 0.9 1.0`;
            switch ( $detail )
                case "low" :
                    $grassDetail = 1;
                break;
                case "medium" :
                    $grassDetail = 3;
```

```
                break;
            case "high" :
                $grassDetail = 5;
            break;
    }
    break;
case "normal":
    {
        $grassHeight = `rand 0.7 1.2`;
        $grassCurl = `rand (-0.25) (-1.0)`;
        $envelopeVal = `rand 0.6 1.0`;
        switch ( $detail )
            case "low" :
                $grassDetail = 3;
            break;
            case "medium" :
                $grassDetail = 5;
            break;
            case "high" :
                $grassDetail = 10;
            break;
    }
    break;
case "long":
    {
        $grassHeight = `rand 1 1.6`;
        $grassCurl = `rand (-0.35) (-1.25)`;
        $envelopeVal = `rand 0.5 1.0`;
        switch ( $detail )
            case "low" :
                $grassDetail = 4;
            break;
            case "medium" :
                $grassDetail = 7;
            break;
            case "high" :
                $grassDetail = 11;
            break;
    }
    break;
case "very_long":
    {
        $grassHeight = `rand 2 3.5`;
        $grassCurl = `rand (-1) (-1.5)`;
        $envelopeVal = `rand 0.5 0.85`;
        switch ( $detail )
            case "low" :
                $grassDetail = 5;
            break;
```

```
                            case "medium" :
                                $grassDetail = 8;
                            break;
                            case "high" :
                                $grassDetail = 13;
                            break;
                    }
                break;
            default:
                {
                warning ( "Type "
                            + $style
                            + " is unknown. Using
                                default settings.";
                $grassHeight = `rand 0.7 1.2`;
                $grassCurl = `rand (-0.25) (-1)`;
                $envelopeVal = `rand 0.6 1.0`;
                switch ( $detail )
                    case "low" :
                            $grassDetail = 3;
                        break;
                        case "medium" :
                            $grassDetail = 6;
                        break;
                        case "high" :
                            $grassDetail = 10;
                        break;
                }
                break;
        }

    // Creation of Poly Cone
    string $blades[] = `polyCone
                            -radius $grassRadius
                            -height $grassHeight
                            -subdivisionsX 3
                            -subdivisionsY $grassDetail
                            -subdivisionsZ 0
                            -axis 0 1 0
                            -texture 1
                            -constructionHistory off
                        `
                    ;
```

ON THE CD *The text for this script is found on the companion CD-ROM as /project_02/v11/ generateGrass.mel.*

Now, when we execute the script, we can define how much detail each blade has. This, combined with our revised density control, allows the user to

construct a scene optimized for rendering speed, but also with a consistent look to the amount of grass. While the user has to create the grass in separate passes to achieve separate levels of detail, this is a minor hassle at best, and many artists will like the control over the "look," as well as the ability to optimize rendering speed.

The final task we face is to overcome a limitation of Maya itself. You might notice, even when creating relatively small patches of grass, that Maya experiences a rather intensive slowdown and can become quite unstable. This is due to Maya's handling of scenes with large numbers of nodes. We are asking Maya to keep track of an obscenely large number of nodes at this point, so it is somewhat excusable, but should be rectified. We do this by again implementing the polyUnite command. However, rather than waiting until the end of the for loop, we will place a conditional if statement within the for loop to combine the objects in 3000 object groups. Because we will be creating a new object, we will have to reset the array holding the names of our created objects. Since we are currently using the for loop iterator $i to assign the name of the created object to the proper index, we will instead nest a size command within the index value. Since the size of an array is always one number larger than the last index value, using the size command in this way allows you to assign values to an array based on the size of the array, regardless of any outside factors. After the polyUnite command we clear the array, and assign our newly united object to the first index of the array so that it will then be combined in our next combine command. The use of the flushUndo command is to free up memory, which can become quite full and cause Maya to crash. See Example 6.56.

EXAMPLE 6.56 Attempting to optimize memory usage.

```
// for loop to create multiple blades of grass
for ( $i = 0; $i < $density; $i++ )
    {
    $createdGrass[`size $createdGrass`] =
        `generateBlade $style $detail` ;

    // Generate Random Values for translation
    float $randomX = `rand -5 5`;
    float $randomZ = `rand -5 5`;

    // Assign the random values to the translate values
    setAttr
        ( $createdGrass[$i] + ".translateX" ) $randomX;
    setAttr
        ( $createdGrass[$i] + ".translateZ" ) $randomZ;

    if ( `size $createdGrass` > 3000 )
        {
        string $united[] = `polyUnite
```

```
                                            -constuctionHistory off
                                            $createdGrass` ;
                clearArray $createdGrass;
                $createdGrass = $united;
                flushUndo;
                }
            }

        // Final Combine
        polyUnite
            -constuctionHistory off
            $createdGrass` ;

        flushUndo;
```

The text for this script is found on the companion CD-ROM as /project_02/
finished/v01/generateGrass.mel.

ON THE CD

The final `polyUnite` command, which is outside the `for` loop, combines any blades created that did not meet the `if` condition, such as if less than 3000 total objects are requested, or if the number created is not evenly divisible by 3000. Again, we use `flushUndo` to clear memory.

At this point, our script can be considered complete. The final results can be seen in Figure 6.23. While there is more that could be done, a very wise man once said that creative work is never finished, just abandoned. Because our tool now satisfies all the requirements of our design, we can call the grass generator done.

Project Conclusion and Review

This project introduced us to real-world uses of conditional statements, the use of loops, and using separate procedures to aid in the programming process. We also learned how to overcome problems that might arise from the limitations in Maya. While there are third-party commercial solutions that can produce grass-like structures, we can use MEL to produce similar effects without adding to our production costs.

Project Script Review

```
proc string generateBlade ( string $style, string $detail )
    {
    // Declaration of variables
    float $grassRadius = `rand 0.02 0.06`;
    float $grassHeight ;
    float $grassCurl ;
    float $envelopeVal ;
    float $grassDetail ;
```

FIGURE 6.23 The results.

```
// Change height and bend values to accommodate
// user input.
switch ( $style )
    {
    case "short":
        {
            $grassHeight = `rand 0.4 0.8`;
            $grassCurl = `rand 0 (-.1)`;
            $envelopeVal = `rand 0.9 1.0`;
            switch ( $detail )
                case "low" :
                    $grassDetail = 1;
                break;
                case "medium" :
                    $grassDetail = 3;
                break;
                case "high" :
                    $grassDetail = 5;
                break;
        }
        break;
    case "normal":
        {
```

```
                        $grassHeight = `rand 0.7 1.2`;
                        $grassCurl = `rand (-0.25) (-1.0)`;
                        $envelopeVal = `rand 0.6 1.0`;
                        switch ( $detail )
                            case "low" :
                                $grassDetail = 3;
                            break;
                            case "medium" :
                                $grassDetail = 5;
                            break;
                            case "high" :
                                $grassDetail = 10;
                            break;
                    }
                break;
            case "long":
                {
                    $grassHeight = `rand 1 1.6`;
                    $grassCurl = `rand (-0.35) (-1.25)`;
                    $envelopeVal = `rand 0.5 1.0`;
                    switch ( $detail )
                        case "low" :
                            $grassDetail = 4;
                        break;
                        case "medium" :
                            $grassDetail = 7;
                        break;
                        case "high" :
                            $grassDetail = 11;
                        break;
                }
            break;
            case "very_long":
                {
                    $grassHeight = `rand 2 3.5`;
                    $grassCurl = `rand (-1) (-1.5)`;
                    $envelopeVal = `rand 0.5 0.85`;
                    switch ( $detail )
                        case "low" :
                            $grassDetail = 5;
                        break;
                        case "medium" :
                            $grassDetail = 8;
                        break;
                        case "high" :
                            $grassDetail = 13;
                        break;
                }
            break;
```

```
            default:
                {
                warning ( "Type "
                            + $style
                            + " is unknown. Using
                                default settings.";
                $grassHeight = `rand 0.7 1.2`;
                $grassCurl = `rand (-0.25) (-1)`;
                $envelopeVal = `rand 0.6 1.0`;
                switch ( $detail )
                    case "low" :
                        $grassDetail = 3;
                    break;
                    case "medium" :
                        $grassDetail = 6;
                    break;
                    case "high" :
                        $grassDetail = 10;
                    break;
                }
                break;
    }

// Creation of Poly Cone
string $blades[] = `polyCone
                        -radius $grassRadius
                        -height $grassHeight
                        -subdivisionsX 3
                        -subdivisionsY $grassDetail
                        -subdivisionsZ 0
                        -axis 0 1 0
                        -texture 1
                        -constructionHistory off
                        `
                    ;

// Bring the bottom of the cone to ground level
setAttr
    ( $blades[0] + ".translateY" )
    ( $grassHeight * 0.5 ) ;

// harden the edges of cone
polySoftEdge
    -angle 1
    -constructionHistory off
    ( $blades[0] + ".e[0:59]" )
    ;
```

```
// go back to object mode
// and ensure the cone is selected
changeSelectMode —object ;
select —replace $blades ;

// make the blade thin;
setAttr ( $blades[0] + ".scaleX" ) 0.25 ;

// Reset transformations and pivot point
makeIdentity
    -apply true
    -translate true
    -rotate true
    -scale true
    $blades[0]
    ;
makeIdentity
    -apply false
    -translate true
    -rotate true
    -scale true
    $blades[0]
    ;

// add the bend deformer, capture the name to move it
string $bend[] = `nonLinear
                    -type bend
                    -lowBound 0
                    -highBound 2
                    -curvature $grassCurl
                    `
                    ;

setAttr ( $bend[1] + ".ty" ) 0 ;
setAttr ( $bend[0] + ".envelope" ) $envelopeVal ;

// select the cone object and delete the history
select —replace $blades ;
delete —constructionHistory $blades ;

return $blades[0];
}

global proc generateGrass ( string $style,
                            string $detail,
                            int $density,
                            float $minX,
```

```
                                float $maxX,
                                float $minZ,
                                float $maxZ )
{
// Declare Variables
string $createdGrass[];

int $amountToCreate = ( ( ( $maxX-$minx )
                        * ( $maxZ-$minZ ) )
                        * ( ( $density / 100.0 )
                        * 325 ) ) ;

// for loop to create multiple blades of grass
for ( $i = 0; $i < $amountToCreate; $i++ )
    {
    $createdGrass[$i] = `generateBlade $style $detail`;

    // Generate Random Values for translation
    float $randomX = `rand -5 5`;
    float $randomZ = `rand -5 5`;
    float $randomRotation = `rand 0 360`;

    // Assign the random values to the translate values
    setAttr
        ( $createdGrass[$i] + ".translateX" ) $randomX;
    setAttr
        ( $createdGrass[$i] + ".translateZ" ) $randomZ;
    setAttr
        ( $createdGrass[$i] + ".rotateY" )
        $randomRotation;

    if ( `size $createdGrass` > 3000 )
        {
        string $united[] = `polyUnite
                            -constuctionHistory off
                            $createdGrass` ;
        clearArray $createdGrass;
        $createdGrass = $united;
        flushUndo;
        }
    }

// Final Combine
polyUnite
    -constuctionHistory off
    $createdGrass` ;

flushUndo;
}
```

PROJECT

6.3: THE GEODESIC SPHERE

Project Overview

In Project 6.1, we built an icosahedron. The icosahedron, in and of itself, can be useful. It is a stable structure for use in dynamic simulations and is simply an interesting shape. Much more interesting is the fact that the icosahedron is the basis for one of the most interesting geometric constructions—the geodesic sphere.

The geodesic sphere is made up of triangles, and only triangles. The very nature of its structure allows an artist to create a rounder sphere with fewer polygons, as well as having a profile that is cleaner compared to the regular polygonal sphere. Geodesic spheres are defined by two values, their radius and their iteration. Figure 6.24 shows a geodesic sphere of iteration 0, iteration 2, and iteration 4. Each iteration contains four times as many triangles as the previous level.

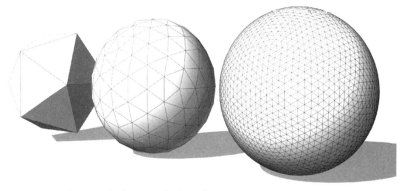

FIGURE 6.24 Our goal, the geodesic sphere.

In addition, this project will introduce us to dealing with geometry components in more detail than in the grass generator, some basic vector math, and will show us how we can expand and build upon previous scripts we create.

Definition and Design

One of the popular ways to build a geodesic sphere is to derive it from one of the three triangle-based Regular Polyhedra, whether the tetrahedron, the octahedron, or the icosahedron. Although we will only be working with an icosahedron, the methodology is the same, and those interested can explore expanding their skill set by trying to build spheres based on any of the three.

Geodesic spheres are built by bisecting the edges of each triangular face, connecting those new points into a triangle, and moving the new vertices out to the radius of the sphere. This process is visualized in Figure 6.25.

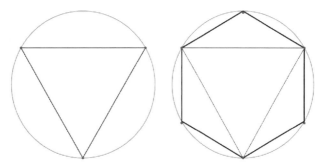

FIGURE 6.25 Bisecting edges to produce a circle.

We can then build a flowchart of the complete tool, as seen in Flowchart 6.4.

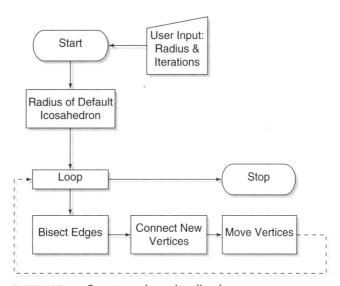

FLOWCHART 6.4 Our procedure visualized.

As you can see, we will again be passing data to the script when we execute it; in this case, both the radius and the number of iterations we want to create.

Research and Development

The majority of our research was actually done during the original construction of our icosahedron. Now, we need only investigate how we will bisect the

edges of our geometry. The easiest way is to use the command `polySubdivideEdge`. We then have to triangulate the faces, again a simple matter of evaluating the `polyTriangulate` command.

Our main challenge will be using one set of commands in a loop to add detail regardless of what level of division our geodesic sphere is currently set to. We will have to evaluate the number of faces in the sphere with each iteration and dynamically build a command based on what we find.

Our final goal is to move our vertices, both the original 12 vertices in the icosahedron and any vertices created during the subdivision of the edges when we increase the detail of our geodesic sphere. We do this with some simple vector math.

In Figure 6.26, we see a circle represented by five vertices. We will say it has an arbitrary radius of 1, as seen by the inscribed circle.

FIGURE 6.26 A circle defined by five vertices.

FIGURE 6.27 The circle defined by bisecting the edges of our five-sided circle.

In Figure 6.27, we see edges of that pentagon bisected, producing five new vertices, each having a radius of approximately 0.81.

To bring this out to our radius of 1.0, we do a scalar multiply on the vector values of each vertex, multiplying it by approximately 1.25 as seen in Figure 6.28.

We will do this same procedure to each edge of our sphere, producing a geodesic sphere. It is a common misconception that all the triangles in a geodesic sphere are equilateral to each other. This is simply impossible, as we learned when we discussed the Regular Polyhedra earlier that the icosahedron is the most complex shape that can be constructed from equilateral triangles.

Implementation

Our first goal will be to implement the radius flag into our icosahedron. We take our finished `buildIcosahedron` script, and save it as `buildGeosphere`, with arguments for both radius and iterations. See Example 6.57.

FIGURE 6.28 The circle is now more defined.

EXAMPLE 6.57 Declaration of our procedure.

```
global proc buildGeosphere
    ( float $radius, int $iterations )
{

. . .
```

To bring the functionality of the radius argument into our script, we first need to determine the radius of the icosahedron as created in our present script. We do this by finding the magnitude of the vector defined by any of the vertices of the icosahedron. A trick when working in MEL to find the magnitude of a vector is to simply assign the vector value to a float variable. MEL automatically assigns the float a value equal to the magnitude of the vector. Following the declaration and initial assignment of our vertices, we add what is shown in Example 6.58.

EXAMPLE 6.58 Using variable conversion to determine the magnitude of a vector.

```
// To determine the vertex positions
// at the user radius
float $currRadius = $vert_01;
```

The radius of the default icosahedron is approximately 1.18 units. We could hard code the value into the script to avoid this small computation, but the value held in the variable is more precise than we could assign by hand, and the computational cost is insignificant. For this reason, we often will assign many standard values with a mathematical evaluation rather than a explicit declaration.

To determine the positions of our vertices at our target radius, we need to multiply each of the vectors defined by their present position by a scalar value. To find the value by which we need to multiply each vector, we divide the target radius by the current radius. See Example 6.59.

EXAMPLE 6.59 Determining how much our target sphere differs from the original.

```
float $scalar = ( $radius / $currRadius );
```

We could unitize the vector first, but this is an unnecessary step for such a simple calculation. We now multiply the scalar by each vector, reassigning the variable holding that vector the new value. See Example 6.60.

EXAMPLE 6.60 Determining the new vertex positions.

```
$vert_01 = ( $vert_01 * $scalar );
$vert_02 = ( $vert_02 * $scalar );
$vert_03 = ( $vert_03 * $scalar );
$vert_04 = ( $vert_04 * $scalar );
$vert_05 = ( $vert_05 * $scalar );
$vert_06 = ( $vert_06 * $scalar );
$vert_07 = ( $vert_07 * $scalar );
$vert_08 = ( $vert_08 * $scalar );
$vert_09 = ( $vert_09 * $scalar );
$vert_10 = ( $vert_10 * $scalar );
$vert_11 = ( $vert_11 * $scalar );
$vert_12 = ( $vert_12 * $scalar );
```

ON THE CD

The text for this script is found on the companion CD-ROM as /project_03/ v01/buildGeosphere.mel

Essentially, we are scaling the icosahedron at the vertex level. If we now run the code, we can create icosahedrons of any size.

Next, we will tackle the more complicated process of subdividing the icosahedron into the geodesic sphere. We know we want to use our `$iterations` variable in the evaluation of whatever operations we want to do on our icosahedron, so we will first construct the conditional statements that will control the executions of these operations.

We will want to use a `for` loop, but we will also want to enclose that `for` loop in an `if` statement, so that we only execute it when a user has requested a geodesic sphere, not just an icosahedron. We place this new section at the very end of the script. See Example 6.61.

EXAMPLE 6.61 Using a conditional statement based on user input.

```
if ( $iterations > 0 )
```

```
{
for ( $i = 0;$i < $iterations ;$i++ )
    {
    }
}
```

The first action we need to take on our geometry is to subdivide every edge of the geometry. To do this, we use the command `polySubdivideEdge`. If in the Maya interface we take an icosahedron and subdivide the edges, then we can see the command in the Script Editor as shown in Example 6.62.

EXAMPLE 6.62 Subdividing the polygonal edges.

```
polySubdivideEdge -ws 0 -s 0 -dv 1
    -ch 0 icosohedron1.e[0:29];
```

We can then translate that into Example 6.63.

EXAMPLE 6.63 Clarifying the command.

```
polySubdivideEdge
    -worldSpace 0
    -size 0
    -divisions 1
    -constructionHistory off
    icosohedron1.e[0:29]
    ;
```

That final argument is our main concern. When addressing object components, we need to explicitly name them by their component number. Because we are evaluating every edge on the object, we first need to find out how many edges the current polygonal geometry has. We use the `polyEvaluate` command, which returns an integer array. To use this returned value in the `polySubdivideEdge`, we have to integrate multiple variables by doing an inline string addition. See Example 6.64.

EXAMPLE 6.64 Determining the number of edges in our object.

```
if ( $iterations > 0 )
    {
    for ( $i = 0;$i < $iterations ;$i++ )
        {
        // Find how many edges are in the geometry
        int $numOfComponents[] =
            `polyEvaluate
                -edge
                $united_poly[0]`;
```

```
// Subdivide those edges
polySubdivideEdge
    -worldSpace 0
    -size 0
    -divisions 1
    -constructionHistory off
    ( $united_poly[0]
        + ".e[0:"
        + ( $numOfComponents[0] -1 )
        + "]" )
    ;
    }
}
```

ON THE CD

The text for this script is found on the companion CD-ROM as /project_03/ v02/buildGeosphere.mel.

If we now evaluate the script, we will get a result similar to Figure 6.29. In Figure 6.29, we have an icosahedron with three subdivision iterations, and the vertices made visible.

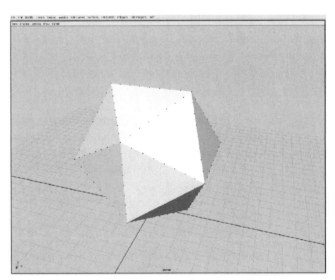

FIGURE 6.29 The subdivided edges.

Next, we use the `polyTriangulate` in a similar fashion. We modify the `polyEvaluate` command to also return the number of faces. Note that the order in which we add the flags for the `polyEvaluate` command is very important. We must keep track of which number stored in which index of the variable `$numOfComponents` refers to which value. In addition, note that we use a

value 1 less than that returned by polyEvaluate. This is because the components are numbered with a 0-based index, but polyEvaluate returns the actual number of components. For example, if you were to use polyEvaluate on an object with just a single face, it would return a value of 1, but that one face would obviously have an index value of 0. See Example 6.65.

EXAMPLE 6.65 Adding the commands to triangulate the resultant faces.

```
if ( $iterations > 0 )
    {
        for ( $i = 0;$i < $iterations ;$i++ )
            {
            // Find how many edges and faces
            // are in the geometry
            int $numOfComponents[] =
                `polyEvaluate
                    -edge
                    -face
                    $united_poly[0]`;

            // Subdivide those edges
            polySubdivideEdge
                -worldSpace 0
                -size 0
                -divisions 1
                -constructionHistory off
                ( $united_poly[0]
                    + ".e[0:"
                    + ( $numOfComponents[0] - 1 )
                    + "]")
                ;
            // Triangulate the faces
            polyTriangulate
                -constructionHistory off
                ( $united_poly[0]
                    + ".f[0:"
                    + ( $numOfComponents[1] - 1 )
                    + "]" )
                ;
            }
    }
```

The text for this script is found on the companion CD-ROM as /project_03/ v03/buildGeosphere.mel.

This, when executed with two iterations, gives us something resembling Figure 6.30.

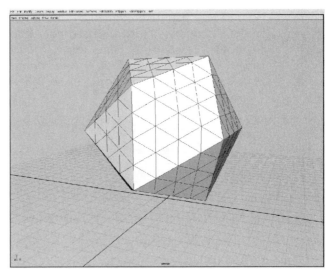

FIGURE 6.30 Two subdivisions, triangulated.

We can now create any level of detail icosahedron, but the object still has the appearance of being constructed of 20 faces, regardless of how many the object actually contains.

To move the vertices out to the desired radius, we combine the techniques we used in all the previous changes we made to the script. First, we count the number of vertices present in the current iteration of the loop. We use our previously declared variable $numOfComponents to hold this value. See Example 6.66.

EXAMPLE 6.66 Counting the vertices in the object.

```
// Find how many vertices are in the geometry
$numOfComponents =
        `polyEvaluate -vertex $united_poly[0]`;
```

We then use a `for` loop to iterate through each of the vertices. Note that we did not use our standard integer iterate, $i, because we are already inside a `for` loop iterating with $i. Our first task is to find the position of each vertex in our geometry. To do this, we use the command xform, one of the most useful and most used commands. The command xform, when queried for a position, returns an array of three floats. We will capture these and assign them to a vector variable. See Example 6.67.

EXAMPLE 6.67 Finding the position of each vertex.

```
for ( $n = 0; $n < $numOfComponents[0]; $n++ )
    {
```

```
float $tfa[] = `xform
                    -query
                    -worldSpace
                    -translation
                    ( $united_poly[0]
                        + ".vtx["
                        + $n
                        + "]" )`
                    ;
vector $v = << $tfa[0], $tfa[1], @dis2:$tfa[2] > ;
```

Next, we find the magnitude of the vector defined by the position of the vector, used to find the scalar value we need to multiply that vector by to bring that vertex out to the radius requested by the user. Unfortunately, this means using a division statement, possibly a very large number of times. It is, however ugly, unavoidable. See Example 6.68.

EXAMPLE 6.68 Finding the magnitude, or radius, of the sphere at each vertex.

```
float $length = $v;
float $scale = ( $radius / $length );
```

Finally, we again use the xform command, used with multiple inline arithmetic statements, to actually move the vertex out to the desired position. See Example 6.69.

EXAMPLE 6.69 Moving the vertices to their final position.

```
xform
    -worldSpace
    -translation
    ( $tfa[0] * $scale )
    ( $tfa[1] * $scale )
    ( $tfa[2] * $scale )
    ( $united_poly[0]
        + ".vtx["
        + $n
        + "]" ) ;
}
```

If you want to see this process in action, add the command refresh; *on the line after the second xform command. This forces the openGL display to refresh, letting you watch the process occur. Although this drastically slows the execution of a script, it is fun to watch and is great for showing off. Occasionally, such as when you both create and delete a constraint within a script, it is actually necessary to refresh the scene.*

The text for this script is found on the companion CD-ROM as /project_03/v04/ buildGeosphere.mel.

If now evaluated, we are given a result similar to Figure 6.31.

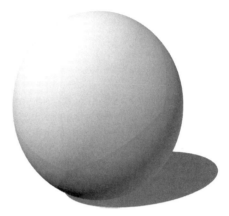

FIGURE 6.31 A sphere, but the edges of the icosahedron are still unsmoothed.

Note that the edges of the original icosahedron are clearly discernable. We will use structures similar to those in all the previous component object evaluations. We do this outside the loop going through the iterations, but still within the `if` statement. See Example 6.70.

EXAMPLE 6.70 Softening the edges of the sphere.

```
int $numOfComponents[] = `polyEvaluate
                            -edge
                            -face
                            $united_poly[0]`;
polySoftEdge
    -angle 90
    -constructionHistory off
    ( $united_poly[0]
        + ".e[0:"
        + ( $numOfComponents[0] - 1 )
        + "]")
    ;
```

With this last revision, our script will produce the result in Figure 6.32.

The text for this script is found on the companion CD-ROM as /project_03/ finished/buildGeosphere.mel.

FIGURE 6.32 The finished geodesic sphere.

Project Conclusion and Review

In this project we did a couple of vital things. First, we showed how to take and expand upon previously constructed scripts. We also learned how to work with object components and to construct inline command constructions. Finally, we exploited some of the features of MEL to carry out our vector calculations, essential to doing complex manipulations of positions in Cartesian space. All these features will aid us in the coming projects.

Project Script Review

```
global proc buildIcosohedron ()
{
float $goldenMean = ((sqrt(5)-1)/2) ;

vector $vert_01 = << 1, 0, $goldenMean >;
vector $vert_02 = << $goldenMean, 1, 0 >;
vector $vert_03 = << 1, 0, ((-1.0)*$goldenMean) >;
vector $vert_04 = << $goldenMean, -1, 0 >;
vector $vert_05 = << 0, ((-1.0)*$goldenMean), 1 >;
vector $vert_06 = << 0, $goldenMean, 1 >;
vector $vert_07 = << ((-1.0)*$goldenMean), 1, 0 >;
vector $vert_08 = << 0, $goldenMean, -1 >;
vector $vert_09 = << 0, ((-1.0)*$goldenMean), -1 >;
vector $vert_10 = << ((-1.0)*$goldenMean), -1, 0 >;
vector $vert_11 = << -1, 0, $goldenMean >;
vector $vert_12 = << -1, 0, ((-1.0)*$goldenMean)>;

string $surf_01[] = `polyCreateFacet
    -constructionHistory off
    -texture 1
    -subdivision 1
```

```
            -point ($vert_01.x) ($vert_01.y) ($vert_01.z)
            -point ($vert_03.x) ($vert_03.y) ($vert_03.z)
            -point ($vert_02.x) ($vert_02.y) ($vert_02.z)
            `

            ;

        string $surf_02[] = `polyCreateFacet
            -constructionHistory off
            -texture 1
            -subdivision 1
            -point ($vert_01.x) ($vert_01.y) ($vert_01.z)
            -point ($vert_04.x) ($vert_04.y) ($vert_04.z)
            -point ($vert_03.x) ($vert_03.y) ($vert_03.z)
            `

            ;

        string $surf_03[] = `polyCreateFacet
            -constructionHistory off
            -texture 1
            -subdivision 1
            -point ($vert_01.x) ($vert_01.y) ($vert_01.z)
            -point ($vert_05.x) ($vert_05.y) ($vert_05.z)
            -point ($vert_04.x) ($vert_04.y) ($vert_04.z)
            `

            ;

        string $surf_04[] = `polyCreateFacet
            -constructionHistory off
            -texture 1
            -subdivision 1
            -point ($vert_01.x) ($vert_01.y) ($vert_01.z)
            -point ($vert_06.x) ($vert_06.y) ($vert_06.z)
            -point ($vert_05.x) ($vert_05.y) ($vert_05.z)
            `

            ;

        string $surf_05[] = `polyCreateFacet
            -constructionHistory off
            -texture 1
            -subdivision 1
            -point ($vert_01.x) ($vert_01.y) ($vert_01.z)
            -point ($vert_02.x) ($vert_02.y) ($vert_02.z)
            -point ($vert_06.x) ($vert_06.y) ($vert_06.z)
            `

            ;

        string $surf_06[] = `polyCreateFacet
            -constructionHistory off
            -texture 1
```

```
    -subdivision 1
    -point ($vert_02.x) ($vert_02.y) ($vert_02.z)
    -point ($vert_03.x) ($vert_03.y) ($vert_03.z)
    -point ($vert_08.x) ($vert_08.y) ($vert_08.z)
    `

    ;

string $surf_07[] = `polyCreateFacet
    -constructionHistory off
    -texture 1
    -subdivision 1
    -point ($vert_03.x) ($vert_03.y) ($vert_03.z)
    -point ($vert_09.x) ($vert_09.y) ($vert_09.z)
    -point ($vert_08.x) ($vert_08.y) ($vert_08.z)
    `

    ;

string $surf_08[] = `polyCreateFacet
    -constructionHistory off
    -texture 1
    -subdivision 1
    -point ($vert_03.x) ($vert_03.y) ($vert_03.z)
    -point ($vert_04.x) ($vert_04.y) ($vert_04.z)
    -point ($vert_09.x) ($vert_09.y) ($vert_09.z)
    `

    ;

string $surf_09[] = `polyCreateFacet
    -constructionHistory off
    -texture 1
    -subdivision 1
    -point ($vert_04.x) ($vert_04.y) ($vert_04.z)
    -point ($vert_10.x) ($vert_10.y) ($vert_10.z)
    -point ($vert_09.x) ($vert_09.y) ($vert_09.z)
    `

    ;

string $surf_10[] = `polyCreateFacet
    -constructionHistory off
    -texture 1
    -subdivision 1
    -point ($vert_04.x) ($vert_04.y) ($vert_04.z)
    -point ($vert_05.x) ($vert_05.y) ($vert_05.z)
    -point ($vert_10.x) ($vert_10.y) ($vert_10.z)
    `

    ;

string $surf_11[] = `polyCreateFacet
    -constructionHistory off
```

```
                    -texture 1
                    -subdivision 1
                    -point ($vert_05.x) ($vert_05.y) ($vert_05.z)
                    -point ($vert_11.x) ($vert_11.y) ($vert_11.z)
                    -point ($vert_10.x) ($vert_10.y) ($vert_10.z)
                    `

                    ;

            string $surf_12[] = `polyCreateFacet
                    -constructionHistory off
                    -texture 1
                    -subdivision 1
                    -point ($vert_05.x) ($vert_05.y) ($vert_05.z)
                    -point ($vert_06.x) ($vert_06.y) ($vert_06.z)
                    -point ($vert_11.x) ($vert_11.y) ($vert_11.z)
                    `

                    ;

            string $surf_13[] = `polyCreateFacet
                    -constructionHistory off
                    -texture 1
                    -subdivision 1
                    -point ($vert_06.x) ($vert_06.y) ($vert_06.z)
                    -point ($vert_07.x) ($vert_07.y) ($vert_07.z)
                    -point ($vert_11.x) ($vert_11.y) ($vert_11.z)
                    `

                    ;

            string $surf_14[] = `polyCreateFacet
                    -constructionHistory off
                    -texture 1
                    -subdivision 1
                    -point ($vert_06.x) ($vert_06.y) ($vert_06.z)
                    -point ($vert_02.x) ($vert_02.y) ($vert_02.z)
                    -point ($vert_07.x) ($vert_07.y) ($vert_07.z)
                    `

                    ;

            string $surf_15[] = `polyCreateFacet
                    -constructionHistory off
                    -texture 1
                    -subdivision 1
                    -point ($vert_02.x) ($vert_02.y) ($vert_02.z)
                    -point ($vert_08.x) ($vert_08.y) ($vert_08.z)
                    -point ($vert_07.x) ($vert_07.y) ($vert_07.z)
                    `

                    ;

            string $surf_16[] = `polyCreateFacet
```

```
    -constructionHistory off
    -texture 1
    -subdivision 1
    -point ($vert_12.x) ($vert_12.y) ($vert_12.z)
    -point ($vert_07.x) ($vert_07.y) ($vert_07.z)
    -point ($vert_08.x) ($vert_08.y) ($vert_08.z)
    `

    ;

string $surf_17[] = `polyCreateFacet
    -constructionHistory off
    -texture 1
    -subdivision 1
    -point ($vert_12.x) ($vert_12.y) ($vert_12.z)
    -point ($vert_08.x) ($vert_08.y) ($vert_08.z)
    -point ($vert_09.x) ($vert_09.y) ($vert_09.z)
    `

    ;

string $surf_18[] = `polyCreateFacet
    -constructionHistory off
    -texture 1
    -subdivision 1
    -point ($vert_12.x) ($vert_12.y) ($vert_12.z)
    -point ($vert_09.x) ($vert_09.y) ($vert_09.z)
    -point ($vert_10.x) ($vert_10.y) ($vert_10.z)
    `

    ;

string $surf_19[] = `polyCreateFacet
    -constructionHistory off
    -texture 1
    -subdivision 1
    -point ($vert_12.x) ($vert_12.y) ($vert_12.z)
    -point ($vert_10.x) ($vert_10.y) ($vert_10.z)
    -point ($vert_11.x) ($vert_11.y) ($vert_11.z)
    `

    ;

string $surf_20[] = `polyCreateFacet
    -constructionHistory off
    -texture 1
    -subdivision 1
    -point ($vert_12.x) ($vert_12.y) ($vert_12.z)
    -point ($vert_11.x) ($vert_11.y) ($vert_11.z)
    -point ($vert_07.x) ($vert_07.y) ($vert_07.z)
    `

    ;
```

```
string $united_poly[] = `polyUnite
    -constructionHistory off
    $surf_01
    $surf_02
    $surf_03
    $surf_04
    $surf_05
    $surf_06
    $surf_07
    $surf_08
    $surf_09
    $surf_10
    $surf_11
    $surf_12
    $surf_13
    $surf_14
    $surf_15
    $surf_16
    $curf_17
    $surf_18
    $surf_19
    $surf_20
    `
    ;

polyMergeVertex
    -distance 0.05
    -constructionHistory off
    ($united_poly[0] + ".vtx[0:59]")
    ;

select -replace $united_poly[0];

if ( $iterations > 0 )
    {
    for ( $i = 0;$i < $iterations ;$i++ )
        {
        // Find how many edges and faces
        // are in the geometry
        int $numOfComponents[] = `polyEvaluate
                                    -edge
                                    -face
                                    $united_poly[0]`;

        // Subdivide those edges
        polySubdivideEdge
            -worldSpace 0
            -size 0
            -divisions 1
```

```
            -constructionHistory off
            ( $united_poly[0]
                + ".e[0:"
                + ( $numOfComponents[0] - 1 )
                + "]")
            ;
        // Triangulate the faces
        polyTriangulate
            -constructionHistory off
            ( $united_poly[0]
                + ".f[0:"
                + ( $numOfComponents[1] -1 )
                + "]" )
            ;

        $numOfComponents = `polyEvaluate
                            -vertex
                            $united_poly[0]`;

        for ( $n = 0; $n < $numOfComponents[0]; $n++ )
            {
            float $tfa[] = `xform
                                -query
                                -worldSpace
                                -translation
                                ( $united_poly[0]
                                    + ".vtx["
                                    + $n
                                    + "]" ) `
                                ;
            vector $v = << $tfa[0], $tfa[1], $tfa[2] > ;
            float $length = $v;
            float $scale = ( $radius / $length );

            xform
                -worldSpace
                -translation
                    ( $tfa[0] * $scale )
                    ( $tfa[1] * $scale )
                    ( $tfa[2] * $scale )
                ( $united_poly[0]
                    + ".vtx["
                    + $n
                    + "]" )
                ;
            }
        }
    int $numOfComponents[] = `polyEvaluate
                                -edge
```

```
                                         -face
                                         $united_poly[0]`;

            polySoftEdge
                -angle 90
                -constructionHistory off
                ( $united_poly[0]
                    + ".e[0:"
                    + ( $numOfComponents[0] - 1 )
                    + "]");
        }

        rename $united_poly[0] "icosohedron1";

    }
```

Conclusion

In this chapter, we started to explore MEL with that most basic element of 3D graphics, polygonal geometry. As we move on to other areas, it will become evident that the basic structures and lessons learned in the previous pages will act as a framework for much of what we want to accomplish.

7 ANIMATION

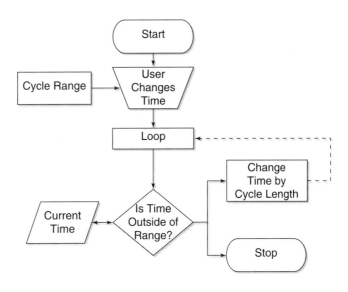

Working with animation is not much different from working with geometry in Maya. The important thing to remember about working in Maya is that all data is stored in nodes; the only thing you have to do is find that node. In this chapter, we will begin to work with animation data, as well as one of the more useful features of MEL, the scriptJob.

7.1: THE CYCLING TOOL

Project Overview

One of the more exciting technologies that has become prevalent among all 3D applications is non-linear animation (NLA). NLA provides a way to take animations and link them together to create a new performance for a character. For game developers, this is nothing new, as this has been the fundamental way character animation in video games has worked since their inception. In Maya this feature is supported through the Trax editor, although we will not be using it here.

When creating animation assets for use within an NLA element, the most important quality for the animation to possess is that it cleanly loop. Ironically, although this is vital for an asset to work effectively, there are surprisingly few ways of working with animation data that guarantees that they are, in fact, looping.

We will rectify this situation with MEL.

Definition and Design

Our project goal is simple to state: alter the Maya environment to aid in the construction of cycling assets. Because we are constructing a tool for animators, it would be advisable to discuss the issue with animators, and find out what their needs are.

After doing so, the items that the animators felt were most important were:

- The ability to scrub animation across a cycling boundary
- Retaining the relationship between start and end keys, including value and tangency
- Little to no setup

Looking at our list of requirements, we can split our tool into two logical sections, one to let the artist scrub across the cycle boundary, the other to work with the key data. The issue of ease of use will be more an issue of implementation than overall design. Our guiding principle in design is that the most input we will require from our user is that he only needs to turn the tool on or off.

The flowchart for the first aspect of our tool is seen in Flowchart 7.1.

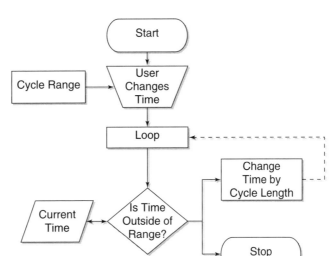

FLOWCHART 7.1 The plan for our first tool.

Our goal is to create a situation where the user is free to alter time and scrub his animation, but if that time is before or after our cycle time, we are returned to the corresponding time within the cycle. This prevents a user from setting a key outside of the cycle.

The second part of our tool requires a slightly more complex flowchart, seen in Flowchart 7.2.

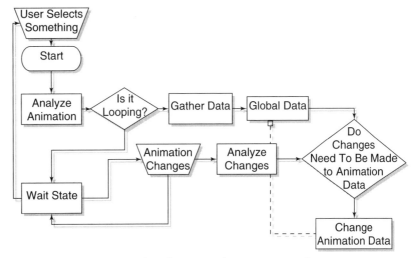

FLOWCHART 7.2 The second tool is somewhat more complex.

Now that our designs are in place, we can figure out exactly how we're going to build it.

Research and Development

Both flowcharts require us to alter the Maya environment to keep track of what the user is doing. To do this we use the *scriptJob*. Although not a difficult concept to understand, script jobs are better explained in context, and we will discuss them in detail later. We will be using script jobs extensively throughout this project.

The major departure we will make from our previous projects is to split the tool into multiple script files. As with procedures, the decision to split a script into multiple files can never really be codified into a hard-and-fast rule. It is often a good idea to make script files as short as possible, which can be aided by splitting the procedures off to their own files. In addition, when your tool is made of multiple global procedures, as this one will be, it is often good practice to allow each of those procedures to be individually sourced and executed.

Since there is no advanced math or physics involved in this project, we can now move on and begin to program our tool.

Implementation

We will first program the tool that allows a user to scrub across time. As always, we begin by creating an empty procedure and executing it to check its validity. Note that we have added a `print` statement to the procedure. We often use `print` statements during the writing and debugging of a script, especially when using script jobs, to track the execution of procedures. Anytime we create a suite of files for a tool, it is a good idea to have a common prefix for all the scripts. In our case, we will use "cyc". See Example 7.1.

EXAMPLE 7.1 Declaring our procedure.

```
global proc cycTimeCheck ()
{
print "Executing timeControl.\n";
}
```

Now, when we execute `cycTimeCheck`, in the Script Editor's history we see our test phrase printed out.

Now that our script works, we can begin to add functionality to it. First, we need to determine the range of our cycle. There are multiple ways we could do this, from asking the user for input, to looking at the time of the first and last keyframes that exist within the scene. However, for our tool, we will simply look to the Playback Time Range, assuming that the user will have that set to the time of his cycle. We can simply document this with the tool. See Example 7.2.

EXAMPLE 7.2 Finding the length of the animation.

```
global proc cycSetTimes ()
{
// Find the start and end times of
// the playback slider
float $cycStartTime = `playbackOptions
                        -query
                        -minimum`
                      ;
float $cycEndTime = `playbackOptions
                        -query
                        -maximum`
                      ;
// determine the length of the animation
float $range = ( $cycEndTime - $cycStartTime ) ;
}
```

Now that we are able to determine the range of our animation, we need to do something with this data. Start a new script file and procedure, both called cycTimeCheck, and check their validity. Our goal with this procedure is to see if the current time is outside the range set in cycSetTimes, and if so, set the current time to be within that range. In order to allow our new procedure to gain access to the start and end times gathered in cycSetTimes, we will change the variables to global variables, to allow them to be accessed by cycTimeCheck. Global variables do not allow a value to be assigned to them upon declaration using a queried value. So first, we declare them, and then assign a value to them. See Example 7.3.

EXAMPLE 7.3 Creating the global variables.

```
global proc cycSetTimes ()
{
// Declare the global variables
global float $cycStartTime;
global float $cycEndTime ;

// Find the start and end times of
// the playback slider
$cycStartTime = `playbackOptions
                        -query
                        -minimum`
                      ;
$cycEndTime = `playbackOptions
                        -query
                        -maximum`
                      ;

    . . .
```

Now we can access this data in `cycTimeCheck`. Whenever you want to access a global variable in a script, we need to declare it, even if we are just accessing the data. We then find the range of the animation. While we could declare the range as a global variable, we should always endeavor to keep the use of global variables to a minimum, so we simply recalculate it in the `cycTimeCheck` procedure. See Example 7.4.

EXAMPLE 7.4 Using the global variables in the time check procedure.

```
global proc cycTimeCheck ()
{
// Declare the global variables
global float $cycStartTime;
global float $cycEndTime;

// Find the range
float $range = $cycEndTime - $cycStartTime;
```

Our next task is to find out what the current time the user has set the time slider to. We do this with a simple query to the command `currentTime`. See Example 7.5.

EXAMPLE 7.5 Finding what the current frame is.

```
float $nowTime = `currentTime
                    -query`
                    ;
```

Next, we use two `while` statements to see if the time assigned to `$nowTime` is outside our established cycle range. If the condition is true, we adjust the time by the range. For example, if the range is from frame 0 to frame 25, a range of 25 frames, and the user sets the time to frame 27, when `cycTimeCheck` is activated the current time should be reset to 27–25, or frame 2. We use a `while` loop instead of an `if` loop so that if the current time is more than one range outside the actual range of the cycle, the process will repeat until the current time is in our range. See Example 7.6.

EXAMPLE 7.6 Changing the current time so it falls within the cycle range.

```
// If the current time is higher than the range
while ( $nowTime > $cycEndTime )
    {
        currentTime -edit ( $nowTime-$range );
        $nowTime = `currentTime -query`;
```

```
    }
// If the current time is lower than the range
while ( $nowTime < $cycStartTime )
    {
        currentTime -edit ( $nowTime+$range );
        $nowTime = `currentTime -query`;

    }
}
```

As long as the procedure `cycSetTimes` is executed first, if we set the current time to anything outside the range and execute `cycTimeCheck`, our time is adjusted.

As our scripts currently exist, the user has to adjust the playback range manually. If instead we add a piece of code to the `cycSetTimes` to add padding to the playback range, we can automate the process, once again abstracting the needed input from the user to simply turning the tool on or off. We will simply triple the range, with the actual cycle range sitting in the middle. See Example 7.7.

EXAMPLE 7.7 Giving the user three cycles in the timeline.

```
global proc cycSetTimes ()
{
// Declare the global variables
global float $cycStartTime;
global float $cycEndTime ;

// Find the start and end times of
// the playback slider
$cycStartTime = `playbackOptions
                        -query
                        -minimum`
                        ;
$cycEndTime = `playbackOptions
                        -query
                        -maximum`
                        ;
// determine the length of the animation
float $range = ( $cycEndTime - $cycStartTime ) ;
playbackOptions -min ( $cycStartTime - $range );
playbackOptions -max ( $cycEndTime + $range );

}
```

Currently, we have two separate procedures. We will now add a new procedure to act as, to borrow a phrase from *TRON*, the master control program. We will call this procedure and the corresponding file `cyclingTool`. Rather

than pass an argument to the script, we will again use a global variable. When the `cyclingTool` command is called, we turn the tool either on or off depending on the value stored in this variable. We also update the value so the next time our tool is executed, the script knows how to react. We will also set a `return` value, just to inform the user of the status of the tool. See Example 7.8.

EXAMPLE 7.8 Addition of a procedure to start the entire tool.

```
global proc string cyclingTool ()
{
// Declare global variables
global int $cycToolStatus;
global float $cycStartTime;
global float $cycEndTime;

// if cyclingTool is inactive
if ( $cycToolStatus == 0 )
    {
        cycSetTimes;
        $cycToolStatus = 1;
        return "Cycling Tool is on." ;
    }
else
    {
        playbackOptions
            -ast $cycStartTime
            -aet $cycEndTime
            ;
        $cycToolStatus = 1;
        return "Cycling Tool is off." ;
    }
}
```

We can now run our cycling tool as much as we want; each time we do, we can watch the time range change with each execution.

We now want to alter the Maya environment to automatically run `cyc-TimeCheck` whenever the user sets the time to something outside of the cycle range determined in `cycSetTimes`. We do this with a `scriptJob`.

A script job is a MEL command that is executed whenever a certain condition is satisfied or a specific action takes place. This condition or action is defined when the script job is created. Script jobs are incredibly useful for modifying or adding functionality to the Maya environment that appears to have been placed there by the original programmers.

In the Script Editor, enter the command from Example 7.9 to create a script job that will execute only once. Make sure the cycling tool is active, so that `cycTimeCheck` will have the information it needs to function.

EXAMPLE 7.9 Creating a scriptJob.

```
scriptJob
    -runOnce true
    -event timeChanged cycTimeCheck
    ;
```

Now, the next time we change the time, cycTimeCheck is executed. To make this a standing condition, we remove the runOnce flag. It is often a good move when testing the construction of script jobs to have the runOnce flag on as a precaution against getting Maya stuck in an endless loop, most particularly when using the idle event to trigger a script. Much like the while loop, a simple typo in a script job can send Maya into a cycle that cannot be stopped short of terminating the Maya process. For this reason, it is good practice to construct script jobs either in scenes that have been backed up or in proxy scenes. See Example 7.10.

EXAMPLE 7.10 Creating the scriptJob to keep the user's time in the cycle range.

```
scriptJob
    -event timeChanged cycTimeCheck
    ;
```

When the script job is executed we see an odd return value, a number; specifically, an integer number. See Example 7.11.

EXAMPLE 7.11 The result of creating a scriptJob.

```
// Result: 31 //
```

This is the *job number*. We can use this integer to stop, or *kill*, the script job. Obviously, we will want to stop the script job when we turn the cycling tool off, as well as when we start a new scene. To have the job automatically killed when a new scene is created, we use the rather obvious -killWithScene flag. To do this, we again use a global variable, and assign the script job number to it. We will use a placeholder integer variable since we cannot directly capture a value to a global integer. See Example 7.12.

EXAMPLE 7.12 Storing scriptJob identities in a global variable.

```
global proc string cyclingTool ()
{
// Declare global variables
global int $cycToolStatus;
global int $cycTimeScriptJob ;
```

```
global float $cycStartTime;
global float $cycEndTime;

// if cyclingTool is inactive
if ( $cycToolStatus == 0 )
    {
    cycSetTimes;

    int $i = `scriptJob
                -killWithScene
                -event timeChanged cycTimeCheck`;

    $cycTimeScriptJob = $i;

    $cycToolStatus = 1;
    return "Cycling Tool is on." ;
    }
else
    {
    scriptJob -kill $cycTimeScriptJob -force;

    playbackOptions
            -ast $cycStartTime
            -aet $cycEndTime;
    $cycToolStatus = 1;
    return "Cycling Tool is off." ;
    }
}
```

With these changes in place, activate the cycling tool. Now, whenever the time is changed to a value outside our declared range, cycTimeCheck is executed, bringing us back into the actual range. Moreover, when we turn the tool off, the script job that executed cycTimeCheck is deleted from memory. We use the force flag to ensure that the job is deleted. Our script job was not created with the protected flag on, so while the force flag is not required to kill it, using it is non-detrimental and can be helpful to remember the option to force the killing of a script job.

It should be noted that while it might seem as if we are breaking one of the major rules of MEL, avoiding global variables, that rule is actually to avoid global variables *unless absolutely necessary*. And in the situations we are using them in, they are. In the last chapter we learned how procedures can pass data to each other, but here, our scripts are not being executed one after the other as steps in a single process. Rather, they are working in conjunction with each other, and in order to pass data to each other we have to store that data somewhere in memory. We are not using extremely large arrays or an inordinate number of global variables, so we are not creating a situation that should cause concern.

We have now successfully completed the first part of our tool. Now, we move onto the more complex tool, which will allow us to edit our bookend keys and maintain their cyclical nature.

Referring to our flowchart, we see that our first goal of this second action is to determine when the user selects keyframes that are both on the bookend times, and are involved in an animation that is cycling. The first step in this is to determine what the user has selected, and to update that information every time the user changes the selection list.

In a new Maya scene, create a sphere, and add animation to any of the channels. If in the Script Editor, we query the selection list using the command `ls -selection`, we get Example 7.13.

EXAMPLE 7.13 Finding the selection list.

// Result: pSphere1 //

However, if we then select any or all of the keyframes on the animation curve within the Graph Editor and query the selection list, we still get what is shown in Example 7.14.

EXAMPLE 7.14 The results do not reflect the selection of keyframes.

// Result: pSphere1 //

While it might seem odd that our selection changed, yet our selection list did not, the answer lies in looking at the up and downstream connections in the Hypergraph, seen in Figure 7.1.

FIGURE 7.1 The up and downstream connections.

As we can see, the actual selection remains the same. The animation curve is a separate node, feeding information into the sphere. The secret to finding

which keys are selected is found by looking at the feedback in the Script Editor, after a keyframe is selected in the Graph Editor. See Example 7.15.

EXAMPLE 7.15 Example results of selecting keyframes.

```
selectKey -clear ;
selectKey -add -k -t 13 pSphere1_rotateY ;
```

Keyframes are actually selected through the command `selectKey`, rather than the command `select`. We can, through some investigation of the command `selectKey` and some logical association, find the command `keyframe`, which is used to set keyframes. Most commands that create data can also be used to query information, and `keyframe` is no different.

Before we start querying animation data, it is important to understand how Maya handles this data "behind the scenes," as it were. Animation and keyframe data are somewhat analogous to geometry and component objects. Keyframe animation is physically stored in a type of node called an `animCurve`. There are currently eight subtypes of animCurves, depending on both the input and the output data type. For example, the animation for a keyframed scale channel is an `animCurveTU`, with time being the input and a double type output. However, the animation for a rotation channel that is driven by a driven key is stored in an `animCurveUA`, which takes a numeric value as an input and outputs angular data. This distinction is normally only important when using the `nodeType` command, which will return the subtype, not the parent type of `animCurve`, although it is a useful method for determining if a channel is driven by a driven key. In order to access the animation stored on any animation curve, we must first determine the name of the animation curve itself.

We could assume that the `animCurve` has the default name Maya assigns to an animation curve, `object_channel`, but assumptions like that are often dangerous and will likely lead to errors. We could also track the connections from the object using the MEL command `listConnections`. However, this is more useful when tracking animation that could be driven by anything—an expression, an animation curve, or even a proprietary solution such as a plug-in that is driven by an external hardware device. In this situation, we only care when the user has selected keys, so we will simply use the command `keyframe` in query mode, looking for the name of the selected animation curve. See Example 7.16.

EXAMPLE 7.16 Finding the selected animation curves.

```
keyframe
    -query
    -selected
    -name
    ;
```

Which returns the name of the `animCurve` on which any selected keys reside. If no keys are selected, the return is empty. We will now create the first piece of our second tool. Start and validate a new file and global procedure called `cycSelectCheck`. We will, for now, simply put our `keyframe` query into the procedure, and `print` that data to the Script Editor. See Example 7.17.

EXAMPLE 7.17 A procedure to find the selected curves.

```
global proc cycSelectCheck ()
{
string $selectedCurves[] = `keyframe
                                -query
                                -selected
                                -name`;
print $selectedCurves;
}
```

Now, when `cycSelectCheck` is evaluated, if there are any keyframes selected, we will see the names of their associated curves printed to the Script Editor. If we now create a script job to execute the script whenever the selection changes, we can constantly monitor the user's selection, and determine if the user has selected any keyframes. See Example 7.18.

EXAMPLE 7.18 Constantly monitoring the users keyframe selection with a scriptJob.

```
scriptJob
    -killWithScene
    -event SelectionChanged cycSelectCheck;
```

Now, we can add this script job to the `cyclingTool` procedure. We use all the same flags and structures we used when adding the `cycTimeCheck` script job, including the addition of another global variable. See Example 7.19.

EXAMPLE 7.19 Updating the master tool procedure to reflect our modifications.

```
global proc string cyclingTool ()
{
global int $cycToolStatus;
global int $cycTimeScriptJob ;
global int $cycSelectScriptJob ;
global int $cycSelectStatus;
global float $cycStartTime;
global float $cycEndTime;

if ( $cycToolStatus == 0 )
```

```
{
    cycSetTimes;

    int $i = `scriptJob
        -killWithScene
        -event timeChanged cycTimeCheck`
        ;

    $cycTimeScriptJob = $i;

    $i = `scriptJob
        -killWithScene
        -event SelectionChanged cycSelectCheck`
        ;

    $cycSelectScriptJob = $i;

    $cycToolStatus = 1;

    return "Cycling Tool is on." ;
}
else if ( $cycToolStatus == 1 )
    {
        scriptJob -kill $cycSelectScriptJob -force;
        scriptJob -kill $cycTimeScriptJob -force;

        playbackOptions
            -ast $cycStartTime
            -aet
            $cycEndTime ;

        $cycToolStatus = 0;

        return "Cycling Tool is off." ;

    }
}
```

Now, the cycling tool will monitor the selection to see if a user selection includes any keys and finds the names of the associated `animCurve` nodes. Of course simply finding the name of the `animCurve` is not much use, we have to find the actual keys that are selected. We can again use the `keyframe` command to query the selected keys, returned as a float array of the time values of the selected keys, by using the command seen in Example 7.20.

EXAMPLE 7.20 Finding the actual keyframes selected in the graph editor.

```
keyframe
   -query
   -selected
   ;
```

This is usable; however, if there are keys on multiple `animCurve` nodes selected, we have no way of knowing which time returned by the query is associated with which `animCurve`. To get the data for each `animCurve` explicitly, we will place the query of the keyframe values in a `for` loop, and use the `for-in` structure since we are iterating through an array. See Example 7.21.

EXAMPLE 7.21 Clarifying our keyframe selection list.

```
global proc cycSelectCheck ()
{
string $selectedCurves[] = `keyframe
                                 -query
                                 -selected
                                 -name`;
print $selectedCurves;

for ( $eachAnimCurve in $selectedCurves )
    {
        float $totalSelectedKeys[] = `keyframe
                                         -query
                                         -selected
                                         $eachAnimCurve`;
        print $totalSelectedKeys;
    }
}
```

Now, when `cycSelectCheck` is evaluated, no matter how many keys on any number of `animCurve` nodes is selected by the end user, we see a neatly ordered listing in the Script Editor.

Next, we need to parse this data, determine if the selected keys are on the bookend times, and determine if the curve those keys are on is cycling. To determine which curves are cycling, we will look at the pre and post infinity behaviors of the animation curves, which are set in the Graph Editor. This allows us to leave the determination of which curves will be accessible to the cycling tool up to the user, and avoid the hassle of building and introducing the user to a new interface.

Because the `animCurve` nodes have attributes, we will query the attributes for both the pre and post infinity value. The attributes are both enumerated, or enum, attributes which hold different text values in a list, with each value assigned an index value, similar to an array. We use a somewhat complicated `if` statement with a series of nested conditional statements to check if a particular

key satisfies both conditions. We again use a for-in loop to iterate through the array. Also note the declaration of the global variables containing our start and end times. See Example 7.22.

EXAMPLE 7.22 Finding whether a curve is set to cycle.

```
global proc cycSelectCheck ()
{
global float $cycStartTime;
global float $cycEndTime;

string $selectedCyclingCurves[];
string $selectedCurves[] = `keyframe
                                -query
                                -selected
                                -name`;

for ( $eachAnimCurve in $selectedCurves )
    {
    float $totalSelectedKeys[] = `keyframe
                                    -query
                                    -selected
                                    $eachAnimCurve`;

    for ( $keyTime in $totalSelectedKeys )
        {
        int $preInfinity = `getAttr
                ( $eachAnimCurve + ".preInfinity" )`;
        int $postInfinity = `getAttr
                ( $eachAnimCurve + ".postInfinity" )`;

        if ( ( $keyTime == $cycStartTime
            || $keyTime == $cycEndTime )
            && ( $preInfinity == 3
            || $preInfinity == 4
            || $postInfinity == 3
            || $postInfinity == 4 ) )

        $selectedCyclingCurves[`size $selectedCyclingCurves`]
            = $eachAnimCurve ;
        }
    }
}
```

Because we might have selected both the start and ending times of a curve, the array containing the names of the cycling curves might contain the same curve multiple times. We will use an accessory script that comes with

Maya called `stringArrayRemoveDuplicates`, which, and this should be no sur-
prise, removes duplicate entries from a string array. See Example 7.23.

EXAMPLE 7.23 Cleaning up the variable arrays.

```
    .  .  .

$selectedCyclingCurves[`size $selectedCyclingCurves`]
    = $eachAnimCurve ;
    }
}
$selectedCyclingCurves =
    `stringArrayRemoveDuplicates $selectedCyclingCurves`;
```

If we wanted, we could now add a `print` statement to test the functionality
so far. For now, we will move on and do something with our gathered selection
info. Next, we have to check each of the curves to determine if a curve held in
the variable `$selectedCyclingCurves` has keys on both the beginning and end
of the cycle range determined when the cycling tool was activated. We do this
to ensure that each of those curves is valid for all further operations we are
going to carry out. See Example 7.24.

EXAMPLE 7.24 Determining the validity of our animation curves.

```
string $cycToolCurves[];

for ( $eachItem in $selectedCyclingCurves )
    {
    float $keyframes[] = `keyframe -query $eachItem`;

    int $onBoth = 0;

    for ( $eachKey in $keyframes )
        if ( ( $eachKey == $cycStartTime )
            || ( $eachKey == $cycEndTime ) )
            $onBoth++;

        if ( $onBoth == 2 )
            $cycToolCurves[`size $cycToolCurves`] =
                $eachItem;
    }
```

Now that we are secure with the sanctity of our gathered data, we need to
gather a vast amount of data from each of these curves. With this data in mem-
ory, we will then set up script jobs to monitor for any changes to the curves,
and then adjust the curves to maintain the cyclic nature of the curve.

For each curve we need to gather, for both of the bookend keys the tangency in angle, the in tangent type, the in tangent weight, the tangency out angle, the out tangent type, the out tangent weight, the tangency lock, the weight lock, and the actual value of the keyframe. The actual gathering of this data is rather easy, a matter of multiple calls of the `keyframe` command with the appropriate flags. The handling of this data is, however, a much more complex beast.

We have a variety of options available to us. We could use a number of arrays, with corresponding indices to co-ordinate values. However, keeping that many global variables in memory could be bad. Instead, we will use a workaround called a *token matrix*.

MEL suffers a major limitation in not allowing for dynamically sized matrices. Because we can never know how many cycling curves a user might select, we need to use a variable that can be dynamically resized, so we will use an array. At the same time, each index of that array needs to hold a variety of information, of varying types. To do this, we will take all the information and combine it into one string. Each value will be treated as a single word, and we can then use the `tokenize` command to split up the string when we once again need it.

Create a new script and procedure called `cycGetCyclingCurveData`. Since we will want to return two strings, one for the keyframe at the beginning of the cycle and one containing all the information for the keyframe at the end of the cycle, we set the return type to a string array. We will also want to pass it the name of the animCurve. See Example 7.25.

EXAMPLE 7.25 Gathering the data of our animation curves.

```
global proc string[] cycGetCyclingCurveData
                         ( string $animCurveName )
{
// string array to hold return variables
string $returnString[];

// declare global variables
global float $cycStartTime;
global float $cycEndTime;

// strings to build return info
string $startInfo, $endInfo;

// add the name of the animCurve
// ( the " " is for tokenizing later )
$startInfo = ( $animCurveName + " " );

// add the start time
// ( the " " is for tokenizing later )
$startInfo = ( $startInfo + $cycStartTime + " " );
```

```
// find the in tangent angle and add it to the string
// ( the " " is for tokenizing later )
float $cycKIA[] = `keyTangent
                        -time $cycStartTime
                        -query
                        -inAngle
                        $animCurveName`;
$startInfo = ( $startInfo + $cycKIA[0] + " " );

// find the in tangent type and add it to the string
// ( the " " is for tokenizing later )
string $cycKITT[] = `keyTangent
                        -time $cycStartTime
                        -query
                        -inTangentType
                        $animCurveName`;
$startInfo = ( $startInfo + $cycKITT[0] + " " );

// find the in tangent weight and add it to the string
// ( the " " is for tokenizing later )
float $cycKIW[] = `keyTangent
                        -time $cycStartTime
                        -query
                        -inWeight
                        $animCurveName`;
$startInfo = ( $startInfo + $cycKIW[0] + " " );

// find the out tangent angle and add it to the string
// ( the " " is for tokenizing later )
float $cycKOA[] = `keyTangent
                        -time $cycStartTime
                        -query
                        -outAngle
                        $animCurveName`;
$startInfo = ( $startInfo + $cycKOA[0] + " " );

// find the out tangent type and add it to the string
// ( the " " is for tokenizing later )
string $cycKOTT[] = `keyTangent
                        -time $cycStartTime
                        -query
                        -outTangentType
                        $animCurveName`;
$startInfo = ( $startInfo + $cycKOTT[0] + " " );

// find the out tangent weight and add it to the string
// ( the " " is for tokenizing later )
float $cycKOW[] = `keyTangent
```

```
                                    -time $cycStartTime
                                    -query
                                    -outWeight
                                    $animCurveName`;
            $startInfo = ( $startInfo + $cycKOW[0] + " " );

            // find if the tangents are locked
            // and add it to the string
            // ( the " " is for tokenizing later )
            int $cycKTL[] = `keyTangent
                                    -time $cycStartTime
                                    -query
                                    -lock
                                    $animCurveName`;
            $startInfo = ( $startInfo + $cycKTL[0] + " " );

            // find if the tangent weights are locked
            // and add it to the string
            // ( the " " is for tokenizing later )
            int $cycKTWL[] = `keyTangent
                                    -time $cycStartTime
                                    -query
                                    -weightLock
                                    $animCurveName`;
            $startInfo = ( $startInfo + $cycKTWL[0] + " " );

            // find the key value and add it to the string
            // ( the " " is for tokenizing later )
            float $cycKV[] = `keyframe
                                    -time $cycStartTime
                                    -query
                                    -eval
                                    $animCurveName`;
            $startInfo = ( $startInfo + $cycKV[0] + " " );

            // Assign the start info to the return array
            $returnString[0] = $startInfo;

            // add the name of the animCurve
            // ( the " " is for tokenizing later )
            $endInfo = ( $animCurveName + " " );

            // add the end time
            // ( the " " is for tokenizing later )
            $endInfo = ( $endInfo + $cycEndTime + " " );

            // find the in tangent angle and add it to the string
            // ( the " " is for tokenizing later )
            float $cycKIA[] = `keyTangent
```

```
                            -time $cycEndTime
                            -query
                            -inAngle
                            $animCurveName`;
$endInfo = ( $endInfo + $cycKIA[0] + " " );

// find the in tangent type and add it to the string
// ( the " " is for tokenizing later )
string $cycKITT[] = `keyTangent
                            -time $cycEndTime
                            -query
                            -inTangentType
                            $animCurveName`;
$endInfo = ( $endInfo + $cycKITT[0] + " " );

// find the in tangent weight and add it to the string
// ( the " " is for tokenizing later )
float $cycKIW[] = `keyTangent
                            -time $cycEndTime
                            -query
                            -inWeight
                            $animCurveName`;
$endInfo = ( $endInfo + $cycKIW[0] + " " );

// find the out tangent angle and add it to the string
// ( the " " is for tokenizing later )
float $cycKOA[] = `keyTangent
                            -time $cycEndTime
                            -query
                            -outAngle
                            $animCurveName`;
$endInfo = ( $endInfo + $cycKOA[0] + " " );

// find the out tangent type and add it to the string
// ( the " " is for tokenizing later )
string $cycKOTT[] = `keyTangent
                            -time $cycEndTime
                            -query
                            -outTangentType
                            $animCurveName`;
$endInfo = ( $endInfo + $cycKOTT[0] + " " );

// find the out tangent weight and add it to the string
// ( the " " is for tokenizing later )
float $cycKOW[] = `keyTangent
                            -time $cycEndTime
                            -query
                            -outWeight
                            $animCurveName`;
```

```
$endInfo = ( $endInfo + $cycKOW[0] + " " );

// find if the tangents are locked and add it to
// the string
// ( the " " is for tokenizing later )
int $cycKTL[] = `keyTangent
                        -time $cycEndTime
                        -query
                        -lock
                        $animCurveName`;
$endInfo = ( $endInfo + $cycKTL[0] + " " );

// find if the tangent weights are locked and add
// it to the string
// ( the " " is for tokenizing later )
int $cycKTWL[] = `keyTangent
                        -time $cycEndTime
                        -query
                         weightLock
                        $animCurveName`;
$endInfo = ( $endInfo + $cycKTWL[0] + " " );

// find the key value and add it to the string
// ( the " " is for tokenizing later )
float $cycKV[] = `keyframe
                        -time $cycEndTime
                        -query
                        -eval
                        $animCurveName`;
$endInfo = ( $endInfo + $cycKV[0] + " " );

// Assign the end info to the return array
$returnString[1] = $endInfo;

// return the data
return $returnString;
}
```

We now will modify `cycSelectCheck` to use the newly created script to gather the data on our qualifying curves. We then assign each of the returned strings to a global string array we have added called $cycleData. We use our standard tricks of iterating through an array with a `for-in` loop, and using the `size` command to dynamically build a new array Add the following after building the array of the curves that have keyframes on both the beginning and end of the cycle. Make sure the global variable $cycleData is declared at the beginning of the procedure. See Example 7.26.

EXAMPLE 7.26 Alter the selectCheck procedure to regather data each time the selection changes.

```
for ( $eachItem in $cycToolCurves )
    {
        string $returnedInfo[] =
                    `cycGetCyclingCurveData $eachItem`;
        for ( $eachInfo in $returnedInfo )
            $cycleData[`size $cycleData`] = $eachInfo;
    }
```

Now that we have gathered the baseline data for our animation curves, we must create a script job to monitor for changes in the animation curves. Because there is no condition available to us to track most of the data we just gathered, we will instead track the attributes controlled by the selected animation curves. The one aspect of the animation curve we can explicitly track is whether the user has an animation curve set to use weighted tangents.

We now will create a script job for each of the animation curves held in $cycToolCurves. To set these up, we will actually create two new scripts and procedures, cycBuildScriptJob and cycUpdateCurve. Again, we will pass the animation curve name to the procedures. We are creating two scripts at the same time, since the script jobs created in cycBuildScriptJob will need a command to execute when the condition is met. For now, we will simply put a print statement in cycUpdateCurve, to give us feedback in the Script Editor, letting us know when our script job executes.

First, our proxy script for cycUpdateCurve. See Example 7.27.

EXAMPLE 7.27 When creating interdependent scripts, it is often necessary to create a proxy script.

```
global proc cycUpdateCurve  ( string $animCurve )
{
    print ( "Executing cycUpdateCurve on "
            + $animCurve
            + "\n" );
}
```

Now that a valid command exists for cycUpdateCurve, we can move on to the script to build the script jobs. Our first task will be to find the attributes connected to our animation curve. We use the command listConnections. Using listConnections can sometimes provide an overflow of data, requiring large amounts of data parsing to bring that returned information into a reasonable form. Here, however, the only connections our curves have are to the attributes they are driving. Using the -plugs flag returns the names of the attributes, rather than the name of the objects. We also set up a script job to monitor if the curve uses weighted tangents. See Example 7.28.

EXAMPLE 7.28 The procedure to build our scriptJobs begins to take shape.

```
global proc cycBuildScriptJob ( string $animCurve )
{
// get the attributes driven by the animations curve
string $connections[] = `listConnections
                                -plugs true
                                $animCurve`;

// setup the command each script job will execute
string $scriptJobCmd = ( "cycUpdateCurve "
                            + $animCurve );

// setup script job for each attribute found
// with listConnections
for ( $eachItem in $connections )
    scriptJob -attributeChange $eachItem $scriptJobCmd;

scriptJob -attributeChange ( $animCurve
                                + ".weightedTangents" )
                            $scriptJobCmd;
}
```

At the same time, we need to make calls to `cycBuildScriptJob` from `cycSelectCheck`. In the same `for` loop we collected the data on each of the animation curves, we now make a call to `cycBuildScriptJob`, which means we now monitor each of the curves named in `$cycToolCurves`. See Example 7.29.

EXAMPLE 7.29 Tool suites require constant updating of multiple procedures. Here we update the SelectCheck procedure again to account for the procedure that creates the scriptJobs.

```
for ( $eachItem in $cycToolCurves )
    {
        string $returnedInfo[] =
                    `cycGetCyclingCurveData $eachItem`;

        for ( $eachInfo in $returnedInfo )
            $cycleData[`size $cycleData`] = $eachInfo;

        cycBuildScriptJob $eachItem;
    }
```

If we now activate the cycling tool with these changes, and modify a valid cycling curve, we see readout in the Script Editor. However, each time we change the selection, and include a previously selected cycling animation curve, our return gets longer, and longer, and longer. The reason for this is that

with each new selection, we are creating new script jobs to monitor the animation curves, but never delete the script jobs previously created. In order to track the script jobs created in `cycBuildScriptJob`, we will capture the script job numbers on creation, and assign them to a global integer array. We will also add the `killWithScene` flag to ensure that the jobs are deleted with a new scene. See Example 7.30.

EXAMPLE 7.30 Killing pre-existing scriptJobs.

```
global proc cycBuildScriptJob ( string $animCurve )
{
// Declare global variables
global int $cyclingScriptJobs[];

// get the attributes driven by the animations curve
string $connections[] = `listConnections
                            -plugs true
                            $animCurve`;

// setup the command each script job will execute and
// the temporary array to hold the job numbers
string $scriptJobCmd = ( "cycUpdateCurve "
                            + $animCurve );
int $scriptJobNumbers[];

// setup script job for each attribute found
// with listConnections
for ( $eachItem in $connections )
    $scriptJobNumbers[`size $scriptJobNumbers`] =
            `scriptJob
                -killWithScene
                -attributeChange $eachItem
                $scriptJobCmd`
                ;

$scriptJobNumbers[`size $scriptJobNumbers`] =
            `scriptJob
                -killWithScene
                -attributeChange ( $animCurve
                        + ".weightedTangents" )
                    $scriptJobCmd`
                ;

// iterate through the temporary array and assign
// the values to the global variable
for ( $eachNum in $scriptJobNumbers )
    $cyclingScriptJobs[`size $cyclingScriptJobs`] = $eachNum;
}
```

Now that we can track any of the script jobs created with `cycBuildScriptJob`, we place the code to delete any existing code in the `cycSelectCheck` procedure. See Example 7.31.

EXAMPLE 7.31 Another modification to the SelectCheck procedure.

```
    .  .  .

$selectedCyclingCurves =
    `stringArrayRemoveDuplicates $selectedCyclingCurves`;

// This kills any existing Script Jobs that check
// for Attribute changes
for ( $eachJob in $cyclingScriptJobs )
    scriptJob -kill $eachJob -force;
clear $cyclingScriptJobs;
```

We use the `clear` command to delete any previous job numbers that might be stored in `$cyclingScriptJobs`, and prevent warnings that would be issued if we tried to delete non-existent script jobs.

We will now add some actual functionality to `cycUpdateCurve`. This procedure needs to do two things. It will only execute when an aspect of our animation curve changes, so its first job will be to find out what data has been modified. The second thing the script will do is initiate the alteration of the corresponding bookend keyframe.

To find out if any data has been modified, first we get updated data on the animation curve. We then compare it to the information stored in the global variable `$cycleData`. Our first goal will be to do a quick `error` check to see if the user has moved a key off the bookend times, and issue a warning if he does. See Example 7.32.

EXAMPLE 7.32 Begin tracing the modifications the user has made to the curve.

```
global proc cycUpdateCurve ( string $animCurve )
{
// declare global variables
global string $cycleData[];

float $keyframes[] = `keyframe -query $animCurve`;
int $onBoth = 0;

for ( $eachKey in $keyframes )
    if ( ( $eachKey == $cycStartTime )
            || ( $eachKey == $cycEndTime ) )
        $onBoth++;
if ( $onBoth != 2 )
```

```
       warning ( "You have altered a key on curve "
                 + $animCurve
                 + " off the bookend times." );

   if ( $onBoth == 2 )
       {
       // find the curve information after the change
       string $updatedCurveInfo[] =
                 `cycGetCyclingCurveData $animCurve`;
       }
   }
```

Next, we will actually compare the data held in the two arrays, $cycleData and $updatedCurveInfo. We use an integer, $dataChanged, to track not only if data is changed, but what the changed data is. We use the command tokenize to break up the stored curve data into individual elements, and then compare them to find any changes. Note that we have again used getAttr to get the pre and post infinity behavior, and assigned those values to variables. See Example 7.33.

EXAMPLE 7.33 Tokenizing the stored data.

```
   if ( $onBoth == 2 )
       {
       // find the curve information after the change
       string $updatedCurveInfo[] =
                 `cycGetCyclingCurveData $animCurve`;

       for ( $data in $cycleData )
           {
           // initialize the integer to track if any
           // data was changed
           int $dataChanged = 0;

           // initialize the token buffer and tokenize
           // the data stored in the global variable
           string $dataBuffer[];
           tokenize $data $dataBuffer;

           // only continue if the current data
           // structure is for the current animCurve
           if ( $dataBuffer[0] == $animCurve )
               {
               // iterate through both the returns
               // stored in the updated info
               for ( $eachUpdated in $updatedCurveInfo )
                   {
                   // initialize the token buffer and
```

```
// tokenize the data stored in the
// updated data variable
string $updateBuffer[];
tokenize $eachUpdated $updateBuffer;

// only continue if the current global
// data structure is for the same frame
// as the data in the updated buffer
if ( $dataBuffer[1] == $updateBuffer[1] )
   {
   // find out if the data has
   // changed

   // In Angle
   if ( $updateBuffer[2] !=
              $dataBuffer[2] )
      $dataChanged = 1;

   // In Weight
   if ( $updateBuffer[4] !=
              $dataBuffer[4] )
      $dataChanged = 1;

   // Out Angle
   if ( $updateBuffer[5] !=
              $dataBuffer[5] )
      $dataChanged = 1;

   // Out Weight
   if ( $updateBuffer[7] !=
              $dataBuffer[7] )
      $dataChanged = 1;

   // Tangency Lock
   if ( $updateBuffer[8] !=
              $dataBuffer[8] )
      $dataChanged = 1;

   // Weight lock
   if ( $updateBuffer[9] !=
              $dataBuffer[9] )
      $dataChanged = 1;

   // Key Value
   if ( $updateBuffer[10] !=
              $dataBuffer[10]
              && ( $preInfinity == 3
              || $postInfinity == 3))
      $dataChanged = (-1);
```

```
                                }
                           }
                      }
                 }
            }
```

We are now aware of which of the selected keyframes has affected an alteration of our stored cycling data. We checked to see if the curve was cycling or cycling with offset in the check of the values because, obviously, if the curve is cycling with an offset, the values will likely not be the same. We now will alter the corresponding bookend keys of the altered curves. Our first step will be to get around a limitation of Maya, which does not allow us to edit keyframe data with MEL if there are any keys selected. Therefore, we simply deselect the keys. However, that will trigger the script job monitoring our selection list, removing all our stored data from memory, and making all that we have done pointless. We will put a flag into cycSelectCheck, in the form of a global integer to give us the ability to temporarily disable the evaluation of cycSelectCheck.

In both cycSelectCheck and cycUpdateCurve, add a global int variable called $cycActivity. In cycSelectCheck, enclose the entire procedure, except the declaration of the global variables, in an if statement. We will now only execute the main body if the value of our variable $cycActivity is zero. What we are doing is letting cycSelectCheck know when the cycling tool is editing data, and to not re-evaluate the selection list. At the same time, it would be a good idea to clear the array $cycleData whenever cycSelectCheck is evaluated with the activity set to off. See Example 7.34.

EXAMPLE 7.34 Preventing the script from entering into a loop.

```
global proc cycSelectCheck ()
{
global float $cycStartTime;
global float $cycEndTime;
global string $cycleData[];
global int $cycActivity;
global int $cyclingScriptJobs[];

if ( $cycActivity == 0 )
    {
    clear $cycleData;
    string $selectedCyclingCurves[];

    . . .
```

Now, in the cycUpdateCurve procedure, after the if statements that check to see what aspects of our animCurve have changed, we can prepare to edit our data. See Example 7.35.

EXAMPLE 7.35 Prepare the environment so we can modify the animation data.

```
// prepare data to be edited
if ( $dataChanged != 0 )
    {
    $cycActivity = 1;
    // so cycSelectCheck doesn't trigger

    selectKey -clear ;
    // Can't edit keyframes with
    // keys selected.
    }
```

To edit the keyframe data, we will use one final script. Create a new script and global procedure call editCycleKey. We will want to pass it both a string array, and an integer argument. We will be passing it both the tokenized data from the updated curve info, and an integer that will control what aspect will be edited. Our first goal will be to determine whether we are editing the start key or the end key. If the first key was edited, we will modify the last key, and vice versa. See Example 7.36.

EXAMPLE 7.36 Create a final procedure to execute the modification of the data.

```
global proc editCycleKey ( string $updateBuffer[],
                                int $index )
{
float $editKey;

if ( $updateBuffer[1] == $cycStartTime )
    $editKey = $cycEndTime;
else
    $editKey = $cycStartTime;
}
```

The order in which we edit the data is very important. If either of the tangency handle locks has been turned off or on, it is important to change those before we alter the other data. Next, in the cycUpdateCurve script, we check to see if the handle type has been changed, then the key value, and finally the angles of the tangent handles. We evaluate for each of these in turn, and evaluate editCycleKey with an integer argument, which we will then use in a switch statement in editCycleKey.

After we edit the key values, we reactivate cycSelectCheck, and reset the $dataChanged integer. See Example 7.37.

EXAMPLE 7.37 Calls to editCycleKey are made based on what has changed.

```
// prepare data to be edited
if ( $dataChanged != 0 )
    {
    $cycActivity = 1;
    // so cycSelectCheck doesn't trigger

    selectKey -clear ;
    // Can't edit keyframes with keys selected.
    }

if ( ( $updateBuffer[8] != $dataBuffer[8] )
    || ( $updateBuffer[9] != $dataBuffer[9] ) )
        editCycleKey $eachUpdated 4;

if ( ( $updateBuffer[3] != $dataBuffer[3] )
    || ( $updateBuffer[6] != $dataBuffer[6] ) )
        editCycleKey $eachUpdated 3;

if ( $dataChanged == (-1) )
    editCycleKey $eachUpdated (-1);

if ( $dataChanged != 0 )
    {
    editCycleKey $eachUpdated 1;
    editCycleKey $eachUpdated 2;
    }

$cycActivity = 0;
$dataChanged = 0;
// resets $dataChanged status
```

In addition, within the `editCycleKey` script, we will add a `switch case` statement and dynamically build a string containing our command, which we will then evaluate. See Example 7.38.

EXAMPLE 7.38 Dynamically building the command.

```
global proc editCycleKey ( string $updateBuffer[],
                           int $index )
{
global float $cycStartTime;
global float $cycEndTime;

float $editKey;

if ( $updateBuffer[1] == $cycStartTime )
```

```
                $editKey = $cycEndTime;
            else
                $editKey = $cycStartTime;

            if ( $index == (-1) )
                {
                string $keyCmd = ( "keyframe -edit -time "
                                    + $editKey
                                    + " -absolute -valueChange "
                                    + $updateBuffer[10]
                                    + " "
                                    + $updateBuffer[0] );
                eval $keyCmd;
                }
            else
                {
                string $keyTanFlags;
                switch ( $index )
                    {
                        case 1:
                            $keyTanFlags = ( " -inAngle "
                                                + $updateBuffer[2]
                                                + " -inWeight "
                                                + $updateBuffer[4]
                                                + " " );
                            break;
                        case 2:
                            $keyTanFlags = ( " -outAngle "
                                                + $updateBuffer[5]
                                                + " -outWeight "
                                                + $updateBuffer[7]
                                                + " " );
                            break;
                        case 3:
                            $keyTanFlags = ( " -inTangentType "
                                                + $updateBuffer[3]
                                                + " -outTangentType "
                                                + $updateBuffer[6]
                                                + " " );
                            break;
                        case 4:
                            $keyTanFlags = ( " -lock "
                                                + $updateBuffer[8]
                                                + " -weightLock "
                                                + $updateBuffer[9]
                                                + " " );
                            break;
                    }
```

```
string $keyTanCmd = ( "keyTangent
                               -edit
                               -absolute
                               -time "
                    + $editKey
                    + $keyTanFlags
                    + $updateBuffer[0] ) ;
       eval $keyTanCmd;
       }
   }
```

After these additions, all of the changes are made to the curve, and our tool is complete. There are some minor user interface additions we could make, like setting up a logic system to reselect what the user started with. However, that would be a whole new tool in and of itself, because Maya cannot easily track what handle the user has selected in the Graph Editor.

Project Conclusion and Review

This project introduced us to a few important concepts useful in creating robust tools in MEL. Primarily was the use of global variables to pass data among different scripts when those scripts are not executed in a particular sequence. In addition, we learned how to modify the operating environment of Maya by using the scriptJob command. Finally, we learned how using multiple scripts can aid in the creation of a tool. While we did all the programming of this tool ourselves, it could easily have been split up among multiple programmers, each working on a separate piece.

Project Script Review

cyclingTool.mel

```
global proc string cyclingTool ()
{
global int $cycToolStatus;
global int $cycTimeScriptJob ;
global int $cycSelectScriptJob ;
global int $cycSelectStatus;
global float $cycStartTime;
global float $cycEndTime;

if ( $cycToolStatus == 0 )
    {
        cycSetTimes;

        int $i = `scriptJob
                    -killWithScene
                    -event timeChanged cycTimeCheck`
                    ;
```

```
                       $cycTimeScriptJob = $i;

                       $i = `scriptJob
                               -killWithScene
                               -event SelectionChanged cycSelectCheck`
                               ;
                       $cycSelectScriptJob = $i;

                       $cycSelectStatus = 0;
                       $cycToolStatus = 1;

                       return "Cycling Tool is on." ;
                 }
            else if ( $cycToolStatus == 1 )
                 {
                       scriptJob -kill $cycSelectScriptJob -force;

                       scriptJob -kill $cycTimeScriptJob -force;

                       playbackOptions -ast $cycStartTime -aet $cycEndTime ;

                       $cycToolStatus = 0;

                       return "Cycling Tool is off." ;
                 }
        }
```

cycSetTimes.mel

```
    global proc cycSetTimes ()
    {
    global float $cycStartTime;
    global float $cycEndTime;

    $cycStartTime = `playbackOptions -q -min`;
    $cycEndTime = `playbackOptions -q -max`;

    float $range = ( $cycEndTime - $cycStartTime );

    playbackOptions -min ( $cycStartTime - $range );
    playbackOptions -max ( $cycEndTime + $range );

    cycTimeCheck;
    }
```

cycTimeCheck.mel

```
    global proc cycTimeCheck ()
    {
```

```
global float $cycStartTime;
global float $cycEndTime;

float $range = $cycEndTime - $cycStartTime;

float $nowTime = `currentTime -q`;

while ( $nowTime > $cycEndTime )
    {
        currentTime -e ( $nowTime-$range );
        $nowTime = `currentTime -q`;
    }

while ( $nowTime < $cycStartTime )
    {
        currentTime -e ( $nowTime+$range );
        $nowTime = `currentTime -q`;
    }
}
```

cycSelectCheck.mel

```
global proc cycSelectCheck ()
{
global float $cycStartTime;
global float $cycEndTime;
global string $cycleData[];
global int $cycActivity;
global int $cyclingScriptJobs[];

if ( $cycActivity == 0 ) {

clear $cycleData;

string $selectedCyclingCurves[];
string $selectedCurves[] = `keyframe -query -selected -name`;

for ( $eachAnimCurve in $selectedCurves )
    {
    float $totalSelectedKeys[] = `keyframe
                                    -query
                                    -selected
                                    $eachAnimCurve`;

    for ( $keyTime in $totalSelectedKeys )
        {
        int $preInfinity = `getAttr
                ( $eachAnimCurve + ".preInfinity" )`;
        int $postInfinity = `getAttr
```

```
                        ( $eachAnimCurve + ".postInfinity" )`;

          if ( ( $keyTime == $cycStartTime
             || $keyTime == $cycEndTime )
             && ( $preInfinity == 3
             || $preInfinity == 4
             || $postInfinity == 3
             || $postInfinity == 4 ) )
                 $selectedCyclingCurves
                     [`size $selectedCyclingCurves`] =
                     $eachAnimCurve ;
           }
      }

$selectedCyclingCurves =
    `stringArrayRemoveDuplicates $selectedCyclingCurves`;

// This kills any Existing Script Jobs that
// check for Attribute changes

for ( $eachJob in $cyclingScriptJobs )
    scriptJob -kill $eachJob -force;

clear $cyclingScriptJobs;

string $cycToolCurves[];

for ( $eachItem in $selectedCyclingCurves )
    {
    float $keyframes[] = `keyframe -query $eachItem`;

    int $onBoth = 0;

    for ( $eachKey in $keyframes )
        if ( ( $eachKey == $cycStartTime )
           || ( $eachKey == $cycEndTime ) )
               $onBoth++;

    if ( $onBoth == 2 )
        $cycToolCurves[`size $cycToolCurves`] =
            $eachItem;
    }

for ( $eachItem in $cycToolCurves )
    {
    string $returnedInfo[] = `cycGetCyclingCurveData
            $eachItem`;

    for ( $eachInfo in $returnedInfo )
```

```
                $cycleData[`size $cycleData`] = $eachInfo;

        cycBuildScriptJob $eachItem;
        }
    }
}
```

cycBuildScriptJob.mel

```
global proc cycBuildScriptJob ( string $animCurve )
{

global int $cyclingScriptJobs[];

string $connections[] = `listConnections
                                -plugs true
                                $animCurve`;

int $scriptJobNumbers[];

string $scriptJobCmd = ( "cycUpdateCurve "
                                + $animCurve );

for ( $eachItem in $connections )
    $scriptJobNumbers[`size $scriptJobNumbers`] =
                `scriptJob
                        -attributeChange $eachItem
                        $scriptJobCmd`;

$scriptJobNumbers[`size $scriptJobNumbers`] =
                `scriptJob
                        -attributeChange
                        ( $animCurve
                        + ".weightedTangents" )
                        $scriptJobCmd`;

for ( $eachNum in $scriptJobNumbers )
    $cyclingScriptJobs[`size $cyclingScriptJobs`] =
        $eachNum;
}
```

cycGetCyclingCurveData.mel

```
global proc string[] cycGetCyclingCurveData
        ( string $animCurveName )
{
// string array to hold return variables
string $returnString[];
```

```
// declare global variables
global float $cycStartTime;
global float $cycEndTime;

// strings to build return info
string $startInfo, $endInfo;

// add the name of the animCurve
// ( the " " is for tokenizing later )
$startInfo = ( $animCurveName + " " );

// add the start time
// ( the " " is for tokenizing later )
$startInfo = ( $startInfo + $cycStartTime + " " );

// find the in tangent angle and add it to the string
// ( the " " is for tokenizing later )
float $cycKIA[] = `keyTangent
                        -time $cycStartTime
                        -query
                        -inAngle
                        $animCurveName`;
$startInfo = ( $startInfo + $cycKIA[0] + " " );

// find the in tangent type and add it to the string
// ( the " " is for tokenizing later )
string $cycKITT[] = `keyTangent
                        -time $cycStartTime
                        -query
                        -inTangentType
                        $animCurveName`;
$startInfo = ( $startInfo + $cycKITT[0] + " " );

// find the in tangent weight and add it to the string
// ( the " " is for tokenizing later )
float $cycKIW[] = `keyTangent
                        -time $cycStartTime
                        -query
                        -inWeight
                        $animCurveName`;
$startInfo = ( $startInfo + $cycKIW[0] + " " );

// find the out tangent angle and add it to the string
// ( the " " is for tokenizing later )
float $cycKOA[] = `keyTangent
                        -time $cycStartTime
                        -query
                        -outAngle
                        $animCurveName`;
```

```
$startInfo = ( $startInfo + $cycKOA[0] + " " );

// find the out tangent type and add it to the string
// ( the " " is for tokenizing later )
string $cycKOTT[] = `keyTangent
                        -time $cycStartTime
                        -query
                        -outTangentType
                        $animCurveName`;
$startInfo = ( $startInfo + $cycKOTT[0] + " " );

// find the out tangent weight and add it to the string
// ( the " " is for tokenizing later )
float $cycKOW[] = `keyTangent
                        -time $cycStartTime
                        -query
                        -outWeight
                        $animCurveName`;
$startInfo = ( $startInfo + $cycKOW[0] + " " );

// find if the tangents are locked and add it to
// the string
// ( the " " is for tokenizing later )
int $cycKTL[] = `keyTangent
                        -time $cycStartTime
                        -query
                        -lock
                        $animCurveName`;
$startInfo = ( $startInfo + $cycKTL[0] + " " );

// find if the tangent weights are locked and add it
// to the string
// ( the " " is for tokenizing later )
int $cycKTWL[] = `keyTangent
                        -time $cycStartTime
                        -query
                        -weightLock
                        $animCurveName`;
$startInfo = ( $startInfo + $cycKTWL[0] + " " );

// find the key value and add it to the string
// ( the " " is for tokenizing later )
float $cycKV[] = `keyframe
                        -time $cycStartTime
                        -query
                        -eval
                        $animCurveName`;
$startInfo = ( $startInfo + $cycKV[0] + " " );
```

```
// Assign the start info to the return array
$returnString[0] = $startInfo;

// add the name of the animCurve
// ( the " " is for tokenizing later )
$endInfo = ( $animCurveName + " " );

// add the end time
// ( the " " is for tokenizing later )
$endInfo = ( $endInfo + $cycEndTime + " " );

// find the in tangent angle and add it to the string
// ( the " " is for tokenizing later )
float $cycKIA[] = `keyTangent
                        -time $cycEndTime
                        -query
                        -inAngle
                        $animCurveName`;
$endInfo = ( $endInfo + $cycKIA[0] + " " );

// find the in tangent type and add it to the string
// ( the " " is for tokenizing later )
string $cycKITT[] = `keyTangent
                        -time $cycEndTime
                        -query
                        -inTangentType
                        $animCurveName`;
$endInfo = ( $endInfo + $cycKITT[0] + " " );

// find the in tangent weight and add it to the string
// ( the " " is for tokenizing later )
float $cycKIW[] = `keyTangent
                        -time $cycEndTime
                        -query
                        -inWeight
                        $animCurveName`;
$endInfo = ( $endInfo + $cycKIW[0] + " " );

// find the out tangent angle and add it to the string
// ( the " " is for tokenizing later )
float $cycKOA[] = `keyTangent
                        -time $cycEndTime
                        -query
                        -outAngle
                        $animCurveName`;
$endInfo = ( $endInfo + $cycKOA[0] + " " );

// find the out tangent type and add it to the string
// ( the " " is for tokenizing later )
```

```
string $cycKOTT[] = `keyTangent
                        -time $cycEndTime
                        -query
                        -outTangentType
                        $animCurveName`;
$endInfo = ( $endInfo + $cycKOTT[0] + " " );

// find the out tangent weight and add it to the string
// ( the " " is for tokenizing later )
float $cycKOW[] = `keyTangent
                        -time $cycEndTime
                        -query
                        -outWeight
                        $animCurveName`;
$endInfo = ( $endInfo + $cycKOW[0] + " " );

// find if the tangents are locked and add it
// to the string
// ( the " " is for tokenizing later )
int $cycKTL[] = `keyTangent
                        -time $cycEndTime
                        -query
                        -lock
                        $animCurveName`;
$endInfo = ( $endInfo + $cycKTL[0] + " " );

// find if the tangent weights are locked and add it
// to the string
// ( the " " is for tokenizing later )
int $cycKTWL[] = `keyTangent
                        -time $cycEndTime
                        -query
                        -weightLock
                        $animCurveName`;
$endInfo = ( $endInfo + $cycKTWL[0] + " " );

// find the key value and add it to the string
// ( the " " is for tokenizing later )
float $cycKV[] = `keyframe
                        -time $cycEndTime
                        -query
                        -eval
                        $animCurveName`;
$endInfo = ( $endInfo + $cycKV[0] + " " );

// Assign the end info to the return array
$returnString[1] = $endInfo;

// return the data
```

```
    return $returnString;
    }
```

cycUpdateCurve.mel

```
global proc cycUpdateCurve ( string $animCurve )
{
global string $cycleData[];
global float $cycStartTime;
global float $cycEndTime;
/*
Anim Curve Name = $index[0];
Time = $index[1];
In Angle = $index[2];
In Tangent Type = $index[3];
In Weight = $index[4];
Out Angle = $index[5];
Out Tangent Type = $index[6];
Out Weight = $index[7];
Lock = $index[8];
Weight Lock = $index[9];
*/

string $newSelectedKeys[];
global int $cycActivity;

int $preInfinity = `getAttr
        ( $animCurve + ".preInfinity" )`;
int $postInfinity = `getAttr
        ( $animCurve + ".postInfinity" )`;

float $keyframes[] = `keyframe -query $animCurve`;

int $onBoth = 0;

for ( $eachKey in $keyframes )
    if (( $eachKey == $cycStartTime )
        || ( $eachKey == $cycEndTime ) )
            $onBoth++;

if ( $onBoth != 2 )
    warning ( "You have altered a key on curve "
                + $animCurve
                + " off the bookend times." );

if ( $onBoth == 2 )
    {
    string $updatedCurveInfo[] =
                `cycGetCyclingCurveData $animCurve`;
```

```
int $dataChanged = 0;

for ( $data in $cycleData )
    {
    string $dataBuffer[];

    tokenize $data $dataBuffer;

    if ( $dataBuffer[0] == $animCurve )
       {
       for ( $eachUpdated in $updatedCurveInfo )
           {
           string $updateBuffer[];
           tokenize $eachUpdated $updateBuffer;

           if ($dataBuffer[1]==$updateBuffer[1])
              {
              // find out if the data
              // has changed;
              // In Angle
              if
              ($updateBuffer[2]!=$dataBuffer[2])
                  $dataChanged = 1;

              // In Weight
              if
              ($updateBuffer[4]!=$dataBuffer[4])
                  $dataChanged = 1;

              // Out Angle
              if
              ($updateBuffer[5]!=$dataBuffer[5])
                  $dataChanged = 2;

              // Out Weight
              if
              ($updateBuffer[7]!=$dataBuffer[7])
                  $dataChanged = 2;

              // Tangency Lock
              if
              ($updateBuffer[8]!=$dataBuffer[8])
                  $dataChanged = 1;

              // Weight lock
              if
              ($updateBuffer[9]!=$dataBuffer[9])
                  $dataChanged = 1;
```

```
// Key Value
if
($updateBuffer[10]!=$dataBuffer[10]
&&
($preInfinity==3||$postInfinity==3)
)
    $dataChanged = (-1);

// prepare data to be edited
if ( $dataChanged != 0 )
    {
    $cycActivity = 1;
    // so cycSelectCheck doesn't
    // trigger

    selectKey -clear ;
    // Can't edit keyframes with
    // keys selected.
    }

if
($updateBuffer[8]!=$dataBuffer[8])
    editCycleKey $updateBuffer 4;

if
($updateBuffer[9]!=$dataBuffer[9])
    editCycleKey $updateBuffer 5;

if
(($updateBuffer[3]!=$dataBuffer[3])
||
($updateBuffer[6]!=$dataBuffer[6]))
    editCycleKey $updateBuffer 3;

if ( $dataChanged == (-1) )
    editCycleKey
        $updateBuffer (-1);

if ( $dataChanged == 1 )
    editCycleKey $updateBuffer 1;

if ( $dataChanged == 2 )
    editCycleKey $updateBuffer 2;
    }

$cycActivity = 0;
$dataChanged = 0;
```

```
                                // resets $dataChanged status
                            }
                        }
                    }
                }
            }
```

editCycleKey.mel

```
global proc editCycleKey ( string $updateBuffer[],
                            int $index )
{
global string $cycleData[];

/*
Anim Curve Name = $index[0];
Time = $index[1]
In Angle = $index[2];
In Tangent Type = $index[3];
In Weight = $index[4];
Out Angle = $index[5];
Out Tangent Type = $index[6];
Out Weight = $index[7];
Lock = $index[8];
Weight Lock = $index[9];
*/

global float $cycStartTime;
global float $cycEndTime;
global string $selectedKeys[];

float $editKey;

if ( $updateBuffer[1] == $cycStartTime )
    $editKey = $cycEndTime;
else
    $editKey = $cycStartTime;

if ( $index == (-1) )
    {
    string $keyCmd = ( "keyframe
                        -edit
                        -time "
                + $editKey
                + " -absolute -valueChange "
                + $updateBuffer[10]
                + " "
                + $updateBuffer[0]);
```

```
eval $keyCmd;
}
else
    {
    string $keyTanFlags;

    switch ( $index )
        {
        case 1:
            $keyTanFlags = ( " -inAngle "
                            + $updateBuffer[2]
                            + " -inWeight "
                            + $updateBuffer[4]
                            + " " );
            break;
        case 2:
            $keyTanFlags = ( " -outAngle "
                            + $updateBuffer[5]
                            + " -outWeight "
                            + $updateBuffer[7]
                            + " " );
            break;
        case 3:
            $keyTanFlags = ( " -inTangentType "
                            + $updateBuffer[3]
                            + " -outTangentType "
                            + $updateBuffer[6]
                            + " " );
            break;
        case 4:
            $keyTanFlags = ( " -lock "
                            + $updateBuffer[8]
                            + " " );
            break;
        case 5:
            $keyTanFlags = ( " -weightLock "
                            + $updateBuffer[9]
                            + " " );
            break;
        }

    string $keyTanCmd = ( "keyTangent
                            -edit
                            -absolute
                            -time "
                        + $editKey
                        + $keyTanFlags
                        + $updateBuffer[0] ) ;
```

```
        eval $keyTanCmd;

} 
```

CONCLUSION

In this chapter, we explored the possibility of embedding our own tools and functionality into the very foundation of Maya. Making our own tools as seamless and friendly to the experienced Maya artist aids both in their use and in their flexibility. We also learned that inside of Maya's node-based structure, even data like animation can be accessed in much the same manner as more traditional data, such as the geometry covered in the previous chapter.

EXPRESSIONS

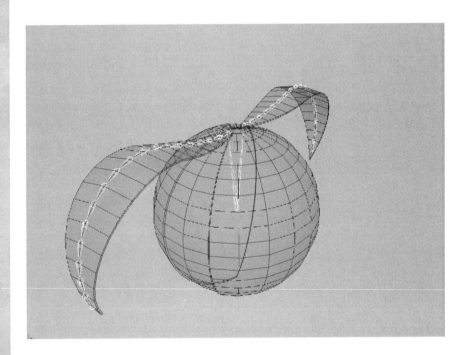

E xpressions are one area of Maya that most people will readily agree requires knowledge of MEL to fully exploit. Yet, by and large, many people who use expressions daily do not fully exploit the fact that expressions are scripts that evaluate during run time. Our project both shows expressions in their more mundane use, but also in a somewhat more exciting manner, creating a very limited AI routine.

PROJECT

8.1: It's a Sine of the Time

Project Overview

Expressions are extraordinarily useful for creating procedural animation, not only in the sense of adding automated follow through or secondary motion to an animated character, but also to create motion.

Our task is to create a small flying ball, with a silvery shell, with rapidly flapping wings. We will use an expression to automate the wings, but still keep them under animator control.

Definition and Design

The design for our flying ball is seen in Figure 8.1, which is a simple design, but suits our purposes well.

FIGURE 8.1 The flying ball.

The two wings will simply open and close, creating a flapping effect.

This file is found on the companion CD-ROM as /project_05/flappingBall01.mb

ON THE CD

Implementation

First, open the model and adjust the pivots of the wings, as seen in Figure 8.2.

FIGURE 8.2 Moving the wing pivot points into position.

On select either wing, and right-click on the Rotate Z channel label in the Channel box, selecting "Expressions…" from the menu that appears. By default, this brings up the Expression Editor, but Maya can be configured to use an external editor to edit expressions. The Maya Expression Editor is seen in Figure 8.3, page 222.

We can also access the Expression Editor from Windows>Animation Editors>Expression Editor.

We should now ensure that the wing object, and the Rotate Z channel, are highlighted in their appropriate sections. This guarantees that if we use any of the shorthand assignment statements in the expression, they are properly converted to reference the object.

We now enter in our first iteration of the expression. See Example 8.1.

EXAMPLE 8.1 Adding a sine wave to the rotation Z channel.

```
rz = sin(time);
```

We then click the "Create" button. Depending on which wing object you selected, the expression text expands to something like what appears in Example 8.2.

EXAMPLE 8.2 The expression expands to the full attribute name.

```
wing01.rotateZ = sin(time);
```

FIGURE 8.3 The Expression Editor window.

What we have done is use a mathematical function, sine, and used one of two variables available to expressions, `time`. The `time` variable returns the global animation time, regardless of frame format. For example, if you were at frame 36, and operating at 24 frames per second (fps), the `time` variable would return a value of 1.5. However, if the user environment is set to 60 fps, it returns a value of 0.6 if, again, we are at frame 36. Because the sine mathematical function always returns a value that varies between –1.0 and 1.0, we get an undulating value, known as a sine wave, which is easily visualized in the Graph Editor by selecting Show>View Results, as seen in Figure 8.4.

If we play the animation, the wing flaps, but at a very slow pace, and not very much. To increase the flapping speed, we multiply the `time` variable by an arbitrary value. See Example 8.3.

EXAMPLE 8.3 Modifying the flap time.

```
wing01.rotateZ = sin( 10 * time );
```

This speeds up the flapping of the wings, but the current methodology does nothing to add in easy tweaking of the value by the animator, as well as the possibility of animating it. Therefore, we add a dynamic float attribute to the main group, called `flapIntensity` as seen in Figure 8.5.

FIGURE 8.4 The Graph Editor shows the sine wave results.

FIGURE 8.5 Adding a dynamic attribute.

We can now use this attribute, even though it is on another object, in our expression. See Example 8.4.

EXAMPLE 8.4 Bringing dynamic attributes into our evaluation.

```
wing01.rotateZ = sin( ball.flapIntensity * time );
```

This file is found on the companion CD-ROM as /project_05/flappingBall02.mb.

Next, to increase the amount the wings open and close with each flap, we will determine a good maximum amount for the wings to open. This can be anything that looks good. Here, we'll use 50°. If we multiply the value returned by our sine operation by that value, we can increase the flapping amount. See Example 8.5.

EXAMPLE 8.5 Increasing the flap of the wings.

```
rz = ((sin(flapIntensity * time))*50);
```

Now, if we press play and see the results, the flapping is increased, but the wing passes through the body. Because the sine value goes into the negative, so does the resulting rotation value.

Also notice that the wing currently has a 100° range of motion. To counter both these problems, we will alter the expression to generate a value between –25 and 25, then add 25 to that value, resulting in a value between 0 and 50. See Example 8.6.

EXAMPLE 8.6 Altering the axis of motion.

```
rz =(((sin(flapIntensity*time))*25)+25);
```

Now, we can add the working expression to the other wing, changing the appropriate object names. While it works, it is not very appealing visually.

To give the wings a more organic appearance, we will modify the setup to create skinned wings. This setup is seen in Figure 8.6.

This file is found on the companion CD-ROM as /project_05/flappingBall03.mb.

While we could put an expression in each of the skeletal joints rotate Z channels, we would have very little control over the look of the animated wings. Instead, we use a *driven key* to get control over the look of the flapping animation. To make our job easier, the dynamic float attribute that controls the driven keys will have a minimum value of –1 and a maximum of 1. After adding the attribute flap, we create a driven key animation of the wings flapping, as seen in Figure 8.7.

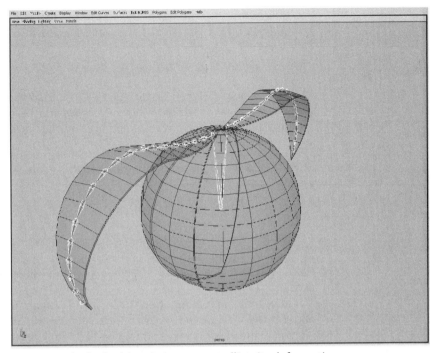

FIGURE 8.6 The ball with a skeleton controlling its deformation.

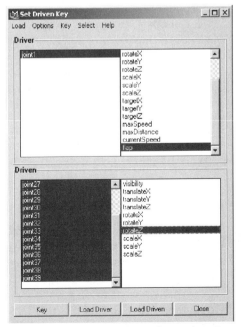

FIGURE 8.7 Creating a driven key animation.

Now as the attribute flap progresses from –1 to 1, the wings flap up. As the attribute goes from 1 back to –1, the wings flap down.

ON THE CD

This file is found on the companion CD-ROM as /project_05/flappingBall04.mb.

We can now add the `flapIntensity` attribute to the root, and add the expression we used in the rigid wing version. We add the expression to the `flap` attribute, having it control the animation of the flap attribute. See Example 8.7.

EXAMPLE 8.7 Using the dynamic attributes in our soft skinned version.

```
flap = sin(flapIntensity*time);
```

Now, as time changes during playback, the attribute `flap` driving the keys updates, so the animation plays, all automatically. The `flapIntensity` attribute can also be animated, and the expression will take this animation into account.

Now that the wing motion is complete, we can animate the ball flying about by hand. However, what about animating the motion of the ball itself with an expression? Is it possible to embed intelligent behavior in an object with an expression? Of course. The level of intelligence is, of course, somewhat limited by the intelligence of the programmer (in this case, the author), so ours won't be overly intelligent. We'll be creating something akin to Artificial Stupidity.

Our goal is to create a routine wherein the ball will randomly move about. Because a single expression can drive multiple channels, we will be putting all of the following into a single expression.

In the Expression Editor, with the skeletal root active, create an expression to randomly assign a value between 0 and 10 to each of the translation channels. See Example 8.8.

EXAMPLE 8.8 Bringing random values into the expression.

```
tx = rand(10);
ty = rand(10);
tz = rand(10);
```

Playing this back shows us the rather erratic results. We want the motion to be erratic, but not insane. Because the expression generates a new random value at every frame, the position from one frame to the next has no relation to each other.

What we want to do is have the expression randomly determine a position, then move to that position over the course of a few frames, and then repeat the process.

The first thing the expression needs to do is to find its current position. Unlike in MEL scripts, in order to get the value of an attribute, and assign it to a variable, we make a simple assignment. Using the getAttr command will actually slow the expression evaluation down and could cause errors. We will assign the position to a vector attribute in order to aid in further mathematical functions. See Example 8.9.

EXAMPLE 8.9 Assignment of variable values in an expression.

```
vector $currLocation = << tx, ty, tz >;
```

Once we have that, we can move on to picking a direction. We will use the rand() function to generate random components of a vector. See Example 8.10.

EXAMPLE 8.10 Randomizing a direction.

```
float $x = rand(-1,1);
float $y = rand(-1,1);
float $z = rand(-1,1);

vector $direction = << $x, $y, $z >;
```

We can then unitize the vector easily, using the unit() function. At the same time, we can optimize the vector creation, by putting the rand() functions directly in the vector assignment. See Example 8.11.

EXAMPLE 8.11 Unitizing the vector.

```
vector $direction = unit(<<rand(-1,1),rand(-1,1),rand(-1,1)>);
```

Now that we have a direction, we can pick a point along that vector as our destination point. While we could put the parameter directly in the expression, we will add a Dynamic attribute to the root joint, called maxDistance. We can now determine our target simply by finding a random number between 0 and that maximum distance. See Example 8.12.

EXAMPLE 8.12 Finding the point to which we want to travel.

```
vector $target = ($direction * rand(maxDistance))
```

We could theoretically add a minimum distance attribute as well, but we have chosen not to.

We could pass values around from one frame to the next; instead, we will use Dynamic attributes added to the root node, targetX, targetY, and

targetZ. Then we can assign the randomly generated target position to those attributes. See Example 8.13.

EXAMPLE 8.13 Storing values on dynamic attributes.

```
targetX = ($target.x);
targetY = ($target.y);
targetZ = ($target.z);
```

Because we want this motion to be erratic, we can also randomly generate a speed at which the ball will travel. Again, we use two dynamic attributes, maxSpeed and currentSpeed. We will limit the minimum possible speed to 0.1 to prevent the possible speed being an infinitely small number, like 0.0003, which would bring the animation to a near halt. See Example 8.14.

EXAMPLE 8.14 Setting the speed of our object.

```
currentSpeed = rand(.1,maxSpeed);
```

In order to determine the new position, we take the vector defined by the difference between our current position and the target location. We unitize that vector, and multiply it times our current speed, giving us the offset position the ball will travel to in one frame of the animation. We can take that result and add it to the current position, and then assign that to the three translation channels. See Example 8.15.

EXAMPLE 8.15 Determining the new position.

```
vector $newPos =
    ((unit($target-$currLocation)*currentSpeed)
    + $currLocation );

tx = $newPos.x;
ty = $newPos.y;
tz = $newPos.z;
```

Right now, the expression is evaluating everything at every frame. We will set up an initialization routine, using an if statement. We will set it so we initialize the values at frame 0. See Example 8.16.

EXAMPLE 8.16 Adding an initializing element.

```
vector $target = << targetX, targetY, targetZ >;
vector $currLocation = << tx, ty, tz >;

if (frame==0)
```

```
{
vector $direction =
unit(<<rand(-1,1),rand(-1,1),rand(-1,1)>);

$target = ( $direction * rand(maxDistance));

targetX = ($target.x);
targetY = ($target.y);
targetZ = ($target.z);
currentSpeed = rand(.1,maxSpeed);
}

vector $newPos =
    ((unit($target-$currLocation)*currentSpeed)
    + $currLocation );

tx = $newPos.x;
ty = $newPos.y;
tz = $newPos.z;
```

Now, when the animation plays, the ball travels along a random vector, but overshoots its target position. We will alter the initialization routine to re-evaluate when the ball reaches the target position. The likelihood of landing directly on the target position is low, so we will use the mag() function to check if the ball's position is closer to the target than the distance defined by the currentSpeed attribute. We also will continue to reinitialize at frame 0. See Example 8.17.

EXAMPLE 8.17 Now reevaluate when the target position is reached.

```
vector $target = << targetX, targetY, targetZ >;
vector $currLocation = << tx, ty, tz >;

if (mag($target-$currLocation)<currentSpeed||frame==0)
    {
    vector $direction =
            unit(<<rand(-1,1),rand(-1,1),rand(-1,1)>);

    $target = ( $direction * rand(maxDistance));

    targetX = ($target.x);
    targetY = ($target.y);
    targetZ = ($target.z);
    currentSpeed = rand(.1,maxSpeed);
    }

vector $newPos =
    ((unit($target-$currLocation)*currentSpeed)
```

```
        + $currLocation );

    tx = $newPos.x;
    ty = $newPos.y;
    tz = $newPos.z;
```

ON THE CD

This file is found on the companion CD-ROM as /project_05/flappingBall05.mb.

With this, the behavior of the ball is suitably erratic, and we can call it finished.

Project Conclusion and Review

In this project, we saw the power of expressions. Expressions create animation based on the ever-changing attributes of objects in the scene. Often used simply to connect attributes or implement simple repetitive motion, we saw how combining expressions and Driven Keys can add complexity to a repetitive motion. We also saw how simple behaviors can be implemented using expressions. Our example behaved erratically, but by putting simple conditional statements into that expression, we could keep the target within a given distance of another object, or limit the new direction to be within a certain angle of the previous vector.

CONCLUSION

Although expressions are not often associated with the scripting languages available in other software, inside of Maya they are nearly one and the same. The syntax and commands are the same, and by using MEL within expressions we greatly expand the possibilities of what can be accomplished with expressions.

LIGHTING AND RENDERING

endering is perhaps the area of Maya that artists most infrequently associate with MEL. However, there are actually sections of Maya completely dedicated to running MEL scripts for rendering purposes. In this chapter, we will construct two tools associated with rendering, including taking advantage of the aforementioned rendering-only scripts. Although our main focus is on rendering, we will also learn about building and navigating node networks, handling system commands, and using control nodes in Maya, so even artists who do not work with rendering very often would be wise to not skip this chapter.

PROJECT

9.1: CREATING CUBIC REFLECTION MAPS

Project Overview

Many artists mistakenly believe that the only way to create accurate reflections for an object in Maya is to raytrace. This, however, is not the case. Maya actually provides multiple ways of projecting a reflection onto an object. However, due to the relative difficulty in creating the maps used in these environment mappings, they are not often used except to provide a general effect, such as to provide a metallic look to a material. In addition, as game technology progresses, more and more artists are being called upon to create environmental maps that accurately reflect the real environment.

In this project, we will create a script that will render out cubic reflection maps. In doing so, we will learn about accessing both internal Maya variables and will work with the `system` command to use MEL to access the operating system itself.

Definition and Design

Cubic reflection maps in Maya offer some major advantages over raytraced reflections. First, they support any number of technologies that cannot be rendered with raytracing, like Maya fur, Paint Effects, and shader glows. In addition, there are a variety of ways a skilled shading Technical Director can use cubic reflections to influence a material other than simply using it as a reflection. Moreover, because the cubic reflections are external image maps, they can be modified using image manipulation software to easily create blurred reflections, or create other stylized effects.

In Figure 9.1, we see a sphere contained in a geometric grid rendered with raytracing.

ON THE CD

This scene file is contained on the companion CD-ROM under scenes/chapter_09/ reflect/raytraced_sphere.mb.

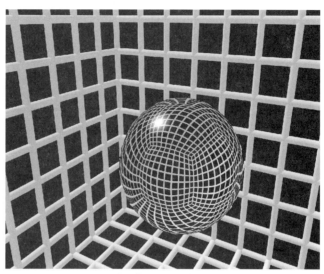

FIGURE 9.1 A raytraced reflecting sphere.

We can compare that to Figure 9.2, the exact same scene with cubic reflection maps, where the reflections have been rendered at a low resolution, creating a blurred effect.

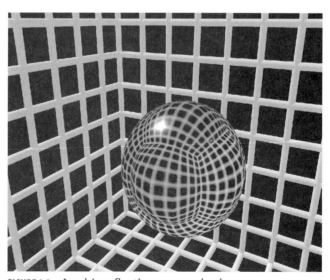

FIGURE 9.2 A cubic reflection mapped sphere.

ON THE CD

This scene file is contained on the companion CD-ROM under scenes/chapter_09/ reflect/cube_sphere.mb.

Although there are differences, they are negligible, and it is rare that the reflections in a production scene would be used as prominently as they are here. In situations where exact reflections are necessary, in all likelihood ray-tracing would actually be used.

The definition of our tool is rather simple. Given any object, or any number of objects, our tool will render out six images, oriented and named properly to create a cubic reflection map for that object. While we could easily add the functionality to create an `envCube` node and assign the textures to the appropriate slots, for this example we will simply create the image files. Because our reflection maps will be specific to an object, and a material might be assigned to multiple objects, if we were to automatically create and assign an `envCube` map to an object we could create unwanted rendering artifacts.

The flowchart for our project is seen in Flowchart 9.1.

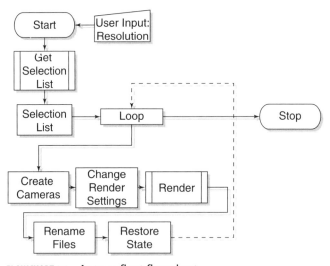

FLOWCHART 9.1 Auto-reflect flowchart.

Research and Development

Before we develop a way of creating reflection maps, we should understand how they are used by Maya. The cubic reflection map is entirely dependent on the normal of the shaded surface using it. If we imagine the `place3dTexture` node of the `envCube` material as surrounding our reflecting object and where to draw a vector from the center point of the `place3dTexture` node through our shaded surface until it intersected the volume of our `place3dTexture` node, we can determine which pixel of which texture map is supplying the color information to be used. This is visualized in Figure 9.3.

We can extrapolate that concept to define the outermost points of any cubic map by projecting vectors out to the eight points that make up the cube defining our reflection environment, seen in Figure 9.4.

FIGURE 9.3 A diagram of how reflection maps work.

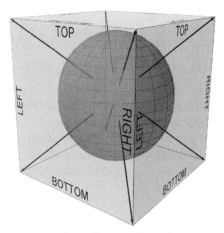

FIGURE 9.4 The cube in cubic reflection.

To create the images, we need to create six cameras, each located at the center point of the object and facing all six of the axes: positive X, negative X, positive Y, negative Y positive Z, and negative Z. As important as the direction a camera is looking is the orientation of the camera, and, of course, the camera node's settings.

To properly orient the cameras, we will again first build the structures by hand in Maya, and then recreate them in code. This is, as has become obvious by now, a standard way in which tools are often constructed in MEL.

ON THE CD

Now, we create a sphere and assign it a reflective material, using an `en-vCube` to drive the reflections. To each of the texture channels, we assign the image found on the companion CD-ROM in scenes/chapter_09/reflect/reflect_basic.tga. If we render that image, we see something similar to that in Figure 9.5.

FIGURE 9.5 The guide image used as a reflection.

We can use the reflections of our guide image to orient six cameras (the following values are in degrees)

Right
Rotation X: 0
Rotation Y: –90
Rotation Z: 0
Top
Rotation X: 90
Rotation Y: 0
Rotation Z: 0
Front
Rotation X: 0
Rotation Y: 180
Rotation Z: 0
Left
Rotation X: 0
Rotation Y: 90
Rotation Z: 0
Bottom
Rotation X: –90
Rotation Y: 0
Rotation Z: 0
Back
Rotation X: 0
Rotation Y: 0
Rotation Z: 0

We also need to set the cameras to create a square image. Set the Angle of View for each of the cameras to 90°, and both the vertical and horizontal film apertures to 1.0.

If we now set the rendering settings to a square image, such as 256x256, and render each of the six views, we can create proper images to use as reflection maps. As a guideline, we will first create some geometry to aid in the confirmation of the orientation of our images. This is seen in Figure 9.6, and can be found on the companion CD-ROM under scenes/chapter_09/reflect/reflect_reference.mb.

ON THE CD

After naming the image files to appropriate names, we create a reflecting sphere and assign the images to its envCube node. The results of this are seen in Figure 9.7, page 238, although we have artificially darkened the reflection maps to easily differentiate it from the white background. This creates accurate reflections for our sphere.

Now that we have worked out the process and details in Maya, we can move on to the coding of our tool.

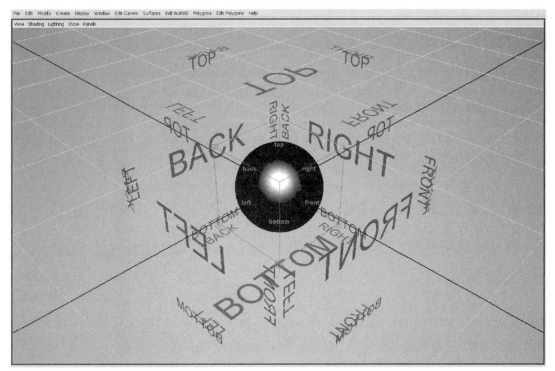

FIGURE 9.6 The reflection reference geometry.

Implementation

Our first step, as always, is to create and validate a script for our tool. We will call this script `generateCubicReflectionMap`. We want to have an argument to control the resolution of the output images, so we will include an `int` variable in the procedure declaration, as seen in Example 9.1.

EXAMPLE 9.1 Declaration of the global procedure.

```
global proc generateCubicReflectionMap
    ( int $resolution )
{
}
```

Next, referring to our flowchart, we see that we will need to carry out all our operations on all the selected objects. In Example 9.2, we add a variable that holds the selection list, and use a `for-in` loop to iterate through each object.

FIGURE 9.7 The six renders assigned as the reflection maps.

EXAMPLE 9.2 Parsing through the selection list.

```
global proc generateCubicReflectionMap
    ( int $resolution )
{
//build selection list
string $selection[] = `ls -selection`;

//iterate through the selection list
for ( $eachItem in $selection )
    {
    }
}
```

Next, we will create the cameras to render out each of the six views. In theory, we could use one camera and reorient it between each render, but this methodology more closely resembles the one we developed inside the Maya workspace. We know we have to create six cameras, so a `for` loop is used. Each time through, we name the cameras, although we will not yet orient them. We instead capture the renamed camera name to a string array, visible outside the loop, shown in Example 9.3.

EXAMPLE 9.3 Creation of the cameras.

```
global proc generateCubicReflectionMap
    ( int $resolution )
{
// build selection list
string $selection[] = `ls -selection`;

// iterate through the selection list
for ( $eachItem in $selection )
    {
    // create the six cameras, and name them
    string $camHold[], $refCams[];

    for ( $i = 0; $i < 6 ; $i++ )
        {
        $camHold = `camera
            -centerOfInterest 5
            -focalLength 12.7
            -lensSqueezeRatio 1
            -cameraScale 1
            -horizontalFilmAperture 1
            -horizontalFilmOffset 0
            -verticalFilmAperture 1
            -verticalFilmOffset 0
            -filmFit Horizontal
            -overscan 1
            -motionBlur 0
            -shutterAngle 2.513274
            -nearClipPlane 0.000001
            -farClipPlane 100000
            -orthographic 0
            `

            ;

        // declare string to append to camera name
        string $direction[];

        $direction[0] = "_right";
        $direction[1] = "_top" ;
        $direction[2] = "_front" ;
        $direction[3] = "_left" ;
        $direction[4] = "_bottom" ;
        $direction[5] = "_back" ;

        $refCams[$i] = `rename $camHold[0]
                ( $eachItem + $direction[$i] )`;
        }
    }
}
```

If the script is evaluated in its current state, remember to delete the cameras that are created. While they won't cause the script to malfunction, they simply clutter the scene.

ON THE CD

The text for this script is found on the companion CD-ROM as /project_06/v01/ generateCubicReflectionMap.mel.

With the cameras in existence, we will now orient them to the six axes. However, to do this, we must first determine whether the user is working in radians or degrees. Putting in a unit settings check such as this is usually only needed when dealing with angular measurements, although it can be necessary with some linear measurement calculations, such as gravity.

We can find the current angular settings by making a query with the command `currentUnit`. We then use some conditional statements to set the rotation attributes of the cameras, using inline string addition. This is a rather simple process at this point, seen in Example 9.4.

EXAMPLE 9.4 Orienting the cameras based on user settings.

```
// Rotate the Cameras

string $angSettings = `currentUnit -query -angle`;

if ( $angSettings == "deg" )
    {
    setAttr ( $refCams[0] + ".RotateY" ) -90;

    setAttr ( $refCams[1] + ".RotateX" ) 90;

    setAttr ( $refCams[2] + ".RotateY" ) 180;

    setAttr ( $refCams[3] + ".RotateY" ) 90;

    setAttr ( $refCams[4] + ".RotateX" ) -90;
    }

if ( $angSettings == "rad" )
    {
    setAttr ( $refCams[0] + ".RotateY" )
        `deg_to_rad -90`;

    setAttr ( $refCams[1] + ".RotateX" )
        `deg_to_rad 90`;

    setAttr ( $refCams[2] + ".RotateY" )
        `deg_to_rad 180`;
```

```
setAttr ( $refCams[3] + ".RotateY" )
    `deg_to_rad 90`;

setAttr ( $refCams[4] + ".RotateX" )
    `deg_to_rad -90`;
}
```

ON THE CD

The text for this script is found on the companion CD-ROM as /project_06/v02/ generateCubicReflectionMap.mel.

Also note that rather than explicitly stating the values for the radian settings, we use the MEL command `deg_to_rad`, which converts the values during the evaluation of the script. This allows for an improvement both in the readability of the script, and in the precision of the assigned values. Because the radian values are based on the irrational number pi, doing a conversion during the assignment allows maximum precision to be maintained.

Once the cameras are rotated into the correct orientation, we need to move them to the location of our object. We could use the `xform` command in query mode, but there are no assurances that the transformation information of the object has not been modified by the user. Instead, we will find the middle of the bounding box of the object. We do this by querying both the minimum and maximum values and finding the average of the values returned, shown in Example 9.5.

EXAMPLE 9.5 Finding the center of the object bounding box.

```
// find the center point of the object
float $minB[] = `getAttr
    ( $eachItem + ".boundingBoxMin" )`;
float $maxB[] = `getAttr
    ( $eachItem + ".boundingBoxMax" )`;

float $objectPosition[]= {
    (($maxB[0] + $mink[0]) * 0.5 ),
    (($maxB[1] + $mink[1]) * 0.5 ),
    (($maxB[2] + $mink[2]) * 0.5 )
    };
```

We then group the cameras together under a single transform, and move that transform to the location we just calculated. We could move each camera individually, but this method eliminates the loop we would have to construct to carry out such an operation, and allows us to have one easily deleteable node later to clean the cameras out of the scene. In addition, should our script terminate due to unforeseen circumstances, such as the rendering crashing, the scene has one easily findable node for a user to delete. This process is seen in Example 9.6.

EXAMPLE 9.6 Grouping the cameras.

```
// create the group containing all 6 views
select -replace $refCams;
string $camGrouping = `group -name "cameraGroup"`;
xform -objectSpace -pivots 0 0 0 $camGrouping;

// move it to position
xform
    -worldSpace
    -transform
    $objectPosition[0]
    $objectPosition[1]
    $objectPosition[2]
    $camGrouping;
```

ON THE CD

The text for this script is found on the companion CD-ROM as /project_06/v03/ generateCubicReflectionMap.mel.

Next, in preparation for rendering we have to do two things. We will want to set the resolution and the corresponding image aspect ratio. These values are actually stored on a node called `defaultResolution`. We can also modify the image prefix on the `defaultRenderGlobals`. The values for all these are just attributes, and can therefore be accessed with simple `setAttr` and `getAttr` calls. We first want to capture the user's settings for these, to restore them after our renderings are completed. Anytime a script modifies settings, which are stored in a file, it is good practice, as well as simple politeness, to return those values to their previous state before ending the script. Notice in Example 9.7 that when setting a non-numerical attribute we must explicitly state the attribute type.

EXAMPLE 9.7 Setting the rendering attributes.

```
// set the rendering attributes

float $currWidth =
    `getAttr defaultResolution.width`;

float $currHeight =
    `getAttr defaultResolution.height`;

float $currAspect =
    `getAttr defaultResolution.deviceAspectRatio`;

string $currPrefix =
    `getAttr defaultRenderGlobals.imageFilePrefix`;
```

```
setAttr defaultResolution.width $resolution;

setAttr defaultResolution.height $resolution;

setAttr defaultResolution.deviceAspectRatio 1;

setAttr defaultRenderGlobals.imageFilePrefix
    -type "string"
    "";
```

While we could set up variables and `setAttr` commands to modify a variety of rendering settings, such as to turn on high-quality anti-aliasing, filtering type, and so forth, we will just use the current settings. Otherwise, we would be forced to either remove these settings from easy user control or add an enormous amount of complexity to our script command.

The last step before doing the renders is to hide the object, so that it does not occlude the view of the cameras. We do this by changing the visibility attribute, as in Example 9.8.

EXAMPLE 9.8 Hiding the object by setting the visibility attribute.

```
setAttr ( $eachItem + ".visibility" ) off;
```

Now we get to do the actual rendering. We will use the `for-in` loop in Example 9.9 to execute the commands for each of our six cameras.

EXAMPLE 9.9 Issuing the renders.

```
// Do renders
for ( $eachCam in $refCams )
    render $eachCam;
```

ON THE CD

The text for this script is found on the companion CD-ROM as /project_06/v04/ generateCubicReflectionMap.mel.

This will render out six images to the current project's "images" directory. However, the images have such useful names as `_pSphere1_backShape_ tmp0.tga`. We will have to rename the image file, because we cannot use an argument with the `render` command to explicitly name the output image. To do this we will use the `system` command. While we could use the Maya command `sysFile -rename`, which is provided as a system independent way to rename files, this provides us a good opportunity to learn about the `system` command. In addition, using the `system` command will allow us to automatically overwrite our old image files, allowing for easy updates to our reflection maps.

 All of the following commands deal specifically with the structures and commands associated with Microsoft Windows. Please consult your operating system documentation to find the appropriate commands.

The `system` command is potentially the most powerful and dangerous command available to a MEL scripter. Using the `system` command, Maya executes operating system commands, as would be issued from a command prompt in Windows, the terminal in OSX, or the shell in Unix. If we combine this with an external scripting language like PERL or a command-line program, such as a image processing routine, or an e-mail program, we can vastly extend the capabilities of Maya. For example, we could combine the `system` command and an `error` to automatically e-mail us whenever a user in the system encounters an error with a script, although this would not be advisable for a publicly distributed tool. Alternatively, we could have Maya send a cell phone text message when a render or complex dynamics simulation is complete. Although it might be disturbing to receive a message from a workstation at 3 a.m. that the cloth simulation is complete, it is possible.

Each operating system might require a specific level of access, such as administrator or root, before every command becomes available. Moreover, anytime we deal with files or system commands in a publicly distributed script any operating system restrictions should be made clear to the user, or we should build multiple command structures based on the current user's operating system, which can be queried with the `about` command.

While MEL provides a variety of commands to work with external data, like the aforementioned `sysFile` command or the `dirName` script, often not all the commands you want to use have MEL equivalents, and are easier to accomplish if we keep similar command structures throughout a script.

Before we carry out any actions on the newly rendered image file, we need to know what that file's name is. Luckily, the `render` command returns the name of the image, which we capture to a string, as in Example 9.10.

EXAMPLE 9.10 Capturing the name of the rendered file to a variable.

```
string $renderedImage = `render $eachCam`;
// actual render
```

Next, we will want to extract the name of the file itself. When Maya returns the name of any file, it uses the forward slash, "/", since the backslash "\" is used to signify escape characters. We will `tokenize` the returned image name with the forward slash, and assign the last item in the array to a string called `$imageName`. In Example 9.11, we see this process, extracting the last item in the array created by the `tokenize` command, which is the name of the file.

EXAMPLE 9.11 Tokenizing the file path.

```
string $tokenBuffer[];
tokenize $renderedImage "/" $tokenBuffer;
string $imageName =
    $tokenBuffer[(`size $tokenBuffer` - 1)];
```

Next, we will build a valid Windows path, which needs the backslash in be-tween the names of each directory and subdirectory. We use a for loop to dy-namically build the path, regardless of how long it is. We do an inline mathematic statement to not add the last element of the array, the filename. Because we are using the backslash in a string, we have to use a double back-slash; otherwise, the backslash escapes out the quote marks, leading to an error. This process is shown in Example 9.12.

EXAMPLE 9.12 Escaping out the backslash to preserve it within the string.

```
$path = "";

for (   $i = 0;
        $i < (`size $tokenBuffer` - 1);
        $i++ )
    $path = ( $path + $tokenBuffer[$i] + "\\" );
```

In Example 9.13 we build a string with the image name, called $old, which contains a valid Windows path to the rendered image.

EXAMPLE 9.13 Rebuilding the path.

```
string $old = ( $path + $imageName );
```

We now want to rename the image according to the camera, which was previously named according to the object and the direction, so the correspond-ing image will be as well. We again use the tokenize command to split up the string data into individual components, so that we can append the appropriate extension to the new filename. The code for this is seen in Example 9.14.

EXAMPLE 9.14 Building the new filename.

```
tokenize $imageName "." $tokenBuffer;
string $extension = $tokenBuffer[1];
string $new = ( $path + $eachCam + "." + $extension );
```

Finally, we build a string of our DOS command. We want to enclose the en-tire path names in quote marks, in case the user has used spaces in any of the di-rectory names. We again use the escape character, \, to tell MEL that the quotes

should be included in the string, not terminate it. We use the `move` OS command rather than the `rename` OS command to automatically overwrite any previously existing files, letting us quickly do new iterations of reflection maps. We then execute the `system` command, passing it the string `$systemCmd`. We finally add the last curly braces, closing the rendering `for-in` loop. See Example 9.15.

EXAMPLE 9.15 Building the system command string.

```
$systemCmd = ( "move \""
               + $old
               + "\" \""
               + $new
               + "\"" );

system ( $systemCmd );
}
```

The text for this script is found on the companion CD-ROM as /project_06/v05/ generateCubicReflectionMap.mel.

After closing out the loop, we do some cleanup, deleting the camera group and returning the rendering attributes to their previous values, as well as making the object visible once more. Finally, before ending the script, we re-select the user's original selection, good practice when not creating any permanent new nodes. The code for this is seen in Example 9.16.

EXAMPLE 9.16 Cleaning up the nodes we created.

```
delete $camGrouping;

setAttr ( $eachItem + ".visibility" ) 1;

setAttr defaultResolution.width $currWidth;

setAttr defaultResolution.height $currHeight;

setAttr
    defaultResolution.deviceAspectRatio $currAspect;

setAttr
    defaultRenderGlobals.imageFilePrefix
    -type "string"
    $currPrefix;
}

select -replace $selection;

}
```

The text for this script is found on the companion CD-ROM as /project_06/finished/ generateCubicReflectionMap.mel.

With that the script is finished. In Figure 9.8, we see the results of the script being executed two times on a collection of primitives.

FIGURE 9.8 Multiple executions of the reflection script.

Because the objects already had a reflective material on them, with the reflection maps being updated with each execution of the script, an almost raytraced effect is achieved, without the time-consuming cost of raytracing. In addition, note the use of the Paint Effects strokes, which are also reflected in each of the surfaces.

Project Conclusion and Review

By creating cubic reflection maps, we can take advantage of the rendering features not supported by raytracing, avoid the rendering speed tradeoffs required to raytrace, and have finite control over the images used in the rendering process. More importantly, we learned how to take control of the operating system from within MEL. Whether it is to manipulate files, launch command-line tools, or even interact with another scripting language such as Perl, the system command is a powerful weapon in any scripter's toolbox.

Project Script Review

```
global proc generateCubicReflectionMap
            ( int $resolution )
{
//build selection list
string $selection[] = `ls -selection`;

//iterate through the selection list
for ( $eachItem in $selection )
    {
    // create the six cameras, and name them
    string $camHold[], $refCams[];

    for ( $i = 0; $i < 6 ; $i++ )
        {
        $camHold = `camera
            -centerOfInterest 5
            -focalLength 12.7
            -lensSqueezeRatio 1
            -cameraScale 1
            -horizontalFilmAperture 1
            -horizontalFilmOffset 0
            -verticalFilmAperture 1
            -verticalFilmOffset 0
            -filmFit Horizontal
            -overscan 1
            -motionBlur 0
            -shutterAngle 2.513274
            -nearClipPlane 0.000001
            -farClipPlane 100000
            -orthographic 0
            `

            ;

        // declare string to append to camera name
        string $direction[];

        $direction[0] = "_right";
        $direction[1] = "_top" ;
        $direction[2] = "_front" ;
        $direction[3] = "_left" ;
        $direction[4] = "_bottom" ;
        $direction[5] = "_back" ;

        $refCams[$i] = `rename
                    $camHold[0]
                    ($eachItem + $direction[$i])`;
        }
```

```
// Rotate the Cameras

string $angSettings = `currentUnit -query -angle`;

if ( $angSettings == "deg" )
    {
    setAttr ( $refCams[0] + ".RotateY" ) -90;
    setAttr ( $refCams[1] + ".RotateX" ) 90;
    setAttr ( $refCams[2] + ".RotateY" ) 180;
    setAttr ( $refCams[3] + ".RotateY" ) 90;
    setAttr ( $refCams[4] + ".RotateX" ) -90;
    }

if ( $angSettings == "rad" )
    {
    setAttr
        ( $refCams[0] + ".RotateY" )
        `deg_to_rad -90`;
    setAttr
        ( $refCams[1] + ".RotateX" )
        `deg_to_rad 90`;
    setAttr
        ( $refCams[2] + ".RotateY" )
        `deg_to_rad 180`;
    setAttr
        ( $refCams[3] + ".RotateY" )
        `deg_to_rad 90`;
    setAttr
        ( $refCams[4] + ".RotateX" )
        `deg_to_rad -90`;
    }

// find the center point of the object
    float $minB[] = `getAttr
            ( $eachItem + ".boundingBoxMin" )`;
    float $maxB[] = `getAttr
            ( $eachItem + ".boundingBoxMax" )`;

    float $objectPosition[]= {
            (($maxB[0] + $minB[0]) * 0.5 ),
            (($maxB[1] + $minB[1]) * 0.5 ),
            (($maxB[2] + $minB[2]) * 0.5 )
            };

// create the group containing all 6 views
    select -replace $refCams;
    string $camGrouping = `group -name "cameraGroup"`;
    xform -objectSpace -pivots 0 0 0 $camGrouping;
```

```
    //move it to position
    xform -worldSpace —transform
        $objectPosition[0]
        $objectPosition[1]
        $objectPosition[2]
        $camGrouping;

// set the rendering attributes
float $currWidth = `getAttr defaultResolution.width`;
float $currHeight = `getAttr defaultResolution.height`;
float $currAspect = `getAttr
                defaultResolution.deviceAspectRatio`;
string $currPrefix = `getAttr
                defaultRenderGlobals.imageFilePrefix`;

setAttr
    defaultResolution.width $resolution;
setAttr
    defaultResolution.height $resolution;
setAttr
    defaultResolution.deviceAspectRatio 1;
setAttr
    defaultRenderGlobals.imageFilePrefix
    -type "string" "";

setAttr ( $eachItem + ".visibility" ) off;

// Do renders
    for ( $eachCam in $refCams )
        {
        string $renderedImage = `render $eachCam`;
        //actual render

        string $tokenBuffer[];
        tokenize $renderedImage "/" $tokenBuffer;
        string $imageName =
            $tokenBuffer[(`size $tokenBuffer`-1)];

        $path = "";

        for (    $i = 0;
                $i < (`size $tokenBuffer` - 1);
                $i++ )
            $path = ( $path + $tokenBuffer[$i] + "\\" );

        string $old = ( $path + $imageName );

        tokenize $imageName "." $tokenBuffer;
        string $extension = $tokenBuffer[1];
```

```
            string $new = ( $path
                            + $eachCam
                            + "."
                            + $extension );

            $systemCmd = ( "move \""
                            + $old
                            + "\" \""
                            + $new
                            + "\"" );
            system ( $systemCmd );
            }
    // Clean Up Scene
    delete $camGrouping;

    setAttr ( $eachItem + ".v" ) 1;
    setAttr
        defaultResolution.width $currWidth;
    setAttr
        defaultResolution.height $currHeight;
    setAttr
        defaultResolution.deviceAspectRatio $currAspect;
    setAttr
        defaultRenderGlobals.imageFilePrefix
        -type "string" $currPrefix;
    }

select -replace $selection;
}
```

PROJECT

9.2: RENDERTIME SMOOTHING

Project Overview

Like non-linear animation, recent trends in computer graphics have led artists to largely abandon NURBs geometry in favor of subdivision surfaces, which offer the flexibility and ease of use of polygons, with the surface detail of spline surfaces. Different packages and renderers support subdivision surfaces in different ways, with Maya offering two possible ways of creating them. First are the hierarchical subdivision surfaces, the other being simple polygonal smoothing. It is interesting to note that the popularity of using polygonal smoothing in Maya is largely due to the work of Dirk Bialluch and his `connect-PolyShape` MEL script.

Although there are many uses for the Maya subdivision surfaces, many artists still prefer or are required to work with polygon smoothed geometry.

This could be because of the tools available only with polygons, using a renderer that does not support Maya subdivisional surfaces like Mental Ray, or a simple matter of artist preference. One feature that some other packages offer that Maya does not is the ability to have different smooth settings based on whether the model is in the viewport or being rendered. Some renderers, like PIXAR's Photorealistic RenderMan, tessellate the surface to an infinitely smooth level, based on the size of each polygon relative to the size of the final image. Other systems, like that found in discreet's 3ds max, let the user explicitly state a level of tessellation. Adding sub-pixel tessellation would require the functionality of the API, to add the ability to subdivide more than four times. Instead, we will add the second functionality to Maya using MEL, and at the same time expose a limitation of integrating MEL with rendering using the methods suggested by the documentation, and overcome it.

Definition and Design

We need to accomplish two distinctly different goals with our tool. First, we have to modify the polygon smooth node to allow a user some type of input. Because the smoothing is controlled by a node in Maya, specifically the `polySmoothFace` node, it is a simple matter of using the `setAttr` command to change the number of smoothing divisions. Although the commands to change the settings are a simple matter, we need to modify the Maya environment to automatically execute the script whenever a render is called. In addition, we will want to set the number of smoothing divisions back to the user level after the render is completed. The flowchart for the first aspect is seen in Flowchart 9.2.

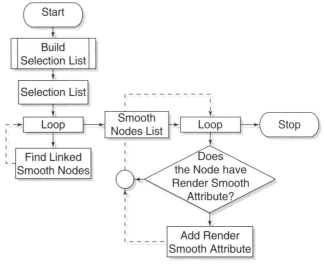

FLOWCHART 9.2 Adding the render smoothing attribute.

We could use a `scriptJob` that is executed whenever a new session of Maya is launched, or modify the command held in the Polygon menu to automatically execute our script whenever the user invokes the polygon smooth command. However, we will be content explicitly executing the command.

The second script is much simpler in theory, but has to be called both before and after the render. It is seen in Flowchart 9.3.

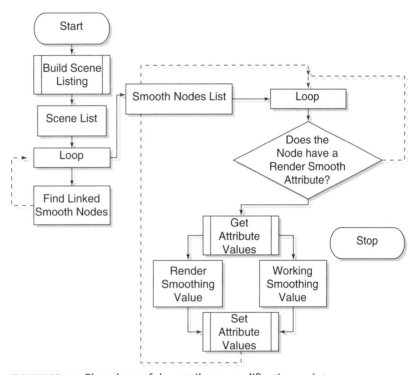

FLOWCHART 9.3 Flowchart of the attribute modification script.

It's interesting to note that we need to do similar sorting actions in both scripts to find the appropriate smoothing nodes. We can simplify matters by grouping the nodes together. Obviously, we aren't going to use a Maya group, so we need to find a way of grouping without grouping. While we could use a *set*, we will instead create artificial connections between objects. This is also useful for keeping track of objects within a script or expression, by avoiding explicit names. We will modify the design of the first script to make a connection between the `polySmoothFace` node and another node inside the Maya scene. Instead of using a user created node, we will, rather appropriately, connect to the `renderGlobals` node. The modified flowchart is seen in Flowchart 9.4.

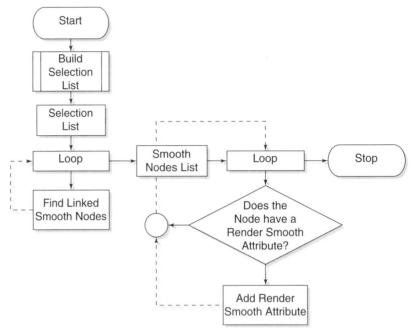

FLOWCHART 9.4 Modified flowchart.

Research and Development

Many aspects of the first script are built on the concepts learned to this point, such as finding the selection list and parsing through it. We have three things we need to know before proceeding to the first script:

- How to get the history of an object
- How to add attributes to an object via MEL
- How to connect attributes of objects via MEL

By simply knowing these things, we can accomplish everything in the setup script. Fortunately, MEL provides commands for all three functions: `listHistory`, `addAttr`, and `connectAttr`.

The second script is much simpler, but requires us of the *Pre Render Mel* and the *Post Render Mel* capabilities of the Maya renderer. In the Render Globals window, under the Render Options section, you can see text fields labeled Pre Render and Post Render, as seen in Figure 9.9.

These two fields allow a user to have Maya execute a command either right before or right after the render. This command could be anything from using `system` commands to copy and convert files to sending an e-mail to the user at the completion of a render. Because these two fields are actually attributes held on the node `defaultRenderGlobals`, we can use the `setAttr` command to automatically add the Pre Render Mel and Post Render Mel behavior

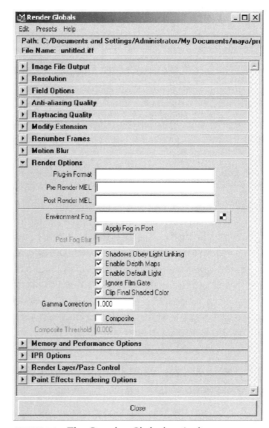

FIGURE 9.9 The Render Globals window.

to our scene, adding this to the setup script after the smooth node modification script is complete.

Implementation

Our first step, as always, is to create and validate a script for our tool, seen in Example 9.17. We will first create the setup script, called `setupSmoothRender.mel`.

EXAMPLE 9.17 Declaration of our procedure.

```
global proc setupSmoothRender ()
{
}
```

Our first task is find the current selection list and parse through it, using the `for-in` loop seen in Example 9.18.

EXAMPLE 9.18 Finding and parsing the selection list.

```
global proc setupSmoothRender ()
{
// build selection list
string $selList[] = `ls -selection`;

// parse the array holding the selection list
for ( $eachItem in $selList )
    {
    }
}
```

Within the loop parsing the selection list we need to get the history for each object, which is returned as a string array, and parse it to find whether any of the nodes contributing to the history of an object are polySmoothFace nodes. The main users of this tool will often have other nodes contributing to an object's history, such as a skinCluster node, so we have to parse the array storing the history of the object, building a new array of only the polySmooth-Face nodes. We have to make the variable declaration outside the for loop parsing the selection list, to make it visible outside the loop. The structure for this is shown in Example 9.19.

EXAMPLE 9.19 Finding the polySmoothFace nodes attached to our selection.

```
// declare array to hold polySmoothFace nodes
string $smoothNodes[];

for ( $eachItem in $selList )
    {
    // build array holding all the items contributing
    // to each object as we parse the array
    string $objHistory[] = `listHistory $eachItem`;

    // parse the history, check to see if
    // it is a smoothing node
    for ( $histNode in $objHistory )
        if ( `nodeType $histNode` == "polySmoothFace" )
            $smoothNodes[`size $smoothNodes`] =
                $histNode;
    }
```

ON THE CD

The text for this script is found on the companion CD-ROM as /project_07/se-tupSmoothRender/v01/setupSmoothRender.mel.

Using the size command inside the assignment statement allows the array to be sized dynamically without having to use an additional variable.

Now that we have a list of all the smoothing nodes, we need to add the attribute to the nodes to give the user input. We will also want to set the newly added attribute to be keyable. We do this for two reasons. First, because without being keyable, the dynamic attribute would not be viewable in the Channel Box, where the other attributes are accessible. Moreover, staying with the theme of keeping things consistent, because the attribute divisions is keyable, so should the newly added attribute, which we will call render-Divisions. Before adding the attribute we first will check if the attribute exists on the node. We do this to avoid Maya reporting an error if the user has an object that has already had setupSmoothRender executed on it. This simple code is seen in Example 9.20.

EXAMPLE 9.20 Adding our dynamic attribute.

```
// parse the list of smoothing nodes
for ( $eachNode in $smoothNodes )
    // check to see if the node already has the
    // added attributes, prevents error
    if (`attributeExists "renderDivisions"
            $eachNode` != 1)
    {
    addAttr
        -longName renderDivisions
        -attributeType long
        -minValue 0
        -maxValue 4
        -defaultValue 0
        $eachNode
        ;
    // make the attribute keyable so that it appears in
    // the Channel Box
    setAttr
        -edit
        -keyable true
        ( $eachNode + ".renderDivisions" )
        ;
    }
```

ON THE CD

The text for this script is found on the companion CD-ROM as /project_07/ setupSmoothRender/v02/setupSmoothRender.mel.

ON THE CD

At this point, we can prepare some test data, such as that seen in the scene poly_smooth_test.mb found on the companion CD-ROM under scenes/chapter09/project07/. We have four polygon objects that have smoothing applied. If we now run setupSmoothRender with the objects selected, we can look in the Channel Box to see a result that should be similar to that seen in Figure 9.10.

FIGURE 9.10 The added attributes.

Obviously, at this stage the added attributes don't really do much, but we can at least be assured the setup script functions properly. Before moving on to the Pre Render Mel and Post Render Mel scripts, we will catalog all the `polySmoothFace` nodes we just added this attribute to.

On the `defaultRenderGlobals`, we will add an attribute called `smoothRen-der`. This attribute will be a multi-message attribute, which will allow for multiple connections. We will also need to create a corresponding attribute on the `polySmoothFace` nodes. To keep things efficient, we will include adding the attribute and make the connection to the `defaultRenderGlobals` node in the same `for` loop we add the renderDivisions attribute in. Because the attribute needs to exist on the defaultRenderGlobals node already, we will place it before the `for` loop, again testing first to avoid any possible errors. This code, similar to that seen in Example 9.20, is shown in Example 9.21.

EXAMPLE 9.21 Adding more dynamic attributes.

```
// check for attribute existence, and adds
// it if necessary
if (`attributeExists "sRender"
        "defaultRenderGlobals"`!=1)
    addAttr
        -longName sRender
        -attributeType message
        -multi
        defaultRenderGlobals
        ;

// parse the list of smoothing nodes
for ( $eachNode in $smoothNodes )
    // check to see if the node already has the
    // added attributes, prevents error
    if (`attributeExists "renderDivisions" $eachNode` != 1)
```

```
{
addAttr
    -longName renderDivisions
    -attributeType long
    -minValue 0
    -maxValue 4
    -defaultValue 0
    $eachNode
    ;
// make the attribute keyable so that it appears in
// the Channel Box
setAttr
    -edit
    -keyable true
    ( $eachNode + ".renderDivisions" )
    ;
addAttr
    -longName sRender
    -attributeType message
    $eachNode
    ;
// connect the sRender attributes for
// later tracking
connectAttr
    -force
    defaultRenderGlobals.sRender
    ( $eachNode + ".sRender" )
}
```

ON THE CD

The text for this script is found on the companion CD-ROM as /project_07/ setupSmoothRender/v03/setupSmoothRender.mel.

If we select the `defaultRenderGlobals` node and display its up and downstream connections in the Hypergraph, we should see something similar to Figure 9.11.

Next, we will write the script to modify the `polySmoothFace.divisions` attribute to increase the tessellation of the smooth objects and return them to their previous state after the render is completed.

First, as always, we create and validate our script, as in Example 9.22.

EXAMPLE 9.22 Declaration of our new procedure.

```
global proc smoothRender ()
{
}
```

Once this is accomplished, we can begin to add our functionality. First, we will build an array of the smooth nodes to which we have added rendertime division. While we could take a brute force approach and search the entire scene

FIGURE 9.11 The connections to `defaultRenderGlobals`.

for any `polySmoothFace` nodes that have the attribute added, that would ignore the advantage we have of having set up the attributes in the first place. We can use the command `listConnections` to gather our node names, and assign the return to an array, seen in Example 9.23

EXAMPLE 9.23 Find all the nodes connected to defaultRenderglobals.

```
// Find all the smooth nodes with render time
// smoothing attributes
string $sNodes[] = `listConnections
                      defaultRenderGlobals.sRender;
```

Then, we simply parse the array and switch the values held in the `divisions` and `renderDivisions` attributes. This allows us to both set the `divisions` attribute to the appropriate value and easily store the old value, as well as creating a very simple script that does not need any arguments. While it's true that creating a more exacting script is possible, this will serve our purposes well enough. The code to switch the attribute values is seen in Example 9.24.

EXAMPLE 9.24 Switching the two values.

```
for ( $eachNode in $sNodes )
    {
    // get the values stored in the two divisions
    // attributes.
    int $renderDiv = `getAttr ( $eachNode
                                  +
                                  ".renderDivisions"
                                  )`;
    int $userDiv = `getAttr ( $eachNode
                                  +
                                  ".divisions"
                                  )`;
```

```
// switch the attribute values
setAttr ( $eachNode + ".divisions" ) $renderDiv;
setAttr ( $eachNode
        + ".renderDivisions" )
        $userDiv;
}
```

ON THE CD

The text for this script is found on the companion CD-ROM as /project_07 /smoothRender/smoothRender.mel.

With this script now in place, we can now call it from the command line and watch how our smoothed objects switch tessellation with each execution, assuming the renderDivisions attribute has been set to a different value.

If we place the command smoothRender in both the Pre Render Mel and Post Render Mel sections of the Render Globals window, as seen in Figure 9.12, and then set the Divisions of our smoothed boxes to 0 and the Render Divisions to 4, our scene is now ready.

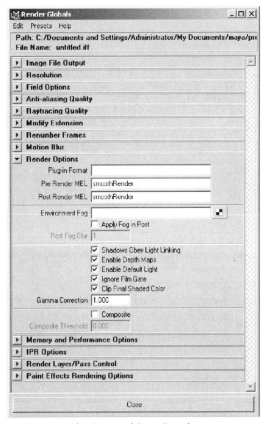

FIGURE 9.12 The Pre and Post Render setup.

This scene file is contained on the companion CD-ROM under scenes/chapter_09/ smooth/pre_post_setup.mb.

Now we can issue a render and immediately see the results of our work. Looking at Figures 9.13 and 9.14, we can see the differences between the working settings and the render settings.

FIGURE 9.13 The viewport view.

While we could, at this point, modify the setup script to edit the `preRenderMel` and `postRenderMel` attributes on `defaultRenderGlobals` to use the `smoothRender` script as soon as we run the setup script, there is one fatal flaw. Most likely, in actual production, our models will have more complexity than the simple cubes used in our tests. If we use a more complex model and issue a render, we can notice a pause between when the request is made for the render and when rendering begins. This is due to the time required to calculate the new surface. This, of course, is unavoidable, but we have a problem when we issue a batch rendering.

The Pre Render Mel and Post Render Mel script is called at every frame. What this means is that after each frame, our object's tessellation is returned to the user setting, and then re-tessellates it before rendering the next frame.

FIGURE 9.14 The rendered view.

This is both the strength and the weakness of Pre Render Mel and Post Render Mel scripts. So instead, we will use a *scriptNode*. Note that if the artists are using a deformation system, like a skin cluster, it might be preferable to smooth every frame, despite the time costs. Situations, as always, will vary.

ScriptNodes are similar to `scriptJobs`, in that they execute a MEL command when a specific action is done. The significant difference is that because they are an actual virtual object inside the Maya scene, the command is stored with the scene file. Note that if you call a custom Maya script from a `scriptNode`, or the Pre Render Mel and Post Render Mel for that matter, the script should be transported with the scene. Often, you can fully imbed the command in the scene using a `scriptNode`.

In addition, `scriptNodes` have a much more limited ways of being called than `scriptJobs`. Therefore, it is sometimes necessary to embed a `scriptNode` that builds a `scriptJob` when the file is opened.

If we want to edit a `scriptNode` inside of Maya, we use the Expression Editor, which has filter options to allow the selection of `scriptJobs`. The Expression Editor is seen in Figure 9.15, with the filter set to see `scriptNodes`.

As we can see, the option exists to execute the command held in the `scriptNode` either before or after, or more specifically to hold separate commands to be executed before and after the `scriptNode` condition. Script-Nodes have the following conditions that can be used:

- On demand
- On file load or when the `scriptNode` is deleted
- On file load or when the `scriptNode` is deleted when the Maya session is not in batch mode
- On software render
- On software frame render

There are also some internal conditions that are used for controlling the UI. The two conditions that should immediately catch our eye are the software render and the software frame render conditions. The software frame render

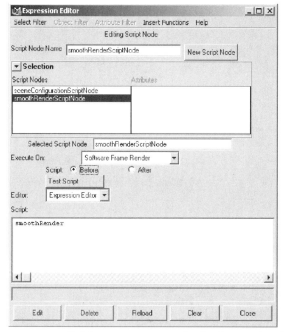

FIGURE 9.15 Editing a `scriptNode` in the Expression Editor.

condition is functionally identical to the Pre Render Mel and Post Render Mel commands. The software render condition, on the other hand, executes only once before a render, and once at the end of the render, depending on settings. We will first build a test `scriptJob`, and then integrate that into the setup script.

Creating a `scriptNode` via the Expression Editor is very easy.

1. Open the Expression Editor under Window > Animation Editors > Expression Editor.
2. In the Expression Editor, type the name "`testScriptJob`" in the name field.
3. In the command area, enter in `smoothRender` and click the Create button.
4. Then, change the pulldown labeled as "Type" to "Software Render."
5. Finally, select the After button, enter in `smoothRender` again, and click Edit.

Now, we can issue a software batch render, and the smooth node tessellation is computed only once, at the beginning of the render. We can now open the `setupSmoothRender.mel` file and add the MEL commands to build the `scriptNode` whenever a user adds render time smoothing to the scene. The actual creation of the script node is similar to that of any object. At the end of the `setupSmoothRender` procedure, if we add the code seen in Example 9.25, we will create the `scriptNode`, but only if one does not already exist.

EXAMPLE 9.25 Creating a scriptNode.

```
// Check for the existence of the scriptNode and create
// it if it does not
if ( `objExists smoothRenderScriptNode` != 1 )
    scriptNode
        -scriptType 4
        -beforeScript "smoothRender"
        -afterScript "smoothRender"
        -name smoothRenderScriptNode
        ;
```

This will now complete all the functionality of our script.

ON THE CD *The text for this script is found on the companion CD-ROM as /project_07/se-tupSmoothRender/finished/setupSmoothRender.mel.*

Project Conclusion and Review

Using MEL commands in the Pre Render Mel and Post Render Mel sections of the `renderGlobals` is a powerful, if somewhat narrow, way of taking control of the render process. The fact that the commands are issued before or after every frame is at the same time both a positive and a negative, depending on which behavior is needed. However, by using `scriptNodes`, we can embed MEL behavior right in the scene file itself. Once again, Maya's open node based structure has allowed us to solve one problem in multiple ways depending on the situation at hand.

Project Script Review

setupSmoothRender.mel

```
global proc setupSmoothRender ()
{
// build selection list
string $selList[] = `ls -selection`;

// parse the array holding the selection list
for ( $eachItem in $selList )
    {
    // declare array to hold polySmoothFace nodes
    string $smoothNodes[];

    for ( $eachItem in $selList )
        {
        // build array holding all the items
        // contributing to each object as we parse
        // the array
```

```
            string $objHistory[] = `listHistory $eachItem`;

            // parse the history, check to see if
            // it is a smoothing node
            for ( $histNode in $objHistory )
                if ( `nodeType $histNode`
                        == "polySmoothFace" )
                    $smoothNodes[`size $smoothNodes`]
                        = $histNode;
            }
        }
    // Add attribute to render globals
    // check for attribute existence, and adds
    // it if necessary
    if ( `attributeExists "sRender" "defaultRenderGlobals"`
        != 1 )
        addAttr
            -longName sRender
            -attributeType message
            -multi
            defaultRenderGlobals
            ;

    // parse the list of smoothing nodes
    for ( $eachNode in $smoothNodes )
        // check to see if the node already has the
        // added attributes, prevents error
        if (`attributeExists "renderDivisions" $eachNode`
            != 1 )
            {
            addAttr
                -longName renderDivisions
                -attributeType long
                -minValue 0
                -maxValue 4
                -defaultValue 0
                $eachNode
                ;
            // make the attribute keyable so that it
            // appears in the Channel Box
            setAttr
                -edit
                -keyable true
                ( $eachNode + ".renderDivisions" )
                ;
            addAttr
                -longName sRender
```

```
                -attributeType message
                $eachNode
                ;
        // connect the sRender attributes for
        // later tracking

        connectAttr
            -force
            defaultRenderGlobals.sRender
            ( $eachNode + ".sRender" )
        }
    // Check for the existence of the scriptJob and create
    // it if it does not
    if ( `objExists smoothRenderScriptNode` != 1 )
        scriptNode
            -scriptType 4
            -beforeScript "smoothRender"
            -afterScript "smoothRender"
            -name smoothRenderScriptNode
            ;
    }
```

smoothRender.mel

```
    global proc smoothRender ()
    {
    // Find all the smooth nodes with render time
    // smoothing attributes
    string $sNodes[] = `listConnections
                        defaultRenderGlobals.sRender;

    for ( $eachNode in $sNodes )
        {
        // get the values stored in the two divisions
        // attributes.
        int $renderDiv = `getAttr ( $eachNode
                                    +
                                    ".renderDivisions"
                                    )`;
        int $userDiv = `getAttr ( $eachNode + ".divisions" )`;
        // switch the attribute values
        setAttr ( $eachNode + ".divisions" ) $renderDiv;
        setAttr ( $eachNode + ".renderDivisions" )
            $userDiv;
        }
    }
```

CONCLUSION

Rendering is a largely passive process, and therefore not an area artists feel they have much influence over, other than the creation of the elements being rendered. However, by using MEL to enhance the pipeline associated with the renderer, even in the most basic ways shown here, we see how much easier an artist's life becomes once the scripting becomes a part of it. We also learned how to use Maya to communicate with the operating system, allowing MEL to pass information, work with files, or even interface with other scripts, such as PERL or Python scripts. This expands the power and flexibility of Maya far beyond what many artists think are its limits.

10 CREATING TOOLS IN MAYA

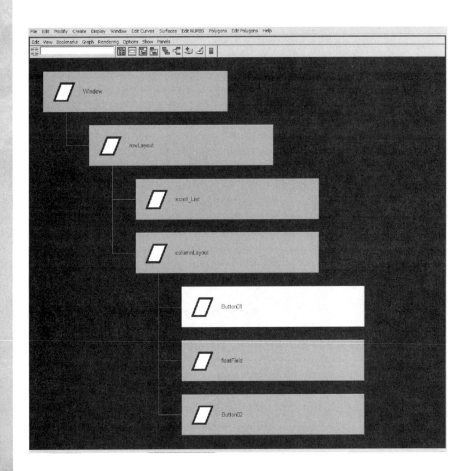

There is perhaps no single thing that adds more polish and usability to a script than a graphical user interface (GUI). Using a subset of MEL called the *Extended Layer Framework*, or ELF, these commands allow a scripter to create or access nearly every aspect of the Maya interface, including but not limited to:

- Modifying such standard Maya elements as the Channel Box and Menus
- Adding heads-up displays
- Building full windows for your scripts

It is important to note that some things cannot be done to the user interface with scripting. Most notably, it is not possible to create custom manipulators without using the API. There are also some elements of the user interface that cannot be accessed with scripting commands. Finally, while it is possible to build incredibly complex windows that combine and optimize existing editors, you cannot create new editor types without the API. What we mean by a new "editor" is a new *class* of editor. You could, for example, build a new interface, using existing interface elements, to edit shading nodes, but you could not implement a totally new editor like the Hypershade (if we imagine for a moment that the Hypershade does not exist).

When it comes to building user interfaces (UIs), there are some positives and negatives to the way they are implemented in Maya. Perhaps their biggest advantage is that because almost every aspect of the Maya interface is created with MEL, they are available to be modified by the MEL-savvy user. In addition, this makes it quite easy to appropriate existing Maya windows for your own use. Moreover, because the user interfaces are created with scripting, they truly are dynamic. For example, you can create a window that has a separate section for each object selected, or displays different options based on what type of geometry is selected. All is not perfect in the world of MEL UI building, however. First and foremost, the syntax rules for building UIs is somewhat more demanding and involved than that of simple MEL scripts. In addition, the scripts that create user interfaces, especially for very complex windows, tend to be very long and therefore slow to execute. Finally, and perhaps where the following pages will be most useful, is that building UI windows that look exactly as we want can be difficult, even for experienced scripters. In fact, many scripters and programmers consider building UIs to be the most frustrating part of working with MEL.

So, as we delve into the exciting world of Maya interfaces, we need to keep a few things in mind. First, as with MEL scripting, it will take some time before we are able to build the incredibly complex windows some Maya tools create. In addition, remember that the look of Maya windows is often an odd mixture on such user variables as operating system, operating system colors, Maya user colors, and screen resolution.

Therefore, if your results do not look identical to those presented in the figures in the following pages, please account for all these variables before panicking.

INTRODUCTION TO MAYA WINDOW STRUCTURES

A user interface window in Maya is similar in many ways to geometric objects that are built in Maya; that is, their structures are hierarchical. Various elements are nested within each other, placed relative to each other, and are referred to by their familial lineage.

Windows

At the root of any Maya UI window is, and this should come as no surprise, the *window*. Windows exist as floating panels, and can be dismissed by either the user or by the issuance of a MEL command. Although optional, most windows use the *title bar*, and the *minimize button*. Although it is possible to have a *maximize button*, many leave this particular element off their user interfaces. The window also gets a free additional element of an optional menu bar. All these options are seen in Figure 10.1, with the code to draw the window seen in Example 10.1.

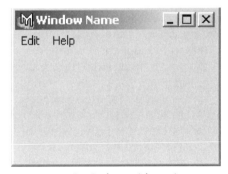

FIGURE 10.1 A window with options on.

EXAMPLE 10.1 The MEL code that created the window in Figure 10.1.

```
string $window = `window
            -title "Window Name"
            -iconName "Icon Name"
            -widthHeight 200 350
            -menuBar on
            -menuBarVisible on
            -minimizeButton on
```

```
                           -maximizeButton on
                           -sizeable on
                           -titleBar on`;
        menu
            -label "Edit"
            -tearOff false;

            menuItem
                -label "Nothing";
        menu
            -label "Help"
            -tearOff 0;

            menuItem
                -label "Script Information";
            menuItem
                -divider 1;
            menuItem
                -label "Visit Charles River Media Homepage"
                -command "showHelp —absolute
                        \"http:\//www.charlesriver.com\"";

    showWindow $window;
```

A window is by default invisible. While it might seem strange and somewhat counter-intuitive to have invisible windows, making a window visible is simply a matter of issuing the showWindow command. The reason being is that in between the two commands is where the actual window is built. First, the window is created, and once all of its elements are in place, the window is made visible. This entire process takes mere fractions of a second in most cases, but the process is important.

As designers, we have a fair amount of control over how a window initially appears. Window size and placement are under the control of the scripter—initially. Unfortunately, the engineers at Alias|Wavefront insist on giving those pesky end users control over how their windows will appear, remembering their position and size when they are closed. We can turn this option off, either in the Maya preferences or via the MEL command windowPref —remove *windowName*, which will allow us to explicitly size and place the window every time.

To this point, we have only discussed windows for UIs you want to create yourself. There are, however, a variety of situational windows available to a MEL scripter. These windows allow for simple interaction and feedback with the end user. The most important of these windows are the *Confirm dialog*, the *Prompt dialog*, and the *Progress window*. We call these *Modal windows*.

The Confirm Dialog window acts as a safety measure in scripts. Often, it is good practice and simply polite to include a Confirm dialog in a script,

which through its most basic functionality is destructive or can take an extraordinary long time to complete. The actual window, seen in Figure 10.2 is created with the command `confirmDialog`, with the options seen in Example 10.2.

FIGURE 10.2 The typical Confirm dialog.

EXAMPLE 10.2 The MEL code that created the window in Figure 10.2.

```
confirmDialog
    -title "Confirm Dialog"
    -message "Are you sure?"
    -button "Yes"
    -button "No"
    -defaultButton "Yes"
    -cancelButton "No"
    -dismissString "No";
```

When called from a script, the execution of that script pauses while waiting for the user to respond. When the user issues his choice via the dialog, we capture that value and use it in an `if` statement to control the execution of the remainder of the script.

The Prompt Dialog window, such as that seen in Figure 10.3, provides a way for additional input to be provided to a script during the execution of the script.

FIGURE 10.3 A Prompt dialog.

EXAMPLE 10.3 The MEL code that created the window in Figure 10.3.

```
string $URL;
```

```
string $result = `promptDialog
                  -title "Open Which URL?"
                  -message "Enter Website:"
                  -button "OK"
                  -button "Cancel"
                  -defaultButton "OK"
                  -cancelButton "Cancel"
                  -dismissString "Cancel"`;

if ($result == "OK")
    {
        $URL = `promptDialog -query`;
        showHelp -absolute $URL;
    }
```

Prompt dialogs are very useful in scripts that need only a single piece of user provided information, especially if that information is text. By using the dialog, called with the `promptDialog` command as seen in Example 10.3, allows the command to be included in a menu or as a shelf button rather than using a variable passed to the procedure. This makes the script both more user friendly and more flexible, which should be the goal of any script after functionality is achieved. Because they are so easily implemented, a series of Prompt dialogs can be used to quickly add interaction to a script, while a more robust UI is developed. The Prompt dialog, unlike the Confirm dialog, needs to be queried before the data can be accessed and used.

The Progress window is one of the best additions to the MEL language since its introduction. Previously, the only way to let the user know his script was doing anything was to use the command `waitCursor`. However, as of Maya 4, it is now possible to give real-time feedback to the user as the script progresses. The Progress window, like the one seen in Figure 10.4, is issued updates from within the script, often in the default form as a percentage.

FIGURE 10.4 A Progress window.

The Progress window can be updated with an explicit value, but the total number of operations needed must be known. For this reason, it is almost never used in a `while` loop; rather, it is easy to use in a `for` loop, as

seen in Example 10.4. The other extremely useful aspect of the Progress window is that it allows the user to cancel a process. For this reason alone, even if a script will not take 20 minutes to execute, it can be beneficial to implement one into loops.

EXAMPLE 10.4 Creation of a Progress window.

```
int $amount = 0;

progressWindow
    -title "Sample Progress"
    -progress $amount
    -status "Percentage Complete: 0%"
    -isInterruptable true;

for ( $amount = 0;$amount < 100 ;$amount++ )
    {
    if ( `progressWindow -query -isCancelled` )
        break;

    progressWindow
        -edit
        -progress $amount
        -status ("Percentage Complete: "
                + $amount
                + "%" );

    pause -seconds 1;
    }

progressWindow -endProgress;
```

Layouts

The window is in effect, a holder, an empty vessel waiting to be filled. The first step is to add a *layout*. Layouts provide the basic framework for all the elements that will be placed within any given window. In the following section, we will first gain an understanding of the various layouts available, and then cover their positioning, sizing, and unique attributes.

A *Column Layout*, seen in Figure 10.5, places its children in a vertical column. In the example pictured, five buttons are stacked on top of each other. The code that draws this window is seen in Example 10.5.

EXAMPLE 10.5 The MEL code that created the window in Figure 10.5.

```
window -title "columnLayout";
```

FIGURE 10.5 A columnLayout with five buttons.

```
columnLayout
    -columnAttach "both" 5
    -rowSpacing 10
    -columnWidth 250;

    button
        -label "First Button";
    button
        -label "Second Button";
    button
        -label "Third Button";
    button
        -label "Fourth Button";
    button
        -label "Fifth Button";

showWindow;
```

Column Layouts are perhaps the most basic of all layouts, perhaps equaled only by the *Row Layout*. A Row Layout, like the one seen in Figure 10.6, places its children in a horizontal row. As seen in Example 10.6, the command to define the Row Layout is slightly more involved than the columnLayout command.

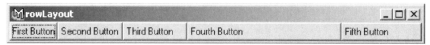

FIGURE 10.6 A rowLayout with five buttons.

EXAMPLE 10.6 The MEL code that created the window in Figure 10.6.

```
window
    -title "rowLayout";

rowLayout
    -numberOfColumns 5
    -columnWidth5 60 70 80 190 100
    -adjustableColumn 2
    -columnAlign  1 "right"
    -columnAttach 1 "both"  0
    -columnAttach 2 "both"  0
    -columnAttach 3 "both"  0
    -columnAttach 4 "both"  0
    -columnAttach 5 "both"  0
    ;

button
    -label "First Button";
button
    -label "Second Button";
button
    -label "Third Button";
button
    -label "Fourth Button";
button
    -label "Fifth Button";

showWindow;
```

Because of their simplicity, the Column and Row Layouts can be used to quickly and easily create UIs that do not require a large variety of controls or need to be built dynamically.

Although the Column Layout and the Row Layout are often used, there is a layout that simplifies their implementation. The *rowColumn* layout allows a user to create either a Row Layout or a Column Layout depending on the flags used during creation.

If you took a Row Layout and a Column Layout and combined them, you would get the *Grid Layout*, seen in Figure 10.7, and the corresponding code in Example 10.7.

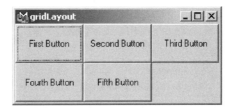

FIGURE 10.7 A gridLayout with nine buttons.

EXAMPLE 10.7 The MEL code that created the window in Figure 10.7.

```
window -title "gridLayout";

gridLayout
    -numberOfColumns 3
    -cellWidthHeight 90 50;

button
    -label "First Button";
button
    -label "Second Button";
button
    -label "Third Button";
button
    -label "Fourth Button";
button
    -label "Fifth Button";

showWindow;
```

Grid layouts are limited by the fact that each cell has to be the same dimension.

Obviously, the previous examples provide simple holders of UI elements. Often, a UI will need to be somewhat more interactive. There are four layouts that provide ways of making windows more interactive, often allowing a large amount of controls to be compressed into a smaller window.

Perhaps the most infrequently used of all layouts is the *Pane Layout*, seen in Figure 10.8. Pane Layouts allow the end user to resize elements of the window by dragging a divider. Pane Layouts can be built with up to four sections.

EXAMPLE 10.8 The MEL code that created the window in Figure 10.8.

```
window
    -title "paneLayout"
    -widthHeight 280 370;

paneLayout
    -configuration "quad";

button
    -label "First Button";
button
    -label "Second Button";
```

FIGURE 10.8 A four-paned paneLayout.

```
button
    -label "Third Button";
button
    -label "Fourth Button";

showWindow;
```

Note that when setting the sizing of the various panes, the values are percentages, rather than the pixel values used by most other layouts. The code used in Example 10.8 uses the default values.

The *Tab Layout* is a very easy way of putting a large number of controls in one window. Seen in Figure 10.9, page 280, the Tab Layout creates pages, each one containing its own set of controls. As seen in Example 10.9, the code used to draw this window uses Child Layouts to create the tabs. We will cover Child Layouts later in this chapter.

EXAMPLE 10.9 The MEL code that created the window in Figure 10.9.

```
window
    -title "tabLayout"
    -widthHeight 280 370;

tabLayout
    -innerMarginWidth 5
    -innerMarginHeight 5;
```

FIGURE 10.9 A window containing a tabLayout.

```
columnLayout
    -columnAttach "both" 5;
    button
        -label "First Button";
    button
        -label "Second Button";
    button
        -label "Third Button";
    setParent..;

columnLayout
    -columnAttach "both" 5;

    button
        -label "Fourth Button";
    button
        -label "Fifth Button";
    setParent..;

showWindow;
```

One of the more useful interactive layouts is the *Frame Layout*. The Frame Layout surrounds its child with a frame that can be made collapsible. In Figure 10.10, the same frame layout is seen both open and collapsed. Note that while in Example 10.10 our Frame Layouts are created with the frames open, it is possible to close them from within code.

EXAMPLE 10.10 The MEL code that created the window in Figure 10.10.

```
window
    -title "frameLayout"
    -widthHeight 280 370;
```

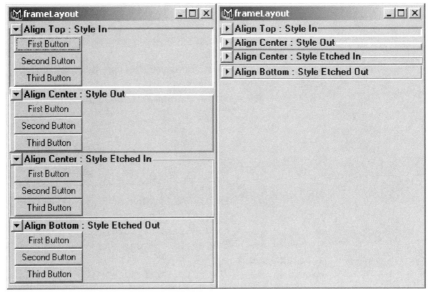

FIGURE 10.10 The same frameLayout, both open and closed.

```
columnLayout -adjustableColumn true;

    frameLayout
        -label "Align Top : Style In"
        -labelAlign "top"
        -borderStyle "in"
        -collapsable true;

        columnLayout
            -columnAttach "both" 5;

            button
                -label "First Button";
            button
                -label "Second Button";
            button
                -label "Third Button";
            setParent..;
        setParent ..;

    frameLayout
        -label "Align Center : Style Out"
        -labelAlign "center"
        -borderStyle "out"
        -collapsable true;
```

```
              columnLayout
                  -columnAttach "both" 5;

                  button
                      -label "First Button";
                  button
                      -label "Second Button";
                  button
                      -label "Third Button";
                  setParent..;
              setParent ..;

          frameLayout
              -label "Align Center : Style Etched In"
              -labelAlign "center"
              -borderStyle "etchedIn"
              -collapsible true;
      columnLayout
                  -columnAttach "both" 5;

                  button
                      -label "First Button";
                  button
                      -label "Second Button";
                  button
                      -label "Third Button";
                  setParent..;
              setParent ..;

          frameLayout
              -label "Align Bottom : Style Etched Out"
              -labelAlign "bottom"
              -borderStyle "etchedOut"
              -collapsable true;

              columnLayout
                  -columnAttach "both" 5;

                  button
                      -label "First Button";
                  button
                      -label "Second Button";
                  button
                      -label "Third Button";
                  setParent..;
              setParent ..;

      showWindow;
```

The last of the truly interactive layouts is the *Scroll Layout*. Scroll Layouts provide just that, a scrolling window, similar to a Web browser or word processor, which allows a large amount of controls to fit into a single window. In Figure 10.11 we see the same window, first without a Scroll Layout, and then with a Scroll Layout holding the remaining controls. Example 10.11 shows how the Scroll Layout equipped window was created.

FIGURE 10.11 The same window; the second view has a scrollLayout.

EXAMPLE 10.11 The MEL code that created the window in Figure 10.11.

```
window
    -title "scrollLayout"
    -widthHeight 70 100;

scrollLayout
    -horizontalScrollBarThickness 10
    -verticalScrollBarThickness   10;

    columnLayout
        -columnAttach "both" 5;
```

```
        for ($i = 0; $i < 20; $i++)
            button
                -label ( "Button " + $i );

    showWindow;
```

Maya has never been accused of not using all of its available screen real estate, so if a window does take up a fair amount of the screen by default, it is often a good idea to include a Scroll Layout to consider the inevitable resizing any end user will do, if the window allows it.

Although perhaps not the most interactive of user interface layouts, perhaps the most familiar and the easiest to add functionality to is the *Shelf Layout*. The Shelf Layout embeds a standard Maya shelf into a window. It has a sibling layout, the *Shelf Tab Layout,* which provides a shortcut to creating tabbed shelves, and includes the "trashcan" used for discarding shelf elements. A Shelf Layout is seen in Figure 10.12, created with Example 10.12.

FIGURE 10.12 A shelfLayout.

EXAMPLE 10.12 The MEL code that created the window in Figure 10.12.

```
    window
        -title "shelfLayout"
        -widthHeight 150 200;

    shelfLayout PolyModel;

        shelfButton
            -enableCommandRepeat 1
            -enable 1
            -width 34
            -height 34
```

```
        -manage 1
        -visible 1
        -annotation "Create Polygon Tool:
                      Create polygon faces"
        -label "Create Polygon Tool"
        -image1 "polyCreateFacet.xpm"
        -style "iconOnly"
        -command "setToolTo polyCreateFacetContext ;
                polyCreateFacetCtx -e -pc `optionVar -q
                polyKeepFacetsPlanar`
                polyCreateFacetContext"
          -doubleClickCommand "setToolTo
                      polyCreateFacetContext ;
                      polyCreateFacetCtx -e -pc
                      `optionVar -q
                      polyKeepFacetsPlanar`
                      polyCreateFacetContext;
                      toolPropertyWindow";
    shelfButton
        -enableCommandRepeat 1
        -enable 1
        -width 34
        -height 34
        -manage 1
        -visible 1
        -annotation "Combine: Combine the selected
                      polygon objects into one single
                      object to allow operations such
                      as merges or face trims"
        -label "Combine"
        -image1 "polyUnite.xpm"
        -style "iconOnly"
        -command "polyPerformAction polyUnite o 0"
        ;
    shelfButton
        -enableCommandRepeat 1
        -enable 1
        -width 34
        -height 34
        -manage 1
        -visible 1
        -annotation "Transfer: Select two objects to
                      be crossed"
        -label "Transfer"
        -image1 "polyTransfer.xpm"
        -style "iconOnly"
        -command "performPolyTransfer 0"
        ;
    shelfButton
```

```
                    -enableCommandRepeat 1
                    -enable 1
                    -width 34
                    -height 34
                    -manage 1
                    -visible 1
                    -annotation "Union: Performs a boolean Union on
                                the selected polygon objects,
                                creating a new object"
                    -label "Union"
                    -image1 "polyBooleansUnion.xpm"
                    -style "iconOnly"
                    -command "polyPerformAction \"polyBoolOp
                                -op 1\" o 0";
            shelfButton
                    -enableCommandRepeat 1
                    -enable 1
                    -width 34
                    -height 34
                    -manage 1
                    -visible 1
                    -annotation "Difference: Performs a boolean
                                Difference on the selected
                                polygon objects, creating a
                                new object"
                    -label "Difference"
                    -image1 "polyBooleansDifference.xpm"
                    -style "iconOnly"
                    -command "polyPerformAction \"polyBoolOp
                                -op 2\" o 0";
            shelfButton
                    -enableCommandRepeat 1
                    -enable 1
                    -width 34
                    -height 34
                    -manage 1
                    -visible 1
                    -annotation "Intersection: Performs a Boolean
                                Intersection on the selected
                                polygon objects, creating a
                                new object"
                    -label "Intersection"
                    -image1 "polyBooleansIntersection.xpm"
                    -style "iconOnly"
                    -command "polyPerformAction \"polyBoolOp —op
                                3\" o 0";
            shelfButton
                    -enableCommandRepeat 1
                    -enable 1
```

```
                    -width 34
                    -height 34
                    -manage 1
                    -visible 1
                    -annotation "Mirror: Mirror geometry
                                across an axis."
                    -label "Mirror Geometry"
                    -image1 "polyMirrorGeometry.xpm"
                    -style "iconOnly"
                    -command "waitCursor -state on;
                                polyMirror 1 0 0 off;
                                waitCursor -state off"
                    -doubleClickCommand "performPolyMirror 1";
            showWindow;
```

Although there are a few other infrequently used layouts, that provides an overview of all the major layouts except one—the *Form Layout*. If there is a secret to creating good-looking interfaces in Maya, it is the Form Layout. Form Layouts allow the placement of its children either relative to each other or with absolute values. More detail on the use of the Form Layout and the placement of elements is found later in this chapter.

Layout Hierarchy

One thing that is key to creating useful and logical window designs is to nest and layer layouts. Some layouts, such as the Tab Layout, essentially require it, because they only allow one child. For example, in Figure 10.13 we see a Row Layout, which has three columns. Each of those columns contains a Column Layout, and each of those Column Layouts contains three buttons. The code for this window is seen in Example 10.13.

FIGURE 10.13 Nesting layouts.

EXAMPLE 10.13 The MEL code that created the window in Figure 10.13.

```
        window
            -title "Nesting Layouts";

        rowLayout
```

```
-numberOfColumns 3
-columnWidth3 100 100 100
-columnAlign  1 "right"
-columnAttach 1 "both" 0
-columnAttach 2 "both" 0
-columnAttach 3 "both" 0 ;
columnLayout
    -columnAttach "both" 5
    -rowSpacing 2
    -columnWidth 100;

    button;
    button;
    button;
    setParent..;

columnLayout
    -columnAttach "both" 5
    -rowSpacing 2
    -columnWidth 100;

    button;
    button;
    button;

    setParent..;

columnLayout
    -columnAttach "both" 5
    -rowSpacing 2
    -columnWidth 100;

    button;
    button;
    button;
    setParent..;

showWindow;
```

By nesting layouts, it is quite easy to create incredibly dense and rich interfaces. For example, by nesting some Column Layouts within some Frame Layouts within some Tab Layouts, it would be possible to pack dozens of buttons in a small window, such as that seen in Figure 10.14.

Now that we have access to a variety of layouts, we need to begin adding the sliders, buttons, and other items that add functionality to an interface. These items, as a general class of items, are called *controls*.

FIGURE 10.14 Packing 500 buttons into a single window.

Controls

Controls often have a basic form, and then a form that combines various controls into a single control to make UI creation theoretically easier. For example, the control *Float Slider* creates a control for entering in a single floating-point value using a slider. There is also a control entitled *Float Slider Group*, which creates a collection of a slider, a label, and a float field as a single control. While this could be useful, it is often better to construct the elements separately to achieve more precise control over the placement of various elements in the window.

There are a few classes of controls that differ only by what type of data they hold. Similar to variables, a control designed to hold a string can still hold a floating point, but not the other way around. This is not to say you need to explicitly have a control be the same type of number with which you want to interact. For example, if you are dealing with a percentage value, you might want to use an integer slider going from 0% to 100%. For the same value, you might instead want to use a floating-point slider going from 0.0% to 100.0%. The choice is made based on what the value is to be used for and how much control you want to give to the end user.

Control Types

The first of the basic classes of controls that exist for multiple data types is the *field*. Field controls allow the entry of data explicitly. In Figure 10.15,

we see a window containing the three basic field controls—the *text field,* the *int field,* and the *float field.* As seen in Example 10.14, even controls as simple as these have a wide variety of options and arguments.

FIGURE 10.15 Various fields.

EXAMPLE 10.14 The MEL code that created the window in Figure 10.15.

```
window
    -title "Field Controls"
    -widthHeight 190 500;

columnLayout;
    floatField;
    floatField
        -editable false;
    floatField
        -minValue
        -20
        -maxValue 20
        -value 0;
    floatField
        -minValue 0
        -maxValue 1
        -precision 2;
    floatField
        -minValue -1
        -maxValue 1
        -precision 4
        -step .01;
    intField;
```

```
        intField
            -editable false;
        intField
             -minValue -10
             -maxValue 10
             -value 0;
        intField
             -minValue -1000
             -maxValue 1000
             -step 10;
        textField
             -text "textField";
    showWindow;
```

In addition to the basic fields, each also has a version representing a control group. Control groups allow multiple fields to be created by and accessed with a single control command. The choice to use a field group rather than multiple individual fields is often defined by what data is held in the control and the desired appearance of the UI. For example, in Figure 10.16, we see two possible control setups. The first control is a float field group containing, in this pretend example, the translate data for some object. The second control is actually three individual float fields, but by constructing them separately, each can be given its own label, as well as a vertical orientation to the three fields. In Example 10.15, it is evident that creating these structures as individual elements is not significantly more complex than using the control groups.

FIGURE 10.16 Using groups vs. individual elements.

EXAMPLE 10.15 The MEL code that created the window in Figure 10.16.

```
    window
        -title "Field Group Controls"
        -widthHeight 390 110;

    columnLayout;
        floatFieldGrp
             -numberOfFields 1
             -label "fieldGroup";
```

```
                    floatFieldGrp
                        -numberOfFields 3
                        -label "multiField Group";
                    text
                        -label "Text Control as label";
                    floatField;
            showWindow;
```

In addition to the three basic fields, there are some additional fields that are more specialized in their functionality. For example, the *Name Group* creates a text field linked to the name of an object in the Maya scene. When the object is renamed, the field updates, or you could use the field to rename the object. Another control related to the text field is the *Scroll Field*, which creates a large scrolling area for text entry.

Two basic control types that are similar are *scrolls* and *sliders*. Seen in Figure 10.17, which shows an *Integer Slider* and an *Integer Scroll*, the differences between scrolls and sliders might seem to be mainly cosmetic. However, the addition of the arrows on the scroll allows for finite tuning of the value the control influences. Example 10.16 shows how the window was constructed.

FIGURE 10.17 A slider vs. a scroll control.

EXAMPLE 10.16 The MEL code that created the window in Figure 10.17.

```
    window
        -title "Slider and Scroll Controls";

    columnLayout
        -adjustableColumn true;

        intSlider;
        intSlider
            -min 0
            -max 100
            -value 0
            -step 1;
        floatScrollBar;
        floatScrollBar
```

```
                    -min 0
                    -max 100
                    -value 0
                    -step 1
                    -largeStep 10;
    showWindow;
```

Both sliders and scrolls can be oriented either horizontally or verti-cally. Moreover, like fields, sliders can be created in groups. In addition, there exists specialty sliders, the *Color Slider Group* and the *Color Index Slider Group*, designed specifically to pick colors, either any RGB/HSV value in the case of the Color Slider, or one of the user's index color val-ues by the latter. In both cases, clicking on the color swatch automatically brings up the appropriate editor. In Figure 10.18 we see both controls, and although they appear nearly identical, they are separate control types, evident in the code seen in Example 10.17.

FIGURE 10.18 Color Picking Sliders.

EXAMPLE 10.17 The MEL code that created the window in Figure 10.18.

```
    window
        -title "ColorSlider Controls";

    columnLayout
        -adjustableColumn true;

        colorIndexSliderGrp
            -label "Select Color"
            -min 0
            -max 20
            -value 10;

        colorSliderButtonGrp
            -label "Select Color"
            -buttonLabel "Button"
            -rgb 1 0 0;
    showWindow;
```

In addition to the scroll controls that are linked to numeric values, the *Text Scroll List* control allows for a listing of text elements. It is possible

to define whether the end user is allowed to select only a single element in the list, or multiple items. Text scroll lists are extremely effective in interfaces in which a user needs to interact with a string array, and are often used for mass editors, such as a tool to quickly access every light in the scene, for example. A Text Scroll List is used in the window seen in Figure 10.19, drawn with the code in Example 10.18.

FIGURE 10.19 The textScrollList control.

EXAMPLE 10.18 The MEL code that created the window in Figure 10.19.

```
string $sceneList[] = `ls`;

window
    -title "textScrollList Control";

    columnLayout -adjustableColumn true;

        string $scroll = `textScrollList
                            -numberOfRows 10
                            -allowMultiSelection true`;

        for ( $each in $sceneList )
            textScrollList
                -edit
                -append $each
                $scroll;
    showWindow;
```

The other two control types that are most often used to control data are the *checkbox* and the *radio button*. Checkboxes are used for controlling Boolean attributes or variables, such as the visibility of an object. Like previous controls, checkboxes can be created in groups of up to four individual checkboxes. A window showing four individual checkboxes is seen in Figure 10.20, drawn with Example 10.19.

FIGURE 10.20 Checkboxes in use.

EXAMPLE 10.19 The MEL code that created the window in Figure 10.20.

```
string $camList[] = `ls -type "camera"`;

window
    -title "checkBox Controls";

    columnLayout -adjustableColumn true;

    for ( $each in $camList )
        checkBox -label $each;

showWindow;
```

Radio buttons are actually elements of another control, the *radio collection*. Because only one of the individual radio buttons that contribute to a radio collection can be selected at any one time, radio collections are useful for accessing enum attributes, or for giving user interface interaction with a `switch case` conditional statement. There is a radio button group, and it is possible to link multiple groups together, allowing only one radio button across multiple groups to be selected. A radio collection is seen in the window shown in Figure 10.21. As is seen in Example 10.20, the radio collection is constructed of two smaller collections that are linked.

FIGURE 10.21 A six-button radio collection.

EXAMPLE 10.20 The MEL code that created the window in Figure 10.21.

```
window
    -title "radioButton Controls";
```

```
columnLayout
    -adjustableColumn true;

string $group1 = `radioButtonGrp
                    -numberOfRadioButtons 3
                    -label "Select Type"
                    -labelArray3 "Camera"
                                 "Light"
                                 "Joint"`;
    radioButtonGrp
        -numberOfRadioButtons 3
        -shareCollection $group1
        -label ""
        -labelArray3 "Mesh" "Handle" "Locator";
showWindow;
```

The final interactive UI control that sees frequent use is the *button*. Buttons' general appearance is largely dictated by the operating system, but for the most part they are rectangular and can be of nearly any size. There are a variety of ways buttons can be constructed. The standard button allows for only a text label; however, it is possible to use the *symbol button* to assign an image to the button, allowing for iconic representation. One advantage of using buttons as opposed to a shelf layout is you are not limited to only a 32x32 pixel bitmap for the icon image. In Figure 10.22, we see a window with both standard buttons and a single, large symbol button. In Example 10.21, we use a standard Maya icon for the image, but it can be of nearly any size. It is also often a good idea to pass the custom image name as a complete path.

FIGURE 10.22 Various buttons.

EXAMPLE 10.21 The MEL code that created the window in Figure 10.22.

```
window
    -title "button Controls"
    -widthHeight 200 225;

    columnLayout
        -adjustableColumn true;

        button
            -label "Default";
        button
            -label "Left"
            -align left;
        button
            -label "Center"
            -align center;
        button
            -label "Right"
            -align right;
        symbolButton
            -image "circle.xpm";
    showWindow;
```

It should be noted that many controls have an associated control group that includes a button object. While sometimes useful, it is often necessary to create each element individually to achieve a specific appearance.

While this does not represent a comprehensive list of every interactive interface control available, it does represent almost every control that is needed to build all but the most specialized interfaces. In addition to such specific controls as the *layer button*, there are also a large variety of controls that are used to create standard user interface features like the Channel Box or the Time Slider.

We have referred to the previous control items as "interactive" because the final three controls we will cover in any depth are the *Text*, *Image*, and *Separator* controls. While these controls can be changed and edited using MEL commands, the end user cannot directly modify them.

Use of the Text Control is often limited to creating labels and giving user feedback in the created user interface. In Figure 10.23, we have a Text Control to label the X, Y, Z fields of a collection of float fields, and another at the bottom of the interface, giving information on the interface purpose. Notice in Example 10.22 the use of the empty `text` control to fill in a layout "slot."

FIGURE 10.23 Using the text control for labeling.

EXAMPLE 10.22 The MEL code that created the window in Figure 10.23. window

```
-title "Combining Controls"
-widthHeight 320 80;

columnLayout -adjustableColumn true;

rowLayout
    -numberOfColumns 4
    -columnWidth4 60 80 80 80
    -columnAlign  1 right
    -columnAlign  2 center
    -columnAlign  3 center
    -columnAlign  4 center
    -columnAttach 1 both 0
    -columnAttach 2 both 0
    -columnAttach 3 both 0
    -columnAttach 4 both 0
    ;

    text
        -label "";
    text
        -label "X"
        -align center;
    text
        -label "Y"
        -align center;
    text
        -label "Z"
        -align center;
    setParent..;

rowLayout
    -numberOfColumns 4
    -columnWidth4 60 80 80 80
    -columnAlign  1 "right"
    -columnAttach 1 "both"    0
    -columnAttach 2 "both"  0
    -columnAttach 3 "both"  0
```

```
        -columnAttach 4 "both"  0
        ;

        text
            -label "Axis :";
        floatField;
        floatField;
        floatField;

        setParent..;
    text
        -label "Feedback: "
        -align left;

showWindow;
```

The Image Control is used to insert an image into the user interface. Images are often used in interfaces either to give instructions or provide some type of logo branding into an interface. One underused use of the image control is as labels for other controls. For example, a custom control UI window could use a mugshot somewhere within it to show which character the UI is for. Or, different phoneme shapes could be used to label sliders animating a blendshape node. In Figure 10.24, an image control is used in conjunction with a text control in a tab layout to give legal information, as well as a Web site URL.

FIGURE 10.24 Placing an image in a window.

The Separator Control is simply that, a visual separator. Available in eight styles, separators are very useful for clarifying and organizing windows. Often, a window will have distinctly different sections, such as that

seen in Figure 10.25. Using separator controls categorizes the sections, hopefully preventing any confusion a user might have when dealing with a complex window. See the code in Example 10.23 as a guide to the different separator types pictured.

FIGURE 10.25 The different separators available.

EXAMPLE 10.23 The MEL code that created the window in Figure 10.25.

```
window
    -title "Separator Controls"
    -widthHeight 220 370;

columnLayout
    -adjustableColumn true;

    text
        -label "Default";
    separator;
    text
        -label "";

    text
        -label "None";
    separator
```

```
            -style "none";
text
    -label "";

text
    -label "Single";
separator
    -style "single";
text
    -label "";

text
    -label "Double";
separator
    -height 15
    -style "double";
text
    -label "";

text
    -label "Single Dash";
separator
    -height 15
    -style "singleDash";
text
    -label "";

text
    -label "Double Dash";
separator
    -height 20
    -style "doubleDash";
text
    -label "";

text
    -label "Etched In";
separator
    -height 20
    -style "in";
text
    -label "";

text
    -label "Etched Out";
separator
    -height 20
    -style "out";
text
```

```
            -label "";

    showWindow;
```

Layout and Control Placement

Within a window, the sizing and placement of layouts and controls can sometimes be a frustrating process. As with the writing of script, planning is vital. It is often a good idea to sketch out a rough design of your window, or possibly construct a mockup in an image processing program before any real work is done.

Once a design has been decided upon, we need to break the window into its component elements. Often, it is possible to look at a single design and derive multiple solutions that will draw the window as we want.

Perhaps the most important thing to determine while designing a UI is the hierarchy of layouts and controls. In order to achieve the desired appearance of a window, it is necessary to build layouts in layers. For example, we see a typical window design in Figure 10.26.

FIGURE 10.26 A window design diagram.

The secret, if it can be called that, to developing UIs is to learn to look at the big picture, and carefully work our way through the layers, almost like an archaeologist. In our example, we can see that the window is mainly a horizontal layout, so we would use a Row Layout, with two columns, seen in Figure 10.27.

FIGURE 10.27 Breaking down the user interface elements.

In the left-hand column we need to place only a single control, the scrolling list of lights. However, in the second column, we want to add three different controls, two buttons with a float field separating them. To place all three of these in the second column, we need to place a Column Layout in the second column, as seen in Figure 10.28.

FIGURE 10.28 Designing the UI layout hierarchy.

We then can place the three controls into the column. When we discussed field controls, it was stated that to have finite control over the appearance of a UI it is often preferable to use separate controls for such things as labels and sliders. If we wished to do so here to label the float field, we would need to place a new Row Layout inside the Column Layout, otherwise the text control would be placed above the field control. Our layout design now looks like that seen in Figure 10.29.

FIGURE 10.29 Further refinement of the UI hierarchy.

In the code to add the text and float field controls, we must then use the command setParent, to navigate back to the Column Layout. Similar to navigating a directory structure from a command line, we can either explicitly name the parent we want to navigate to, or simply move one level up by using setParent... After returning to the Column Layout, we would add the final button control and use setParent to return to the window level before using showWindow to make the window visible. It is often good practice to use the setParent.. form to add any additional controls to a layout.

This hierarchical relationship of controls and layouts and windows is absolutely vital to understand if we want to construct usable interfaces. It

is a relationship that should already be familiar to any artist working in Maya, especially if we visualize it in a form more readily recognizable, like that seen in Figure 10.30.

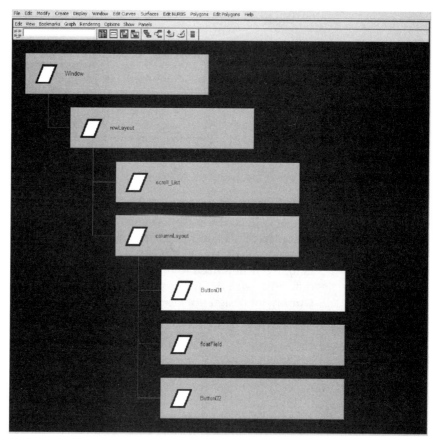

FIGURE 10.30 Visualizing the hierarchy in the Hypergraph with transforms.

Once all the familial relationships of the elements that make up a window are determined, decisions need to be made based on how the user is able to interact with the window. For example, will we allow the user to resize the window? If so, will the controls resize to fit or simply stay the same size and in the same position? If the controls do resize, will all of them, or just some of them?

The answers to these questions determine the options and arguments that will be used in the creation of the layouts and controls, specifically in regard to their *adjustability* and *attachment* properties.

Some layouts allow you to set the adjustability of one or more sections. For example, if a two-column Row Layout is created, we can set

options so that neither column grows when the window is resized, that only the left or right column is resized, or that both are resized together.

Related to adjustability is the attachment argument available to most controls and layouts. Attachment allows controls to have their sides linked, or attached to the sides of a layout. This allows for very specific relationships among controls and layouts to be developed, keeping the appearance of UIs consistent and attractive even as a window is resized.

The concept of attachment is the key to what is regarded as the most powerful of all layouts available to a MEL scripter, the Form Layout. In the Form Layout, each child is explicitly attached, either to the edges of the Form Layout itself, or to a sibling control or layout. It is also possible to attach the edges of controls to arbitrary division markers within the layout. By default, there are 100 divisions to a Form Layout in each direction, allowing, for example, a button to always occupy 75% of the width of the layout.

Using the Form Layout is often the best choice when creating user interfaces in which exacting control is needed. Although slightly more complex to construct than a simple Column or Row Layout, the results, especially in more complex UIs, are well worth the effort. Because layouts can be nested, it is always a good idea to use Form Layouts as the final holder of your controls, even if they are the child of a Tab Layout or Frame Layout or even a simple Column Layout.

Naming

Like nodes within a Maya scene, every layout and control has to have its own unique name, and when the layout or control is created, the command returns a string giving the name of the created element. While capturing these names to variables can be useful when using the form layout, since controls are attached to each other by names, it is important to explicitly name any control you want to later query for information. In Example 10.24, we create a window with a text field control, which is seen in Figure 10.31.

FIGURE 10.31 The textField window.

EXAMPLE 10.24 The MEL code that created the window in Figure 10.31.

```
string $window = `window testWindow`;
   string $textField = `textField
```

```
                                    -text "MEL is Cool!"
                                    testTextfield`;
            showWindow $window;
```

We can then reference the control, even from another procedure, seen in Example 10.25.

EXAMPLE 10.25 Using the textField command to query the text in the control.

```
string $textInField = `textField
                              -query -text
                              testTextfield`;
// Result : MEL is Cool!
```

It is also vital to name windows, and to check for the existence of a window before attempting to create the window. There are actually two approaches a programmer can take on the process of creating a window if there is a pre-existing window. The first is to delete the existing window and create a new version of the window. This method is demonstrated in Example 10.26.

EXAMPLE 10.26 A conditional statement deletes the window if it already exists, and then recreates it.

```
if ( `window —exists testWindow` )
    deleteUI testWindow;

string $window = `window testWindow`;
string $textField = `textField
                              -text "MEL is Cool!"
                              testTextfield`;
showWindow $window;
```

The other method is to create the window, but only if the window does not already exist. While both methods are valid approaches, the second, as seen in Example 10.27, is slightly more elegant.

EXAMPLE 10.27 Nesting the window command in a conditional statement.

```
if ( `window —exists testWindow` != 1 )
    {
    string $window = `window testWindow`;
    string $textField = `textField
                                  -text "MEL is Cool!"
                                  testTextfield`;
```

```
showWindow $window;
}
```

UI Templates

In order to easily keep UI elements consistent, and to aid in the elimination of repetitive typing, it is possible to define templates for controls and layouts. Not only do templates aid in keeping UI elements consistent, but because the definitions held in the template are kept in a parsed state, UIs containing large numbers of the same element that can be largely defined in the template are built faster.

Working with UI templates requires the use of two commands, in addition to the commands for any UI element for which you want to define new default parameters. The first step is to create the actual template. Again, as with every situation where we use MEL to create an object, we use an `if` statement to first confirm that it does not already exist. This confirmation, as well as the creation of a UI template called `tmcUITemplate`, is seen in Example 10.28.

EXAMPLE 10.28 Adding a UITemplate.

```
if ( `uiTemplate -exists tmcUITemplate` != 1 )
    uiTemplate tmcUITemplate;
```

After the template has been created, it is a simple matter of defining new default parameters for UI elements, such as that seen in Example 10.29, by using the flag `-defineTemplate` with the name of the desired template as the argument.

EXAMPLE 10.29 Adding values to our template definition.

```
button
    -defineTemplate tmcUITemplate
    -height 25
    -align "right";
columnLayout
    -defineTemplate tmcUITemplate
    -columnAttach "both" 5;
```

Now, in order to use the template, we have to tell Maya to make it the active template. After which, whenever a button control is used, it will conform to the new default values defined in Example 10.29. In Example 10.30, we build a window using the default variables for the controls.

EXAMPLE 10.30 The MEL code that created the window in Figure 10.32.

```
window;

columnLayout
    -rowSpacing 2
    -columnWidth 250
    ;
button -label "Button One";
button -label "Button Two";
button -label "Button Three";
button -label "Button Four";
button -label "Button Five";

showWindow;
```

Giving us the result seen in Figure 10.32.

FIGURE 10.32 The window created using the default Maya values.

If we look at the results of this same window creation code, but with the template active, we get a different look. To make the template active, we use the `setUITemplate` command. This is seen in action in Example 10.31, with the results seen in Figure 10.33.

EXAMPLE 10.31 The MEL code that created the window in Figure 10.33.

```
window;
setUITemplate -pushTemplate tmcUITemplate;

columnLayout
    -rowSpacing 2
    -columnWidth 250
    ;
button -label "Button One";
```

```
button -label "Button Two";
button -label "Button Three";
button -label "Button Four";
button -label "Button Five";
setUITemplate -popTemplate;

showWindow;
```

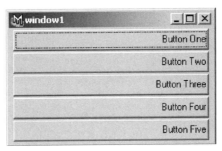

FIGURE 10.33 The same window, using our template.

Now that we have a fair understanding of the syntax and logic used to create interfaces, we will complete three projects dealing with common approaches to interface creation: Modal Dialogs, Using MEL Features to Dynamically Build a UI, and Building a Designed UI.

PROJECT

10.1: A MODEL OF MODALITY

In this project, we will use a basic function of MEL, the `for` loop, to rename all the objects the user has selected. While the actual code for this is exceedingly simple, we will implement the `promptDialog`, the `confirmDialog`, and the `progressWindow`.

Before implementing the windows, we will take a quick look at the code, seen in Example 10.32, simply so we are familiar with it and can find the ideal places to add in our dialogs.

EXAMPLE 10.32 The procedure to rename the selection list.

```
global proc massRename ( string $newName )
{
// get selection list
string $selList[] = `ls —selection`

// parse the list and rename
```

```
int $i = 0;

for ( $each in $selList )
    {
// rebuild selection list to account for
// renaming of parents and possibly having
// multiple objects with the same short name
    string $newList[] = `ls -selection -long`;
    rename $newList[$i] ( $newName + $i++ );
    }
}
```

ON THE CD *The text for this script is found on the companion CD-ROM as Chapter_10/ project_UI01/v01/massRename.mel.*

As it stands now, this requires the user to enter the command from either the Command Line, Script Editor, or Command Shell so that we can pass it text to be used as the string variable $newName. Since this command would be much more useful as a simple shelf button or menu item, we will replace the passing of $newName with a prompt dialog, similar to the Prefix Hierarchy command that exists already. In addition, since this could be a rather drastic action, we will enclose the entire body of the procedure with an if statement, which will use a confirmDialog as its condition. Finally, because we are using a for loop as the main functionality of the script, we can easily use a progressWindow to give the end user feedback as the loop parses.

First, we remove the passing of the variable from the procedure declaration, and use a promptDialog to get the information we need. In Example 10.33 we see the addition of the dialog.

EXAMPLE 10.33 Using a prompt dialog in place of a passed variable.

```
global proc massRename ()
{
string $newName;

string $promptResult = `promptDialog
                        -title
                            "Mass Rename Objects"
                        -message "Enter New Name:"
                        -button "OK"
                        -button "Cancel"
                        -defaultButton "OK"
                        -cancelButton "Cancel"
                        -dismissString "Cancel"`
                        ;
```

```
if ($promptResult == "OK")
    {
    $newName = `promptDialog -query`;

    // get selection list
    string $selList[] = `ls -selection`
```

The text for this script is found on the companion CD-ROM as Chapter_10/ project_UI01/v02/massRename.mel.

Next, we will confirm that the user does, in fact, want to rename the objects. We got the selection list first so that we can use that data in the dialog. While not necessary, it adds some nice detail and class to our script. The code for this addition is seen in Example 10.34.

EXAMPLE 10.34 Adding a Confirm dialog.

```
string $confirm = `confirmDialog
                    -title "Confirm Mass Rename"
                    -message ("Do you really want
                        to rename "
                        + `size $selList`
                        + " objects?" )
                    -button "Yes"
                    -button "No"
                    -defaultButton "Yes"
                    -cancelButton "No"
                    -dismissString "No"`;

if ( $confirm == "Yes" )
    {
```

The text for this script is found on the companion CD-ROM as Chapter_10/ project_UI01/v03/massRename.mel.

Now, we go into the `for` loop. We first find how much each iteration adds to the entire percentage of objects and use that in our Progress window updating. Note that we use 1.0 in our calculation to guarantee that a float value is returned. In Example 10.35 we see how the Progress Window is added. It is often good practice to find the increase amount outside the loop and assign it to a variable to avoid the repeated division operations required if the new amount was calculated in an inline arithmetic statement.

EXAMPLE 10.35 Addition of a Progress window.

```
// Build Progress Window
float $increase = (1.0/`size $selList`);
float $amount = 0;
```

```
progressWindow
    -title "Renaming Object"
    -progress $amount
    -status "Renaming: 0%"
    -isInterruptable true
    ;

// parse the list and rename
int $i = 0;

for ( $each in $selList )
    {
    // Check if the dialog has been cancelled
    if ( `progressWindow -query -isCancelled` )
        break;

    // rebuild selection list to account for
    // renaming of parents and possibly having
    // multiple objects with the same short name
    string $newList[] = `ls -selection -long`;
    rename $newList[$i] ( $newName + $i++ );

    $amount+= $increase;

    progressWindow
        -edit
        -progress $amount
        -status ("Renaming: "+$amount+"%");
    }

progressWindow -endProgress;

}
```

ON THE CD

The text for this script is found on the companion CD-ROM as Chapter_10/ project_UI01/final/massRename.mel.

Now, by simple executing the command massRename, the user is given a dialog to give the new object's name, and then given the opportunity to back out of the operation. Because the user can select any number of objects, this operation could take quite a while; it's simple politeness to add the Progress window.

Project Conclusion and Review

Using modal dialogs is a simple, effective way of adding interactivity and polish to a tool. Without much effort, we went from a command-line-only tool to

one with all the polish and class of those that come with Maya. Adding ease of use is often the last step of a script, and therefore the most often neglected. Modal dialogs are so easy to implement that there is no excuse not to implement them when appropriate.

10.2: DYNAMIC UI CREATION

Windows and interfaces in Maya are created with MEL commands. This allows for an incredible amount of flexibility to be built into UI creation scripts. In the following example, we will dynamically build a UI based on the number of lights in the scene. Not only is this simple, but there is no functionality to the script other than the UI. This shows how new functionality can easily be built simply by changing how the user interacts with a command.

Design

The goal of the tool is quite simple, to build a small user interface that allows for the quick selection of any of the lights in the scene. We first begin by roughing out the design on paper, as seen in Figure 10.34.

FIGURE 10.34 Our proposed UI.

We then are able to break the design down into its component layout and control pieces. For our example, this step is particularly easy, but this will only aid us in dynamically building the UI. Our breakdown diagram is seen in Figure 10.35.

FIGURE 10.35 Breaking down the UI elements.

Implementation

As with the mass renaming tool, we will begin by creating the basic MEL functionality first. For the Light Window, we simply need to find every light in the scene. All we need to do is use the `ls` command to build an array of all the light shapes that exist in the scene, and then parse the array to find their parent transform, as in Example 10.36.

EXAMPLE 10.36 The code to find all the lights in the scene.

```
global proc lightWindow ()
{
// build a list of all the light shapes in the scene
string $lights[] = `ls -type "light"`;
string $lightTransforms[];

// parse the array to find the transform
// associated with each light shape
for ( $each in $lights )
    {
    string $parentList[] = `listRelatives
                            -parent $each`;
    $lightTransforms[`size $lightTransforms`] =
```

```
                                       $parentList[0];
           }
     }
```

The text for this script is found on the companion CD-ROM as Chapter_10/ project_UI02/v01/lightWindow.mel.

Our first goal in the creation of our UI is the creation of the window itself. After closing out the loop that builds the list of transforms, we can add the code seen in Example 10.37.

EXAMPLE 10.37 Creating a window.

```
if ( `window -exists lightWindowUI` != 1 )
     {
     window
          -maximizeButton 0
          -resizeToFitChildren on
          -title "Light Window"
          -iconName "Light Window"
          -menuBar false
          -menuBarVisible false
          lightWindowUI
          ;
     showWindow lightWindowUI;
     }
```

The text for this script is found on the companion CD-ROM as Chapter_10/ project_UI02/v02/lightWindow.mel.

Each of the flags and arguments were chosen to minimize the amount of screen real estate the UI would occupy. Right now, if the script is run, a small, barely there window would appear. In Example 10.38 we add the Column Layout, in preparation for the buttons to be added.

EXAMPLE 10.38 Adding a columnLayout to hold further controls.

```
if ( `window -exists lightWindowUI` != 1 )
     {
     window
          -maximizeButton 0
          -resizeToFitChildren on
          -title "Light Window"
          -iconName "Light Window"
          -menuBar false
          -menuBarVisible false
          lightWindowUI
          ;
```

```
                        columnLayout
                            -columnAttach "both" 0
                            -rowSpacing 1
                            -columnWidth 250
                            ;
                       showWindow lightWindowUI;
                  }
```

ON THE CD

The text for this script is found on the companion CD-ROM as Chapter_10/ project_UI02/v03/lightWindow.mel.

For now, we can use an arbitrary width for the Column Layout, which we can revise later. Now that we have a layout, we start adding controls, seen in Example 10.39. We use a `for in` loop to add a button for each item held in the array `$lightTransforms`.

EXAMPLE 10.39 Adding controls based on dynamic information.

```
for ( $each in $lightTransforms )
            button;
```

If we create a scene with a bunch of lights and run the script, we get something similar to Figure 10.36.

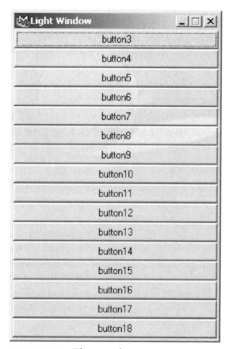

FIGURE 10.36 The results.

We can use the variable to label each button with the name of the light, and to build a command string that is executed when the button is pressed. We also can make the buttons slightly smaller, by changing their height to 20 pixels high; we see this in Example 10.40.

EXAMPLE 10.40 Using the variable in the creation of the buttons.

```
for ( $each in $lightTransforms )
        button
            -label $each
            -height 20
            -command ( "select -r " + $each );
```

The text for this script is found on the companion CD-ROM as Chapter_10/ project_UI02/v04/lightWindow.mel.

Executing the script at this stage gives us a result similar to Figure 10.37, providing that there are lights in the scene.

Light Window
ambientLight1
ambientLight2
ambientLight3
directionalLight1
pointLight1
pointLight2
pointLight3
pointLight4
pointLight5
spotLight1
spotLight2
spotLight3
spotLight4
spotLight5
spotLight6
spotLight7

FIGURE 10.37 The results with thinner buttons.

Since one of the main goals with this UI is to minimize the amount of screen real estate it occupies, it seems illogical to always have our width set to 250 pixels. At the same time, we will want to account for those artists who have lights called "spotlight_which_shines_down_on_the_left_side_of_the_lead_ characters_head." We will now tie the width of our window to the length of the longest name of any light.

The first step in this process is to find the longest name of any light, and count the number of characters in that name. We can integrate this into the loop that parses the light list immediately after finding the name of the parent transform, as seen in Example 10.41.

EXAMPLE 10.41 Finding the longest name of a light in the scene.

```
global proc lightWindow ()
{
string $lights[] = `ls -type "light"`;
string $lightTransforms[];

int $longestName;

for ( $each in $lights )
    {
    string $parentList[] = `listRelatives
                            -parent $each`;
    $lightTransforms[`size $lightTransforms`]
                        = $parentList[0];

    if ( `size $parentList[0]` > $longestName )
        $longestName = `size $parentList[0]`;

    }
```

The test is simple. If the transform name is longer than the number of characters stored in the variable $longestName, the length of that transform's name is assigned to $longestName. Once this value is determined, we can use it in a mathematical statement in the columnLayout to determine the appropriate width for the window, as in Example 10.42.

EXAMPLE 10.42 Altering the columnLayout command to account for the new information.

```
columnLayout
        -columnAttach "both" 0
        -rowSpacing 1
        -columnWidth (( $longestName * 6 ) + 2 )
        ;
```

ON THE CD *The text for this script is found on the companion CD-ROM as Chapter_10/ project_UI02/v05/lightWindow.mel.*

This gives us the result seen in Figure 10.38. Smaller and much more efficient, the window is given six pixels of width for each character, as well as two extra pixels to prevent errors if there are no lights in the scene.

FIGURE 10.38 The window width is now based on the names of the lights in the scene.

While this solution works, for scenes with a large number of lights the UI becomes unwieldy or even impossible to use, with buttons falling off the screen itself. We will enclose the Column Layout in a Scroll Layout, allowing the window to be reasonably sized, yet still have access to all the buttons. While we could use a text scroll field, our goal is a tool to quickly select lights, which the small selection area of the list does not allow. Simply adding a scroll layout will not produce the results we want, as the window does not resize automatically to fit. What we will do is twofold:

- Only implement the Scroll Layout when needed. Arbitrarily, we will implement the scroll if there are more than 10 lights in the scene. We could have chosen 5, 15, or 21—but we chose 10.
- Calculate the size of the window based on how many buttons are needed, and whether the scroll is included.

This is shown in Example 10.43.

EXAMPLE 10.43 Addition of the scrollLayout depending on need.

```
global proc lightWindow ()
{
string $lights[] = `ls -type "light"`;
string $lightTransforms[];

int $longestName;

for ( $each in $lights )
    {
    string $parentList[] = `listRelatives
                            -parent $each`;

    $lightTransforms[`size $lightTransforms`]
                            = $parentList[0];

    if ( `size $parentList[0]` > $longestName )
        $longestName = `size $parentList[0]`;
    }

if( `window -exists lightWindowUI` != 1 )
    {
    int $height=((`size $lightTransforms` * 21) + 35 );

    int $width = (( $longestName * 6 ) + 1 );

    if ( `size $lightTransforms` > 10 )
        {
        $height = 245;
        $width = (( $longestName * 6 ) + 35 );
        }

    window
        -maximizeButton 0
        -resizeToFitChildren 0
        -title "Light Window"
        -iconName "Light Window"
        -menuBar false
        -menuBarVisible false
        -widthHeight $width $height
        lightWindowUI
        ;

    if ( `size $lightTransforms` > 10 )
        scrollLayout -horizontalScrollBarThickness 0 ;

    columnLayout
        -columnAttach "both" 0
        -rowSpacing 1
```

```
              -columnWidth (( $longestName * 6 ) + 2 )
              ;

      for ( $each in $lightTransforms )
          {
           button
              -label $each
              -height 20
              -command ( "select -r "
                          + $each
                          + ";lightWindow;" );
          }
      showWindow lightWindowUI;
      }
  }
```

The text for this script is found on the companion CD-ROM as Chapter_10/ project_UI02/final/lightWindow.mel.

Executing this code gives the result in Figure 10.39, assuming there are more than 10 lights in the scene.

FIGURE 10.39 The addition of a scrollLayout.

10.3: ADDING A UI TO A SCRIPT

It is easy to add a UI that controls the execution of a script that has been created previously, or has no UI created by the original programmer. Moreover, with more complex tools, the task of creating the UI can be done by one scripter while another handles the actual operational portion of the tool. In this project, we will add a user interface to the `generateGrass` script from Chapter 6, "Geometry."

Design

Our goal will be to create a user interface that gives control of all the aspects of the script, is consistent with the Maya interface, and preferably makes the tool more intuitive to work with. After some thought and sketching, we can come up with a design we like, such as that in Figure 10.40.

FIGURE 10.40 The Grass Generator UI design.

Once a design is approved, we can move on to the breakdown process. We need to identify each layout and control we will need to construct the UI. We know that the Form Layout gives us the most control, so we will use that as the root layout, seen in Figure 10.41.

FIGURE 10.41 Breaking down the window to the Form Layout.

Within that Form Layout, we will place a column layout to hold the majority of our controls. We will put the buttons directly in the Form Layout, for a reason we will discuss later. In Figure 10.42, we see the diagram of this third layer of layouts and controls.

FIGURE 10.42 Inserting a columnLayout.

To keep the labels and controls properly aligned, we will place the controls in row layouts. Each of the labels will be created with text controls, and all of the controls will be created without labels. In Figure 10.43, we see a mapping of the finished UI, including which controls will be in which layout cell.

Text	Dropdown	Text	Dropdown
Text (Empty)	Text		Text
Text	Float Field		Float Field
Text	Float Field		Float Field
	Button		Button

FIGURE 10.43 The finished UI mapping.

Implementation

Adding UI windows should be done with a separate procedure than that which creates the actual functionality of the script. While developing the window, it is often preferable to keep this procedure in an entirely separate file, to allow for easy sourcing and execution, and to avoid accidentally causing errors in the functional script. Even after the UI is finished, it is not necessary to put all the procedures in one file, to keep both the command line and window interactions available to the end user.

Create and validate a script and procedure entitled grassUI. Our first goal is to create the window itself. To make the process of getting the dimensions of the labels and controls right and easy to change, we will use simple integer

variables to hold assigned values, letting us quickly change them without searching through large volumes of text. In Example 10.44 we see the initial window definition, with two conditional statements used. The first is temporary, used to delete the UI if it exists, and used only during the construction of the UI.

EXAMPLE 10.44 Validation of the script.

```
global proc grassUI ()
{
// for use during building
if( `window -exists grassUI` != 1 )
    deleteUI grassUI;

if( `window -exists grassUI` != 1 )
    {
    int $uiLabelWidth = 140;
    int $uiInputWidth = 240;
    int $uiWidth = ( $uiLabelWidth + $uiInputWidth );

    window
        -maximizeButton false
        -resizeToFitChildren false
        -title "Grass Generator"
        -iconName "Grass Generator"
        -menuBar false
        -wh 600 500
        grassUI;

    showWindow grassUI;
    }
}
```

ON THE CD *The text for this script is found on the companion CD-ROM as Chapter_10/project_UI03/v01/grassUI.mel.*

We can now execute this code, getting a result similar to Figure 10.44, although the relative size of the window is dependent on your desktop resolution and your operating system. We make the window inordinately large so we don't obscure any of our controls. Later, we will resize it to make it a much more reasonable size.

Next, we insert the Form and Column Layouts, capturing the names to variables. The code in Example 10.45 is placed after the window creation, but still within the `if` statement.

FIGURE 10.44 The window in which we will build.

EXAMPLE 10.45 Addition of the basic layout elements.

```
string $grassGenForm = `formLayout
                           -numberOfDivisions 100`;
string $grassColumn = `columnLayout
                          -adjustableColumn true
                          -rowSpacing 5`;
```

Executing this code produces no visible differences. However, because we put the deleteUI statement within for testing, we are assured that the window is deleted and redrawn. This is essential when building a UI.

Next, we put in the control for selecting the style of grass and level of detail. First, we create a Row Layout with four columns. We then place our controls, seen in Example 10.46. Note the use of the variable in the definition of the layout.

EXAMPLE 10.46 The first controls are added.

```
rowLayout
    -numberOfColumns 4
    -columnAttach 1 "right" 5
    -columnAttach 2 "both" 5
    -columnAttach 3 "right" 5
    -columnAttach 4 "both" 5
    -columnWidth 1 $uiLabelWidth
    -columnWidth 3 $uiLabelWidth
    ;

text
    -label "Grass Style"
    -annotation
        "Select Grass Style.";
optionMenu
    -label ""
```

```
        grassGenStyleDropdown;

        menuItem -label "Short";
        menuItem -label "Normal";
        menuItem -label "Long";
        menuItem -label "Very Long";

    text
        -label "Detail"
        -annotation
            "Select Amount of Detail.";
    optionMenu
        -label ""
        grassGenDetailDropdown;

        menuItem -label "Low";
        menuItem -label "Medium";
        menuItem -label "High";
    setParent ..; // Return to column layout
```

ON THE CD *The text for this script is found on the companion CD-ROM as Chapter_10/ project_UI03/v02/grassUI.mel.*

Using the `annotation` flags add what are more commonly known as "tool tips," giving quick instructions to the user. If we execute the script at this point, we get a result similar to Figure 10.45.

FIGURE 10.45 Adding the "Grass Style" and "Detail" pull-downs.

Next, we add the slider, again by adding a Row Layout. This time, however, we will use three columns, to put the percentage label at the end. Since the desired layout conforms with that provided by the Float Slider Group, we will use it, rather than constructing it from components. This is shown in Example 10.47.

EXAMPLE 10.47 Adding sliders, with separate text controls for labels.

```
rowLayout
    -numberOfColumns 3
    -columnAttach 1 "right" 5
    -columnWidth 1 $uiLabelWidth
    -columnWidth 2 $uiInputWidth
    grassDensityRow;

    text
        -label "Density"
        -annotation
            "Set the density parameter for the grass.";
    floatSliderGrp
        -field true
        -minValue 0
        -maxValue 100
        -value 100
        grassGenDensity;
    text -label "0% - 100%";
    setParent ..; // Return to column layout
```

ON THE CD

The text for this script is found on the companion CD-ROM as Chapter_10/ project_UI03/v03/grassUI.mel.

We again use the variables in the Row Layout definition, this time using both variables. Using this code results in the window seen in Figure 10.46.

FIGURE 10.46 Adding the Density slider.

The fields for the minimum and maximum dimensions will be float fields. Again, this will require three Column Row Layouts. To have the two fields together be the same width as the slider above, we will set each of the non-label columns to be half the width of the slider, conveniently defined with our variable. Example 10.48 shows this code.

EXAMPLE 10.48 Float fields used to define our dimensions.

```
rowLayout
    -numberOfColumns 3
    -columnAttach 1 "right" 5
    -columnWidth 1 $uiLabelWidth
    -columnWidth 2 ( $uiInputWidth * 0.5 )
    -columnWidth 3 ( $uiInputWidth * 0.5 )
    grassGenXRow;

    text
        -label "X Value"
    floatField
        -precision 6
        -width ( $uiInputWidth * 0.5 )
        -value -1
        grassGenMinX;
    floatField
        -precision 6
        -width ( $uiInputWidth * 0.5 )
        -value 1
        grassGenMaxX;
    setParent ..; // Return to column layout

rowLayout
    -numberOfColumns 3
    -columnAttach 1 "right" 5
    -columnWidth 1 $uiLabelWidth
    -columnWidth 2 ( $uiInputWidth * 0.5 )
    -columnWidth 3 ( $uiInputWidth * 0.5 )
    grassGenZRow;

    text
        -label "Z Value"
    floatField
        -precision 6
        -width ( $uiInputWidth * 0.5 )
        -value -1
        grassGenMinZ;
    floatField
        -precision 6
        -width ( $uiInputWidth * 0.5 )
        -value 1
        grassGenMaxZ;
    setParent ..; // Return to column layout
```

ON THE CD

The text for this script is found on the companion CD-ROM as Chapter_10/ project_UI03/v04/grassUI.mel.

This gives us the results in Figure 10. 47. However, we wanted to place labels above the numerical columns.

FIGURE 10.47 The dimension fields are added.

In order to place the labels, although there are only two obvious text controls, we will use another three-column Row Layout, the code for which will be placed above the Row Layout definitions for the dimension attributes. In the first of the three columns, we will place an empty text control. In Example 10.49 we place text controls for the labels in the remaining two columns.

EXAMPLE 10.49 Labels for the float field columns are added.

```
rowLayout
    -numberOfColumns 3
    -cat 2 "both" 5
    -cat 3 "both" 5
    -columnWidth 1 $uiLabelWidth
    -columnWidth 2 ( $uiInputWidth * 0.5 )
    -columnWidth 3 ( $uiInputWidth * 0.5 )
    grassGenLabelRow;

text
    -label "";
text
    -label "Minimum Value"
    -align center;
text
    -label "Maximum Value"
    -align center;
setParent ..; // Return to column layout
```

The text for this script is found on the companion CD-ROM as Chapter_10/ project_UI03/v05/grassUI.mel.

ON THE CD

We have also added `separator` controls in between each of the three distinct sections. This provides the results seen in Figure 10.48.

FIGURE 10.48 The labeled floatFields and the added separators.

Now that we have controls representing all the variables that need to be passed to `generateGrass`, we will add a `button` control in Example 10.50.

EXAMPLE 10.50 Addition of a button.

```
button
    -height 40
    -label "Generate Grass"`;
```

However, the results of this produce a less than desirable result. The window appears similar to that in Figure 10.49. Maya windows have the buttons at the bottom, and they always stay at the bottom. They also resize with the resizing of the window.

FIGURE 10.49 Adding the buttons to the columnLayout makes a rather non-dynamic window.

We will move one level up, into the Form Layout, and we will also add the Close button. We capture the names of the created buttons to use in the form layout. Form Layouts allow for exacting attachment based on either the division marker or the edge of another UI element. Unlike other layouts, the positioning of elements is done after creation. After all, we can't attach to a `button` that does not yet exist. In our case, we will attach the top left corner of the column layout to the top left corner of the window. We will also attach the bottom of the Column Layout to the top of the of the "Generate Grass" button. That button will occupy 75% of the horizontal dimensions of the window, and the "Close" button will occupy the remaining 25%, and is attached to the right side of the window. Example 10.51 replaces the button added in Example 10.50.

EXAMPLE 10.51 Attaching the buttons to the formLayout.

```
setParent ..; // Return to the form layout

    string $grassGenButton = `button
                                -height 40
                                -label "Generate Grass"`;

    string $grassCloseUIButton = `button
                                -height 40
                                -label "Close"
                                -command "deleteUI grassUI"`;

    setParent ..; // Return to the window

    formLayout -edit
            -attachForm $grassColumn "top" 2
            -attachForm $grassColumn "left" 2
            -attachControl
                $grassColumn "bottom" 2 $grassGenButton
            -attachForm $grassColumn "right" 2

            -attachNone $grassGenButton "top"
            -attachForm $grassGenButton "left" 2
            -attachForm $grassGenButton "bottom" 2
            -attachPosition $grassGenButton "right" 0 75

            -attachNone $grassCloseUIButton "top"
            -attachPosition $grassCloseUIButton "left" 0 75
            -attachForm $grassCloseUIButton "bottom" 2
            -attachPosition
                $grassCloseUIButton "right" 2 100
        $grassGenForm;
```

ON THE CD

The text for this script is found on the companion CD-ROM as Chapter_10/ project_UI03/v06/grassUI.mel.

Executing this code gives the window shown in Figure 10.50.

FIGURE 10.50 Now using the formLayout to control element placement.

Because we are interacting with the users, we can provide them extra information that could be useful, such as how much grass they are about to create. In Example 10.52 we add a `text` control to the bottom of the Column Layout.

EXAMPLE 10.52 Addition of a text control to give user feedback.

```
text
    -align left
    grassGenFeedback
    ;
```

We then need a way to update it whenever the user modifies anything in the interface. To do this, we will create a new global procedure, held in the same file, called `updateGrassUI`. Using procedures to update UI windows is also how reactive UIs are built, such as enabling controls if the user selects a checkbox, or even enabling an entire layout type. For example, the UI creation script could create a `scriptJob` that rebuilds the UI whenever the selection changes, enabling a `tabLayout` if more than one object is selected.

Our UI updating procedure uses the same math as our `generateGrass` script. In fact, it's a simple matter of copying and pasting the line of code from that script. To gather the values for each of variables, in Example 10.53 we query the controls used in the UI. This is why clear, meticulous naming of UI controls is needed.

EXAMPLE 10.53 A separate procedure to update the user feedback area.

```
global proc updateGrassUI ()
{
float $maxX = `floatField -query
                       -value grassGenMinX`;
float $minX = `floatField -query
                       -value grassGenMaxX`;
float $maxZ = `floatField -query
                       -value grassGenMinZ`;
float $minZ = `floatField -query
                       -value grassGenMaxZ`;
float $density = `floatSliderGrp -query
                       -value grassGenDensity`;

int $amountToCreate =
    abs ( ( ( $maxX - $minx )
        * ( $maxZ - $minZ ) )
        * ( ( $density / 100.0 )
        * 325 ) );
```

After calculating the value, we use the `text` command again, this time in edit mode, to update the `text` field. An inline string addition statement, shown in Example 10.54, produces the desired result.

EXAMPLE 10.54 The actual command to update the text control.

```
text -edit
    -label ( "This will create "
            + $amountToCreate
            + " blades of grass" )
    grassGenFeedback
    ;
}
```

To have the `textField` update whenever one of the controls has its value changed, we add the argument `-changeCommand updateGrassUI` to each of the controls. After doing so, we also add the `updateGrassUI` command to the script immediately before issuing the `showWindow` command, ensuring that the `textField` is correct when the window is first created. The window, seen in Figure 10.51, now updates with the total number of grass that will be created.

ON THE CD *The text for this script is found on the companion CD-ROM as Chapter_10/ project_UI03/v07/grassUI.mel.*

Notice that the window has been resized to a more compact, pleasing size. To get this result, we simply resize the window to the desired size. Then, in Script Editor, we issue the command in Example 10.55.

FIGURE 10.51 The finished window.

EXAMPLE 10.55 Finding the size of the current Grass Generator window.

```
window —query —widthHeight grassUI;
```

We can take the resulting values and plug them into the window definition.

To add functionality to the Generate Grass button, and still retain the possibility of issuing the command from the command line, we will create another sub-procedure. This procedure, entitled `makeGrass`, simply gathers information from the UI, and issues the `generateGrass` command with the values. Note that the menu is a 1-based index, not a 0-based index, as arrays are. In Example 10.56 we use a `switch` statement to convert the value held in the menu to the string `generateGrass` expects.

EXAMPLE 10.56 This procedure acts as an intermediary between the UI and the command line version of the script.

```
global proc makeGrass ()
{
int $styleVal = `optionMenu -query
                 -select grassGenStyleDropdown`;
int $detailVal = `optionMenu -query
                 -select grassGenDetailDropdown`;

float $maxX = `floatField —query
                 -value grassGenMinX`;
float $minX = `floatField —query
                 -value grassGenMaxX`;
float $maxZ = `floatField —query
                 -value grassGenMinZ`;
```

```
float $minZ = `floatField —query
                    -value grassGenMaxZ`;
float $density = `floatSliderGrp —query
                    -value grassGenDensity`;

string $style;

switch ( $styleVal )
    {
    case 1:
        $style = "short";
        break;
    case 2:
        $style = "normal";
        break;
    case 3:
        $style = "long";
        break;
    case 4:
        $style = "very_long";
        break;
    }

string $detail;

switch ( $detailVal )
    {
    case 1:
        $detail = "low";
        break;
    case 2:
        $detail = "medium";
        break;
    case 3:
        $detail = "high";
        break;
    }

generateGrass $style
                $detail
                $density
                $minx
                $maxX
                $minZ
                $maxZ ;
}
```

While the UI is finalized, matches the original design, and is fully functional, there is one final aspect we can add to improve the user interaction.

One of the useful things Maya does is remember the settings a user has se-lected. We can add these with the `optionVar` command.

Option Variables

The first step to using option variables is to create them. Because the com-mand to create and to modify option variables is identical, to avoid overwrit-ing any previous settings we protect them with `if` statements.

At the beginning of the UI creation script, we add Example 10.57, which adds the `optionVars` with default values if they do not already exist.

EXAMPLE 10.57 The addition of optionVar commands.

```
// Add Option Variables
if ( !`optionVar -exists "tmcGrassGenType"` )
    optionVar -intValue "tmcGrassGenType" 2;

if ( !`optionVar -exists "tmcGrassGenDetail"` )
    optionVar -intValue "tmcGrassGenDetail" 3;

if ( !`optionVar -exists "tmcGrassGenDensity"` )
    optionVar -floatValue "tmcGrassGenDensity" 100;

if ( !`optionVar -exists "tmcGrassGenMinX"` )
    optionVar -floatValue "tmcGrassGenMinX" -1;

if ( !`optionVar -exists "tmcGrassGenMaxX"` )
    optionVar -floatValue "tmcGrassGenMaxX" 1;
if ( !`optionVar -exists "tmcGrassGenMinZ"` )
    optionVar -floatValue "tmcGrassGenMinZ" -1;

if ( !`optionVar -exists "tmcGrassGenMaxZ"` )
    optionVar -floatValue "tmcGrassGenMaxZ" 1;
```

Next, in Example 10.58, we assign the values stored in the option variable to variables.

EXAMPLE 10.58 Gathering data stored in the optionVars.

```
int $grassType = `optionVar -query "tmcGrassGenType"`;

int $grassType = `optionVar -query
                        "tmcGrassGenDetail"`;

float $grassDensity = `optionVar -query
                        "tmcGrassGenDensity"`;

float $grassMinX = `optionVar -query
```

```
                                      "tmcGrassGenMinX"`;
        float $grassMaxX = `optionVar -query
                                      "tmcGrassGenMaxX"`;
        float $grassMinZ = `optionVar -query
                                      "tmcGrassGenMinZ"`;
        float $grassMaxZ = `optionVar -query
                                      "tmcGrassGenMaxZ"`;
```

We can then use these variables in the creation of the controls. To update the option variables with the values used when the grass is generated, we add Example 10.59 to the `makeGrass` procedure.

EXAMPLE 10.59 Updating the optionVars with the user's current settings.

```
        optionVar -intValue "tmcGrassGenType" $style;

        optionVar -intValue "tmcGrassGenDetail" $detail;

        optionVar -floatValue "tmcGrassGenDensity" $density;

        optionVar -floatValue "tmcGrassGenMinX" $minX;

        optionVar -floatValue "tmcGrassGenMaxX" $maxX;

        optionVar -floatValue "tmcGrassGenMinZ" $minZ;

        optionVar -floatValue "tmcGrassGenMaxZ" $maxZ;
```

ON THE CD

The text for this script is found on the companion CD-ROM as Chapter_10/ project_UI03/final/grassUI.mel.

Now, whenever the Generate Grass button is pressed, the option variables are updated. If we change the values, generate grass, and re-run the script, the values are the same as before.

Project Conclusion and Review

In addition to building a UI using the form layout, we learned how to use `optionVar` to store user settings. Of course, use of `optionVar` is not limited to being used in a UI. One thing to always keep in mind with option variables is that because they are all stored in one location, unique naming is mandatory.

Project Script Review

```
        global proc grassUI ()
        {
```

```
// Add Option Variables
if ( !`optionVar -exists "tmcGrassGenType"` )
    optionVar -intValue "tmcGrassGenType" 1;
if ( !`optionVar -exists "tmcGrassGenDensity"` )
    optionVar -floatValue "tmcGrassGenDensity" 100;
if ( !`optionVar -exists "tmcGrassGenMinX"` )
    optionVar -floatValue "tmcGrassGenMinX" -1;
if ( !`optionVar -exists "tmcGrassGenMaxX"` )
    optionVar -floatValue "tmcGrassGenMaxX" 1;
if ( !`optionVar -exists "tmcGrassGenMinZ"` )
    optionVar -floatValue "tmcGrassGenMinZ" -1;
if ( !`optionVar -exists "tmcGrassGenMaxZ"` )
    optionVar -floatValue "tmcGrassGenMaxZ" 1;

int $grassType = `optionVar -query "tmcGrassGenType"`;
float $grassDensity = `optionVar -query
                            "tmcGrassGenDensity"`;
float $grassMinX = `optionVar -query "tmcGrassGenMinX"`;
float $grassMaxX = `optionVar -query "tmcGrassGenMaxX"`;
float $grassMinZ = `optionVar -query "tmcGrassGenMinZ"`;
float $grassMaxZ = `optionVar -query "tmcGrassGenMaxZ"`;

if( `window -exists grassUI` != 1 )
    {
    int $uiLabelWidth = 140;
    int $uiInputWidth = 240;
    int $uiWidth = ( $uiLabelWidth + $uiInputWidth );

    window
        -maximizeButton false
        -resizeToFitChildren false
        -title "Grass Generator"
        -iconName "Grass Generator"
        -menuBar false
        -wh 448 274
        grassUI;
    string $grassGenForm = `formLayout
                                -numberOfDivisions 100`;

    string $grassColumn = `columnLayout
                                -adjustableColumn true
                                -rowSpacing 5`;

    rowLayout
        -numberOfColumns 4
        -columnAttach 1 "right" 5
        -columnAttach 2 "both" 5
        -columnAttach 3 "right" 5
        -columnAttach 4 "both" 5
```

```
    -columnWidth 1 $uiLabelWidth
    -columnWidth 3 $uiLabelWidth
    ;

    text
        -label "Grass Style"
        -annotation
        "Select Grass Style.";
    optionMenu
        -label ""
        grassGenStyleDropdown;

        menuItem -label "Short";
        menuItem -label "Normal";
        menuItem -label "Long";
        menuItem -label "Very Long";

    text
        -label "Detail"
        -annotation
        "Select Amount of Detail.";
    optionMenu
        -label ""
        grassGenDetailDropdown;

        menuItem -label "Low";
        menuItem -label "Medium";
        menuItem -label "High";

separator -height 10;

rowLayout
    -numberOfColumns 3
    -columnAttach 1 "right" 5
    -columnWidth 1 $uiLabelWidth
    -columnWidth 2 $uiInputWidth
    grassDensityRow;

    text
        -label "Density"
        -annotation
            "Set the density parameter for the grass.";
    floatSliderGrp
        -field true
        -minValue 0
        -maxValue 100
        -changeCommand updateGrassUI
        -value $grassDensity
        grassGenDensity;
```

```
            text -label "0% - 100%";
            setParent ..;

    separator -height 10;

    rowLayout
        -numberOfColumns 3
        -columnAttach 2 "both" 5
        -columnAttach 3 "both" 5
        -columnWidth 1 $uiLabelWidth
        -columnWidth 2 ( $uiInputWidth * 0.5 )
        -columnWidth 3 ( $uiInputWidth * 0.5 )
        grassGenLabelRow;

        text
            -label "";
        text
            -label "Minimum Value"
            -align "center";
        text
            -label "Maximum Value"
            -align "center";
        setParent ..;

    rowLayout
        -numberOfColumns 3
        -columnAttach 1 "right" 5
        -columnWidth 1 $uiLabelWidth
        -columnWidth 2 ( $uiInputWidth * 0.5 )
        -columnWidth 3 ( $uiInputWidth * 0.5 )
        grassGenXRow;

        text
            -label "X Value"
        floatField
            -precision 6
            -width ( $uiInputWidth * 0.5 )
            -changeCommand updateGrassUI
            -value $grassMinX
            grassGenMinX;
        floatField
            -precision 6
            -width ( $uiInputWidth * 0.5 )
            -changeCommand updateGrassUI
            -value $grassMaxX
            grassGenMaxX;
        setParent ..;

    rowLayout
```

```
        -numberOfColumns 3
        -columnAttach 1 "right" 5
        -columnWidth 1 $uiLabelWidth
        -columnWidth 2 ( $uiInputWidth * 0.5 )
        -columnWidth 3 ( $uiInputWidth * 0.5 )
        grassGenZRow;

        text
            -label "Z Value"
        floatField
            -precision 6
            -width ( $uiInputWidth * 0.5 )
            -changeCommand updateGrassUI
            -value $grassMinZ
            grassGenMinZ;
        floatField
            -precision 6
            -width ( $uiInputWidth * 0.5 )
            -changeCommand updateGrassUI
            -value $grassMaxZ
            grassGenMaxZ;
        setParent ..;

    separator -height 10;

    text
        -label ( "This will create "
                + "0"
                + " blades of grass" )
        -align left
        grassGenFeedback
        ;

    setParent ..;

    string $genButton = `button
                        -height 40
                        -label "Generate Grass"
                        -command "makeGrass"`;

    string $closeUIButton = `button
                        -height 40
                        -label "Close"
                        -command "deleteUI grassUI"`;

    setParent ..;

    formLayout -edit
        -attachForm $grassColumn "top" 2
```

```
                    -attachForm $grassColumn "left" 2
                    -attachControl $grassColumn "bottom" 2 $genButton
                    -attachForm $grassColumn "right" 2

                    -attachNone $grassGenButton "top"
                    -attachForm $grassGenButton "left" 2
                    -attachForm $grassGenButton "bottom" 2
                    -attachPosition $grassGenButton "right" 0 75

                    -attachNone $grassCloseUIButton "top"
                    -attachPosition $grassCloseUIButton "left" 0 75
                    -attachForm $grassCloseUIButton "bottom" 2
                    -attachPosition $grassCloseUIButton "right" 2 100
                    $grassGenForm;

            updateGrassUI;
            showWindow grassUI;
            }
    }

    global proc updateGrassUI ()
    {
    float $maxX = `floatField -query -value grassGenMinX`;
    float $minX = `floatField -query -value grassGenMaxX`;
    float $maxZ = `floatField -query -value grassGenMinZ`;
    float $minZ = `floatField -query -value grassGenMaxZ`;
    float $density = `floatSliderGrp -query
                                    -value grassGenDensity`;

    int $amountToCreate =
            abs ( (
                ( $maxX-$minX )
                *
                ( $maxZ-$minZ )
                ) * (
                ( $density / 100.0 )
                *
                325
                ) ) ;
        text
            -edit
            -label ( "This will create "
                    + $amountToCreate
                    + " blades of grass" )
            grassGenFeedback
            ;
    }
```

```
global proc makeGrass ()
{
int $styleVal = `optionMenu -query
                      -select  grassGenStyleDropdown`;
int $detailVal = `optionMenu -query
                      -select grassGenDetailDropdown`;
float $maxX = `floatField -query -value grassGenMinX`;
float $minX = `floatField -query -value grassGenMaxX`;
float $maxZ = `floatField -query -value grassGenMinZ`;
float $minZ = `floatField -query -value grassGenMaxZ`;
float $density = `floatSliderGrp —query -value
                                    grassGenDensity`;

string $style;

switch ( $styleVal )
    {
    case 1:
        $style = "short";
        break;
    case 2:
        $style = "normal";
        break;
    case 3:
        $style = "long";
        break;
    case 4:
        $style = "very_long";
        break;
    }

string $detail;

switch ( $detailVal )
    {
    case 1:
        $detail = "low";
        break;
    case 2:
        $detail = "medium";
        break;
    case 3:
        $detail = "high";
        break;
    }

optionVar -intValue "tmcGrassGenType" $style;
optionVar -intValue "tmcGrassGenDetail" $detail;
optionVar -floatValue "tmcGrassGenDensity" $density;
```

```
    optionVar -floatValue "tmcGrassGenMinX" $minX;
    optionVar -floatValue "tmcGrassGenMaxX" $maxX;
    optionVar -floatValue "tmcGrassGenMinZ" $minZ;
    optionVar -floatValue "tmcGrassGenMaxZ" $maxZ;

    generateGrass $style
                  $detail
                  $density
                  $minx
                  $maxX
                  $minZ
                  $maxZ ;
  }
```

CONCLUSION

Adding user interfaces to scripts can be a time-consuming and sometimes frustrating process; however, the payoffs are immense. Besides adding usability to a tool, a UI immediately adds a sense of sophistication and completeness to a script. In the next section, we continue our exploration of the Maya user interface, and how we can use MEL to take control of it.

11

CUSTOMIZING THE MAYA INTERFACE

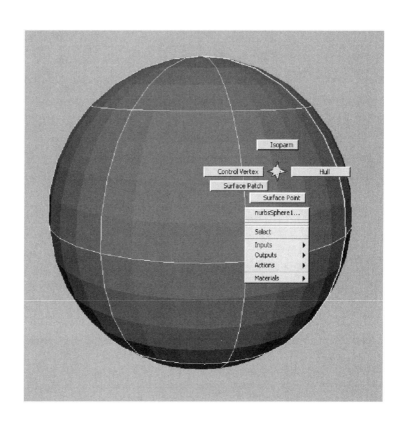

Working with UIs is not limited to creating windows. Almost the entire interface is available to modify. Many artists limit their customizing of the Maya interface to changing colors and perhaps modifying the hotkey assignments. This is only the beginning. In this chapter, we will examine the user elements of *panels*, *menus*, and *heads-up displays*.

While panels and menus can be and often are implemented into windows, much of the power in using them comes in accessing the menus and panels that make up the main Maya interface. Menus are not only the bar at the top of the interface and each of the modeling views. In Maya, there exist two other types of menus: *marking menus*, seen in Figure 11.1, and *popup menus*, seen in Figure 11.2.

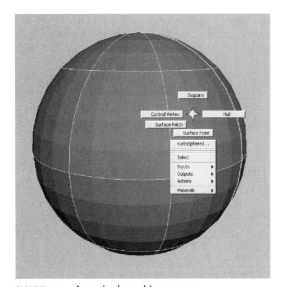

FIGURE 11.1 A typical marking menu.

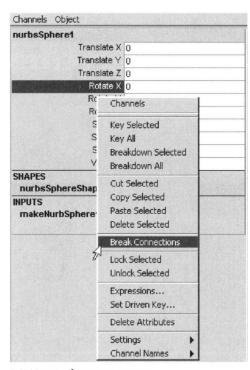

FIGURE 11.2 A popup menu.

Heads-up displays exist as an overlay of the *modelPanel*. Because a modelPanel can be implemented into a window, it can be said that heads-up displays can be part of windows, but that is dependent on there being a `modelPanel`, so it is a matter of semantics.

MENUS

While addressing menus, we will use the term "menu" to refer to those menus that exist at the top of the window and panels. Other menus, like popupMenus, optionMenus, and other specialty menus will be explicitly referred to. Unlike simple controls like a slider or textField, menus are defined by multiple commands. The first command defines the type of menu, and the command menuItem is used to add entries to a menu. In this sense, menus act much like layouts, acting only as a holder of other items. Interestingly, menuItem is used to define any submenus that exist for the menu. Although it does create a new menu item that can be accessed from MEL, the command menuItem acts in many ways like a variety of separate controls, so we will cover some of the flags possible for use with the command

Perhaps the three most important are the checkbox, optionBox, and radioButton options. In Figure 11.3, we see a menu demonstrating all three of these flags. In the first section are three check-box menu items, the third one enabled. The second section contains check-box menu items, and the third section contains a menu item with an option box. The radio buttons are part of a radioMenuItemCollection. Although they appear similar to the checkboxes visually, their behavior is quite different. Of all the menuItems that make up the radio collection, only one can be selected. The checkbox items, on the other hand, are either on or off on an individual basis.

FIGURE 11.3 The checkbox, optionBox, and radioButton menuItem options.

Note that the different menu sections were differentiated with the divider flag used on the menuItem command. This flag makes the menuItem into a visual separator, similar to the separator control, but without the wide variety of drawing styles. Also important to realize is that the optionBox flag does not add an option box to a menuItem; rather, it turns that menuItem into an option box that has separate command flags. This means

that if a menu has only a single listing, but with an option box, the menu requires two `menuItem` entries.

Not surprisingly, sub-menus are defined with the flag `-subMenu`. After creating a submenu, each subsequent `menuItem` command issued will be part of that submenu, until the command `setParent –menu` is issued. A menu with a submenu is seen in Figure 11.4.

FIGURE 11.4 The subMenu.

When the submenu is created, you have the option to enable the new menu's ability to be torn off and whether it allows child items to have option boxes.

Menu items can either issue a command, or simply exist for later data gathering. For example, one menu item could print out a series of statements to the Script Editor, but first that command issues a query to find out whether the user has the (theoretical) `checkbox` `menuItem` "Clear Script Editor History" enabled. The checkbox and radio button menu items can also issue commands, so by having that command check the status of a menu item, you can easily create menu items that enable options. This is how many features of standard Maya editors, such as the "Show Buffer Curves" menu item in the Graph Editor, work.

In our last chapter, we used MEL to dynamically build UIs with varying amounts of buttons based on how many lights existed in the scene. While it is possible to dynamically build menus in much the same way, in general it is best to avoid this practice. There are exceptions, such as the menu to choose which camera a panel uses. The reason for this is that if options disappear from a menu, users might lose track of where to find certain items. Rather than removing items, simply disable them, by using the `enable` flag. Because you can execute a command when a menu is asked to be drawn, you can dynamically enable or disable items before the menu is seen by the end user. A menu showing some disabled items is seen in Figure 11.5.

FIGURE 11.5 Disabled menu items.

Menus can be embedded into windows, layouts, and the general UI it-self. Because of this, the screen can sometimes be overflowing with menus. For example, if we look at Figure 11.6, we see a large number of menus.

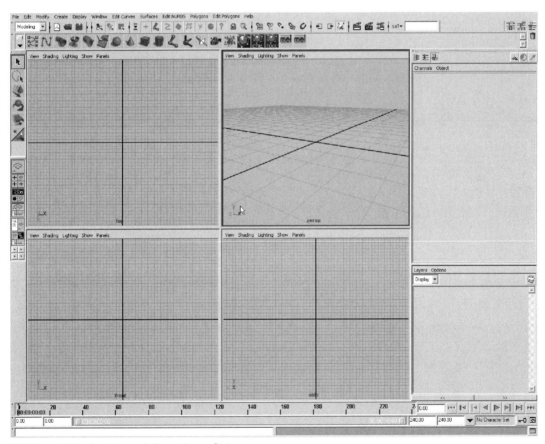

FIGURE 11.6 The basic modeling view of Maya.

In this somewhat basic Maya view, there are 40 menus. Each modeling pane has 5 menus, the Script Editor has 4, the Channel Box and Layer Editor each have 2, and the remaining 12 are found as part of the main Maya menu set. To ease the confusion for the user, menus generally follow guidelines according to what order they come in. While there are no brigades of menu police who will come to take away programmers who don't follow these rules, it is a sign of a considerate and intelligent programmer who does. If the menu set contains a File menu, it should come first, working from left to right. Then, the Edit menu, if it exists, coming next. If a Help menu exists, that should come as the last menu. In fact, due to the way different operating systems treat Help menus, there is a flag on the `menu` command to notify Maya that the menu is a Help menu.

 The command `showHelp` *can be used to launch a Web browser pointing to either a URL or to a location on the local drive. This allows programmers to put both documentation and a method for the user to find the author quite easily. It is even possible to put a "Check for Updates . . ." option in, by passing the script version in the URL and some clever Web site construction.*

Now that we are able to create menus for menu bars, the inevitable question arises, can we add menus to the main Maya window? The answer is, obviously, yes. Not only can we add menus, we can also delete items in the menus that exist already, or even delete entire menus.

There are many reasons to remove or add items to the Maya menus. Most obvious is to add menus for the scripts we have taken the time to write. Or, perhaps we want to rearrange the order of menus or items in the menus. We can even take the drastic action of removing entire suites of tools from the artist.

To add a menu to the main Maya window, we first must give it a name, such as Edit Polygons. This menu name is defined by the global variable `$gMainWindow`. We can use the Command menu and explicitly name its parent as `$gMainWindow`, as seen in Example 11.1.

EXAMPLE 11.1 Creating a menu in the main Maya interface.

```
// creates a menu in Main Menu
// named "MEL Companion"

menu
    -label " MEL Companion "
    -tearOff true
    -parent $gMainWindow
    melCompanionMenu;
menuItem
    -label "Generate Grass"
    -command "generateGrass";
```

```
menuItem
    -label "Front"
    -command "switchModelView front;";
```

This produces the menu seen in Figure 11.7.

FIGURE 11.7 Adding a menu to the
main interface.

However, if we switch modes, such as to Modeling from Animation,
the menu persists. If we want to add the menu just to one of these, we
have to access further global variables, which hold the names of all the
menus. The four basic modules are:

- $gModelingMenus
 MayaWindow|mainEditCurvesMenu
 MayaWindow|mainSurfacesMenu
 MayaWindow|mainEditSurfacesMenu
 MayaWindow|mainPolygonsMenu
 MayaWindow|mainEditPolygonsMenu
- $gAnimationMenus
 MayaWindow|mainKeysMenu
 MayaWindow|mainDeformationsMenu
 MayaWindow|mainSkeletonsMenu
 MayaWindow|mainSkinningMenu
 MayaWindow|mainConstraintsMenu
 MayaWindow|mainCharactersMenu
- $gDynamicsMenus
 MayaWindow|mainParticlesMenu
 MayaWindow|mainFieldsMenu
 MayaWindow|mainDynBodiesMenu
 MayaWindow|mainDynEffectsMenu
 MayaWindow|mainDynSettingsMenu
- $gRenderingMenus
 MayaWindow|mainShadingMenu
 MayaWindow|mainRenTexturingMenu
 MayaWindow|mainRenderMenu
 MayaWindow|mainCreatorMenu

 We found the global variables holding the names of all these menus by using the env *command to get a list of every global variable. Then, we can just explore what each is, if not readily apparent from its name.*

To add a menu to one of the modal sets, we simply capture the name of the menu upon creation and add it to the array representing the menu set we want to add to, as seen in Example 11.2. Note that in the example, we check to see if the menu already exists. This is always a good idea, to avoid errors.

EXAMPLE 11.2 Adding our menu only to the modeling menu set.

```
int $companionMenuExists;

// Check for the existence of a menu containing the
// word "Companion" in its title
for ( $eachMenu in $gModelingMenus )
    if ( `match "Companion" $eachMenu` == " Companion" )
        $companionMenuExists = 1;

if ( $companionMenuExists != 1 )
    {
    $gModelingMenus[`size $gModelingMenus`] =
        `menu -label "The MEL Companion"
            -label " MEL Companion "
            -tearOff true
            melModellingCompanionMenu`;
        menuItem
            -label "Generate Grass"
            -command "generateGrass";
        menuItem
            -label "Front"
            -command "switchModelView front;";
    }
```

Now, the menu appears only in the Modeling menu set.

To modify the appearance of the default Maya menus simply requires the modification of the scripts that define these menus. In the directory in which Maya is installed, look for a directory called Maya*XX*, where *XX* represents the version number of Maya with which you are working. There will be a directory called *scripts*, and within that a directory entitled *startup*, as seen in Figure 11.8.

Within this directory, we find a vast number of scripts. Modification of these scripts will allow us to alter the menus as they appear. It is, however, a very bad idea to modify the original scripts. Instead, we can write scripts that delete elements of the array, using the scripts found in "../startup/ to find the names of the menuItem controls you want to elimi-

FIGURE 11.8 The Maya 4.0 Startup
Scripts directory in Windows.

nate or replace the creating scripts with or own copies, after backing up
the originals. To remove an entire menu, simply find the full internal
name of the menu you want to eliminate and use the command `deleteUI`
on it.

Now that we are able to modify the Maya menus from within the in-
terface, how do we modify Maya with these menu changes? The answer
lies in a special script called `userSetup.mel`.

userSetup.mel

When Maya initializes, it looks in the current user's scripts directories for
a file called `userSetup.mel`. If it finds the file, it is executed, a new file is
created, and the program is ready for the user to use. If we put our menu
commands into that script, we are able to rebuild the Maya interface be-
fore the user ever encounters it. The `userSetup.mel` is also where you can
define any standard global variables you want, as well as use the `alias`
command to further customize the Maya environment.

If the goal is to add items to or re-arrange a standard Maya menu,
such as the File or Edit menu, there are two approaches. The first is to
delete each item in the menu and rebuild it as you want. The second,
slightly more dangerous approach, is to modify the scripts found in the
../scripts/startup/ directory. It must be stressed that this can prove to be
very dangerous, so users doing this must back up the files they change so
they can recover them if necessary.

Menu bars are not the only types of menu available to you within Maya. As previously stated, both marking menus and popups are considered menus. They are actually the same command, `popupMenu`.

While Maya provides a method for creating Marking menus for use in the viewport, it is possible to attach both to controls used in user interfaces you create.

Doing this is a simple matter of adding in the `popupMenu` command in the UI definition (see Example 11.3).

EXAMPLE 11.3 Window—title "Popup Menus On Controls";.

```
window;
    columnLayout
        -columnAttach "both" 5
        -rowSpacing 10
        -columnWidth 250;
        button
            -label "Has Popup";
            popupMenu;
                menuItem
                    -label "popItem 01";
                menuItem
                    -label "popItem 02";
                menuItem
                    -label "popItem 03";
        button
            -label "No Popup";
    showWindow;
```

This window is seen in action in Figure 11.9.

FIGURE 11.9 Popup menu attached to controls.

A popup menu can be added to nearly every control, but some such as buttons and fields limit the popup to being activated with the third mouse button to reduce conflicts with the behaviors of these controls.

To learn more about how to properly implement popups in a user interface, we will construct a simple UI for globally setting transformation attributes.

PROJECT

11.1: IMPLEMENTING POPUPS

Using layouts that construct user interface elements from separate controls is often necessary to fully exploit the benefits of using popup controls. For example, in Figure 11.10 we see a design for a user interface that integrates two float field groups representing the translation and rotation channels for transforms. Beyond the float fields we have eight buttons to get the values from the selected object, one to get all three, and one to retrieve each individual channel.

Translate X	
Translate Y	
Translate Z	
Rotate X	
Rotate Y	
Rotate Z	

Get Translate XYZ
Get Translate X
Get Translate Y
Get Translate Z
Get Rotate XYZ
Get Rotate X
Get Rotate Y
Get Rotate Z

FIGURE 11.10 Possible design for the window.

This window is overly cluttered, with the main purpose of the window, the float fields, overpowered by the buttons. If we were to create a window with two float field groups, as seen in Figure 11.11, we could attach a popupMenu to each that has commands to get the x, the y, the z, or all three.

If instead we use multiple rowLayouts, each with a text control and three individual float fields, we can attach separate popups to each of the controls, as seen in Figure 11.12.

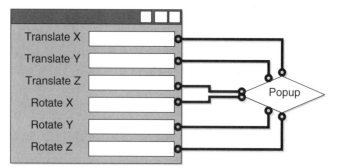

FIGURE 11.11 Alternative design for the proposed window.

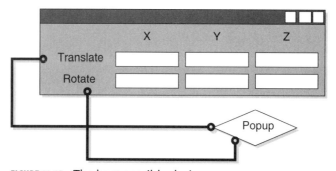

FIGURE 11.12 The best possible design.

Not only is this design efficient in terms of screen real estate, it also conforms to the behavior of the Attribute Editor.

Now that we have our finalized design, we can see a breakdown of elements in Figure 11.13.

	Text	Text	Text
Text	floatField	floatField	floatField
Text	floatField	floatField	floatField

FIGURE 11.13 UI element breakdown.

We can then implement the script, using all the techniques we have learned so far. See Example 11.4.

EXAMPLE 11.4 We begin our script.

```
global proc massSetTransform ()
{
```

First, we check for the existence of the window, and if it does not exist, we continue with the UI creation. We again use variables to define widths for UI elements to quickly alter the UI during script creation. See Example 11.5.

EXAMPLE 11.5 We begin construction of our UI window.

```
if( `window -exists massTransUI` != 1 )
    {
    int $uiLabelWidth = 80;
    int $uiInputWidth = 240;
    int $uiWidth = ( $uiLabelWidth + $uiInputWidth );

    window
        -maximizeButton false
        -resizeToFitChildren false
        -title "Set Transforms"
        -iconName "Set Transforms"
        -menuBar false
        -wh 330 174
        massTransUI;
```

ON THE CD

The text for this script is found on the companion CD-ROM as Chapter_11/ project_UI04/v01/massSetTransform.mel.

Note that the window size was determined after the full window was designed, and then added to the file.

Add the main column layout that holds the row layouts. See Example 11.6.

EXAMPLE 11.6 Adding the column to our UI.

```
string $transColumn = `columnLayout
    -adjustableColumn true
    -rowSpacing 5`;
```

Add the row layout that contains the labels at the top of each column. We use columnAlign and columnAttach flags to make sure the labels are properly centered. See Example 11.7.

EXAMPLE 11.7 Adding the row layout.

```
rowLayout
    -numberOfColumns 4
```

```
              -columnAlign  2 center
              -columnAlign  3 center
              -columnAlign  4 center
              -columnAttach 1 right 5
              -columnAttach 2 both 0
              -columnAttach 3 both 0
              -columnAttach 4 both 0
              -columnWidth 1 $uiLabelWidth
              -columnWidth 2 ( $uiInputWidth / 3 )
              -columnWidth 3 ( $uiInputWidth / 3 )
              -columnWidth 4 ( $uiInputWidth / 3 )
              trans_mainRow01;
```

Now, add the labels. The first `text` control is empty to simply fill the far-left column. Again, we use the `align` flag on the text fields to guarantee centering of labels. See Example 11.8.

EXAMPLE 11.8 Using text controls as labels.

```
              text
                  -label "";
              text
                  -label "X"
                  -align center;

              text
                  -label "Y"
                  -align center;
              text
                  -label "Z"
                  -align center;
              setParent ..;

          rowLayout
              -numberOfColumns 4
              -columnAttach 1 right 5
              -columnWidth 1 $uiLabelWidth
              -columnWidth 2 ( $uiInputWidth / 3 )
              -columnWidth 3 ( $uiInputWidth / 3 )
              -columnWidth 4 ( $uiInputWidth / 3 )
              trans_mainRow02;

          text
              -label "Translate";
```

The text for this script is found on the companion CD-ROM as Chapter_11/ project_UI04/v02/massSetTransform.mel.

We begin to add popup menus to the UI. We use the default right mouse button to access the menu. We make a call to the procedure `massSetGet`, which we will soon write, and pass it the appropriate flag. See Example 11.9.

EXAMPLE 11.9 The addition of popup menus to the window.

```
popupMenu;

    menuItem
        -label "Get All Translate Values"
        -command "massSetGet t";

floatField
    -width ( $uiInputWidth / 3 )
    msTXField;

popupMenu;

    menuItem
        -label "Get Translate X"
        -command "massSetGet tx";

floatField
    -width ( $uiInputWidth / 3 )
    msTYField;

popupMenu;

    menuItem
        -label "Get Translate X"
        -command "massSetGet ty";

floatField
    -width ( $uiInputWidth / 3 )
    msTZField;

popupMenu;

    menuItem
        -label "Get Translate Z"
        -command "massSetGet tz";
setParent ..;

rowLayout
    -numberOfColumns 4
    -columnAttach 1 right 5
    -columnWidth 1 $uiLabelWidth
    -columnWidth 2 ( $uiInputWidth / 3 )
```

```
                    -columnWidth 3 ( $uiInputWidth / 3 )
                    -columnWidth 4 ( $uiInputWidth / 3 )
                    trans_mainRow03;

           text
                    -label "Rotate";

               popupMenu;

                   menuItem
                        -label "Get All Rotate Values"
                        -command "massSetGet r";

           floatField
                    -width ( $uiInputWidth / 3 )
                    msRXField;

               popupMenu;

                   menuItem
                        -label "Get Rotate X"
                        -command "massSetGet rx";

           floatField
                    -width ( $uiInputWidth / 3 )
                    msRYField;

               popupMenu;

                   menuItem
                        -label "Get Rotate Y"
                        -command "massSetGet ry";

           floatField
                    -width ( $uiInputWidth / 3 )
                    msRZField;

               popupMenu;

                   menuItem
                        -label "Get Rotate Z"
                        -command "massSetGet rz";
           setParent ..;
```

ON THE CD

The text for this script is found on the companion CD-ROM as Chapter_11/ project_UI04/v03/massSetTransform.mel.

We can now add a button to execute the set procedure. The UI is simple enough that it doesn't need a formLayout, although we could use one to sim-

plify any expansion of the user interface if we need to. We could even lock the window to prevent it from being resized, if we so desired. See Example 11.10.

EXAMPLE 11.10 Adding a button to execute the set procedure.

```
string $massSetButton = `button
                  -height 30
                  -label "Set On Selected"
                  -command "doMassSet"`;

    showWindow massTransUI;
    }
}
```

ON THE CD

The text for this script is found on the companion CD-ROM as Chapter_11/ project_UI04/v04/massSetTransform.mel.

Add the procedure that sets the values gathered from the window on all the selected objects. There is actually a lot more error checking we could be doing above and beyond just making sure the attribute exists. We could also check to make sure the channel is not locked, and that the channel is not being controlled by an outside influence, such as an expression. See Example 11.11.

EXAMPLE 11.11 The procedure to set the transformation values on the selected objects.

```
global proc doMassSet ()
{
string $selTrans[] = `ls -selection`;

float $tx = `floatField -query -value msTXField`;
float $ty = `floatField -query -value msTYField`;
float $tz = `floatField -query -value msTZField`;
float $rx = `floatField -query -value msRXField`;
float $ry = `floatField -query -value msRYField`;
float $rz = `floatField -query -value msRZField`;

for ( $each in $selTrans )
    {
        if ( `attributeExists "tx" $each` == 1 )
            setAttr ( $each + ".tx" ) $tx;
        if ( `attributeExists "ty" $each` == 1 )
            setAttr ( $each + ".ty" ) $ty;
        if ( `attributeExists "tz" $each` == 1 )
            setAttr ( $each + ".tz" ) $tz;
        if ( `attributeExists "rx" $each` == 1 )
            setAttr ( $each + ".rx" ) $rx;
        if ( `attributeExists "ry" $each` == 1 )
```

```
                              setAttr ( $each + ".ry" ) $ry;
                  if ( `attributeExists "rz" $each` == 1 )
                      setAttr ( $each + ".rz" ) $rz;
      }
  }
```

The text for this script is found on the companion CD-ROM as Chapter_11/ project_UI04/doMassSet.mel.

This procedure, massSetGet, is the one called from the popup menus. It accepts a string argument, and depending on which one is requested, updates the appropriate field. See Example 11.12.

EXAMPLE 11.12 The procedure called from the popup menus.

```
global proc massSetGet ( string $attr )
{
string $selTrans[] = `ls -selection`;

if ( `size $selTrans` > 0 )
    {
    float $tx = `getAttr ( $selTrans[0] + ".tx" )`;
    float $ty = `getAttr ( $selTrans[0] + ".ty" )`;
    float $tz = `getAttr ( $selTrans[0] + ".tz" )`;
    float $rx = `getAttr ( $selTrans[0] + ".rx" )`;
    float $ry = `getAttr ( $selTrans[0] + ".ry" )`;
    float $rz = `getAttr ( $selTrans[0] + ".rz" )`;

    if ( ($attr == "tx") || ($attr == "t" ))
        floatField -edit -value $tx msTXField;

    if ( ($attr == "ty") || ($attr == "t" ))
        floatField -edit -value $ty msTYField;

    if ( ($attr == "tz") || ($attr == "t" ))
        floatField -edit -value $tz msTZField;

    if ( ($attr == "rx") || ($attr == "r" ))
        floatField -edit -value $rx msRXField;

    if ( ($attr == "ry") || ($attr == "r" ))
        floatField -edit -value $ry msRYField;

    if ( ($attr == "rz") || ($attr == "r" ))
        floatField -edit -value $rz msRZField;
    }
}
```

The text for this script is found on the companion CD-ROM as Chapter_11/ project_UI04/final/massSetTransform.mel.

This gives us the final window, seen in Figure 11.14.

FIGURE 11.14 The finished window, with popups.

PROJECT

11.2: MARKING MENUS A GO-GO

While the Marking Menu Editor should always be the first place a user, even a MEL-savvy one, should go to create and edit new Marking menus, it is often necessary to go to the original source script files to alter the behavior of the Marking menus that exist within Maya by default.

Maya creates an amazingly large variety of Marking menus based on the same action, the press of the right mouse button. Upon pressing, Maya goes through a complicated series of actions, all to determine what items need to be in the Marking menu, builds the menu, and shows it to the user. All of these actions are contained in a script in the MayaX.X/scripts/others directory called `dagMenuProc.mel`.

Finding the appropriate file to modify when we want to change the behavior of an Alias|Wavefront script can sometimes be challenging. If we include all the scripts that make up a default installation of Maya, there are more than 2300 separate script files, many with multiple procedures, to wade through. It is often a matter of some simple detective work to find the correct file and procedure. If the Script Editor echoes the name of the procedure, simply look for a `.mel` file of the same name. If that yields no results, using either your operating system's search capabilities or some data mining software to search for the procedure name in the body of all the scripts will often find the appropriate file. If this still yields no results, then the command might be one of the few hard-coded commands that exist in Maya. It is good practice to keep a journal file or log of what each procedure does as it is discovered. For

example, the `dagMenuProc.mel` file was discovered accidentally after looking for the scripts associated with the modeling views. This led to looking at `ModEdMenu.mel`, which led to `buildObjectMenuItemsNow.mel`, which in turn led to `dagMenuProc.mel`. Having kept track of these relationships lets us quickly find the appropriate files when we do want to change the behavior defined therein.

What we want to do is add functionality to the Marking menu that appears when a user right-clicks over a joint. By default, all that appears are two commands associated more with skinning than with skeleton construction, Assume Preferred Angle and Set Preferred Angle, as seen in Figure 11.15.

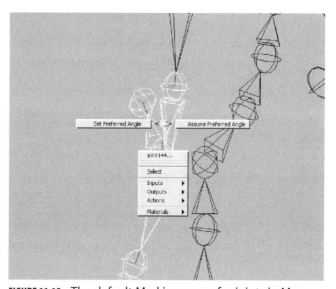

FIGURE 11.15 The default Marking menu for joints in Maya.

One of the attributes unique to joints is `jointOrient`. Serving as a rotational offset for its parent, `jointOrient` is incredibly useful for positioning a bone and keeping its rotation values at 0, similar to Freeze Transform.

Design

The script to reset the joint orientations is quite simple, the type of script MEL-savvy artists write every day to aid in their workflow. Example 11.13 shows the script text.

EXAMPLE 11.13 The script to reset joint rotation values.

```
global proc int resetJointRotations ( string $joint )
{
```

Chapter 11 Customizing the Maya Interface **365**

```
// Find the rotation values of the joint
float $rx = `getAttr ( $joint + ".rotateX" )`;
float $ry = `getAttr ( $joint + ".rotateY" )`;
float $rz = `getAttr ( $joint + ".rotateZ" )`;

// Find the joint orient values for the joint
float $jox = `getAttr ( $joint + ".jointOrientX" )`;
float $joy = `getAttr ( $joint + ".jointOrientY" )`;
float $joz = `getAttr ( $joint + ".jointOrientZ" )`;

// Reset the rotation values to 0
setAttr ( $joint + ".rotateX" ) 0 ;
setAttr ( $joint + ".rotateY" ) 0 ;
setAttr ( $joint + ".rotateZ" ) 0 ;

// Set the joint orients to their new value
setAttr ( $joint + ".jointOrientX" ) ( $jox + $rx );
setAttr ( $joint + ".jointOrientY" ) ( $joy + $ry );
setAttr ( $joint + ".jointOrientZ" ) ( $joz + $rz );

return 1;
}
```

ON THE CD

The text for this script is found on the CD-ROM as Chapter_11/project_UI05/ resetJointRotations.mel

Now that the command exists to accomplish what we want, we can add it to the Marking menu that appears when a user right-clicks on a joint. After making a backup of the file, open the `dagMenuProc.mel` file found in the ../others/ directory.

The file is quite large, and finding the appropriate section of such files can sometimes be a daunting task. However, in this case, we can simply use the "Find . . ." capabilities of a text editor to search for the phrase "Set Preferred Angle," which finds the section that builds the Marking menu for right-click over a joint. Part of an enormous `if-else if` statement, the appropriate section is seen in Example 11.14.

EXAMPLE 11.14 The code that defines the Marking menu for joints.

```
    . . .

else if ($isJointObject) {
    menuItem -l "Set Preferred Angle"
        -echoCommand true
        -c (`performSetPrefAngle 2` + " " + $item)
        -rp "W"
        setPrefAngleItem;
```

```
menuItem -l "Assume Preferred Angle"
    -echoCommand true
    -c (`performAssumePrefAngle 2` + " " + $item)
    -rp "E"
    assumePrefAngleItem;

// Check if the current context is the skinPaint context
// and the thc joint is connected to a skinCluster
```

Following the comment is a more intense section that checks to see if the user has the Paint Weights tool (termed a *context* in Maya programming) selected, and if so places a Paint Weights item in the north quadrant of the Marking menu. This means we have five remaining areas in which to place our tool. For our example, we will use the southwest corner. We add the section shown in Example 11.15 to `dagMenuProc.mel` to add the menu. Note the commenting added to easily find the user added section.

EXAMPLE 11.15 The code we added to modify.

```
    . . .

else if ($isJointObject) {
    menuItem -l "Set Preferred Angle"
        -echoCommand true
        -c (`performSetPrefAngle 2` + " " + $item)
        -rp "W"
        setPrefAngleItem;

    menuItem -l "Assume Preferred Angle"
        -echoCommand true
        -c (`performAssumePrefAngle 2` + " " + $item)
        -rp "E"
        assumePrefAngleItem;

    //*********************************************
    //
    //        USER ADDED SECTION
    //
    //*********************************************

    // The following adds resetJointRotations to the
    // context sensitive joint marking menu
    // added on 19.October.2002
    menuItem
        -label "Reset Joint Rotations"
        -echoCommand true
        -command ( "resetJointRotations " + $item )
        -rp "SW"
```

```
resetJointRotationsItem;
```

// Check if the current context is the skinPaint context

The text for this script is found on the CD-ROM as Chapter_11/project_UI05/ dagMenuProc.additions

To see the results of this, we have to source the `dagMenuProc.mel` file, or start a new Maya session. After this is done, we get the menu pictured in Figure 11.16.

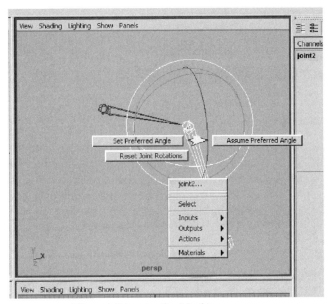

FIGURE 11.16 The addition to the Marking menu now appears.

Now that we can customize the context-sensitive marking menus, we have an amazing amount of control over the way a user interacts with objects in the Maya interface. We can confidently modify the scripts defining the marking menus defined by the scripts in the ../startup and ../other directories. Remember to always back up these files, to ensure that any problems can be easily fixed.

Panels

For all the time we have spent discussing UI elements such as layouts and controls, it is interesting to realize that the vast majority of the user interface is actually made up of panels. Panels make up the Channel Box, the Outliner, the Graph Editor—even the Modeling views. Once we are able to access panels,

we can create more intelligent hotkeys and hotkey behavior, and incorporate them into our own UIs. Finally, we will learn about the power of a family of panels called *scripted panels*.

Looking at a list of the panels available in Maya is almost like looking at the list of editors available to the Maya artist. Some panel types include:

- componentEditor
- hyperShade
- outlinerPanel
- modelPanel
- hardwareRenderPanel
- visor
- hyperGraph

Looking at that list, we see that nearly every part of the interface we use to work with data in Maya is handled by panel constructs. If we can access these panels from MEL, we suddenly gain control over the vast majority of the interface.

There are two pieces of information we need to gather when working with panels that, while similar, result in vastly different behavior. Those two pieces of information are the panel with *focus* and the panel *under*.

If we refer to Figure 11.17, we see that the Modeling view has a darkened border. This represents the panel with focus. The easy definition of focus is that it is the last panel the user was working in, or clicked in. The other way to find which panel the user intends to work in is to find which panel is underneath

FIGURE 11.17 A Modeling panel with focus.

the pointer. In Figure 11.18, although the outliner has focus, the Graph Editor is currently under the pointer.

FIGURE 11.18 The difference between focus and under pointer status of panels.

We access both of these qualities with the command getPanel. With get-Panel, we can gather a variety of data from the operating environment. We will be using some of its other arguments later when we begin to work with scripted panels. Now that we can find what panel is active, we can begin to do something with that information.

Within Maya are a number of options that are available to customize and tweak the appearance of the modeling windows. One of the more recent additions was the ability to activate a mode called "Isolate Select." Isolate Select allows an artist to hide any unselected objects, but only in a particular viewport, rather than as a global visibility change. Creating a single hotkey that toggles the isolate select state of a window is a simple matter of finding which window the user wants to isolate in, and use a simple if-else conditional statement to

set the state based on its current status. Simple for any artist to do, with a little MEL knowledge. Hotkey assignments can have MEL commands entered directly in them, as is seen in Figure 11.19.

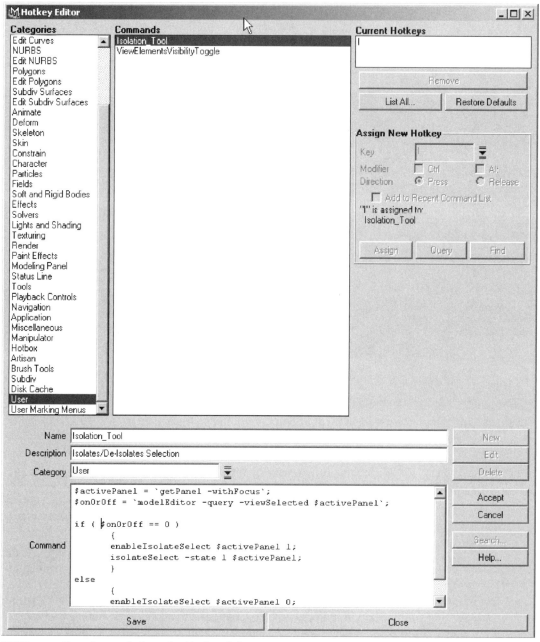

FIGURE 11.19 Entering code into the Hotkey Editor.

The actual code is, as stated, simple, and seen in Example 11.16.

EXAMPLE 11.16 The code to change the Isolate Select hotkey into a toggle.

```
$aPanel = `getPanel -withFocus`;

$isoStatus = `modelEditor
        -query -viewSelected
        $aPanel`;

if ( $isoStatus == 0 )
    {
    enableIsolateSelect $aPanel 1;
    isolateSelect -state on $aPanel;
    }
else
    {
    enableIsolateSelect $aPanel 0;
    isolateSelect -state off $aPanel;
    }
```

Similarly, a single hotkey could be used to toggle between shading types, shadows, or even the tessellation of NURBS objects replacing the 1, 2, and 3 keys by simply pressing – or + to increase detail as wanted.

Panels can also be easily inserted into UIs created by the user. Note that many of the panel types are actually scripted panels, which follow a different set of rules, which we will get to later. In our next UI project, we will explore how to insert a modeling panel into a user window.

PROJECT

11.3: THAT'S A REAL PANE IN MY WINDOW

A popular method for working with blend shape animation for facial animation is to link a camera to the face, often by constraining or parenting it underneath a joint representing the skull. This view then stays with the character, allowing a stable view for creating animation. In this project, we will create an interface optimized for animation of blend shape animation.

First, let's take a quick look at the standard Maya Blend Shape Editor, seen in Figure 11.20.

The Blend Shape Editor provides more control than an animator needs. While allowing an artist to add and remove blend shapes is great for a technical director, once it gets to the animation stage, all those issues should be resolved, and it would be awful if the animator were to accidentally deform the

FIGURE 11.20 The Maya Blend Shape Editor.

blend shapes. Therefore, we will remove those. Moreover, the huge scroll layout seems like an awful waste of space.

Design

Unfortunately, we cannot easily create a vertical slider as fully featured as that in the Blend Shape Editor. We want our sliders to possess the following attributes:

- Horizontal or vertical orientation
- Real-time updating of model (rather than on slider release)
- Representation of animation data

Unfortunately, we cannot do all three. While MEL provides the facility to connect attributes directly, with the command `connectControl`, and we could build each individual element out of sliders and fields, they will not give the user feedback on whether a channel is animated. However, if we are simply willing to give up the vertical orientation, we get all this and more, in the form of automatic popup menus with the control `attrFieldSliderGrp`. This control sets up the two-way connection, gives us pre-made popup menus, and an interface with which animators are familiar.

Our first step is to design the window with all the layout breakdowns needed to create our window, seen in Figure 11.21.

By this point, the process that we will use to find all our data to build our user interface should be readily familiar, so let's get to it.

Implementation

We begin, as always, by validating our script. See Example 11.17.

FIGURE 11.21 Blender window breakdown.

EXAMPLE 11.17 Script validation.

```
global proc blender ()
{
}
```

Knowing that we have a valid script, we can begin adding functionality. Before we can build the window, we need to gather data from the scene. Specifically, we need to find the single object with a blendshape node we want to take control of. See Example 11.18.

EXAMPLE 11.18 Finding the blendshape node of the selected object.

```
// Find all the info on the blend node
// on current object

// Build Selection List
string $sel[] = `ls -selection`;

// Check to make sure the user has a single
// object selected
if ( `size $sel` != 1 )
    error "Please select a blendshape object";

// Get the history listing for the object
// to find any blendshapes
string $hist[] = `listHistory`;

string $attribs[], $blendShapeNode;

// Find the blendshape
for ( $each in $hist )
    if ( `nodeType $each` == "blendShape" )
```

```
        $blendShapeNode = $each;

// This finds the names of the attributes
// that drive the blend shape definition
string $contrib[] = `listAttr
                    -multi ( $blendShapeNode
                             + ".weight" )`;
```

The text for this script is found on the companion CD-ROM as Chapter_11/ project_UI06/v01/blender.mel.

Now that we have our data gathered, we are ready to build the UI. Like any window, we first define the window, using an integer to define its width, aiding in window construction. See Example 11.19.

EXAMPLE 11.19 The process begins with the creation of a window.

```
if ( `size $contrib` > 0 )//we build only if we qualify
    {
    // Build Window
    int $windowWidth = 750;

    if( `window -exists blenderUI` != 1 )
        {
        window
            -maximizeButton false
            -resizeToFitChildren false
            -title "Blender"
            -iconName "Blender"
            -menuBar false
            -widthHeight $windowWidth 274
             blenderUI;
```

The text for this script is found on the companion CD-ROM as Chapter_11/ project_UI06/v02/blender.mel.

Next, we add the `formLayout`. While using the form layout makes the process of building a dynamic UI somewhat trickier, it is pretty much the only way to get the exact look we want. See Example 11.20.

EXAMPLE 11.20 The addition of a form layout.

```
// Form Layout
string $blenderForm = `formLayout
                -numberOfDivisions 100`;
```

We will embed the modeling panel in a Pane Layout. Our modeling window will not have the menu bar, nor will it respond to key commands to turn

on its shading status, so all that, along with camera assignment, must be done in code. After creating the `paneLayout`, we create the `modelEditor` panel. The Model Editor has many arguments that can influence its appearance. We have chosen to set the bare minimum to get a decent view with which to work. After creation, we assign the view to use the perspective camera. We could use a `popupMenu` or a `optionMenu` to control which camera to use or view settings. It would also be very easy, through a carefully constructed naming convention or by building artificial connections, to add the capability to switch between different characters. See Example 11.21.

EXAMPLE 11.21 Adding a modeling panel to our UI.

```
//Pane Layout
string $modPane = `paneLayout
                -configuration single`;

//Modeling Pane
string $modEdit = `modelEditor
    -displayAppearance smoothShaded
    -grid 0`
    ;

// CHANGE CAMERA USED HERE
modelEditor
    -edit
    -camera perspShape
    $modEdit;

    setParent..; //up to form
showWindow blenderUI;
```

The text for this script is found on the CD-ROM as Chapter_11/project_UI06/v03/ blender.mel

If we execute the script, we see something resembling Figure 11.22.

FIGURE 11.22 The first build of the UI.

The collapsed panel is due to not using the power of the `formLayout`. We add the form layout edit before the window is drawn. We will have the modeling panel take up 45% of the form layout. See Example 11.22.

EXAMPLE 11.22 Sizing the modeling panel element.

```
formLayout -edit
    -attachForm $modPane "top" 2
    -attachForm $modPane "left" 2
    -attachForm $modPane "bottom" 2
    -attachPosition $modPane "right" 0 45

    $blenderForm;

showWindow blenderUI;
```

ON THE CD

The text for this script is found on the companion CD-ROM as Chapter_11/ project_UI06/v04/blender.mel.

After adding this edit statement, our UI appears somewhat similar to Figure 11.23.

FIGURE 11.23 The properly sized modeling panel.

Now that we have the first half of the user interface finished, we can move into the dynamically built area.

The first objective will be to place a column layout to which we will add our sliders. Using a column layout is the best way to add an unknown number of controls to a UI and still have some control over its appearance. We capture the name of the column, which is a child of the `formLayout`, for later alignment. See Example 11.23.

EXAMPLE 11.23 Adding a column layout to hold future additions to the UI.

```
string $blenderColumn = `columnLayout
```

```
                                     -adjustableColumn true
                                     -rowSpacing 5`;
```

To dynamically build the slider controls, we use a `for` loop to add a `rowLayout`, `attrFieldSliderGroup`, and `button` for each of the shapes that contribute to the blendshape node. Note that while some people like to over-crank the values of the blendshapes, we have limited the slider to between 0 and 1. This is the generally expected behavior, and the values that will be used by most artists most of the time. Should the need arise to go outside the expected range, it is a simple matter to go into the script and alter the limits. See Example 11.24.

EXAMPLE 11.24 Using a loop to dynamically add controls to our layout.

```
for ( $each in $contrib )
    {
    rowLayout
        -numberOfColumns 2
        -columnWidth2 $windowWidth 50
        -adjustableColumn 1
        -columnAlign 1 center
        -columnAlign 2 center
        -columnAttach 1 both 0
        -columnAttach 2 both 0
        ;

    attrFieldSliderGrp
        -min 0.0
        -max 1.0
        -at ( $blendShapeNode + "." + $each )
        -label $each
        -adjustableColumn 3
        -columnAlign 1 right
        -columnWidth 1 90
        -columnWidth 4 1
        ;
    button
        -label "Key"
        -align center
        -command ( "setKeyframe " + $blendShapeNode +
                    "." + $each );
    setParent..; //back to Column
    }
```

The text for this script is found on the companion CD-ROM as Chapter_11/ project_UI06/v05/blender.mel.

We now want to modify the `formLayout` edit statement to account for and place the `columnLayout` in the `formLayout`. We will attach the left side of the `columnLayout` to the right side of the `paneLayout` that contains the `model-Panel`. See Example 11.25.

EXAMPLE 11.25 Using the formLayout command with the edit flag to control the appearance of our UI.

```
formLayout -edit
    -attachForm $modPane "top" 2
    -attachForm $modPane "left" 2
    -attachForm $modPane "bottom" 2
    -attachPosition $modPane "right" 0 45

    -attachForm $blenderColumn "top" 2
    -attachControl $blenderColumn left 5 $modPane
    -attachForm $blenderColumn "bottom" 2
    -attachForm $blenderColumn right 2

    $blenderForm;
```

ON THE CD

The text for this script is found on the companion CD-ROM as Chapter_11/ project_UI06/v06/blender.mel.

Right now, the UI works, and works as planned, seen in Figure 11.24. Because we used the `formLayout`, the user is free to resize the UI to his liking, and the 3D viewport and the sliders scale with the window.

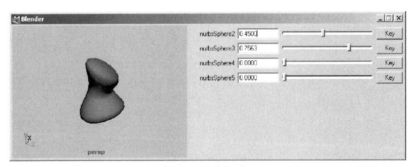

FIGURE 11.24 th2:Project Conclusion and Review

Because it is possible for the user to have enough blendshapes to more than fill the UI, in the script review we have incorporated conditional statements to implement in a scroll layout when needed. Note that when the `scrollLayout` is active, we have to add conditional `setParent` and `formLayout -edit` statements.

The text for the final script is found on the companion CD-ROM as Chapter_11/ project_UI06/final/blender.mel.

We have seen how the flexibility and power of user-created UIs can be greatly enhanced by incorporating appropriate panel elements. Next, we will cover scripted panels, which take almost the antithesis approach, incorporating controls and layouts into panels.

Project Script Review

```
global proc blender ()
{
// Find All the info on the blend node
// on current object

string $sel[] = `ls -sl`;

if ( `size $sel` == 0 )
    error "Please select a blendshape object";

string $hist[] = `listHistory -il 2`;

string $attribs[], $blendShapeNode;

for ( $each in $hist )
    if ( `nodeType $each` == "blendShape" )
        $blendShapeNode = $each;

string $contrib[] = `listAttr
                    -multi ( $blendShapeNode
                            + ".weight" )`;

float $conWts[] = `getAttr ( $blendShapeNode
                            + ".weight" )`;

if ( `size $contrib` > 0 )
    {
    // Build Window
     int $windowWidth = 750;

    if( `window -exists blenderUI` != 1 )
        {
        window
            -maximizeButton false
            -resizeToFitChildren false
            -title "Blender"
            -iconName "Blender"
            -menuBar false
```

```
            -wh $windowWidth 274
            blenderUI;

// Form Layout
string $blenderForm = `formLayout
        -numberOfDivisions 100`;

// Pane Layout
string $modPane = `paneLayout
                 -configuration single`;

// Modeling Pane
string $modEdit = `modelEditor
-displayAppearance smoothShaded
-grid 0`
;

// CHANGE CAMERA USED HERE
modelEditor
    -edit
    -camera perspShape
    $modEdit;

setParent..; //up to form

string $scrollLay;
if ( `size $conWts` > 10 )
    $scrollLay = `scrollLayout
              -horizontalScrollBarThickness 0
              -verticalScrollBarThickness 5`;

string $blenderColumn = `columnLayout
                     -adjustableColumn true
                     -rowSpacing 5`;

for ( $i = 0; $i < `size $conWts`; $i++ )
    {
    rowLayout
        -numberOfColumns 2
        -columnWidth2 ($windowWidth ) 50
        -adjustableColumn 1
        -columnAlign 1 "center"
        -columnAlign 2 "center"
        -columnAttach 1 "both" 0
        -columnAttach 2 "both" 0
        ;

            attrFieldSliderGrp
                -min 0.0
```

```
                                        -max 1.0
                                        -at ( $blendShapeNode
                                                + "."
                                                + $contrib[$i] )
                                        -label $contrib[$i]
                                        -adjustableColumn 3
                                        -columnAlign 1 right
                                        -columnWidth 1 90
                                        -columnWidth 4 1
                                        ;
                                button
                                        -label "Key"
                                        -align center
                                        -command ( "setKeyframe "
                                                + $blendShapeNode
                                                + "."
                                                + $contrib[$i] );
                                setParent..; //back to Column
                        }

        if ( `size $scrollLay` > 0 )
                setParent ..; // up to scroll if needed

        setParent ..; // up to form

if ( `size $scrollLay` == 0 )
        {
        formLayout
                -edit
                -attachForm $modPane "top" 2
                -attachForm $modPane "left" 2
                -attachForm $modPane "bottom" 2
                -attachPosition $modPane "right" 0 45

                -attachForm $blenderColumn "top" 2
                -attachControl $blenderColumn left 5 $modPane
                -attachForm $blenderColumn "bottom" 2
                -attachForm $blenderColumn right 2

                $blenderForm;
        }
else
        {
        formLayout
                -edit
                -attachForm $modPane "top" 2
                -attachForm $modPane "left" 2
                -attachForm $modPane "bottom" 2
                -attachPosition $modPane "right" 0 45
```

```
                    -attachForm $scrollLay "top" 2
                    -attachControl $scrollLay left 5 $modPane
                    -attachForm $scrollLay "bottom" 2
                    -attachForm $scrollLay right 2

                $blenderForm;
            }
        showWindow blenderUI;
        }
    }
}
```

SCRIPTED PANELS

There exists within Maya a special and specific type of panel, called a *scripted panel*. This is an apt name, as they are panels defined by scripts. The term *panel* is slightly misleading in its use here. As we have just learned, a panel under its correct definition in MEL is little more than a complex type of control. However, within the Maya interface that users are familiar with, a panel is a much more complex item.

In Figure 11.25, we see a typical modeling panel. However, it is not just the modelPanel panel type, as we saw in the last UI project; it is in fact a modelPanel with a menu above it.

All of the so-called "panels" that users are familiar with are, in actuality, collections of different panels and controls assembled together in a script. Again, this seemingly complicated structure opens up an immense amount of power and flexibility to the user who wants to exploit it.

Creating these user panels with scripts allows us to both modify the predefined scripted panels, such as the Graph Editor, and create our own. Creating scripted panels allows us to dock our custom controls in the view panes, and to tear off those panels into a window, essentially giving us two UI options with one definition.

The process of designing a scripted panel is similar to that used to design a floating window. However there are some additional considerations to remember. First and foremost is the realization that the user can and probably will resize the panel both to miniscule size and up to full screen. Second is that creating panels leaves an entry in the Panels menu of each pane. This means that if we make 300 tools, each creating a scripted panel for its UI, our menu becomes incomprehensibly filled with entries.

The solution to the first issue is just to plan for any resizing that might occur. This means becoming familiar with layouts that can accept dramatic resizing and still be useful. In most situations this means using a

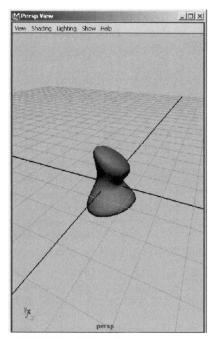

FIGURE 11.25 A Modeling pane.

`formLayout`, a `scrollLayout`, or a `frameLayout`, if not a combination of all three. Using these layouts, as well as the appropriate alignment and at-tachment arguments on the controls and sub-layouts used in the panel, will allow us to construct a panel that accepts almost any resizing while still retaining a useful and appealing appearance.

One thing to remember about constructing designs for resizing in panels is that the user often has a good reason for resizing the panel. For example, if your UI has sliders, and the user makes the UI full screen, it is likely that he wants to have more finite control over the sliders, so they should grow and shrink with the panel. Likewise, if your panel has a large number of buttons, they should resize down as much as possible, but not necessarily become full screen.

The second issue is much less complicated. The answer is to only use scripted panels when necessary or when their benefits are worth an entry into the panel listing. This is more a judgment call than anything else, al-though other considerations of the production might play a role in the decision.

One last word on creating scripted panels before we delve into the details. The Maya engineers put a great amount of time, effort, and re-search into creating the scripted panels that exist already. Although it is possible to edit the ones that exist, or to recreate them, it is wise to

consider whether it is truly necessary to do so. Ask yourself if it would it be easier and more efficient to create a window UI to act as this editor, rather than having to dissect and perform open script surgery on one of Alias|Wavefront's UI scripts?

Creating a scripted panel involves multiple procedures and a reliance on Maya's internal structures. Ironically, we do not create scripted panels with the `scriptPanel` command. We use instead the `scriptedPanelType` command. This command essentially defines the scripted panel name, and the various procedures that will be called during different actions the user might take. These actions are termed *callbacks*. In Example 11.26 we see the `scriptedPanelType` command, which defines a panel type called `examplePanel`.

EXAMPLE 11.26 Defining a scripted panel called exampleScriptedPanelType.

```
scriptedPanelType
    -createCallback exampleCreateCallback
    -initCallback exampleInitCallback
    -addCallback exampleAddCallback
    -removeCallback exampleRemoveCallback
    -deleteCallback exampleDeleteCallback
    -saveStateCallback exampleSaveStateCallback
    -unique true
    exampleScriptedPanelType;
```

The first flag, `-createCallback`, defines the procedure that will be used to create the panel entry. In this procedure, we create any panel type objects, such as `outlinerPanels`, `hyperPanels`, and the like; however, we create them unparented. This is also the procedure in which we do all our initializing procedures, such as checking for the existence of `option-Vars`, initializing global variables, and other standard initializations. Not that these initializations need to be carried out by this procedure itself; they can be located in another procedure that is called from this create procedure.

The `-initiCallback` argument specifies what procedure will be called whenever `file -new` or `file -open` is called, either from code or from the user interface. It allows us to embed behavior into the panel to reinitialize whenever the scene itself changes.

The procedure executed by the `-addCallback` argument is the one that actually defines the appearance of the UI. This is also the procedure where we parent any editors created in the procedure called from the `-createCallback`. By default, when the procedure begins, the parent object is the layout. If we need to explicitly name a parent of an object to be the panel, we can capture it to a variable by calling `setParent -query` at the very beginning of the procedure.

The –removeCallback procedure is where, and again this should be no surprise, we execute commands associated with the removal of the scripted panel. This is where we update any global variables to store the state of the controls in the panel, as well as where we unparent any editors from the panel.

The –deleteCallback actually deletes the panel from existence. Therefore, the procedure here would delete any editors created in the createCallback, and clear any global arrays that might have been declared.

The last callback flag, the –saveStateCallback returns a string, which is executed after the procedure specified by the createCallback flag. This requires some careful and often extensive coding of the return string to create an effective return string. It is used to restore the state of a panel to its state as it existed the last time it was closed during this Maya session.

The –unique flag is used to guarantee that we only have one instance of a panel, likely accessing and editing the same set of global variables, open at one time.

The final argument is the name of the scripted panel object itself.

All the procedures called from the callback flags of the scriptedPanelType command, except the -saveStateCallback flag, follow the declaration format of global proc procName (string $panelName). The procedure called from the –saveStateCallback flag follows a similar structure, with the obvious addition of the string return declaration, global proc string procName (string $panelName).

We will now take the slider portion of the blender window created in Project 11.3 and build a scripted panel out of them, essentially creating an optimized Blendshape panel.

PROJECT

11.4: SCRIPTED PANEL CREATION

The design for the blenderPanel will be slightly modified from the blender window, as seen in Figure 11.26.

Notice that the design incorporates a vertical scroll, to account for the user placing the panel in a pane that is horizontally aligned, such as the Outliner is in Figure 11.27. Should the user align the panel in a vertically oriented pane, as the Hypergraph is in Figure 11.28, the panel will do its best to fit. However, should the user size the panel to an orientation too thin, it will lose its functionality. This loss of functionality is unavoidable, but follows the paradigm set by many of the editors in Maya that lose any real functionality when sized too thin, such as the Graph Editor.

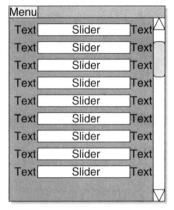

FIGURE 11.26 The new blend shape editing panel.

FIGURE 11.27 The Outliner, designed to be a vertically oriented editor.

We will also eliminate the modelingPanel, instead letting the users use the standard modeling panels. This will allow them more control over the layout of their workspace, and it simplifies our task as scripters.

We will also add the capability to the blender UI to effectively hold onto the blendshape node, allowing anything to be selected and still retaining control over the blendshape. This will also require us to add a Load Blendshape Node button to the interface, allowing the user to explicitly load the blendshape attributes for the selected node.

The first step is to create a valid script, and issue the statement defining the scriptedPanelType, seen in Example 11.27. One difficult aspect of creating scripted panels is that all the callback procedures need to be in place and have at least a minimum of their intended functionality before the script can even be tested.

EXAMPLE 11.27 Begin the procedure by defining our scripted panel.

```
global proc blendPanelDefinition ()
{
```

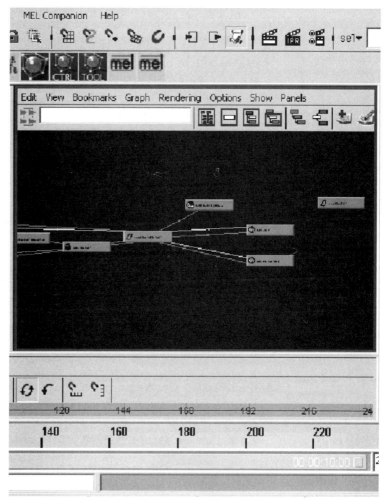

FIGURE 11.28 Maya does not prevent the user from resizing panels into unusable sizes.

```
// define the scripted panel type for the blender
// panel
scriptedPanelType
    -createCallback blenderCreateCallback
    -initCallback blenderInitCallback
    -addCallback blenderAddCallback
    -removeCallback blenderRemoveCallback
    -deleteCallback blenderDeleteCallback
    -saveStateCallback blenderSaveStateCallback
    -unique true
```

```
        blenderScriptedPanelType;
}
```

Next, we add the procedures for each of the callbacks. The first procedure, `blenderCreateCallback` is very simple, as we have no editors to create. This is shown in Example 11.28.

EXAMPLE 11.28 All the procedures in a scripted panel definition have to exist, even if empty.

```
global proc blenderCreateCallback( string $panelName )
{
// Empty panel creation procedure
}
```

Next, we add the initialization procedure. Note that although we are writing these scripts in the order called from the `scriptEditorType` command, there is no requirement that we must do so. The scripts are simply presented here in this order for convenience. Likewise, after script construction is complete, it is good practice to organize the procedures into this order to allow for easy editing after initial construction. In Example 11.29, we see the code for the initialization procedure.

EXAMPLE 11.29 Once again, the empty required procedure.

```
global proc blenderInitCallback ( string $panelName )
{
// Empty panel initialization procedure
}
```

The `addCallback` procedure is where we begin to see our panel take shape. This code is adapted from the `blenderUI` code from Project 11.3. Note that the initialization section of the `blenderUI`, along with the variable arrays that result, has been replaced with the simple declaration of global variables, which are then used in the construction of the UI controls. See Example 11.30.

EXAMPLE 11.30 Adapted code from the blenderUI.

```
global proc blenderAddCallback ( string $panelName )
{
// declaration of global variables
global string $blndPanbShape;
global string $blndPanCon[];
global float $blndPanWts[];

string $blenderForm = `formLayout
```

```
                                          -numberOfDivisions 100
                                          blndPanFrm`;

string $scrollLay = `scrollLayout
                         -horizontalScrollBarThickness 2
                         -verticalScrollBarThickness 5
                         -childResizable true
                         blndPanScrl`;

string $blenderColumn = `columnLayout
                            -columnAttach "both" 0
                            -adjustableColumn true
                            blndPanCol`;

for ( $i = 0; $i < `size $blndPanWts`; $i++ )
    {
        rowLayout
            -numberOfColumns 2
            -columnWidth2 30 50
            -adjustableColumn 1
            -columnAlign 1 "center"
            -columnAlign 2 "center"
            -columnAttach 1 "both" 0
            -columnAttach 2 "both" 0
            ( "blndPanRow_" + $i )
            ;

        attrFieldSliderGrp
                    -min 0.0
                    -max 1.0
                    -at ( $blndPanbShape
                        + "."
                        + $blndPanCon[$i] )
                    -label $blndPanCon[$i]
                    -adjustableColumn 3
                    -columnAlign 1 right
                    -columnWidth 1 90
                    -columnWidth 4 1
                    ;

        button
            -label "Key"
            -align center
            -command ( "setKeyframe "
                    + $blndPanbShape
                    + "."
                    + $blndPanCon[$i] );
        setParent..;
        }
```

```
            setParent..;
        setParent..;

    string $getButt = `button
                        -label "Update Panel"
                        -command "blenderPanelGetVars;
                                blenderUpdatePanel;"`;

    formLayout
        -edit
        -attachForm $scrollLay "top" 2
        -attachForm $scrollLay left 2
        -attachControl $scrollLay "bottom" 2 $getButt
        -attachForm $scrollLay right 2
        -attachForm $getButt left 2
        -attachForm $getButt "bottom" 2
        -attachForm $getButt right 2
        $blenderForm;
    }
```

We now need to construct a procedure, seen in Example 11.31, which evaluates the selected object and builds the global variables needed to build the user interface controls. This is one of the two commands issued by the button created in the addCallback procedure. This procedure is not called from the scriptPanelType command, so we will have to later figure out a way to bring this procedure into the construction of the panel.

EXAMPLE 11.31 The procedure to assign values to the global variables.

```
    global proc int blenderPanelGetVars ()
    {
    // declaration of global variables
    global string $blndPanbShape;
    global string $blndPanCon[];
    global float $blndPanWts[];

    // Find All the info on the blend node
    // on current object

    string $sel[] = `ls -selection`;
    string $hist[], $attribs[], $blendShapeNode;

    if ( `size $sel` == 1 )
        {
        $hist = `listHistory -il 2`;

        for ( $each in $hist )
```

```
        if ( `nodeType $each` == "blendShape" )
            $blendShapeNode = $each;

    string $contrib[] = `listAttr
                        -multi ( $blendShapeNode
                            + ".weight" )`;

    float $conWts[] = `getAttr ( $blendShapeNode
                            + ".weight" )`;

    // assign found values to variables
    $blndPanbShape = $blendShapeNode;
    $blndPanCon = $contrib;
    $blndPanWts = $conWts;
    }
else
    warning "Please select a single blendshape object";

if ( `size $blendShapeNode` == 0 )
    {
    warning "Selected object is not a blendshape";
    return 0;
    }
else
    return 1;

}
```

The return value is there as a way of easily checking within MEL scripts whether the user has a blendshape object selected. Constructing the script with this return value check allows us to rebuild the panel if and only if the user has a blendshape object selected.

We now have to construct a procedure that will update the user interface when the user presses the Update button. This first requires some modification of the procedure that constructs the panel, as well as the addition of a global variable. We begin in Example 11.32 by assigning the name of the column layout holding the child row layout to a variable. We then assign this to a global variable, allowing us to access this layout by simply using the setParent command to explicitly declare the active layout to the scripted panel, letting us delete the appropriate user controls.

EXAMPLE 11.32 MEL code to update the UI.

```
global proc blenderAddCallback ( string $panelName )
{
// declaration of global variables
global string $blndPanbShape;
global string $blndPanCon[];
```

```
global float $blndPanWts[];
global string $blndPanName;

string $blenderForm = `formLayout
                            -numberOfDivisions 100
                            blndPanFrm`;

string $scrollLay = `scrollLayout
                            -horizontalScrollBarThickness 2
                            -verticalScrollBarThickness 5
                            -childResizable true
                            blndPanScrl`;

string $blenderColumn = `columnLayout
                                -columnAttach "both" 0
                                -adjustableColumn true
                                blndPanCol`;

string $panLayout =  `setParent -query`;
$blndPanName = $panLayout;
. . .
```

We can now create a procedure to update the controls held in the panel, seen in Example 11.33.

EXAMPLE 11.33 The procedure to update the controls of the UI.

```
global proc blenderUpdatePanel ()
{
// declaration of global variables
global string $blndPanbShape;
global string $blndPanCon[];
global float $blndPanWts[];
global string $blndPanName;

int $numRowLayouts;

if ( `columnLayout -exists $blndPanName` )
    {
        $numRowLayouts = `columnLayout
                                -query
                                -numberOfChildren
                                $blndPanName`;
        if ( $numRowLayouts > 0 )
            for ( $i = 0; $i < $numRowLayouts; $i++ )
                if ( `rowLayout -exists
                                ( "blndPanRow_" + $i )` )
                    deleteUI ( "blndPanRow_" + $i );
```

```
        }

        // Explicitly state the path to place the rowLayouts in
        if ( `columnLayout -exists $blndPanName` )
            setParent $blndPanName;

        for ( $i = 0; $i < `size $blndPanWts`; $i++ )
            {
                rowLayout
                    -numberOfColumns 2
                    -columnWidth2 30 50
                    -adjustableColumn 1
                    -columnAlign 1 "center"
                    -columnAlign 2 "center"
                    -columnAttach 1 "both" 0
                    -columnAttach 2 "both" 0
                    ( "blndPanRow_" + $i )
                    ;
                attrFieldSliderGrp
                            -min 0.0
                            -max 1.0
                            -at ( $blndPanbShape
                                + "."
                                + $blndPanCon[$i] )
                            -label $blndPanCon[$i]
                            -adjustableColumn 3
                            -columnAlign 1 right
                            -columnWidth 1 90
                            -columnWidth 4 1
                            ;
                button
                    -label "Key"
                    -align center
                    -command ( "setKeyframe "
                                + $blndPanbShape
                                + "."
                                + $blndPanCon[$i] );
                setParent..;
            }
    }
```

Before continuing on to the other callback procedures, we should modify
the creation and initialization procedures to include the declaration of the
global variables in both, and the update procedure should be called from
the initialization procedure after resetting the global procedure values. This
process is seen in Example 11.34.

EXAMPLE 11.34 Updating the previously created procedures to include the global variables.

```
global proc blenderCreateCallback( string $panelName )
{
// panel creation procedure
// just declare global variables
global string $blndPanbShape;
global string $blndPanCon[];
global float $blndPanWts[];
global string $blndPanName;
}

global proc blenderInitCallback ( string $panelName )
{
// panel initialization procedure
// declaration of global variables
global string $blndPanbShape;
global string $blndPanCon[];
global float $blndPanWts[];
global string $blndPanName;

// reset global variable values
$blndPanbShape = "";
clear $blndPanCon;
clear $blndPanWts[];

// update the panel
blenderUpdatePanel;

}
```

Now that all of our existing procedures have been brought up to date, we can add procedures for the remaining callbacks.

In Example 11.35, we see the remove callback, which normally calls commands to store the state of the controls in the panel. Because the controls in our layout are linked to the attributes of the blendshape node, we have no need to store their values. When the controls are redrawn, their values will automatically be updated. Note that not only is this where we would store the values of any sliders, but also the collapse state of any frameLayouts in the panel, which tab is active in a tabLayout, or even which item is selected in a textScrollList control.

EXAMPLE 11.35 The procedure normally called upon to store the state of a UI.

```
global proc blenderRemoveCallback ( string $panelName )
{
```

```
// panel initialization procedure
// declaration of global variables
global string $blndPanbShape;
global string $blndPanCon[];
global float $blndPanWts[];
global string $blndPanName;
}
```

Next is the callback for the deletion of the UI elements. Normally, this is just used for the deletion of any editors that are created unparented, such as an `outlinerPanel`. Here, however, the `formLayout`, and all of the child controls, are deleted with the panel. See Example 11.36.

EXAMPLE 11.36 The procedure issued upon deletion of a UI.

```
global proc blenderDeleteCallback ( string $panelName )
{
// panel delete procedure
// declaration of global variables
global string $blndPanbShape;
global string $blndPanCon[];
global float $blndPanWts[];
global string $blndPanName;
}
```

Finally, we use the `saveStateCallback` procedure, seen in Example 11.37, to do nothing. If we wanted to have the panel automatically take into account the user's current selection when the panel is redrawn, we could have the `saveStateCallback` return a string that would evaluate the `blenderPanelGet-Vars` procedure, which would update the global variables and therefore change the sliders which are drawn in the `blenderAddCallback` procedure. The declaration of global variables even in procedures that have no real functionality is for consistency and to aid in any future additions to the panel definition.

EXAMPLE 11.37 The procedure to update the controls UI, although here it is unused.

```
global proc string blenderSaveStateCallback
                        ( string $panelName )
{
// panel save state procedure
// declaration of global variables
global string $blndPanbShape;
global string $blndPanCon[];
global float $blndPanWts[];

return "";
}
```

Now that the scripted panel is defined, we can actually create the panel, using the `scriptedPanel` command to create an unparented panel, as seen in Example 11.38.

EXAMPLE 11.38 The actual creation of the panel.

```
scriptedPanel
    -unParent
    -type blenderScriptedPanelType
    -label "BlendShape Plus"
    blenderScriptedPanel;
```

After executing this, in the Maya viewports, under the menu Panels>Panels, we see an entry for BlendShape Plus, as seen in Figure 11.29. On selecting this view, and updating the data with some sample blendshape data, we see a view similar to that in Figure 11.30.

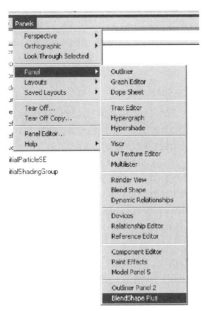

FIGURE 11.29 Panel entry for our new panel.

In addition to the panel, we also have the ability to tear off the panel, effectively turning it into a window, as seen in Figure 11.31.

Now that our panel is functional, we can place all the procedures in a single script, `blendPanelDefinition.mel`, and source this file from our `userSetup.mel` file. We also can create the unparented panel in the `userSetup` file, effectively adding it to our default Maya interface.

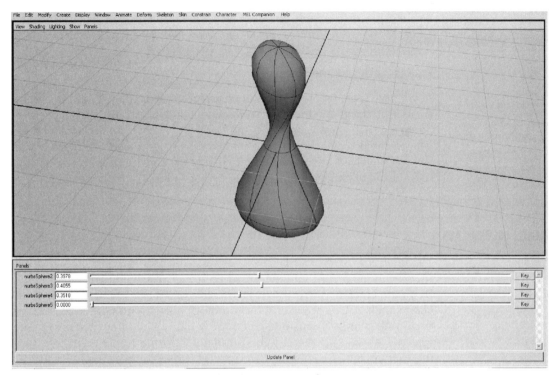

FIGURE 11.30 The Blendshape Plus panel in the Maya interface.

FIGURE 11.31 Tearing off the panel gives us a free window with the creation of our scripted panel.

ON THE CD *The text for these scripts can be found on the companion CD-ROM under Chapter_11/project_UI07/ as /blendPanelDefinition.mel and userSetup.addition.*

Project Conclusion and Review

As we have seen, scripted panels are a useful and powerful way of integrating created interfaces into the Maya workspace. It also is a way of accessing and re-designing such Maya windows as the Hypergraph and Graph Editor. Such endeavors should not be undertaken lightly, as the scripts that define these editors are quite involved, and the editors are part of the core functionality of Maya itself. Altering or removing properties from these editors can confuse users.

HEADS-UP DISPLAYS

The *heads-up display*, or HUD, is a very specific user interface item. Rather than being a class of commands, it is in and of itself a MEL command. HUDs are created as text that is projected as a 2D layer on top of the modeling panels. HUDs are useful for monitoring data within a scene, such as the number of polygons on screen, how many keyframes are set on the selected object, or even such mundane information as what camera the user currently is looking through.

HUDs have more in common with script jobs than they do with other user interface elements. They can monitor the Maya environment for many of the same conditions and update accordingly, providing ever-changing feedback on the environment. In fact, through the clever use of system commands and such internal MEL commands as memory, a HUD could be constructed to monitor system resources or monitor the status of a network render. An interesting use of HUDs at one production facility using Maya is to embed legal information, as well as the name of the currently logged-in user, into the Maya viewport, as an aid against leaked information.

Maya comes pre-enabled with a number of HUDs available to the user from the menu, all of which are shown active in Figure 11.32.

All of these HUDs are available as preset options of the headsUpDisplay command. However, almost any command that provides return data can be tied to a HUD. The command, be it an existing MEL command or a script created by a user, is what provides the data. How this data is formatted and displayed is the role of the headsUpDisplay command.

Three things must be decided upon when creating a HUD. First, what is the information to be displayed? Second, what commands or procedures must be executed, and possibly created, to provide this information? And third, where and how will this information be displayed?

The answer to the first question is always easy, as it is the reason for creating the HUD in the first place. The second, however, can be slightly

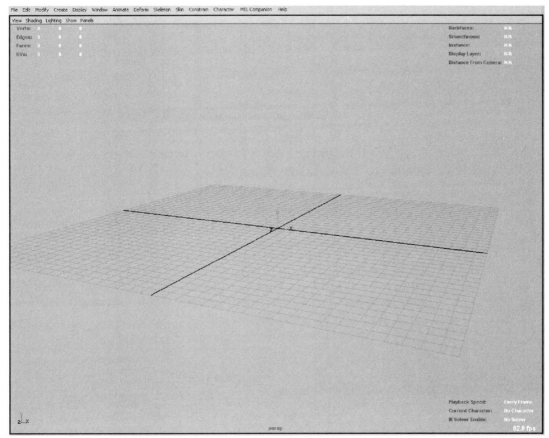

FIGURE 11.32 A panel with all the default HUDs active.

more complicated. Occasionally, even if a command exists that provides the information needed, it will not provide the return data in a format conducive to our intended HUD design. In this instances, we need to write accessory scripts that provide return data in a format we want.

Formatting a HUD is somewhat more involved. First, we need to gain an understanding of the two arguments the `headsUpDisplay` command uses for positioning display elements, *sectors* and *blocks*. To the `headsUp-Display` command, a modeling pane is made of 10 sectors. The panel is split into a 10x2 grid, as seen in Figure 11.33. Each sector is assigned an index value with which it is identified. An important consideration to remember is that the five columns that define the sectors each have a minimum width of 200 pixels. Meaning, for all five columns to be visible, the modeling pane has to have a width of at least 1000 pixels. If the modeling pane has a resolution less than that, either due to limited screen resolution or the panel being resized, sector columns are eliminated. Sector Columns 2 and 4, composed of sectors 1, 3, 6, and 8 are eliminated first. Then,

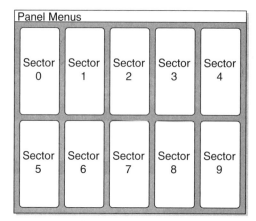

FIGURE 11.33 The Heads-Up sector layout.

Sector Column 3, comprising sectors 2 and 7, is eliminated. Note that this is only relevant if those sectors are currently being used. If only sector 7 is being used, and the panel is resized to only 100 pixels wide, the HUD remains, as seen in Figure 11.34.

FIGURE 11.34 The HUD remains the same.

However, if multiple HUD sectors contain information and the pane is similarly resized, as in Figure 11.35, HUDs are removed, though a warning is issued to the user.

FIGURE 11.35 HUDs are removed as the panel is resized.

Each sector is made up of blocks. The number of blocks each section is comprised of dynamically changes as HUDs are added and removed from the interface. For this reason, whenever we want to add a HUD, it is best to first find out how many HUDs exist and put ours in the next available spot, rather than being brutish and deleting the HUDs that might occupy the location we want to fill. In Figure 11.36, we see the layout of a block.

The various formatting settings for a block, including the justification and size of text, the vertical size of the block, and the block alignment are all set with separate arguments and variables. Note that the floating-point precision, which is set via an argument, is limited to only eight places. Should we want to provide more, an accessory script that converts the data to a string is needed.

One aspect of HUD blocks to remember is that their vertical placement is dependent on which sector they are in. Blocks placed in sectors 0

FIGURE 11.36 Block layout.

through 4, the top row, are placed starting at the top, while the sectors in the bottom row, sectors 5 through 9, are placed starting at the bottom of the screen. This is quite a nice, well thought-out feature of HUD placement. However, by default all blocks are left justified, so those placed in the center and right sides of the screen must be explicitly justified to a more pleasing position.

Many Maya users mistakenly believe that HUDs that provide multiple items of data are created with a single `headsUpDisplay` command. Rather, the display is created by multiple issuances of the command. Most often, these commands are all contained within their own procedure, and through intelligent use of variables, easily reformat the HUDs quickly. We will take advantage of this in the HUD project.

PROJECT

11.5: HEADS UP!

Because HUDs are constantly on screen, they often serve to give feedback on scene information, either the scene or a selected object. Although most often associated with artists working with polygons, often games artists, to keep assets within pre-defined limitations on geometry, artists working with other types of geometry can benefit from using HUDs. In this project we will construct a HUD to track some of the more pertinent information needed by artists working with NURBs surfaces.

It is sometimes interesting to watch an artist work with a model constructed of NURBs geometry. Constantly opening and closing the Attribute Editor to check the number of spans, the degree of curvature, and other such information needed to properly construct adjacent surfaces is tedious for any artist. Rather than having to surrender screen real estate to the Attribute Editor, we will give NURBs artists the HUD tools their polygon-using brethren have.

Design

We will track four different aspects of NURBs surfaces:

- U Spans
- V Spans

- U Degree
- V Degree

And two different aspects of NURBs curves:

- Spans
- Degree

We will rebuild the HUD whenever the selection changes, as well as whenever the appropriate attributes change. In addition, when the user has no valid object selected, the HUD will have to accommodate this. Moreover, unlike the polygon HUD, we are not interested in data that can be summed up, such as the number of polygons in the current selection; rather, we have to pick which of the selected objects to use. How do we account for multiple NURBs objects being selected? If we use the last selection, do we simply use the last selection, or do we use the last NURBs object selected? For simplicity, we will only consider the last item selected in our script. If that is a NURBs curve or surface, our HUD will evaluate it; otherwise, it will display "-". We will have to generate a single procedure that both evaluates the selection and returns the appropriate info. This script, `nurbsInfo.mel` is found on the companion CD-ROM under /chapter11/scripts/others/.

ON THE CD

We then can move on to building the HUD. We will place the construction of the HUD in its own script, `buildNurbsInfoHud.mel`. The first thing we need to do is decide where on screen we want to place our information. Although we have 10 sectors from which to choose, we will add this HUD to the same one that contains the polygonal information, sector 0. In Example 11.39, we begin by issuing our four `headsUpDisplay` commands.

EXAMPLE 11.39 Each line of our HUD requires a separate command.

```
global proc buildNurbsInfoHud ()
{
// to allow for easy manipulation of HUD placement
int $HUDSection = 0;

headsUpDisplay
    -section $HUDSection
    -block 0
    -blockSize "small"
    -label "Spans U"
    -labelFontSize "small"
    -labelWidth 100
    -command "nurbsInfo 0"
    -event "SelectionChanged"
    -nodeChanges "attributeChange"
    niHUDSpanU;
```

```
headsUpDisplay
    -section $HUDSection
    -block 1
    -blockSize "small"
    -label "Spans V"
    -labelFontSize "small"
    -labelWidth 100
    -command "nurbsInfo 1"
    -event "SelectionChanged"
    -nodeChanges "attributeChange"
    niHUDSpanV;

headsUpDisplay
    -section $HUDSection
    -block 2
    -blockSize "small"
    -label "Divisions U"
    -labelFontSize "small"
    -labelWidth 100
    -command "nurbsInfo 2"
    -event "SelectionChanged"
    -nodeChanges "attributeChange"
    niHUDDivU;

headsUpDisplay
    -section $HUDSection
    -block 3
    -blockSize "small"
    -label "Divisions V"
    -labelFontSize "small"
    -labelWidth 100
    -command "nurbsInfo 3"
    -event "SelectionChanged"
    -nodeChanges "attributeChange"
    niHUDDivV;
}
```

 nurbsInfo.mel *needs to be copied into the active script path directory before the Heads-Up Display project functions correctly.*

ON THE CD *The text for this script is found on the companion CD-ROM as Chapter_11/project_UI08/v01/buildNurbsInfoHud.mel.*

The results from this are seen in Figure 11.37, with a simple NURBs patch selected.

While this does work if there are no other HUDs active and occupying HUD sector 0, we can start running into problems when other HUDs attempt to oc-

FIGURE 11.37 Our NURBs HUD.

cupy the same location. Therefore, we must build a script to find whether there are any HUDs already in existence, and what their current screen position is. We will construct this as a separate procedure, and because this could be useful for the construction of other HUDs as well, we will make it a separate script. We begin in Example 11.40 by declaring the procedure, which will return an integer representing the next open block. We also want to pass it an integer representing the HUD sector we want to examine, as well as how many blocks we need.

EXAMPLE 11.40 The procedure to find the next empty HUD block.

```
global proc int getNextHudBlock ( int $HUDSection,
                                  int $blocksNeeded )

{
// get all HUDs
string $allHUDs[] = `headsUpDisplay
                        -lh`;
string $blockContents[];
int $returnInt;

// parse the list of HUDS
```

```
for( $eachHUD in $allHUDs )
    {
    // find out which section this HUD is in
    int $thisHUDSection = `headsUpDisplay
                                    -query
                                    -section
                                    $eachHUD`;
    // If it is in the target section
    if ($thisHUDSection == $HUDSection )
        {
        int $block = `headsUpDisplay
                            -query
                            -block
                            $eachHUD`
        $blockContents[$block] = $eachHUD;
        }
    }

int $found, $i;

while ( $found == 0 )
    {
    if ( $blockContents[$i] == "" )
        for ( $n = $i;$n < ($i + $blocksNeeded);$n++ )
            if ( $blockContents[$n] == "" )
                {
                $returnInt = $i;
                $found = 1;
                }
    }
return $returnInt;
}
```

ON THE CD

The text for this script is found on the CD-ROM as bonusscripts/getNextHud-Block.mel.

Now, we can call getNextHudBlock from within the procedure creating the NURBs HUD to get the first empty block that has three empty blocks after it. Sometimes a script will simply look for the next available open block, but this doesn't take into account the possibility of intermediary blocks being occupied, and if we want to have all our HUD elements contiguous, we have to look for a block of blocks. In Example 11.41 we see the HUD display procedure with both the block searching call in place, as well as if statements that turn the display of the HUD on or off, depending on the current state of the HUD.

EXAMPLE 11.41 The addition of the call to the getNextHudBlock procedure.

```
global proc buildNurbsInfoHud ()
{
// to allow for easy manipulation of HUD placement
int $HUDSection = 0;
int $block = `getNextHudBlock $HUDSection 4`;

if( `headsUpDisplay -exists niHUDSpanU` != 1 )
    headsUpDisplay
        -section $HUDSection
        -block $block++
        -blockSize "small"
        -label "Spans U"
        -labelFontSize "small"
        -labelWidth 100
        -command "nurbsInfo 0"
        -event "SelectionChanged"
        -nodeChanges "attributeChange"
        niHUDSpanU;

if( `headsUpDisplay -exists niHUDSpanV` != 1 )
    headsUpDisplay
        -section $HUDSection
        -block $block++
        -blockSize "small"
        -label "Spans V"
        -labelFontSize "small"
        -labelWidth 100
        -command "nurbsInfo 1"
        -event "SelectionChanged"
        -nodeChanges "attributeChange"
        niHUDSpanV;

if( `headsUpDisplay -exists niHUDDivU` != 1 )
    headsUpDisplay
        -section $HUDSection
        -block $block++
        -blockSize "small"
        -label "Divisions U"
        -labelFontSize "small"
        -labelWidth 100
        -command "nurbsInfo 2"
        -event "SelectionChanged"
        -nodeChanges "attributeChange"
        niHUDDivU;

if( `headsUpDisplay -exists niHUDDivV` != 1 )
    headsUpDisplay
        -section $HUDSection
        -block $block++
```

```
                -blockSize "small"
                -label "Divisions V"
                -labelFontSize "small"
                -labelWidth 100
                -command "nurbsInfo 3"
                -event "SelectionChanged"
                -nodeChanges "attributeChange"
                niHUDDivV;

     if ( `headsUpDisplay
                -query
                -visible
                niHUDSpanU`
                == 0 )
          headsUpDisplay -edi -visible 1 niHUDSpanU;
     else
          headsUpDisplay -edi -visible 0 niHUDSpanU

     if ( `headsUpDisplay
                -query
                -visible
                niHUDSpanU`
                == 0 )
          headsUpDisplay -edi -visible 1 niHUDSpanU;
     else
          headsUpDisplay -edi -visible 0 niHUDSpanU

     if ( `headsUpDisplay
                -query
                -visible
                niHUDSpanU`
                == 0 )
          headsUpDisplay -edi -visible 1 niHUDSpanU;
     else
          headsUpDisplay -edi -visible 0 niHUDSpanU

     if ( `headsUpDisplay
                -query
                -visible
                niHUDSpanU`
                == 0 )
          headsUpDisplay -edi -visible 1 niHUDSpanU;
     else
          headsUpDisplay -edi -visible 0 niHUDSpanU
     }
```

The text for this script is found on the companion CD-ROM as Chapter_11/pro-ject_UI08/final/buildNurbsInfoHud.mel.

CONCLUSION

This concludes our coverage of Maya interface control with MEL. Note that we have merely scratched the surface of building interfaces in Maya. Exploration and experimentation coupled with planning and an understanding of the logic and structures behind Maya's UI construction will allow the near limitless customization of the Maya interface and the construction of any window imaginable. One major interface script we did not cover is the AETemplate, but this is usually only used by those creating new object classes with the API. Those wanting to explore AETemplates are encouraged to dissect the scripts located in the /scripts/ AETEmplates/ directory, as well as the appropriate command documentation.

12 FILE HANDLING IN MEL

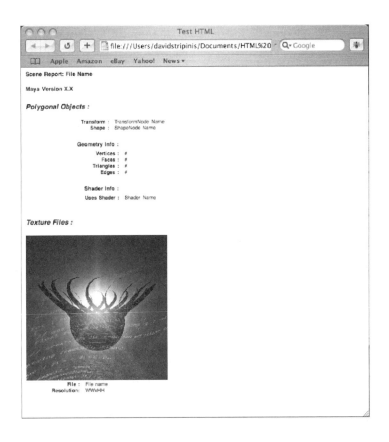

To this point, we have only covered handling data inside the Maya environment, with the obvious exception of our use of the system command in Chapter 9, "Lighting and Rendering." In this chapter, we will examine writing and reading files in and out of Maya, and the Maya ASCII file type, which is actually a MEL script.

The ability to read files in and out of Maya using MEL is a powerful tool, allowing artists and technical directors to efficiently share data without having to share and pass Maya files themselves. This would allow, for example, one artist to work on tweaking the weighting of a skin while another begins adding controls. Perhaps an exporter is needed to an external model format that Maya does not natively support or whose specifications have changed since the last release of Maya. By being able to read data in from files, Maya can use data from other applications, either by writing a script that reads their file format, or by creating an interchange format that all applications can read.

Similarly, understanding the Maya ASCII file format will increase the usability and openness of Maya. Because ASCII files are MEL scripts, if there are problems with a scene file that are causing Maya problems, it is a simple matter to open the scene file in a text editor to find and correct the problem. A popular use of this is to bring data created in a current version of Maya into an earlier version, an operation normally not possible.

FILE TYPES AND FILE HANDLING

Files, as a general rule, can be categorized into two basic types: *binary* and *ASCII*. Binary files are highly structured and organized files, the specifications for which are often governed by either a single company, as in the case of .PSD format used by Photoshop and owned by Adobe, or by a consortium of individuals and/or corporations, as in the case of the PNG graphic file format. Binary files are often the preferred type of file for commercial applications due to considerations of space and security. It is very important to note that many binary file format specifications are owned by companies that either forbid their use or require licensing fees from those who want to implement them, such as .GIF. And in some cases involving encrypted file formats, it is illegal in the United States to write software that circumvents these protections, as in the case of Adobe Acrobat files (.PDF). ASCII files are a simpler way of storing data, and due to their ability to be opened in any text editor, are often much more open to public use. Formats are often developed by a company and evolve into an open interchange format, as in the case of Wavefront Object files (.OBJ), or are designed by an individual or consortium to be an open standard from the very start, as in the case of .HTML. One obvious advantage of text files, especially in association with Maya and MEL, is their inherent openness and therefore cross-platform capabilities.

As binary files are a much more complex subject than is suitable for simple scripting, we will only deal with ASCII files in this chapter. MEL does provides the facility to read and write binary files, and those wanting or needing to do so are encouraged to pick up one of the many programming texts that cover file formats for their specifications.

Reading and writing files is, at minimum, a three-step process:

1. Opening the file
2. Reading/writing the file
3. Closing the file

Note that these steps are not dependent on the particular operation the user requested. When we read a file, we open it, read the data in, and then we close the file. When we write a file, we open it, write the data out, and then close the file.

To open a file we use the command `fopen`. When using `fopen`, we can use one of four possible options. We can open a file for writing, which destroys any information that previously might have been stored within the file. We can open a file to append data, which is to add data at the end of the file. We can also open the file for purposes of reading. Lastly, we can open the file for both reading and writing simultaneously. The default behavior of the `fopen` command is to open a file for writing. Note that even when adding information to a pre-existing file, it is best to completely rewrite the file. Appending files is most often used for log files. To close a file, we use the command `fclose`. This is a much simpler command. We just issue the command, with the file identifier, an integer returned by `fopen` we capture to a variable, most often called `$fileID`. The command used to write to a text file is `fprint`. For binary files, the command `fwrite` is used.

In Example 12.1, we create a simple one-line text file, using the three commands we have learned to this point.

EXAMPLE 12.1 Creating a text file with MEL.

```
// create a string naming the file.  Place it in
// the user's temp directory.

string $fileName = ( `internalVar -userTmpDir`
                 + "file.txt" ) ;

// Open the file for writing and capture the file
// indentifier for later use
int $fileID = `fopen $fileName "w"`;

// write the following to a file
fprint $fileID "Look, I can write a file!!";
```

```
// close out the file
fclose $fileID;

print ( "Created " + $fileName + "\n" );
```

After executing this code, open the resulting file in your text editor to see a single-line text file with the quoted text from the fprint command.

Just being limited to writing out explicit lines of text is slightly less than useful, turning Maya into an extremely expensive and hard-to-use word processor. Rather, we are able to pass the fprint command any variable, which it will then pass into text. By combining this with a for loop, we are able to easily write out large volumes of data. In Example 12.2, we see how a simple loop is used to write out a listing of the scene contents to a file.

EXAMPLE 12.2 MEL code demonstrating a loop with the fprint command.

```
// create a string naming the file.  Place it in
// the user's temp directory.

string $fileName = ( `internalVar -userTmpDir`
                    + "file_02.txt" ) ;

// Gather scene data
string $sceneListing[] = `ls`;

// Open the file for writing and capture the file
// indentifier for later use
int $fileID = `fopen $fileName "w"`;

// write the name of each item in the array
// to a the file on it's own line
for ( $eachItem in $sceneListing )
    fprint $fileID ( $eachItem + "\n" );

// close out the file
fclose $fileID;

print ( "Created " + $fileName + "\n" );
```

Now, if we open the text file we just created, we see a listing of each object in the scene, each on its own line due to the use of the new line escape character \n in the constructed string passed to the fprint command.

Now that we have files on disk, we would likely want to read them into Maya. Two commands are available to read data into Maya, fgetword

and `fgetline`. The differences between the commands are subtle, but important when constructing code to parse read data.

The command `fgetword` reads the data in one word at a time, with *word* defined as the collection of characters separated by the character used in the argument of `fgetword`, by default a space. In Example 12.3, we create a file and then read it in one word at a time. If we then look at the file created by the first section of our example code in a text editor, we can see that each item is separated by a space.

EXAMPLE 12.3 MEL code demonstrating how to read a file into memory.

```
// create a string naming the file.  Place it in
// the user's temp directory.
string $fileName = ( `internalVar -userTmpDir`
                    + "file_03.txt" ) ;

// Gather scene data
string $sceneListing[] = `ls`;

// Open the file for writing and capture the file
// indentifier for later use
int $fileID = `fopen $fileName "w"`;

// write the name of each item in the array
// to the file separated by " "
for ( $eachItem in $sceneListing )
    fprint $fileID ( $eachItem + " " );

// close out the file
fclose $fileID;

print ( "Created " + $fileName + "\n" );

// Now read the file in word by word

// open the file
$fileID =`fopen $fileName "r"`;

// Get the first word of the file, and declare an
// array to hold the entirety of the file
string $word = `fgetword $fileID`;
string $fileContents[];

// continue as long as fgetword returns info
while ( size( $word ) > 0 )
    {
    $fileContents[`size $fileContents`] = $word;
```

```
        $word = `fgetword $fileID`;
        }

// close out the file
fclose $fileID;

print ( "Contents of " + $fileName + "\n" );

print $fileContents;
```

While this makes the file slightly more difficult for our human eyes to read, Maya has no problems interpreting the file, differentiating the different words regardless of their contents, regarding only the whitespace. In fact, we could use any separator we want, but should not use the vertical pipe Maya uses for hierarchal name separation, "|", to avoid any possible confusion that could result.

The other command used to read ASCII files with MEL is `fgetline`. This command works in a similar fashion to `fgetword`, but rather than use whitespace or a defined separator to partition the data, `fgetline` reads in data until it encounters a new line character or reaches the end of file. In Example 12.4, we use the `fgetline` command, along with other string handling commands we have previously used, to keep information intelligently and logically handled.

EXAMPLE 12.4 Code to organize file data as it is read into memory.

```
// Create some sample data
string $emptyGroups[];
for ( $i = 0; $i < 10; $i++ )
    {
    $emptyGroups[$i] = `group -empty`;
    setAttr ( $emptyGroups[$i] + ".translateX" )
        `rand -10 10`;
    setAttr ( $emptyGroups[$i] + ".translateY" )
        `rand -10 10`;
    setAttr ( $emptyGroups[$i] + ".translateZ" )
        `rand -10 10`;
    }

// create a string naming the file.  Place it in
// the user's temp directory.
string $fileName = ( `internalVar -userTmpDir`
                     + "file_04.txt" ) ;

// Open the file for writing and capture the file
// indentifier for later use
int $fileID = `fopen $fileName "w"`;
```

```
// write the name of each item in the array
// to the file followed by it's position
for ( $eachItem in $emptyGroups )
    {
    fprint $fileID ( $eachItem + " " );
    float $tfa[] = `getAttr  ( $eachItem + ".translate" )`;
    fprint $fileID ( $tfa[0] + " " );
    fprint $fileID ( $tfa[1] + " " );
    fprint $fileID ( $tfa[2] + "\n" );
    }

// close out the file
fclose $fileID;

print ( "Created " + $fileName + "\n" );

// Now read the file in line by line

// open the file
$fileID = `fopen $fileName "r"`;

// Get the first line of the file, and declare an
// array to hold the entirety of the file
string $line = `fgetline $fileID`;
string $fileContents[];

// continue as long as fgetline returns info
while ( size( $line ) > 0 )
    {
    $fileContents[`size $fileContents`] = $line;
    $line = `fgetline $fileID`;
    }

// close out the file
fclose $fileID;

// parse the read data, and organize it
for ( $eachItem in $fileContents )
    {
    string $tokenBuffer[[]];
    tokenize $eachItem $tokenBuffer;
    print ( "Object: " + $tokenBuffer[0] + "\n" );
    print ( "\tTranslate X: " + $tokenBuffer[1] + "\n" );
    print ( "\tTranslate Y: " + $tokenBuffer[1] + "\n" );
    print ( "\tTranslate Z: " + $tokenBuffer[1] + "\n" );
    }
```

Because we have control over the formatting the files we are creating, we are able to easily parse the resulting data. Other common text file

formats, such as Wavefront Object or Acclaim Motion Capture, have their own specifications, although these are often easily found within the documentation of the associated software or on the Internet.

When creating custom file formats, it is good practice to both document the format and to construct the format to allow for expansion. A robust format, such as the Renderman Standard, has shown through its over 15 years of existence that an open and robust format can accept the ever-evolving technology that defines modern 3D graphics. Although we used only fgetword and fgetline in our handling of reading in text files, be aware that the command fread exists to read in binary files, much the same way the command fwrite is used to write binary files.

In the previous examples, we used the size command to check for the end of the file. There is, however, a command specifically meant for this purpose, feof. By using the return value from feof, a Boolean integer value, in a conditional statement, we create a more elegant way of reading until the end of file. In Example 12.5, we use the feof command as the condition in the while statement used to read in this file.

ON THE CD

Example 12.5 references the file created by Example 12.4. If this file has been deleted, recreate it by rerunning the code in Example 12.4.

EXAMPLE 12.5 Using the more reliable eof command to aid in the reading of a file.

```
// create a string naming the file.
string $fileName = ( `internalVar -userTmpDir`
                     + "file_04.txt" ) ;

// open the file
$fileID = `fopen $fileName "r"`;

// Get the first line of the file, and declare an
// array to hold the entirety of the file
string $line = `fgetline $fileID`;
string $fileContents[];

// continue as long as fgetline returns info
while ( `feof $fileID` == 0 )
    {
    $fileContents[`size $fileContents`] = $line;
    $line = `fgetline $fileID`;
    }

// close out the file
fclose $fileID;
```

```
// parse the read data, and organize it
for ( $eachItem in $fileContents )
    {
    string $tokenBuffer[[];
    tokenize $eachItem $tokenBuffer;
    print ( "Object: " + $tokenBuffer[0] + "\n" );
    print ( "\tTranslate X: " + $tokenBuffer[1] + "\n" );
    print ( "\tTranslate Y: " + $tokenBuffer[1] + "\n" );
    print ( "\tTranslate Z: " + $tokenBuffer[1] + "\n" );
    }
```

This produces a behavior identical to that using the size command, but only stops at the end of the file, rather than when the returned line is empty, which can happen before the true end of file is reached.

PROJECT

12.1: SCENE SUMMARY

Introduction

Occasionally, in the course of a production, reports need to be generated on the status of the assets that have been created. This could be to monitor the work of an artist, to aid in the construction of a schedule, or to simply gain an understanding of the status of the current project. In this project, we will create a simple tool to write out a text file, formatted for human consumption. In this text file we will catalog all the polygonal objects in the scene, with details such as their associated materials and their component objects.

Design

Similar to the examples seen previously in this chapter, the first task with any script that will write out the file is to gather the data, sort the data, and then to finally write the data out to the file in a format of our own design. The data gathering process is seen in Flowchart 12.1.

The procedures shown in the flowchart are a rather simple task at this point. Our concern for this project will be with constructing and formatting the text. Our goal will be to format the text into something resembling the following:

```
Polygonal Objects :
        Transform : TransformNode Name
           Shape : ShapeNode Name

        Geometry Info :
               Vertices : # of vertices
```

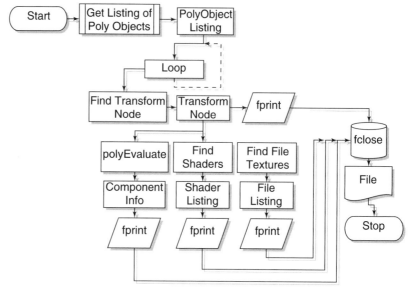

FLOWCHART 12.1 The plan for our data gathering script.

```
            Faces : # of faces
        Triangles : # of triangles
            Edges : # of edges

Shader Info :
        Uses Shader : shader name
        Uses Shader : shader name
```

We will also place the name of all the file textures used, along with their resolutions, at the bottom of the text file, after all the object information. The format for this will be as follows:

```
Texture Files :
            File : full path to file
      Resolution : width x height
```

Notice that the colons of each section are aligned. We will have to carefully construct our strings to keep this alignment, with empty spaces, and possibly tab escape character, \t, used.

Implementation

In Example 12.6, we begin gathering the information on which we want to base our report. For now, we will print out the gathered information to the Script Editor for testing.

EXAMPLE 12.6 The code to find each polygon object and the associated information.

```
global proc sceneReport ()
{
// get a list of every polygonal
// object in the scene
string $meshes[] = `ls -type "mesh"`;

for ( $each in $meshes )
    {
    // Gather Data on each polygon object
    // The parent object of any mesh node will be the
    // transform node associated with the shape node
    string $parents[] = `listRelatives -parent $each`;
    print $parents; // Testing
    print ( $each + "\n" ); // Testing

    // find the component information
    int $components[] = `polyEvaluate
                            -vertex
                            -face
                            -triangle
                            -edge
                            $each`
                            ;

    print $components; // Testing

    // gather the shader information
    string $connections[] = `listConnections $each`;
    string $shaders[];

    for ( $node in $connections )
        if ( `nodeType $node` == "shadingEngine" )
            $shaders[`size $shaders`] = $node;

    $shaders = `stringArrayRemoveDuplicates $shaders`;

    print $shaders; // Testing
    clear $shaders;
    }

// Get list of Image files
string $imageFiles[] = `ls -type "file"`;

for ( $iFile in $imageFiles )
    {
    string $actualFile = `getAttr ( $iFile
                            + ".fileTextureName" )`;
```

```
            int $xRes = `getAttr ( $iFile + ".outSizeX" )`;
            int $yRes = `getAttr ( $iFile + ".outSizeY" )`;

            print ( $actualFile + "\n" ); // Testing
            print ( $xRes + " " ); // Testing
            print ( $yRes + "\n" ); // Testing
            }
        }
```

The text for this script is found on the companion CD-ROM as Chapter_12/project_08/v01/sceneReport.mel.

Obviously, our formatting needs some work, but we can see that we have successfully gathered all our data. Next, in Example 12.7, we add formatting. To adjust our formatting, we first `print` to the Script Editor, using the command `scriptEditorInfo -clearHistory` to clean out the History portion of the Script Editor first. After using `print` statements to properly format the output in the Script Editor window, we can simply change the `print` statement to `fprint` statements to write to the file. We will place our information in a file in the temporary directory.

EXAMPLE 12.7 By changing our print statements to `fprint`, we create our file.

```
global proc sceneReport ()
{
// create a string naming the file. Place it in
// the user's temp directory.
string $fileName = ( `internalVar
                            -userTmpDir`
                            + "sceneReport.txt" ) ;

// Open the file for writing and capture the file
// identifier for later use
int $fileID = `fopen $fileName "w"`;

// get a list of every polygonal object in the scene
string $meshes[] = `ls -type "mesh"`;

for ( $each in $meshes )
    {
    // Gather Data on each polygon object
    // The parent object of any mesh node will be the
    // transform node associated with the shape node
    string $parents[] = `listRelatives -parent $each`;

    for ( $item in $parents )
        fprint $fileID ( $item + "\n" ); // Testing
```

```
        fprint $fileID ( $each + "\n" ); // Testing

        // find the component information
        int $components[] = `polyEvaluate
                            -vertex
                            -face
                            -triangle
                            -edge
                            $each`
                            ;

    for ( $item in $components )
        fprint $fileID ( $item + "\n" ); // Testing

    // gather the shader information
    string $connections[] = `listConnections $each`;
    string $shaders[];

    for ( $node in $connections )
        if ( `nodeType $node` == "shadingEngine" )
            $shaders[`size $shaders`] = $node;
    $shaders = `stringArrayRemoveDuplicates $shaders`;

    for ( $item in $shaders )
        fprint $fileID ( $item + "\n" ); // Testing

    clear $shaders;
    }

// Get list of Image files
string $imageFiles[] = `ls -type "file"`;

for ( $iFile in $imageFiles )
    {
    string $actualFile = `getAttr ( $iFile
                        + ".fileTextureName" )`;
    int $xRes = `getAttr ( $iFile + ".outSizeX" )`;
    int $yRes = `getAttr ( $iFile + ".outSizeY" )`;
    fprint $fileID ( $actualFile + "\n" ); // Testing
    fprint $fileID ( $xRes + " " ); // Testing
    fprint $fileID ( $yRes + "\n" ); // Testing
    }

fclose $fileID;
}
```

ON THE CD

The text for this script is found on the companion CD-ROM as Chapter_12/ project_08/v02/sceneReport.mel.

Now, in the temp directory, we find a properly formatted text file with all the information in it. Obviously, we don't want to force the user to change the MEL code or go searching for the file in his temp directory. We will now add a modal dialog window provided specifically for this situation, the File dialog. The File dialog, shown in Figure 12.1, creates a window allowing the user to point to a directory and select a pre-existing file. Unfortunately, MEL provides no browser for creating a new file.

FIGURE 12.1 The default Maya fileDialog window.

By capturing the return string from the command, `fileDialog`, we get the name of the user's target file. Note that to Maya for Windows, an additional type of file dialog exists, the `fileBrowserDialog`, which provides additional options. If the script is for public distribution and uses the `fileBrowserDialog`, always use the `about` command to confirm that the user is operating in a Windows environment, and use the `fileDialog` if not. In Example 12.8, we implement the `fileDialog` and add some header information to the file. Also note, referring to the complete script on the companion CD-ROM, that we have added a string `return`, the name of the file created. This follows the standard set by Maya, and is simply good practice.

ON THE CD

EXAMPLE 12.8 Implementation of the fileDialog command.

```
global proc sceneReport ()
{
// open a file dialog to name the file.
string $fileName = `fileDialog` ;

// Open the file for writing and capture the file
// identifier for later use
```

```
int $fileID = `fopen $fileName "w"`;

// Add scene file name
string $mayaFile = `file -query -sceneName`;
fprint $fileID ( "Scene Report : " + $mayaFile + "\n" );

// add Maya version information
string $mayaVer = `about -version`;
fprint $fileID ( "Maya Version : " + $mayaVer + "\n\n" );

// get a list of every polygonal object in the scene
. . .
```

The text for this script is found on the companion CD-ROM as Chapter_12/project_08/v03/sceneReport.mel.

ON THE CD

While we could, at this point, consider this tool done, the simple text file, while usable, is somewhat less than presentable. It also is somewhat less than convenient. We will now alter the script to instead create our file in HTML, which can easily be shared on a company's intranet. It also gives us much more robust formatting options.

To begin, we create a template Web page. Using any of the many visual editors available, we can create the Web page to appear in the format we want, including any tables, fonts, and so forth. We can also include images of our texture maps, assuming we are using a format readable by our Web browser as the texture map. Even if that is not the case, we could use system to call on a command-line image editor, like Alias|Wavefront's imgcvt command to convert and resize the image to a Web-compatible format. The Web version of our scene report is seen in Figure 12.2, page 426.

This HTML file, created with Microsoft Word, is then opened in a text editor to take the essential elements. Ideally, a person skilled in hand coding HTML documents could assist, both to optimize the code, and likely improve the overall design of the page.

After editing the HTML code that generates our page to its essential elements, we get the HTML code on the CD-ROM under /chapter12/project_08/html/layout.html. We have used some slightly more advanced features, such as using a font called Tahoma, available on most default OS installations, and thanks to the nature of HTML doesn't do any harm if the font is not installed. By simply adapting this code to our MEL script, and judiciously using the fprint command, we can have Maya generate out a file readable by our Web browser. See Example 12.9.

This script uses an accessory script found on the CD-ROM under /bonus_scripts called dirNameExt.mel. dirNameExt returns a string array, the first index holds the directory, the second holds the filename, and the third holds the extension.

ON THE CD

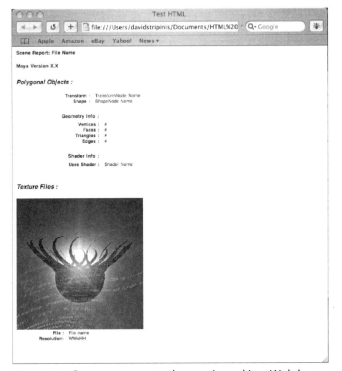

FIGURE 12.2 Our scene report plan as viewed in a Web browser.

EXAMPLE 12.9 Formatting our text into HTML.

```
global proc string sceneReport ()
{
// open a file dialog to name the file.
string $fileName = `fileDialog` ;

// Open the file for writing and capture the file
// identifier for later use
int $fileID = `fopen $fileName "w"`;

// Get scene file name
string $mayaFile = `file -query -sceneName`;

// Add HTML header code
fprint $fileID "<html>\n";
fprint $fileID "<head>\n";
fprint $fileID "<title>\n";
fprint $fileID $mayaFile;
fprint $fileID "</title>\n";
fprint $fileID "<style>\n";
```

```
fprint $fileID "<!--\n";
fprint $fileID "@font-face\n";
fprint $fileID "\t{font-family:Tahoma;\n";
fprint $fileID "\tpanose-1:0 2 11 6 4 3 5 4 4 2;}\n";
fprint $fileID "-->\n";
fprint $fileID "</style>\n";
fprint $fileID "</head>\n\n";
fprint $fileID "<body bgcolor=white style='tab-
                    interval:.5in'>\n";

// Add File Name Info
fprint $fileID "<p>\n";
fprint $fileID "<span style='font-size:13pt;
                    font-family:Tahoma'>\n";
fprint $fileID ( "<b>Scene Report: "
                    + $mayaFile
                    + "</b>\n" );
fprint $fileID "</span>\n";
fprint $fileID "</p>\n";

// add Maya version information
string $mayaVer = `about -version`;
fprint $fileID "<p>\n";
fprint $fileID "<span style='font-size:11pt; font-
                    family:Tahoma'>\n";
fprint $fileID ( "<b>Maya Version "
                    + $mayaVer
                    + "</b>\n" );
fprint $fileID "</span>\n";
fprint $fileID "</p>\n";

// get a list of every polygonal object in the scene
string $meshes[] = `ls -type "mesh"`;
fprint $fileID "<p>\n";
fprint $fileID "<span style='font-size:12pt; font-
                    family:Tahoma'>\n";
fprint $fileID "<b><i>Polygonal Objects :</i></b>
                    </span>\n";
fprint $fileID "</p>\n";

for ( $each in $meshes )
    {

    // Gather Data on each polygon object
    // The parent object of any mesh node will be the
    // transform node associated with the shape node
    string $parents[] = `listRelatives -parent $each`;

    // Build table for transform and shape node
```

```
fprint $fileID "<table border=0 cellspacing=0
                cellpadding=0 style= 'border-
                collapse:collapse'>\n";
fprint $fileID "<tr>\n";
fprint $fileID "<td width=145 valign=top style =
                'width:145pt;padding:0in 5.4pt
                0in 5.4pt'>\n";
fprint $fileID "<p align=right style= 'text-
                align:right'>\n";
fprint $fileID "<span style='font-size:12pt; font-
                family:Tahoma'>\n";
fprint $fileID "<b>Transform :</b></span></p>\n" ;
fprint $fileID "</td>\n" ;
fprint $fileID "<td width=300 valign=top style=
                'width:300pt;padding:0in 5.4pt
                0in 5.4pt'>\n" ;
fprint $fileID "<p> <span style='font-size:9pt;
                font-family:Tahoma'>\n" ;
fprint $fileID $parents[0] ;
fprint $fileID "</span></p>\n" ;
fprint $fileID "</td>\n" ;
fprint $fileID "</tr>\n" ;
fprint $fileID "<table border=0 cellspacing=0
                cellpadding=0 style= 'border-
                collapse:collapse'>\n";
fprint $fileID "<tr>\n";
fprint $fileID "<td width=145 valign=top style =
                'width:145pt;padding:0in 5.4pt
                0in 5.4pt'>\n";
fprint $fileID "<p align=right style= 'text-
                align:right'>\n";
fprint $fileID "<span style='font-size:9pt; font-
                family:Tahoma'>\n";
fprint $fileID "<b>Shape :</b></span></p>\n" ;
fprint $fileID "</td>\n" ;
fprint $fileID "<td width=300 valign=top style=
                'width:300pt;padding:0in 5.4pt
                0in 5.4pt'>\n" ;
fprint $fileID "<p> <span style='font-size:9pt;
                font-family:Tahoma'>\n" ;
fprint $fileID $each ;
fprint $fileID "</span></p>\n" ;
fprint $fileID "</td>\n" ;
fprint $fileID "</tr>\n" ;
fprint $fileID "</table>\n" ;
fprint $fileID " \n" ;

// find the component information
int $components[] = `polyEvaluate
```

```
                                   -vertex
                                   -face
                                   -triangle
                                   -edge
                                   $each`
                                   ;

    // Write the table for the component info
    fprint $fileID "<table border=0 cellspacing=0
                    cellpadding=0 style='border-
                    collapse:collapse'>\n\n" ;
    fprint $fileID "<tr>\n" ;
    fprint $fileID "<td width=163 valign=top style=
                    'width:163pt;padding:0in 5.4pt
                    0in 5.4pt'>\n" ;
    fprint $fileID "<p align=right style='text-
                    align:right'>\n" ;
    fprint $fileID "<span style='font-size:10.0pt;
                    font-family:Tahoma'>\n";
    fprint $fileID "<b>Geometry Info :</b> </span>
                    </p>\n" ;
    fprint $fileID "</td>\n" ;
    fprint $fileID "<td width=280 valign=top style=
                    'width:280pt;padding:0in 5.4pt
                    0in 5.4pt'>\n" ;
    fprint $fileID "<p> </p>\n" ;
    fprint $fileID "</td>\n" ;
    fprint $fileID "</tr>\n\n" ;
    fprint $fileID "<tr>\n" ;
    fprint $fileID "<td width=163 valign=top style=
                    'width:163pt;padding:0in 5.4pt
                    0in 5.4pt'>\n" ;
    fprint $fileID "<p align=right style='text-
                    align:right'>\n" ;
    fprint $fileID "<span style='font-size:9pt; font-
                    family:Tahoma'>\n" ;
    fprint $fileID "<b>Vertices :</b></span></p>\n" ;
    fprint $fileID "</td>\n" ;
    fprint $fileID "<td width=280 valign=top style=
                    'width:280pt;padding:0in 5.4pt
                    0in 5.4pt'>\n" ;
    fprint $fileID "<p><span style='font-size:9pt;
                    font-family:Tahoma'>\n" ;
    fprint $fileID $components[0];
    fprint $fileID "</span></p>\n" ;
    fprint $fileID "</td>\n" ;
    fprint $fileID "</tr>\n" ;
    fprint $fileID "<tr>\n" ;
    fprint $fileID "<td width=163 valign=top style=
```

```
                                    'width:163pt;padding:0in 5.4pt
                                    0in 5.4pt'>\n" ;
        fprint $fileID "<p align=right style='text-
                                    align:right'>\n" ;
        fprint $fileID "<span style='font-size:9pt; font-
                                    family:Tahoma'>\n" ;
        fprint $fileID "<b>Faces :</b></span></p>\n" ;
        fprint $fileID "</td>\n" ;
        fprint $fileID "<td width=280 valign=top style=
                                    'width:280pt;padding:0in 5.4pt
                                    0in 5.4pt'>\n" ;
        fprint $fileID "<p><span style='font-size:9pt;
                                    font-family:Tahoma'>\n" ;
        fprint $fileID $components[1];
        fprint $fileID "</span></p>\n" ;
        fprint $fileID "</td>\n" ;
        fprint $fileID "</tr>\n" ;
        fprint $fileID "<tr>\n" ;
        fprint $fileID "<td width=163 valign=top style=
                                    'width:163pt;padding:0in 5.4pt
                                    0in 5.4pt'>\n" ;
        fprint $fileID "<p align=right style='text-
                                    align:right'>\n" ;
        fprint $fileID "<span style='font-size:9pt; font-
                                    family:Tahoma'>\n" ;
        fprint $fileID "<b>Triangles :</b></span></p>\n" ;
        fprint $fileID "</td>\n" ;
        fprint $fileID "<td width=280 valign=top style=
                                    'width:280pt;padding:0in 5.4pt
                                    0in 5.4pt'>\n" ;
        fprint $fileID "<p><span style='font-size:9pt;
                                    font-family:Tahoma'>\n" ;
        fprint $fileID $components[2];
        fprint $fileID "</span></p>\n" ;
        fprint $fileID "</td>\n" ;
        fprint $fileID "</tr>\n" ;
        fprint $fileID "<tr>\n" ;
        fprint $fileID "<td width=163 valign=top style=
                                    'width:163pt;padding:0in 5.4pt
                                    0in 5.4pt'>\n" ;
        fprint $fileID "<p align=right style='text-
                                    align:right'>\n" ;
        fprint $fileID "<span style='font-size:9pt; font-
                                    family:Tahoma'>\n" ;
        fprint $fileID "<b>Edges :</b></span></p>\n" ;
        fprint $fileID "</td>\n" ;
        fprint $fileID "<td width=280 valign=top style=
                                    'width:280pt;padding:0in 5.4pt
                                    0in 5.4pt'>\n" ;
```

```
fprint $fileID "<p><span style='font-size:9pt;
                  font-family:Tahoma'>\n" ;
fprint $fileID $components[3];
fprint $fileID "</span></p>\n" ;
fprint $fileID "</td>\n" ;
fprint $fileID "</tr>\n" ;
fprint $fileID "</table>\n" ;
fprint $fileID " \n" ;

// gather the shader information
string $connections[] = `listConnections $each`;
string $shaders[];

for ( $node in $connections )
    if ( `nodeType $node` == "shadingEngine" )
        $shaders[`size $shaders`] = $node;

$shaders = `stringArrayRemoveDuplicates $shaders`;

fprint $fileID "<table border=0 cellspacing=0
                  cellpadding=0 style='border -
                  collapse:collapse'>\n" ;
fprint $fileID "<tr>\n" ;
fprint $fileID "<td width=163 valign=top style=
                  'width:163pt;padding:0in 5.4pt
                  0in 5.4pt'>\n" ;
fprint $fileID "<p align=right style='text -
                  align:right'>\n" ;
fprint $fileID "<span style='font-size:10.0pt;
                  font-family:Tahoma'>\n" ;
fprint $fileID "<b>Shader Info :</b></span></p>\n";
fprint $fileID "</td>\n" ;
fprint $fileID "<td width=280 valign=top style=
                  'width:280pt;padding:0in 5.4pt
                  0in 5.4pt'>\n" ;
fprint $fileID "  \n" ;
fprint $fileID "</td>\n" ;
fprint $fileID "</tr>\n" ;

// Loop builds table of every shader used
for ( $eachShader in $shaders )
    {
    fprint $fileID "<tr>\n" ;
    fprint $fileID "<td width=163 valign=top style=
                      'width:163pt;padding:0in 5.4pt
                      0in 5.4pt'>\n" ;
    fprint $fileID "<p align=right style= 'text-
                      align:right'>\n" ;
    fprint $fileID "<span style='font-size:9pt;
```

```
                              font-family:Tahoma'>\n" ;
            fprint $fileID "<b>Uses Shader :</b>";
            fprint $fileID "</span></p>\n" ;
            fprint $fileID "</td>\n" ;
            fprint $fileID "<td width=280 valign=top style=
                              'width:280pt;padding:0in 5.4pt
                              0in 5.4pt'>\n" ;
            fprint $fileID "<p><span style='font-size:9pt;
                              font-family:Tahoma'>\n" ;
            fprint $fileID $eachShader;
            fprint $fileID "</span></p>\n" ;
            fprint $fileID "</td>\n" ;
            fprint $fileID "</tr>\n" ;
            }

        fprint $fileID "</table>\n" ;
        fprint $fileID "  \n\n" ;
        fprint $fileID "  \n\n" ;
        fprint $fileID "  \n\n" ;
        }

    // Get list of Image files
    string $imageFiles[] = `ls -type "file"`;
    fprint $fileID "  \n\n" ;
    fprint $fileID "<p><span style='font-size:12pt;font-
                      family:Tahoma'>\n" ;
    fprint $fileID "<b><i>Texture Files :" ;
    fprint $fileID "</i></b></span></p>\n" ;

    for ( $iFile in $imageFiles )
        {
        string $actualFile = `getAttr ( $iFile
                      + ".fileTextureName" )`;

        int $xRes = `getAttr ( $iFile + ".outSizeX" )`;
        int $yRes = `getAttr ( $iFile + ".outSizeY" )`;

        fprint $fileID "<img width=256 height=256 src=\"\n" ;
        fprint $fileID $actualFile ;
        fprint $fileID "\">\n" ;
        fprint $fileID "<table border=0 cellspacing=0
                      cellpadding=0 style='border-
                      collapse:collapse'>\n" ;
        fprint $fileID "<tr>\n" ;
        fprint $fileID "<td width=60 valign=top style=
                      'width:60pt;padding:0in 5.4pt
                      0in 5.4pt'>\n" ;
        fprint $fileID "<p align=right style= 'text-
                      align:right'>\n" ;
```

```
            fprint $fileID "<span style='font-size:9pt; font-
                            family:Tahoma'>\n" ;
            fprint $fileID "<b>File :</b></span></p>\n" ;
            fprint $fileID "</td>\n" ;
            fprint $fileID "<td width=352 valign=top style=
                            'width:352pt;padding:0in 5.4pt
                            0in 5.4pt'>\n" ;
            fprint $fileID "<p><span style='font-size:9pt;
                            font-family:Tahoma'>\n" ;
            fprint $fileID $actualFile ;
            fprint $fileID "</span></p>\n" ;
            fprint $fileID "</td>\n" ;
            fprint $fileID "</tr>\n" ;
            fprint $fileID "<tr>\n" ;
            fprint $fileID "<td width=60 valign=top style=
                            'width:60pt;padding:0in 5.4pt
                            0in 5.4pt'>\n" ;
            fprint $fileID "<p align=right style= 'text-
                            align:right'>\n" ;
            fprint $fileID "<span style='font-size:9pt; font-
                            family:Tahoma'>\n" ;
            fprint $fileID "<b>Resolution:</b></span></p>\n";
            fprint $fileID "</td>\n" ;
            fprint $fileID "<td width=352 valign=top style=
                            'width:352pt;padding:0in 5.4pt
                            0in 5.4pt'>\n" ;
            fprint $fileID "<p><span style='font-size:9pt;
                            font-family:Tahoma'>\n" ;
            fprint $fileID ( $xRes + "x" + $yRes );
            fprint $fileID "</span></p>\n" ;
            fprint $fileID "</td>\n" ;
            fprint $fileID "</tr>\n" ;
            fprint $fileID "</table>\n" ;
            }

    // print the footer
    fprint $fileID "</body>\n" ;
    fprint $fileID "</html>\n" ;

    // Close the file
    fclose $fileID ;

    // Return the created file
    return $fileName;
    }
```

The text for this script is found on the companion CD-ROM as Chapter_12/
ON THE CD *project_08/final/sceneReport.mel.*

Project Conclusion and Review

We have seen how by using the file writing capabilities of MEL, we are able to create both simple text files and more robust documents for human consumption. Note that the second file we created was, in fact, code to be interpreted by other software. Using Maya to create external files is a wonderful way to share information about a scene with users who might not have ready access to Maya, or to coordinate productions from remote locations. ✂

PROJECT

12.2: Skin Weight Info

Introduction

When writing out files for consumption by the computer, rather than by human eyes, different considerations need to be accounted for. As with MEL scripts, the whitespace and formatting of the file is largely irrelevant to the application. This is not to say that these qualities should be ignored. Formatting a file so it can easily be comprehended by a human user allows us to exploit the external file, perhaps bringing in data from an external program like Microsoft Excel, or to manually debug the file. In this project, we will create an external file format that stores the `skinCluster` information of all selected meshes, ignoring component numbers, allowing the exporting of skinning data regardless of history changes that might occur after the export. Both our import and export routines will deal with vertices according to explicit world space locations. By doing so, we counter any component renumbering that might occur due to the actions of the user, and overcomes the flaw of using images to store weight info, as importing that information is reliant on UV co-ordinates.

Design

Our tool is by necessity made of two procedures. The first writes out the file, and is shown in Flowchart 12.2. The second script, which reads in the skinning data is shown in Flowchart 12.3, page 436.

There are a couple of issues related to the design of which we should be aware. First, we are relying on the user selecting the skin objects in the same order, and that none of the joints will be renamed. Although this is a slight hindrance to the end user, it could be remedied by a clever UI, if we so desired. For now, we will simply construct the script and leave the UI for later.

We also need to develop a format for our file. First, we determine what information we need to store.

- Mesh name
- Skin cluster name

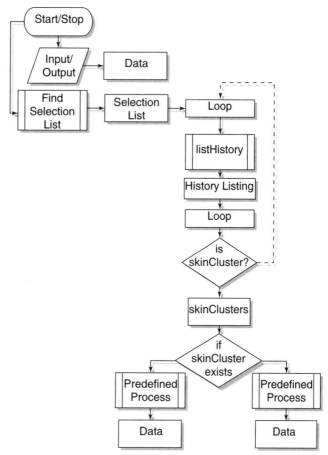

FLOWCHART 12.2 The procedure to write out the file.

- Skin cluster influences
- Component identifier (component location)
- Influence/component relationship

While the name of the mesh and skin cluster are largely irrelevant, they will help for matters of bookkeeping and error checking. To store each of these pieces of information, we will head each section with an appropriate labeling string. In Example 12.10, we layout a dummy file structure.

EXAMPLE 12.10 Our desired file layout.

```
[mesh]
meshName
```

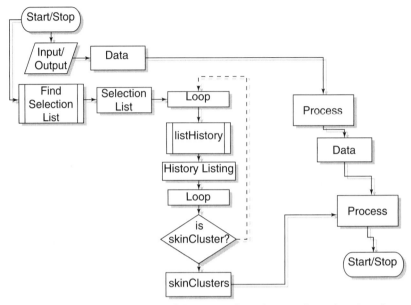

FLOWCHART 12.3 The flowchart of the procedure that reads in skinning data.

```
[skincluster]
skinclusterName

 [influences]
 influence influence influence influence
 influence influence . . .

[components]
 x.xxxxxx y.yyyyyy z.zzzzzz
  influence_value
  influence_value
  influence_value
  . . .
 x.xxxxxx y.yyyyyy z.zzzzzz
  influence_value
  influence_value
  influence_value
  . . .
[mesh]
meshName

 [skincluster]
 skinclusterName

 . . .
```

We optimize readability while still retaining an effective and clean format for reading the data into the computer. By bracketing the header labels, we can easily find them using the `substring` command and a conditional statement to compare the first character of the retrieved word to the character "[" to find the headers.

Implementation

We begin our script simply enough by declaring our write-out procedure. In Example 12.11 we start, including a `fileDialog` to choose the location of the file.

EXAMPLE 12.11 The start of our procedure, finding the file to write to.

```
global proc string skinDataOut ()
{
// open a file dialog to name the file.
string $fileName = `fileDialog` ;

// Open the file for writing and capture the file
// identifier for later use
int $fileID = `fopen $fileName "w"`;

return $fileName;

fclose $fileID;
}
```

ON THE CD

The text for this script is found on the companion CD-ROM as Chapter_12/ project_09/part_01/v01/skinDataOut.mel.

Next, we begin gathering data from the scene we need to create our file. We get the user's selection list, and parse the history of each object in that list, looking for `skinCluster` nodes. In Example 12.12, we can begin to gather data, format it, and write it out to a file.

EXAMPLE 12.12 Finding the data for each of skinClusters and writing it out to the file.

```
global proc string skinDataOut ()
{
// open a file dialog to name the file.
string $fileName = `fileDialog` ;

// Open the file for writing and capture the file
// identifier for later use
```

```
    int $fileID = `fopen $fileName "w"`;

    // Gather user selection
    string $selList[] = `ls -selection`;

    // parse selection list
    for ( $obj in $selection )
        {
        string $hisList[] = `listHistory $obj` );
        string $sknClstr;

        for ( $aNode in $hisList )
            if ( `nodeType $aNode` == "skinCluster" )
                $sknClstr = $aNode;

        // add mesh header and mesh name
        fprint $fileID "[mesh]\n";
        fprint $fileID ( $obj + "\n\n" );

        // add skin header and cluster name
        fprint $fileID " [skincluster]\n";
        fprint $fileID ( " " + $sknClstr + "\n\n" );
        }

    return $fileName;

    fclose $fileID;
    }
```

ON THE CD

The text for this script is found on the companion CD-ROM as Chapter_12/ project_09/part_01/v02/skinDataOut.mel.

Next, we can go and retrieve the names of the influences associated with each skin cluster, using the `skinCluster` command. To format the listing of influences so there are only four per line, we use an integer variable with a conditional statement to add a new line character and indentation when appropriate. We see this used in Example 12.13.

EXAMPLE 12.13 Using a simple conditional statement to add text formatting.

```
    // parse selection list
    for ( $obj in $selection )
        {
        string $hisList[] = `listHistory $obj` );
        string $sknClstr;

        for ( $aNode in $hisList )
```

```
    if ( `nodeType $aNode` == "skinCluster" )
        $sknClstr = $aNode;

// add mesh header and mesh name
fprint $fileID "[mesh]\n";
fprint $fileID ( $obj + "\n\n" );

// add skin header and cluster name
fprint $fileID " [skincluster]\n";
fprint $fileID ( " " + $sknClstr + "\n\n" );

// get a list of all the influences used by skin
string $infList[] = `skinCluster –query $sknClstr`;

// add the influences
fprint $fileID " [influences]\n  ";

int $n = 1;
for ( $aInf in $infList )
    {
    fprint $fileID $aInf;
    $n++;
    if ( $n > 4 )
        {
        fprint $fileID "\n  ";
        $n = 1;
        }
    else
        fprint $fileID " ";
    }
}
```

ON THE CD

The text for this script is found on the companion CD-ROM as Chapter_12/ project_09/part_01/v03/skinDataOut.mel.

The last piece of our file is to write out the vertex designations. Unfortunately, this has two problems. Although we are using the vertex locations in world space as the identifier in our file, internally we must query the weighting values using their component index. Because a user might have placed history after the skin cluster node and changed the component numbers, our actual query might be faulty. There is, unfortunately, no way to avoid this; it simply must be documented with the tool. The second problem relates to one of floating-point precision. In Example 12.14, we create a variable holding a relatively precise floating-point number, and then print it out.

EXAMPLE 12.14 Demonstration of the lack of precision of printing out floating-point values.

```
float $floatTest = 0.1234567890123 ;
print $floatTest ;
// Result : 0.123456
```

We get six places of floating-point precision even when our floating point contains whole number values, seen in Example 12.15.

EXAMPLE 12.15 Precision is independent of the integer value.

```
float $floatTest = 1234.1234567890123 ;
print $floatTest ;
// Result : 1234.123456
```

We start to lose important detail at this point. Alias|Wavefront's suggestion is to convert the float value to a string, seen in Example 12.16.

EXAMPLE 12.16 Conversion to a string adds precision to numbers, but is limited to 11 characters.

```
float $floatTest = 0.1234567890123 ;
string $floatString = $floatTest ;
print $floatString ;
// Result : 0.123456789
```

This provides slightly more precision, unless we start dealing with floats above an absolute value of 1000. In Example 12.17, we see how we begin to get major data loss.

EXAMPLE 12.17 The 11 characters include the integer values of the number.

```
float $floatTest = 123456789.1234567890123 ;
string $floatString = $floatTest ;
print $floatString ;
// Result : 123456789.1
```

This could cause problems as we progress, not only on this script but as we progress into increasingly detailed file writing and scripts that might require extreme amounts of precision and detail. This is why we have created a custom accessory procedure, `preciseFloatString.mel`, seen in Example 12.18.

EXAMPLE 12.18 A script that gives a workaround to this issue.

```
global proc string preciseFloatString ( int $precision,
                                         float $value )
```

```
{
string $convertedString = ".";

// get only the number to the left of the decimal point
int $baseInteger = $value;

// get only the number to the right of the decimal point
$value = abs($value - $baseInteger );

// build new decimal value
while ( `size $convertedString` < ( $precision + 1 ) )
    {
    // 0.123 becomes 1.23
    $value = ( $value * 10 );
    // get only the number to the left of the decimal point
    int $digitToAddToString = $value;

    // build string
    $convertedString = ( $convertedString
                                  + $digitToAddToString );

    // get only the number to the right of the decimal point
    $value = abs( $value - $digitToAddToString );
    }

// add original integer
$convertedString = ( $baseInteger + $convertedString );

return $convertedString;
}
```

The text for this script is found on the companion CD-ROM as bonusscripts/ preciseFloatString.mel.

ON THE CD

Now, we can use this in our file write out string to construct extremely precise number strings to write to our file. When read back in, these numbers will retain all their precision, converted back to floats. See Example 12.19.

EXAMPLE 12.19 Use of the preciseFloatString script in our file writeout script.

```
// find number of vertices
      $numVerts = `polyEvaluate -vertex $each`;

      // add the component information
      fprint $fileID "\n\n [components]\n "

      for ( $n = 0; $n< $numVerts; $n++ )
```

```
{
float $pos[] = `xform –query
                     –transform –worldspace
                     ( $each + ".vtx[" + $n + "]" )`;
fprint $fileID `preciseFloatString 15 $pos[0]`;
fprint $fileID " " ;
fprint $fileID `preciseFloatString 15 $pos[1]`;
fprint $fileID " " ;
fprint $fileID `preciseFloatString 15 $pos[2]`;
fprint $fileID "\n" ;

for ( $aInf in $infList )
    {
    float $weight = `skinPercent
                        -transform $aInf
                        -query
                        $sknClstr
                        ( $each + ".vtx["
                        + $n + "]" )`;
    fprint $fileID " " ;
    fprint $fileID
        `preciseFloatString 15 $weight`;
    fprint $fileID "\n" ;
    }
}
```

ON THE CD

The text for this script is found on the companion CD-ROM as Chapter_12/ project_09/part_01/final/skinDataOut.mel.

Now, we can run the script to export out a file from a valid scene. Next, we have to create the script to read our data back in. See Example 12.20.

EXAMPLE 12.20 The procedure to read the data back in.

```
global proc string skinDataIn ()
{
// open a file dialog to name the file.
string $fileName = `fileDialog` ;

// Open the file for writing and capture the file
// identifier for later use
int $fileID = `fopen $fileName "r"`;

// Get the first line of the file, and declare an
// array to hold the entirety of the file
string $word = `fgetword $fileID`;
string $fileContents[];

// continue as long as fgetline returns info
```

```
while ( `feof $fileID` == 0 )
    {
    $fileContents[`size $fileContents`] = $word;
    $word = `fgetword $fileID`;
    }

// close out the file
fclose $fileID;

// test read data
for ( $eachItem in $fileContents )
    print ( $eachItem + "\n" );
}
```

The text for this script is found on the companion CD-ROM as Chapter_12/ project_09/part_02/v01/skinDataIn.mel.

This successfully reads in the file, and prints it out to the Script Editor. We now need to parse the data. In Example 12.21, we begin searching the read in data for headers by checking each string to see if it begins with" "[".

EXAMPLE 12.21 Code used to parse the data to find the section headers.

```
// test read data
    for ( $eachItem in $fileContents )
        if ( `substring $eachItem 1 1` == "[" )
            print ( $eachItem + "\n" );
```

The text for this script is found on the companion CD-ROM as Chapter_12/ project_09/part_02/v02/skinDataIn.mel.

While this allows us to very quickly find the section headers, it does not let us find the data held in any logical manner. What we need to do is combine both the data and a call to a procedure to handle the compiled data. In Example 12.22, we parse the array, sorting data into separate arrays that are then passed to a separate procedure.

EXAMPLE 12.22 The code to sort the data into appropriate variable arrays.

```
$n = 0
while ( $n < `size $fileContents` )
    {
    vector $vrt;
    string $influences[];
    float $weights;
```

```
if ( $fileContents[$n] == "[mesh]" )
    {
    while ( $fileContents[$n] != "[influences]" )
        $n++ ;
    while (`substring $fileContents[++$n] 1 1`
            != "[" )
        $influences[`size $influences`] =
                $fileContents[$n] ;

if ($fileContents[$n] == "[components]" )
    {
    while (`substring $fileContents[$n] 1 1`
            != "[" )
        {
        $vrt = << $fileContents[++$n],
                $fileContents[++$n],
                $fileContents[++$n] > ;

        // read in one number for each influence
        for ($i=0;$i<`size $influences`;$i++ )
            $weights[`size $weights`] =
                    $fileContents[++$n];

        // Separate editing procedure
        skinReadEdit $vrt $influences $weights;

        // clear out weights to hold fresh date
        clear $weights;
        }
    }
    }
}
```

ON THE CD *The text for this script is found on the companion CD-ROM as Chapter_12/ project_09/part_02/final/skinDataIn.mel.*

This is possibly some of the most complicated code we have yet created. Flowchart 12.4 illustrates how this read-in code functions.

Although it is a lengthy process to execute, this method produces very good results, although some tweaking of tolerances in the skinReadEdit pro-

ON THE CD cedure, found on the companion CD-ROM under Chapter_12/project_09/skin-ReadEdit.mel.

Project Conclusion and Review

As we have seen, it is more than possible to create files that are easily readable by both human and computer. There are a vast number of file formats from

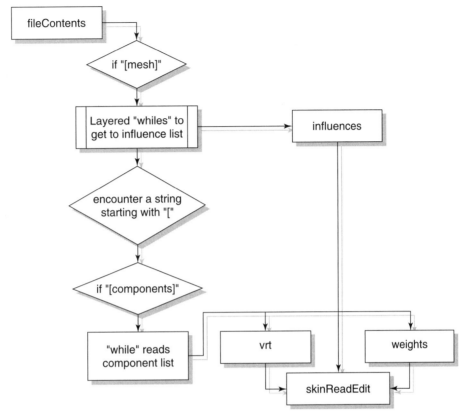

FLOWCHART 12.4 A diagram to clarify the code used to parse our data.

which to glean ideas. For example, we could have used HTML as a basis, and used [mesh] and [/mesh] to bracket each object. We could have put a header into the file to let us know how many objects exist. The robustness and structure of a file format is a question of how much time can be dedicated to it and what its primary purpose is. We have also learned that occasionally, data errors might not be the fault of the code, but the way Maya handles data, and we must be prepared to react to these issues.

Project Script Review

skinDataOut.mel

```
global proc string skinDataOut ()
{
// open a file dialog to name the file.
```

```
string $fileName = `fileDialog` ;

// ensure we create a .skin file
string $splitFile[] = `dirName $fileName`;
$fileName = ( $splitFile[0] + $splitFile[1] + ".skin" )

// Open the file for writing and capture the file
// identifier for later use
int $fileID = `fopen $fileName "w"`;

// Gather user selection
string $selList[] = `ls -selection`;

// parse selection list
for ( $obj in $selection )
    {
    string $hisList[] = `listHistory $obj` );
    string $sknClstr;

    for ( $aNode in $hisList )
        if ( `nodeType $aNode` == "skinCluster" )
            $sknClstr = $aNode;

    // add mesh header and mesh name
    fprint $fileID "[mesh]\n";
    fprint $fileID ( $obj + "\n\n" );

    // add skin header and cluster name
    fprint $fileID " [skincluster]\n";
    fprint $fileID ( " " + $sknClstr + "\n\n" );

    // get a list of all the influences used by skin
    string $infList[] = `skinCluster -query $sknClstr`;

    // add the influences
    fprint $fileID "  [influences]\n  ";

    int $n = 1;
    for ( $aInf in $infList )
        {
        fprint $fileID $aInf;
        $n++;
        if ( $n > 4 )
            {
            fprint $fileID "\n  ";
            $n = 1;
            }
        else
            fprint $fileID " ";
```

```
        }

    // find number of vertices
    $numVerts = `polyEvaluate -vertex $each`;

    // add the component information
    fprint $fileID "\n\n [components]\n "

    for ( $n = 0; $n< $numVerts; $n++ )
        {
        float $pos[] = `xform -query
                        -transform -worldspace
                        ( $each + ".vtx[" + $n + "]" )`;
        fprint $fileID `preciseFloatString 15 $pos[0]`;
        fprint $fileID " " ;
        fprint $fileID `preciseFloatString 15 $pos[1]`;
        fprint $fileID " " ;
        fprint $fileID `preciseFloatString 15 $pos[2]`;
        fprint $fileID "\n" ;

        for ( $aInf in $infList )
            {
            float $weight = `skinPercent
                            -transform $aInf
                            -query
                            $sknClstr
                            ( $each + ".vtx["
                            + $n + "]" )`;
            fprint $fileID " " ;
            fprint $fileID
                `preciseFloatString 15 $weight`;
            fprint $fileID "\n" ;
            }
        }
    }

return $fileName;

fclose $fileID;
}
```

skinDataIn.mel

```
global proc string skinDataIn ()
{
// open a file dialog to name the file.
string $fileName = `fileDialog` ;

// Open the file for writing and capture the file
```

```
// identifier for later use
int $fileID = `fopen $fileName "r"`;

// Get the first line of the file, and declare an
// array to hold the entirety of the file
string $word = `fgetword $fileID`;
string $fileContents[];

// continue as long as fgetline returns info
while ( `feof $fileID` == 0 )
    {
    $fileContents[`size $fileContents`] = $word;
    $word = `fgetword $fileID`;
    }

// close out the file
fclose $fileID;

$n - 0
while ( $n < `size $fileContents` )
    {
    vector $vrt;
    string $influences[];
    float $weights;

    if ( $fileContents[$n] == "[mesh]" )
        {
        while ( $fileContents[$n] != "[influences]" )
            $n++ ;
        while (`substring $fileContents[++$n] 1 1`
                    != "[" )
            $influences[`size $influences`] =
                        $fileContents[$n] ;

    if ($fileContents[$n] == "[components]" )
        {
        while (`substring $fileContents[$n] 1 1`
                    != "[" )
            {
            $vrt = << $fileContents[++$n],
                        $fileContents[++$n],
                        $fileContents[++$n] > ;

            // read in one number for each influence
            for ($i=0;$i<`size $influences`;$i++ )
                $weights[`size $weights`] =
                            $fileContents[++$n];

            // Separate editing procedure
```

```
        skinReadEdit $vrt $influences $weights;

        // clear out weights to hold fresh date
        clear $weights;
        }
    }
    }
  }
}
```

UNDERSTANDING THE MAYA ASCII FILE

The Maya ASCII file format is a MEL script. It follows some very specific rules and specifications, but it is at its core simply a collection of a small handful of commands. While it is possible to embed further commands directly into a Maya ASCII, or .ma, file with a text editor after the fact, Maya will not save this information with the file if the file is resaved within Maya. To embed MEL commands in a Maya file, use a `scriptNode`.

There can be multiple reasons to open and edit a Maya ASCII file in a text editor. As Maya has evolved, many of the so-called "tricks" people would do, such as changing time settings without moving keyframes have been addressed by Alias|Wavefront in the interface. But one still popular reason to edit .ma files is to bring data into an earlier version of Maya. Moreover, occasionally a scene file will have "issues," as it were. If the file is causing an artist grief, and is saved as a .ma file, it can be opened in a text editor and debugged. For this reason alone, many production facilities work exclusively with the Maya ASCII format.

Understanding the Maya ASCII format will allow you to open and edit the files in a text editor, and write software for other programs that will properly write to the Maya ASCII format. This can be as simple as a model exporter, although supporting all the geometry types that Maya supports could be challenging, to the full export of animation, lights, colors, and materials. In fact, Maya exports shading networks as Maya ASCII files.

A .ma file is split into eight distinct sections:

- Header
- File referencing
- Requirements
- Units
- Body
- Script nodes
- Disconnections
- Connections

The file must be constructed in this order.

The header information, which must begin with the six characters `//Maya`, details such information as how and when the file was created. Other than the first six characters, the header section is a standard Maya comment block.

The next section contains the list of file references, using the `file` command. This is one of the sections that often proves useful, changing references or eliminating them completely from the file. Note that not every scene uses file referencing, so this section might be empty.

Following the file references is the requirements section. This is simply a series of `requires` statements. At minimum, it contains a minimum version of Maya that is needed to open the file. This is where we must make our edits if we want to open a file in an earlier version. Note that this can still cause errors, if the file uses features of the newer version, and can completely be invalidated if there are nodes dependent on these new features. Note that in the past, Maya has used non-numeric version numbers. Although, due to customer complaints, this is not likely to occur again, be prepared to handle version checks based on string information, rather than numeric. Be aware, this section is also where any plug-in requirements are stated.

Next is the units section, where the `currentUnit` command is used to set the file's operating settings.

The body of the file is most often the lengthiest section. Consisting of a series of `createNode` and `setAttr` commands, the main body of the file creates the majority of what is in the scene file. This section can also contain the `addAttr` command and the `parent` command for nodes that cannot be parented upon creation.

The script node section is where script nodes, both user created and those native to Maya scenes, like the `animationScriptNode`, are created.

The final two sections of the Maya ASCII file disconnect and connect various attributes together. For example, if the scene contains an animated ball, the ball and the animation curves are created in the main body, and then the curves are connected to the ball in this section.

CONCLUSION

Now that we have an understanding of how MEL and Maya interact with files on disk, a whole world of possibilities is open to us. Although many programmers turn to the API to develop import and export plug-ins, it is possible to create much of the same functionality using MEL. By using custom file formats, we can trade Maya scene information independent of a Maya file itself. We have also learned how, by leveraging our understanding of MEL with the use of Maya ASCII files, we can aid productions by retrieving data, debugging scenes, or quickly making changes using a text editor.

13 YOUR JOURNEY BEGINS HERE: A FINAL WORD ON MEL

With that last project, we bring our lessons to an end. However, this does not bring the learning to an end. MEL is a very broad, very deep subject that we have only barely begun to broach. The language is ever evolving, with a handful of commands being added and revised with each release of Maya. As new elements are added to the Maya feature set, the corresponding MEL commands are also added. In addition, Alias|Wavefront responds to the requests of its users, and continually adds additional commands and flags independent of the main feature set. Recent additions of this nature include the `progessWindow` and the `scriptEditorInfo` commands.

In addition, previously existing commands can change. Arguments might be added or sometimes removed, or might become redundant. For this reason, it is sometimes necessary to revise scripts to account for these changes in behavior.

Of course, the other aspect of our learning was our journey into programming. We literally only glimpsed a fraction of what is possible with MEL. We covered the creation and editing of geometry. We discovered how to use script jobs to seamlessly integrate our own functionality into Maya. We also learned how to access the nodes that contribute to the history and animation of objects within Maya, whether that animation comes from animation curves or expressions.

Finally, we learned all the many ways to bring the Maya interface under our control. By building windows, panels, and heads-up displays, we put the powerful tools we create with MEL under the control of artists

Throughout this book we learned that MEL is just that—a way of putting Maya completely under the control of an artist. By using the skills

learned over the previous pages, a whole new world of possibilities is open to you.

However, this is not to say that we know all there is to know about MEL or programming. With every release, new features and capabilities are added to Maya. With these new features come new commands and capabilities to the MEL toolbox. Moreover, because the world of computer graphics is still a rapidly developing field of discovery, each year brings new techniques and technologies that can be implemented by a diligent scripter. Be sure to visit the Web page for this book on *www.charlesriver.com* to see if there are any updates for newer versions of Maya that add functionality to MEL as well.

Simply picking up this book and working through its pages proves that you have what it takes to be a successful scripter: the inner desire to expand your knowledge with new skills. The greatest toolbox ever offered to a 3D artist is now open to you. Now, it is up to you to exploit it.

A ABOUT THE CD-ROM

The companion CD-ROM contains iterative versions of the scripts for the projects within this book. The general structure is as follows:

Project_##/v#/script.mel

By using this structure, each version of a script file can be copied directly to a user's scripts directory. Note that the scripts in Chapter 12 will not function in Maya PLE, which has the file handling commands disabled.

To get the full value of this book, you should take the time to create the script files to completely understand the syntax involved.

Also included on the CD-ROM are image and Maya files used in the projects where noted.

SYSTEM REQUIREMENTS

Maya Complete 4.0 or later on any available platform. Maya PLE 4.5 users cannot use the file functions of MEL. An external text editor suited to programming, such as Edit Plus, vi, or Visual SlickEdit, is recommended, but not required.

B WEB RESOURCES

CHARLES RIVER MEDIA

www.charlesriver.com
This is the publisher of this book. Here you will find a wide variety of books related to all aspects of computer graphics, from books designed for the artist to those specifically for programmers. Plus, there might be updated scripts when a new version of Maya becomes available.

ALIAS|WAVEFRONT

www.aliaswavefront.com
This is the Web site of Maya's developer. Essential for finding the latest updates to the Maya software, frequent releases of scripts and tools for Maya, and tutorials on all aspects of Maya.

MATHWORLD

http://mathworld.wolfram.com
This is the developer of the Mathmatica software, an advanced tool for scientific and mathematical research. This site should always be your first stop for any research into mathematics, from geometry to trigonometry to complex equations understandable only by those with advanced degrees.

ACM SIGGRAPH

www.siggraph.org
This is the Web site for the ACM SIGGRAPH organization. Provides information on the annual worldwide conference and the many local chapters, as well as a store to purchase the proceedings from past conferences. As mentioned, these proceedings can provide insight and methodologies into the latest computer graphics research.

GAMAGROUP

www.gamasutra.com
www.gdconf.com
From the people behind *Game Developer Magazine* come Gamasutra and the Game Developers Conference. This site provides information on the fastest growing field of computer graphics, and the ability to purchase conference proceedings and back issues of the magazine. Useful to more than just game developers, as many of the routines demonstrated are optimized to run in real time. In addition, a wonderful place to find actual application of behavioral equations.

HIGHEND 3D

www.highend3d.com
The most complete site on the Web for all Maya information, Highend 3D also serves as the MEL scripting repository. Almost every publicly available MEL script can be found here for download. A wonderful place to distribute scripts or find other scripts for inspiration. Highend3d.com also provides multiple e-mail listserves dedicated to Maya, including one exclusively for those dealing with Maya programming issues.

INDEX